HOMO
AESTHETICUS

HOMO AESTHETICUS

Where Art Comes From and Why

ELLEN DISSANAYAKE

THE FREE PRESS

A Division of Macmillan, Inc.
New York

Maxwell Macmillan Canada
Toronto

Maxwell Macmillan International
New York • Oxford • Singapore • Sydney

Copyright © 1992 by Ellen Dissanayake

The Free Press
A Division of Macmillan, Inc.
866 Third Avenue, New York, N.Y. 10022

Maxwell Macmillan Canada, Inc.
1200 Eglinton Avenue East
Suite 200
Don Mills, Ontario M3C 3N1

Macmillan, Inc. is part of the Maxwell Communication Group of Companies.

Printed in the United States of America

printing number
1 2 3 4 5 6 7 8 9 10

Library of Congress Cataloging-in-Publication Data

Dissanayake, Ellen.
 Homo aestheticus : where art comes from and why / Ellen Dissanayake.
 p. cm.
 Includes bibliographical references.
 ISBN 0-02-907885-7
 1. Aesthetics. I. Title.
BH39.D56 1992
701'.17—dc20 91-45335
 CIP

The author and the publisher gratefully acknowledge permission to reproduce the following material:

Page 47. Photograph: Ernst Haas.

Page 57. United Nations Photo 148530, Carolyn Redenius.

Page 59. Photograph: Don Mohr.

Page 60. Photograph: Jimmie Froehlich.

Page 65. Negative No. 2A 17188, courtesy Department of Library Services, American Museum of Natural History. Photograph: Rota.

Page 67. UNICEF 760/84/NEPAL, Heidi Larson.

Page 80. Negative No. 15511, courtesy Department of Library Services, American Museum of Natural History.

Page 93. Negative No. 325944, courtesy Department of Library Services, American Museum of Natural History. Photograph: Yourow.

Page 103. Photograph: Michael O'Hanlon.

Page 106. United Nations Photo 96730.

Page 110. Photograph: Michael O'Hanlon.

Page 119. Photograph: Ernst Haas.

Page 121. Photograph: Ernst Haas.

Page 161. Courtesy Judith H. Langlois.

Page 163. Photographs: Becky Cohen.

Page 165. Negative No. 315398, courtesy Department of Library Services, American Museum of Natural History.

Page 183. Photographs: Irenaus Eibl-Eibesfeldt.

For my parents
Edwin Chalmer Franzen
Margaret Leppanen Franzen

my husbands
John F. Eisenberg
S. B. Dissanayake

and my children
Karl John Otto Eisenberg
Elise Eisenberg Forier

Contents

Preface

A science of art is therefore a far more urgent necessity in our own days than in times in which art as art sufficed by itself alone to give complete satisfaction.

—G. W. F. Hegel, *The Philosophy of Fine Art*

To say that religion or art or music are useful seems to me not in the least to devalue them but on the contrary it improves our estimation of their value. I believe that these "spiritual" and creative activities are even *more important*, in the literal, practical sense, than the more mundane ones that are the concern of politics, business, and industry.

—J. Z. Young, *Programs of the Brain* (1978)

One thing Westerners notice with some puzzlement when visiting African universities is that even in oppressive heat the African staff members are dressed to perfection—the men, for example, wear three-piece suits, gold watches, shined shoes. In decided contrast to the Africans' bandbox freshness, Western men look sweaty and hairy in their wrinkled shirts and shorts, ambling about sockless in thong sandals. This difference is not to be explained simply: the Africans are not "showing off" their status, as it might seem to a Westerner for whom fashionable attire indicates the desire to impress, and casual clothes demonstrate a care for comfort or an admirable disdain for outward indicators of wealth or rank. Rather, the Africans are exemplifying a belief that goes back to village society: care in grooming and dress manifests a civility and refinement that are considered to be fundamental human virtues. To witness sheer splendor and dignity of appearance, attend any public gathering in Africa and observe on men and women alike gorgeous costumes made of swaths of lace and bright printed or lacy fabric. The practice of dressing up as an aesthetic activity, the act of "making oneself special," continues to characterize the descendants of African people all over the world: we see this resplendence in our own African-American churchgoers.

It may be difficult for today's white Americans who seek out and deify

the "natural"—whether it be natural surroundings, natural fabrics, or natural foods—to understand that the truly natural human attitude has always been to honor and respect the ways in which people show that they civilize and humanize nature. In our society, in which the technological control of nature has reached the point where people are almost totally insulated from it—so that seldom do our feet touch bare earth, our faces feel unprocessed or uncontaminated air, our eyes see nonfabricated sights, our ears hear nonelectronic or nonmechanical sounds—we naturally thirst for the natural and pay it the homage and reverent regard that people tend to bestow on things and experiences that are mysterious and rare (for further discussion of this idea, see Chapter 5).

I begin my study of *Homo aestheticus*, the aesthetic or artistic human, with this example of contrasting attitudes because it conveniently summarizes what I see as three critical keys to understanding where art comes from and why. The most noticeable key, of course, is that individuals and cultures vary concerning what they practice and revere. The second key can be described as the relationship, the inherent tension, between what is often called the "natural" (the given) and the "cultural" (the humanly imposed) that has characterized our human species for at least several hundred thousand years. The third important key is the attraction that humans, more than any other species, seem to find in what is unusual and *extra*-ordinary, that is, outside the ordinary or everyday routine (see pages 42–51), so that we tend to go out of our way not just to experience but even to fabricate it deliberately.

At first glance, the fact that the arts and related aesthetic attitudes vary so widely from one society to another would seem to suggest that they are wholly learned or "cultural" in origin rather than, as I will show, also biological or "natural." One can make an analogy with language: learning to speak is a universal, innate predisposition for all children even though individual children learn the particular language of the people among whom they are nurtured. Similarly, art can be regarded as a natural, general proclivity that manifests itself in culturally learned specifics such as dances, songs, performances, visual display, and poetic speech.

Undeniably, one of the most striking features of human societies throughout history and across the globe is a prodigious involvement with the arts. Even nomadic people who own few material possessions usually decorate what they do own; embellish themselves; use elaborate poetic language for special occasions; and make music, sing, and dance. All known societies practice at least one of what we in the West call "the

arts," and for many groups engaging with the arts ranks among their society's most important endeavors.

This universality of making and enjoying art immediately suggests that an important appetite or need is being expressed. One might expect biologically informed observers of human behavior, ethologists or biobehavioral anthropologists, for example, to have noticed and tried to explain this proclivity, but (with a few notable exceptions) they seem almost as unaware of art's inherent and defining importance as those who consider it to be wholly a product of culture. Humankind has been called tool-using (*Homo faber*), upright (a hominid precursor, *Homo erectus*), playful (*Homo ludens*), and wise (*Homo sapiens*).[1] But why not *Homo aestheticus*? When mentioned at all, art is usually regarded as an indication of human intelligence, as evidence of the ability to make and use symbols, or of degree of cultural development, not as something biologically distinctive and noteworthy in its own right.

At least some behavioral scientists may have failed to recognize art as universal and biological because, like the larger society to which they belong, they consider art to be either totally "useless" or something created in the service of sociopolitical ends. In the opposite camp, art lovers may recoil from biological and universalist explanations of art as a result of their own mistaken adherence to a now untenable tradition of considering the mind and body, or the soul and body, to be separate, and from a prejudice that distorts science into something pitilessly mechanistic and reductionist. Each side misunderstands the other, and both are affected by the limited and confused ideas that have come to characterize twentieth-century thought about art.

General readers, not familiar with the arcane discourses of today's art world, may not be aware of the recent cataclysmic changes in aim and consciousness that go by the general label of "postmodernism." In the larger society, "modernist" art (what used to be called "modern art"—everything from the works of the French impressionists to the stuff that is not immediately recognizable as art and that most people would dismiss as something one's child could make just as well) has scarcely been assimilated. Indeed, even the art of the Old Masters remains unfamiliar and foreign to the great mass of society. Thus the internecine squabbles of a bunch of artists and intellectuals may seem to be of little consequence.

These arguments encapsulate, however, a larger debate that is occurring in late twentieth-century America, the debate between those who wish to preserve the two-millennium heritage of Western, Greco-Roman,

Judeo-Christian civilization and those who consider this heritage to be seriously inadequate. A vociferous and growing movement criticizes the traditional Western interpretation of art and culture, with its Eurocentric bias, for its neglect or outright oppression of non-Western cultures (of those "minorities" who are increasingly visible and vocal in a "multicultural" society) and of women. The movement calls for a compensating recognition that suppressed members of world society have contributed much that goes unacknowledged, have the potential to contribute more, and should be represented and honored for their achievements.

Critics of the standard Western civilization position range from moderates who agree that it is valid to include non-Western societies' arts and histories in school curricula to more radical others who see all worldviews as structures of power and domination that constrain the liberty of those who are indoctrinated into them. Defenders of Western civilization rightly fear that its very preservation and future are at stake, and wonder what a society that does not esteem symphonies, museums, and the wisdom of "the Great Books" could possibly offer in their place. No wonder that some of the most conservative defenders of the status quo overreact and attempt to stifle all but the most innocuous and familiar forms and themes. Far from being merely academic, then, the controversy—much of which arises from postmodernist theory and writings—reaches into the schools and other areas of public policy and deserves to be taken seriously.

Let us look briefly at the confused and confusing state of the arts today. Although the buying and selling of artworks is a billion-dollar business and although hundreds of thousands of people throng to major art exhibitions, the arts today for most people are more occasions for perplexity than avenues to insight. Some people regard art as rare and valuable, something made by geniuses and sanctified by its presence in museums, a source of transcendent value. Others insist that it is a kind of pretentious folderol that most people quite obviously manage to live without. Still others believe art to be something that should disturb, challenge, provoke, and ultimately liberate people from stagnant tradition. Contemporary philosophers of art admit that they cannot define their subject anymore. "We have entered a period of art so absolute in its freedom that art seems but a name for an infinite play with its own concept," states (or, more likely, laments) Arthur Danto (1986, 209).

Certainly, intimations of sacredness, beauty, privilege, refinement, and imperturbability continue to cling to the idea of art like wisps of mist shrouding a tree's higher reaches. More evident, however, is the trashy

clutter at ground level, the less estimable associations of commodification, provocation, charlatanry, fickleness, and vulgarity.

Shrill iconoclasts have recently cried out that capital-A Art is a lot of high-minded ornamented rhetoric concealing a big nothing. The establishment denounces these critics as heretics, and in doing so often appears shrilly hyperdefensive because it is not easy to justify the relevance of art in a society where it costs so much, and where art competes with educational, health, and environmental claims on finite funds. Because of the grand, somewhat forbidding garments that art has accumulated over the centuries, it is difficult, when asked what is art that it should take priority over hospitals and schools, to discern if there is anything really there, or if so what the naked creature underneath might really be.

The most up-to-date and influential practitioners and critics of the arts today—those who exhibit in the smartest galleries or whose dances, musical compositions, books, and plays are most celebrated, whose works command the highest prices, and those who write for the influential critical magazines—are for the most part united in their dissatisfaction with the "high-art" view. Loudly and clearly, they proclaim by deeds as well as words that hallowed notions of "fine art" and "aesthetic appreciation" are inadequate, misguided, parochial, chauvinistic, and even pernicious.

The views just described generally go under the label of postmodernism. Many proponents of postmodernism stress that theirs is not just one more "ism" but instead represents a radical change of consciousness that throws into question Western society's "modernist" ideology of the exalted and redemptive character of art. By their critical examination of the orthodox, established assumption that art is inviolable and sacred, and by their discovery that orthodoxy has often masked repressive or narrow-minded elitism, postmodern theorists have opened the door to a new consideration of the place that art has had or might have in human life.

Still, despite the fresh air that postmodernist challenges have provided, reservations—not due simply to elitist snobbery or privileged Western chauvinism—remain. While one might concur broadly with their diagnosis, that "high" or "fine" art repudiates or disregards much that is valuable in human imaginative and expressive activity, one must also agree that those who have found sustenance and even transcendence in their experiences of the fine arts have good reasons to remain convinced that these sources and occasions are real and valuable. Repudiating the whole of Western civilization is a harsh and rash response to admitted social inequities, so that postmodernist remedies that recommend flush-

ing away the baby with the bathwater can well seem even more misguided than the malady.

Such remedies definitely seem inadequate. Proclaiming that there are a multiplicity of individual realities that are infinitely interpretable and equally worthy of aesthetic presentation and regard, many postmodernists forswear the rich, opulent cuisine of high art to offer instead a mess of unsavory, nonnourishing pottage. And oddly, although postmodernism's aim is to challenge the old elite order, its brutally impenetrable theory is far more arcane and inaccessible to even the well-meaning ordinary reader than anything high art apologists ever composed.

Even though some postmodernists claim to be cleaning out the Temple of Art, the money changers are as visible as ever, and many of the high priests who dance around the naked and broken idol within seem to be celebrating her desecration and violation. Recognition of art's dependence on culture has not precluded but rather intensified commodification, shallowness, cynicism, and nihilism.

Whether they praise, bemoan, or simply analyze the current disorder in the art world that I have just described, today's humanists and social scientists alike seem unable to provide a convincing, positive, humanly relevant view of art. Over the past century or so, a clear if gradual distancing between people and art has occurred. To earlier generations, art was a divine and mysterious visitation. More recently it was demoted to a mere individual or cultural product, for example, a projected wish, according to Freudian orthodoxy, or part of the "superstructure," as materialist philosophy would have it. Even those august modernist aesthetes for whom art was supreme nevertheless described it as tangential: "life-*enhancing*" (rather than life-*sustaining*), in Bernhard Berenson's famous phrase, or as an alternative to or a substitute for life. Today it is even further detached: a representation, simulacrum, image.

Yet acquaintance with the arts in other times and other places reminds us that they have been overwhelmingly integral to people's lives. Far from being peripheral, dysfunctional, trivial, or illusory, the arts have been part of human beings' most serious and vital concerns. If they are not so today, we should perhaps look for the reason not simply in some flawed metaphysical status of the concept of art but rather in the way we live. And I am convinced that contemporary art and contemporary life can best be regarded not from the perspective of philosophy, sociology, history, anthropology, psychology, or psychoanalysis—in their modern or postmodern forms—but within the long view of human biological evolution.

This idea may seem heretical, I know. I also know that it is ironic to invoke as an epigraph the mandate of Hegel, the great modern philosopher whose thought predicted and even seems to have led inexorably to the present impasse in Western philosophy of art (see Chapter 7), for I am certain that a Darwinian "science of art" is not what Hegel (and even less his contemporary postmodern followers) had in mind. Nevertheless, challenging long-held prejudices, I will show that it is only by means of a Darwinian[2] (and, as I also will refer to it, a "species-centered" or "bio-evolutionary") perspective that we can comprehend the predicament of the arts today and rescue them from all their assailants, those who, variously, would falsely idolize, cynically trivialize, self-righteously limit, philosophically vaporize, or—worst of all—ignorantly dismiss them as frivolous and dispensable pastimes. My readers should note that I am not arguing that a biological understanding automatically rules out the other perspectives I mentioned above. It does, however, precede these and provides a broader justification than other views for reclaiming the arts, humanizing them, giving them once more the relevance they originally possessed in human existence.

With a Darwinian perspective, one can claim that art is more important—primal and perduring—than has ever before been recognized or demonstrated, insofar as it originated from and played a critical role in human biological adaptation. Indeed, I will claim that the refocusing of aim and vision provided by species-centrism amounts to a new "Copernican" view of general human endeavor that precedes, underlies, and makes coherent the presently accepted "Ptolemaic" (the culture-centered or individual-centered) views of Western humanities and the social sciences, including their postmodern wings. My analogy with medieval astronomy is not simply an idle or a clever conceit. Pre-Copernican theorists trying to explain that the sun and other heavenly bodies revolved around the earth, in the face of ever-growing indications to the contrary, were forced to invent ever more elaborate epicycles to sustain an entrenched but untenable geocentrism. In a similar way, many recent theories of art and culture, stemming from established ideas of the centrality and authority of Western civilization, have been driven to a complex and thoroughgoing relativism in order to account for the apparent lack of order or unity in human enterprise. The intricacies of Ptolemaic geometry were exposed as unnecessary and absurd when enough people finally accepted the idea that the earth revolves around the sun and that there was indeed a larger and simpler order to it all. Just so I believe that the confusing heterogeneity of human art and culture that seems to require

labyrinthine relativistic theories can be more sensibly viewed from the wider, deeper, and more unifying perspective of species-centrism, which points out these theories' excesses and redresses their limitations.

For example, the species-centered perspective provides, from the bottom up, as it were, a truth about human existence and human nature that postmodernist philosophies—and indeed all the permutations of romantic thought—are responses to and attempts to deal with. This truth is that reason and rationality, analysis and objectivity, which modern societies extol and attempt to enshrine as supreme values, a bastion against barbarism, are not in themselves fully satisfying to the human animal. Despite all the benefits of comfort and leisure they have bestowed, they are not *enough*. Dionysus coexists with Apollo in the human breast, and individuals who are deprived of socially sanctioned routes to ecstasy and transformation are likely to seek them in asocial "barbaric" ways. Not everyone in post-Enlightenment society has the inclination or opportunity to employ the high arts as sources of transfiguration, though undeniably they can serve that function for the fortunate few. Contemporary social systems must provide avenues to emotional satisfaction for all their members or deal with the consequences of its deprivation.

As I will describe, the species-centered view is poorly understood and unpopular, and nowhere more so than among intellectuals who think and write about the arts. Likewise, the subject of art and the arts is just as poorly understood and unpopular among evolutionary-minded anthropologists and biologists. Occupying a sort of buffer zone between the two, as I do, means that I can identify relevancies that art or biology alone have been unable to discern, caught up as they have been in their traditional prejudice or ignorance about each other.

During the decade between 1975 and 1985, I examined the subject of art from a species-centered (then called "bioevolutionary") point of view, and in *What Is Art For?* (1988) I traced a hypothetical course of the evolution of art as a human behavior. My work required the synthesis of a number of specialist fields, leading me into places where angels and certainly nonspecialists fear to tread.

Discounting a few slings and arrows, however, the response the book received confirmed me in my belief that this approach to art is both valid and valuable. Artists and teachers of art, for example, find that with it they can demonstrate, not just vaguely feel, that the human behavior of art is wider and deeper than simply the practice of art by artist–specialists and the exhibition of their works in museums and galleries. To artists and laymen alike it offers new insights and understanding about art's place in their own lives as well as in human evolution.

In the unsettled world of the contemporary arts, the species-centered approach allows one to combine the high-art proclamation that art is of supreme value and a source for heightened personal experience with the more recent postmodernist insistence that it belongs to everyone and is potentially all around us. For the species-centered view of art reveals that the aesthetic is not something added to us—learned or acquired like speaking a second language or riding a horse—but in large measure is the way we *are*, *Homo aestheticus*, stained through and through. One can describe and elucidate artistic proclivities that are inherent in human psychobiology and universally spontaneously shown in cultural activities—the way humans naturally and commonly think and behave. If these are obscure and unrecognized today, it is because posttraditional, postindustrial, postmodern life requires us to ignore or devalue the naturally aesthetic part of our nature. The cynicism, vulgarity, and self-regard of much contemporary art may indeed reflect a morally corrupt and bankrupt society. But simply challenging the elite status of art and declaring that anything goes does not offer the radical change-of-consciousness that is possible and required.

If a declaration that art is fundamental to humankind is to be more than just political rhetoric or wishful thinking, it is necessary to frame one's thought within an understanding of human nature as it has evolved by natural selection over the past three or four million years. Only by knowing where art comes from biologically will we know what it is and what it means.

While artists and art teachers might especially welcome a biological justification for the intrinsic importance of their vocation, everyone, particularly those who feel a loss or absence of beauty, form, meaning, value, and quality in modern life, should find this biological argument interesting and relevant. Ironically, today, words such as *beauty* and *quality* may be almost embarrassing to employ. They can sound empty or false, from their overuse in self-help and feel-good manuals, or tainted by association with now-repudiated aristocratic and elitist systems in which ordinary people were considered "common" for not having the opportunity to cultivate appreciation of these features. But the fact remains that even when we are told that "beauty" and "meaning" are socially constructed and relative terms insofar as they have been used by elites to exclude or belittle others, most of us still yearn for them. What the species-centered view contributes to our understanding of the matter is the knowledge that humans were evolved to require these things. Simply eliminating them creates a serious psychological deprivation. The fact that they are construed as relative does not make them unimportant or

easily surrendered. Social systems that disdain or discount beauty, form, mystery, meaning, value, and quality—whether in art or in life—are depriving their members of human requirements as fundamental as those for food, warmth, and shelter.

In my view, an examination of the stratospheric ideas of postmodernism taken from the earthbound Darwinian perspective is imperative, particularly since species-centrism, it will be found, provides the very change-of-consciousness that postmodernism has erroneously claimed for itself. Indeed, the change of consciousness demanded by accepting the species-centered view (applicable to life as well as art) is much more far-reaching and radical than anything the postmodern project has yet proposed. I believe it is not too much to say that the more familiar and engaged contemporary postmodern factions (e.g., feminism, neo-Marxism, ecologism) will find that species-centrism, far from attacking or wishing to supplant them, will support and give an embracing coherence to their political dreams and visions (see Chapter 7).

Acknowledgments

A number of people have contributed in various important ways to the emergence and development of the ideas that became *Homo Aestheticus*. I owe much to the providers of two atmospheres in which I worked. A five-week solitary summer holiday in Maine at the home of Barbara Sjogren-Holt and John Holt enabled me to conceive an early draft of the text. More recently I have had the good fortune to share with Lillian Ben-Zion the incomparable ambience of the Ben-Zion House in New York City—an inspiring setting in which to pursue any creative project.

I would like to thank Dr. Sondra Farganis of the Vera List Center at the New School for Social Research for inviting me to participate in two public lecture series, for which parts of Chapter 7 were originally prepared. The talks were subsequently revised for publication in *The World & I* before finding their final form here. Sherry and Hiram Levit and Carmen Sanchez of Transcript Associates Inc. generously provided technological expertise and access to their equipment, making the mechanics of manuscript production far less daunting than they otherwise would have been. Photographic advice and assistance were given by Todd Weinstein and Miles Barkan.

I am greatly indebted to those who read parts or all of the book and to a few experts whose advice I sought with regard to specific points. Listing them in alphabetical order hardly seems sufficient acknowledgment for their invaluable suggestions, but I give heartfelt thanks to Gerald Beal, S. B. Dissanayake, John Eisenberg, Wendy Eisner, Jim Gordon, Jan Lauridsen, Don Mohr, Francis V. O'Connor, Pamela Rosi, Joel Schiff,

Roger Seamon, Colwyn Trevarthen, and R. B. Zajonc. A disparate group with widely different minds and interests, each contributed to my thought and expression. Pamela Rosi and Joel Schiff, in particular, were simultaneously resonant sounding boards and steadying anchors.

I affectionately acknowledge the editors of my first book at the University of Washington Press for graciously continuing to support my ideas and efforts even though I forsook them for the trade-book world. I thank Helen Fisher who originally introduced me to my editor, Peter Dougherty, whose interest and encouragement has been much appreciated. I have the highest praise for the superlative editorial abilities of Loretta Denner and Philip G. Holthaus, who were, respectively, my production editor and copy editor. Their attentions to *Homo Aestheticus* were thoroughly professional and exacting, but to its author they were invariably sympathetic and indulgent.

❧1❧

Introduction
Why Species–Centrism?

The hero in one of Thomas Mann's early novellas was an aspiring artist born of a Northern European father and a Southern European mother. The mingling in his nature of the temperamental qualities of the "north" ("solid, reflective, puritanically correct, with a tendency to melancholia") and "south" ("sensuous, naive, passionate . . . careless . . . irregular by instinct") was reflected in his name, Tonio Kröger. The commingling in the present book of the subjects of biology and art makes it a kind of Tonio Kröger in the contemporary world of ideas. As author, it is my task to make this hybrid anomaly intelligible and appealing to both progenitors. For each has preconceived, long-standing, sometimes justifiable prejudices and suspicions about the other, not to mention the viability of any offspring of the two.

Biology is a science concerned with animal life and function. To the art lineage, whatever biology might say about art (which like language, reason, and the use of tools appears to be one of the traits that sets humans *apart* from animals) is suspected of being reductionist, inadequate, and probably trivial and boring. Meanwhile, the tough-minded scientific stock worries that even a "biological" art inquiry is likely to be tainted with the insubstantiality that, to them, characterizes most talk about art. To say, as I do, that humans "need" art is to veer perilously close to the reefs of wishful thinking, sophistry, or muddleheadedness.

There is yet a third response: some people react to the idea that art is biologically essential with an immediate and uncritical star-struck reverence. I surmise that the very notion seems to them inspiring and dem-

1

ocratic, and confirms some inarticulate subterranean intuition or unsubstantiated belief they have about the importance of creativity, self-expression, emotional intensity, beauty, and seriousness—all of which are fragmented or denigrated or lacking in contemporary life and art. But these people do not then go on to learn what a species-centered view really claims, or to take the trouble of altering their ideas about what art is and what it does.

To be misunderstood (even by allies) or, worse, dismissed as naive or in error by both sides—humanists and scientists, reactionaries and liberals, creationists and the intellectual vanguard, modernists and postmodernists alike—seems to be the fate of anyone who proposes a biological view of art, at least in the present intellectual climate. Therefore, rather than cast unfamiliar ideas on soil that is stony with prevailing prejudices and misconceptions, I will first try to clear and prepare the ground. There are times that are ripe for some ideas and, by the same token, times when ideas cannot be heard, either because they conflict with reigning pervasive belief systems or because they are "ahead of their time" and there are not enough immediate or accessible referents to assess them. In the present case, both and neither pertain.

The prevailing intellectual paradigm in the West is still largely that of Western science, so my ethological ideas do not conflict with and indeed are well established there. But the entire scientific worldview is strongly criticized (e.g., as patriarchal, mechanical, reductionist) by many members of one large audience I wish to reach: practitioners of the arts along with humanists and social scientists. It is not difficult to understand why this should be so.

Despite the many creature comforts and liberties that a scientific worldview has made possible in modern society, the individualism, secularism, and technorationalism also fostered by science conspicuously fail to provide certain fundamental verities and satisfactions that were inherent in traditional, prescientific societies. As people search for a more humane way of life, many have found it all too easy to repudiate science altogether and blame it for all our dissatisfactions and problems. It has even become common to look for truth in the belief systems of prescientific societies: in astrology, magic, contact with a spirit world, and so forth. These beliefs usually are expressed in beautiful and compelling rituals and practices that seem far more emotionally satisfying than any abstract scientific theory.

A species-centered view based on the scientific postulates of biological evolution does not, of course, deal with planetary influences, magic, or spirits. It looks upon those who do, however, with some sympathy, for

they are manifesting a core human nature that was evolved to *require* aesthetic and spiritual satisfactions. Rather as children or laboratory animals reportedly choose for themselves apples or carrots after having been fed only a diet of carbohydrates, an attraction to shamanism or spirit quests or harmonic convergence celebrations is a natural human response to the real spiritual deprivations of modern Euro-American technorational society. Far from adhering to a coldly mechanistic, pernicious, "outworn paradigm," a species-centrist does not ridicule or dismiss such needs but rather seeks to understand and justify their imperative nature. It should be possible to establish that humans as a species do not live by bread (or even cake) and television alone. As *Homo aestheticus*, we really require beauty and meaning—those answers to human questions and desires that are to be found in (what should be evident in the name we give them) "the humanities." However, as I mentioned in the preface, people are asking whether these as presently taught should automatically be assumed to be the final word on the matter.

Humanity or The Humanities

The subject matter of the humanities derives from ideas and principles about human life and culture articulated and laid down in the regions surrounding the Mediterranean Sea during a remarkable historical period when classical Greek and Roman civilization and the Judeo-Christian tradition met and mingled, creating "Western" civilization. Western civilization has bestowed upon humankind powerful ideas of justice, freedom, rational inquiry, charity, moderation, goodness, truth, and beauty, embodied in what are often called "Great Books," writings that are considered to be repositories of wisdom—the best that has been thought and said. As such, they have been the foundation for Euro-American education, law, government, and the practice of the arts and sciences.

Yet the very fact that our culture's heritage resides primarily in *books* is to the species-centrist a matter that requires pause. Literacy is a recent human invention and an even more recent widespread accomplishment. It can be reasonably claimed that 99 percent of the humans who ever existed could not have read the Great Books, or any books, indeed anything at all. Perhaps one can say that they were the poorer for it, but can we then go on to presume that we are not also poor for not having been acquainted with their cultures' wisdom? For every human society can be found to possess traditional beliefs, encoded and expressed if not in books then in oral traditions and ceremonial practices of abiding value to its

members. We are all engaged in the universal human predilection for making sense of our individual and collective experience.

Without claiming that these other repositories of cultural wisdom are equal to or superior to our own, I would at the same time suggest that we cannot presume ours are superior to theirs. We should not carelessly discard ours, but neither should we disdainfully disregard theirs. In fact, just as the non-Western world has learned from us, it is perhaps time that we begin learning from them.

There are more reasons to look outside the Western tradition than the simple one of turnabout being fair play. For few would deny that the ideals of Western civilization are transgressed more often than they are exemplified, and that the civilization that continues to profess them is in increasingly disturbed and perilous straits. What has gone wrong? It is as if while we were becoming more and more enlightened and "civilized"—distancing ourselves from the exigencies of nature and the superstitions of the tribe—we were also progressively forsaking ancient, elemental, human satisfactions and ways of being. Todd Gitlin has pointed out that almost everything considered "smart" and natural today is opposed to the way we lived as a species for 99/100ths of human history. No wonder that life with all its comforts and perpetual novelty seems still somehow phony, bland, and superficial. Chances are that we are missing something.

It is worth emphasizing how long we were "feral" or "natural," and how recently we have been domesticated into separate cultures. As animal taxa go, hominids are quite recent, becoming distinct only about four million years ago. But for 39/40ths of that four-million-year period, during all of which time we were gradually "evolving," we inhabited essentially the same environment and lived in essentially the same way, as nomadic savannah-dwelling hunter–gatherers in small groups of twenty-five or so. "Cultural" diversity has occurred so recently that what happened to us for 3,900,000 years in that essentially uniform environment and way of life is what still touches us most deeply and continues to inspire our strongest feelings. How could it be otherwise? To adapt an old phrase, You can take the species out of the evolutionary milieu, but you can't take the evolutionary milieu out of the species.

What this means is that the customary accepted philosophical and historical views of human existence and their answers to questions about human nature are pitifully (and literally) superficial. As anthropologists John Tooby and Leda Cosmides (1990, 391) have expressed it, "in trying to understand the forces that laid down the sediments at the Grand Canyon over millions of years, studies of which way the wind is presently blowing can only contribute so much. They document the explanation of

the last 0.02 millimeters of the upper layer, but may lead to entirely incorrect conclusions about the events that created the other three thousand meters of sediment deposition." We misrepresent our human depth to the extent that we regard human history as being only some ten thousand or at most twenty-five to forty thousand years in length (rather than one hundred to four hundred times longer).

Moreover, whereas it is usual to think of human nature as being the product of gods, societies, and cultures, the species-centric position takes the reverse view: it holds that gods, societies, and cultures are the products, the answers, and embodiments of the species needs and potentials of an already existing human nature. Having recognized this truth, one can then go on, if one desires, to examine and understand cultural differences.

The humanities have been studied in the past for guidance about how to live. We might now study humanity itself for the same reason. I was intrigued to find two eminent figures associated with modernist theory and criticism recently invoking quasi-biological assumptions to support their beliefs. Hilton Kramer (1988), in a lecture at the New School protesting against the proliferation of bad art in New York City galleries, suggested that humans have an "innate judgment capacity"—his implication being that this innate capacity could be the foundation for standards of taste. Richard Wollheim, in his book *Painting as an Art* (1987), suggests that painter and viewer share certain native perceptual capacities that are part of a uniform human nature, and that therefore during an aesthetic experience the perceiver actually reenacts part of the artist's perceptual experience. These examples of biological assumptions concerning art were not placed by their authors in a broader evolutionary context, but they demonstrate at least a tacit understanding of the explanatory power of appealing to the species-centric position.

There is another widespread indication that a species-centric sense of humanity in some measure underlies the culture-centric self-understanding that the humanities are commonly said to provide. This is the recurring complex and contradictory fascination from the time of the Renaissance with the primal and primitive, aspects of which pervade literature and the arts for several hundred years. The voyages of discovery in the late fifteenth to early seventeenth centuries gradually acquainted the peoples of Western Europe with ways of life that differed markedly from their own. While the dominant response was then—and often still is today—repugnance and smugness or missionary zeal to uplift the savage heathen, a continuing undercurrent of fascinated interest indicates the strong allure of primitive life. In 1960 the anthropologist Charles

Leslie could suggest that primitive cultures are to modern thought what classical antiquity was to the Renaissance. I think there is much food for thought in Leslie's assertion.

The underlying sympathy shown by Montaigne in his satiric defense of cannibals (1579) was echoed a century and a half later in Rousseau's (1755) well-known claim (contrary to Hobbes's [1651]) that man living in a state of nature was basically good; other Enlightenment social philosophers in France and England similarly included "primitives" or "natural man" in their speculations on human nature (Bloch and Bloch 1980). More recently, both in the "dominant patriarchal culture" (e.g., the beginnings of anthropology, Freud's primal horde [1913] and the discontents of civilization [1939], Engels's *Origin of the Family, Private Property, and the State* [1884], and Nietzsche's Dionysos [1872]), in much nineteenth- and twentieth-century literature, and today in New Age searchings, primitive cultures have repeatedly seemed to be taken as the ground zero against which we could measure ourselves. [1]

How much have we improved upon or how far have we strayed from a core human nature? Is that primitive self something to fear, guard against, and amend, or something to exalt and return to? Indeed, as our lives become increasingly mechanized, rational, and unnatural, we seem to have become proportionately more intrigued by and drawn to the primitive as the source for some kind of elementary truth about ourselves, and perhaps even for instructions on where we went wrong and how we should proceed.

The life and work of Paul Gauguin, so much in the eye and mind of the public in recent years, speaks to us a century later uncannily as a premonition of our own contemporary yearning for a more simple, direct, and sensuous world. Gauguin is the archetypal modern figure who not only proclaimed the artistic and spiritual bankruptcy of European civilization but put his money where his mouth was, forsaking family, friends, and country in his search for a hoped-for but ultimately chimerical paradise.

During the intervening century, many artists and others have been and still are preoccupied with the primitive as it exists in the world and in ourselves. [2] This preoccupation takes forms as varied as borrowing or adapting motifs or artifacts from other traditions, exhibiting a concern with timeless archetypal symbols or elemental and universal subject matter, using natural materials, imparting or leaving a raw or unfinished quality to one's work, or making a kind of art (performative as well as visual) that will approximate in modern society the functions the arts have traditionally served in premodern cultures.

Among the general public, various spiritual practices \
tional cultures are now regularly pursued by thousands wh \
society immoral and dehumanizing. As Europe, America \
East become more and more alike, Western travelers se \
remote and exotic places to visit, causing some developing \
resurrect old "authentic" traditions that were otherwise van. \
the pressure to modernize.[3]

Marianna Torgovnick (1990) has recently written a sensit. \
lightening history and analysis of attitudes in Western cultu \
regarding primitive peoples and societies. Prefigured in the stor \
seus and the Cyclops (and, as Hall [1990] also shows, in Greek \
that "invented" the "barbarian"), these attitudes have proliferat \
variety of modern manifestations, including mixed disgust and \
tion, sexual and bodily morbidity, envy, and patronizing justifica \
exploitation. Using a wealth of examples from the works and \
explorers and adventurers, art theorists and artists, writers, psycho \
and anthropologists, Torgovnick shows how we project onto "the (\
our fantasies and needs. Primitive people and societies have bee \
continue to be seen variously as childlike (innocent, unspoiled, ii \
ture, underdeveloped), mystical (like females, in tune with the body \
with nature and its harmonies), and untamed (healthily free of the \
contents and repressions of civilization, libidinous, violent, dangero \
More often than not these projections satisfy imperialist, colonialist, \
ist, racist, sexist, and other chauvinist preconceptions and arise from the \
wish to dominate and master one's own weaknesses in the guise of the \
inferior and "natural" other.

We need to be made aware of the less-than-fully-conscious attitudes \
that lurk within our interest in premodern peoples. At the same time we \
should also realize that this fascination with a more "innocent," "natu- \
ral," and "harmonious" life is not simply romanticized fantasy, pruri- \
ence, or a form of sublimination, but rather is indicative of the \
undeniable deficits in modern and postmodern society. Torgovnick in- \
vokes Georg Lukács's notion of transcendental homelessness, the longing \
within a secular society for the sacred, of the individual for community, \
of the rootless questioning mind for the absolute. She suggests that "going \
primitive" may be viewed as trying—unavailingly, she seems to imply—to \
go home.

To the species-centrist, Torgovnick's way of putting it makes sense: \
"home" is our human nature (as evolved over three to four million years \
on the African savannah, prior to the Upper Paleolithic "creative explo- \
sion" and proliferation of cultures), which in ways as diverse as New Age

practices or exotic tourism is asserting itself against the social and spiritual impoverishment that characterizes our time and place.

Torgovnick concludes that rather than projecting our needs onto primitive peoples, our task may better be to trace alternative patterns in Western history that will do for us what we have wanted primitive societies to do: "to tell us how to live better, what it means to be human, to be male or female, to be alive and looking for peace, or to accept death" (1990, 247–248). I should note here that while we can certainly profit from questioning and reexamining our Western past, both earlier and contemporary social and political theorists who have attempted this task have been circumscribed by their own culture-bound presuppositions, ideas basic to the Western humanist tradition, but not universally held: for example, that humans are wax tablets waiting to be inscribed by their societies, that mind and body are separate entities, that instrumental reason is the best means for solving problems, that change and innovation are desirable, that history is unilinear, that individual freedom is the highest good, and so forth. We have much to learn about and from (as opposed to projecting onto) cultures that are less materially complex but more spiritually complex than our own, and trying to place what we learn about them, and by comparison ourselves, into a species-centered framework.

Instead of ransacking premodern cultures for motifs and practices to copy; or patronizing or romanticizing them as worse or better than ourselves; or including their arts or epics or modern writers in our humanities curricula and thinking such gestures are enough, the species-centrist will examine and compare cultures to identify the underlying needs their individual distinguishing practices are meant to fulfill. Cultures and their institutions, practices, and artifacts—different though they be—are means of satisfying fundamental human needs. And what these needs are, as well as a broader range of workable satisfactions, is to be discovered by accepting the reality that humanity is the underlying landscape upon which one approaches (but not with which one replaces) the humanities. Both have made us what we are.

Why Art Needs Ethology

Ethology is the study of the behavior of animals in their natural habitat. Quite simply, ethologists describe what an animal normally does, and try to understand what behaviors characterize a species and how these behaviors have contributed to its evolutionary adaptedness.

During the past several decades workers in a number of fields have turned their attentions to the human animal, which no longer lives in its original habitat, the African savannah, but in villages, towns, and cities. Ethology has provided a fresh perspective for those who seek naturalistic explanations of activities that have usually been presumed to be entirely culturally (and earlier, divinely) derived. Underneath a thick cloak of culturally learned variations, human nature reveals certain regularities. Such prominent universal human behaviors as aggression, attachment or bonding, parenting, male and female roles, sexual behavior, the incest taboo, and the trait of optimism have been treated ethologically, in both scholarly and popular accounts.

I mentioned in the preface that despite the observable and obvious fact that humans everywhere make and use the arts, few ethologists have turned their attentions to art as a human behavior. It is interesting to speculate why this should be so.

Out of curiosity I examined twenty-four of the most acclaimed, comprehensive, or otherwise noteworthy books on human behavior and evolution written or edited during the past twenty years by professional academic ethologists, anthropologists, sociobiologists, and others, wondering how important a role they assigned to art or the arts.[4]

Admitting bewilderment, the anthropologist Marvin Harris, in a large book comprehensively titled *Our Kind: Who We Are, Where We Came From, Where We Are Going* (1989), stated baldly in his preface that he would especially have liked to be able to say more about the evolution of music and the arts than he does, "but these are aspects of human experience that are difficult to explain in terms of evolutionary processes" (xi). Harris's confessed perplexity showed at least that he had considered them to be interesting. But in over one-third (nine) of the books, the words *art* or *arts* did not even appear in the index, and another eight in which they did appear referred to art only briefly, often without further comment, in connection with other things like amusement or wonder, or—most commonly—with the mention of Upper Paleolithic visual art and artifacts.

Only seven books (the products of five authors: Eibl-Eibesfeldt, Geist, Morris, Wilson, and Young) specifically addressed in a considered manner the contribution of the arts to human evolution. Each offered stimulating and cogent observations, obviously believed that art or the arts had been evolutionarily important, and addressed various behaviors and functions with which art is associated. But none attempted to treat it as a behavior in its own right, and only J. Z. Young, the distinguished British anatomist (whose interest in life and the universe extends far beyond the

dissecting table), asserted outright that the arts must be essential. In addition to his statement about the importance of art and music that appears as an epigraph to my preface (Young 1978, 38), he said that "the arts have the most central of all biological functions—of insisting that life be worth while, which, after all, is the final guarantee of its continuance" (1971, 360). Yet apart from noting the arts' contributions to communication and finding them to be part of the inherent biological "program" of enjoying, playing, and creating, Young did not address their specific selective value, remarking simply that "presumably both aesthetic creation and religious beliefs and practices were somehow of assistance to Palaeolithic man in the business of getting a living" (1971, 519).

In general, the various origins proposed by the thirteen authors who discussed human art making, or the behaviors with which it was associated, included play, display, exploration, amusement and pleasure, creativity and innovation, transformation, the joy of recognition and discovery, the satisfaction of a need for order and unity, the resolution of tension, the emotion of wonder, the urge to explain, and the instinct for workmanship. But I find these to be unsatisfactory explanations for art's nature, origin, purpose, or value because each can be demonstrated to exist without the addition of art. That is, one cannot say that art *is* exclusively any of these things or that they are, in turn, in some necessary way, art. The question as to why specifically *artistic* pleasure, creativity, discovery, order, workmanship, communication, transformation, and so forth should have ever arisen in human evolution does not seem to have been asked, much less answered. Indeed, allying art to exploration, wonder, and the rest implies that it has no reality in itself but is merely an offshoot or epiphenomenon of one or more antecedents.[5]

The selective value of art, when discussed at all, was most commonly proposed to be enhancement of communication (e.g., Alland 1979; Eibl-Eibesfeldt 1989a, 1989b; Tiger and Fox 1971; Young 1971) or a means for individual display (e.g., Eibl-Eibesfeldt, 1989a, 1989b; Geist 1978; Harris 1989; Wilson 1978)—to aid sexual selection (Low, in Chagnon and Irons 1979; Eibl-Eibesfeldt, 1989a, 1989b), identification (Eibl-Eibesfeldt, 1989a, 1989b), or to give prestige (Eibl-Eibesfeldt, 1989a, 1989b; Harris 1989). But stating that art is used for display does not explain why it arose in the first place. To be sure, once a feature exists, it can be used communicatively and competitively for display and identification: hairstyles, hunting ability, even (as Glenn Weisfeld wittily observed at the 1990 Human Behavior and Evolution Society annual meeting) how accurately or far a man can aim and urinate. But it does

not follow that hair, hunting, and male urination initially evolved or prospered for the purposes of competitive display or, for that matter, of enhancing communication. Display and communication are significant human behaviors and the arts may be called into their service and even developed there, but their evolutionary origin and purpose may have been and continue to be something very different.

Acceptance of the assumption that art arose to augment other behaviors partakes too much of the presupposition in Western culture that it is superfluous, a pleasant but ultimately dispensable frill. When discussing other universal human practices, the authors of these books have shown boldness, insight, and imagination, finding far more, and sometimes less, than meets the eye in such behaviors as altruism, kinship systems, the incest taboo, sexual bonding, and parenting. Apparently the penumbra of mystery and untouchability that has shrouded the Western notion of art for centuries and that made it remote from everyday life has beclouded even biologists and social scientists who more than anyone should have noticed that engaging with the arts is as universal, normal, and obvious in human behavior as sex or parenting. Their often simplistic comments about the biological role of the arts suggest to me that most do not really regard them as being essential; in fact Harris's "cultural materialism" explicitly regards the arts as "superstructure." By ignoring art, or suggesting that it is beyond explanation, they merely echo their larger society and show that their aesthetic presuppositions are as parochial, culture-bound, and tacit as those of anyone else.

In the chapters that follow I intend to show, using an ethological perspective, that a behavior of art is universal and essential, that it is a biologically endowed proclivity of every human being, and not the peripheral epiphenomenon that other explainers of the subject, including most evolutionary biologists, have heretofore assumed.

Why Human Ethology Needs Art

While the species-centered view will provide an alternative to Western culture's conflicting and conflicted attitudes regarding art, including contemporary intimations that art is mysterious, superficial, or relative, ethology also has something to gain from giving attention to art as a universal human behavior.

It is axiomatic in modern sociobiological theory that individuals have evolved to pursue what is in their best interests. The preponderance of

studies in human behavior and evolution to date concern themselves with aggression and dominance: in law, economics, politics, ethics, or criminology. Subjects like homicide, rape, war, gender conflict, and despotism, and traits like envy, competitiveness, status seeking, and deceit are the usual fare, so that it is all too easy to look on the admittedly bleak side of the fundamental sociobiological theorem that "individual self-interest" is the driving force in human affairs.[6]

Starkly valid as this may be, it should not be forgotten that in human evolution, the development of behavioral means to promote cooperation, harmony, and unity between and among individual members of a group has been every bit as important as the development of aggression and competitiveness. The arts, in concert with ritual ceremonies, play, laughter, storytelling, synchronized movement, and the sharing of self-transcendent, ecstatic emotions, are no less evolutionarily salient and intrinsic to our humanness than individual conflicts of interest.[7]

Although it is not widely appreciated outside the fold, sociobiological theory does find a place for reciprocity and altruism. For example, in *The Biology of Moral Systems* (1987), Richard Alexander has suggested that the tendencies toward moral behavior and the establishment of moral systems promote the goals of society as a whole, and that these develop because all of the individuals of society often share the same goals (104). In this view, groups and individuals are mutually dependent, and individual behavioral mechanisms that promote group unity are of selective value. Even though the evolutionary function of cooperation, harmony, and unity in human social life may ultimately be (as Alexander claims) to allow the group to compete against hostile forces, especially other human groups (153, 163), the evolutionary importance and individual emotional satisfaction of these parts of human experience are beyond question.

A human ethology that stresses human bondedness, group harmony, interdependence, and cooperation (albeit in the service of perceived individual self-interest) is more likely to attract the interest of a wider public than a position that emphasizes deception, competitiveness, and strife. Wider public acceptance of human ethology is not just a matter of renown or popularity: it is of crucial importance. In order to chart what is and what is not possible in a humanly desirable and humanly attainable future, we must know the possibilities and limitations endowed by our evolutionary past. As sociobiologists would be the first to admit, flies are more attracted to honey than to vinegar: it seems not in the best survival

interest of the field to advertise its fallen arches, halitosis, and bad temper when displaying itself to prospective recruits or bedfellows.

Why Darwinism Has Been Ignored or Worse

What I have called species-centrism,[8] implicit in Darwin's theory of evolution by means of natural selection, offers the possibility of a revolutionary—in the Copernican sense—change in human self-understanding. Yet more than a century after its introduction, the theory and its implications for human philosophy and social life have scarcely been assimilated by either the general or intellectual society. This situation contrasts strikingly with that of the other great recent paradigm-shattering theories, those of Freud and Marx, that have made the unconscious and the material economic base of society so indelible a part of twentieth-century consciousness. While the psychology of Freudian and the political economy of Marxian writings might well be more accessible and interesting to a general public than the genetics and population biology that is necessary for an understanding of evolutionary theory, lack of knowledge of the latter has not hindered criticism or even dismissal of Darwinism—quite the opposite. Yet relativity theory in physics, which also demands a high degree of scientific understanding, is usually uncritically accepted by nonphysicists. Quite obviously, Darwinism is more threatening and uncomfortable to large segments of the population than either relativity, sexuality, or the dictatorship of the proletariat.

Theological objections to evolutionary theory promulgated by religious fundamentalists and creationists who believe in divine creation are regrettable, but understandable. The truly distressing enemies of Darwinism are the many "educated" people who have renounced supernatural bases for their theories and explanations, who espouse objectivity, who accept "Darwinian evolution" in a broad, general, zoological way, but yet who dismiss it out of hand without trying to grasp its exciting and revolutionary implications for understanding human thought and behavior. Despite their professed liberalism, they admit (like people who do not know much about art but "know what they like") to not knowing much about Darwin or evolution, but knowing what they do not like about them. In both cases, evolutionary theory and art, that which is liked or disliked can only be based on ignorance or prejudice born of hearsay.

How can a powerful explanatory paradigm that has proved to be so

fertile in paleontology, geology, and the life sciences be so neglected or misunderstood by those who work in the human and social sciences? I can offer a number of historical reasons, and also point to the general difficulties people have of amending folk notions (such as the solidity of matter or the sun revolving around the earth) based upon common sense or convictions of human preeminence.

For example, objections to Darwinism may arise from observing the evident differences between humans and other animals. Apart from a widespread prejudice against animals (now waning, as the animal-rights movement indicates) for being brute, dumb, smelly, unclean, or without shame, anti-Darwinists note that while animals have evolved to have a way of life—a set of species-specific behaviors—in a particular environment, humans live in many environments: igloos in the Arctic, grass huts in the tropics, condominiums in Miami, and stilt houses in Manus. Adaptations to these different climates and geographies are largely and indisputably *cultural*, not biological, and in each of these places our clothing, food, and daily activities, not to mention our belief systems and arts, are different. Humans "impose culture on nature," as anthropologists say (or used to say), and thereby set themselves apart from nature, and apart from all other animals. Rather than relying on inborn determined programs, like other animals, humans pass on their cultural traits through a process of teaching and learning. Anti-Darwinists thus can argue from common sense that we are essentially released from biological evolution. For Darwinists to suggest that there are genetically endowed universal human needs, potentials, and tendencies thus taxes the common sense of ordinary people. But even more it offends an intellectual establishment of relativists who find the fundamental unit of human behavior to be in culture.

Common sense also tells us that we are set apart from other animals by a complexity that seems different not only in degree but in kind. After all, do not humans show a wide and subtle range of thought and emotion in their ability to act from volition and deliberation rather than simply from instinct? So while anti-Darwinians admit that humans exhibit the effects of biological evolution in the sense that humans like other animals need to eat, sleep, reproduce, and maintain homeostasis, they would argue that such biological necessities seem pretty uninteresting and irrelevant to true understanding of the really unique and interesting things that make us human.

Those, like myself, who hold to a Darwinian or species-centered view do not deny that as humans evolved we became less dependent than other

animals on instinctive reactions and increasingly reliant on being born into a cultural milieu with a language, with customs, beliefs, traditional ways of doing things, explanations for the way the world is. We also do not deny that humans are different from other animals.[9] But we also begin with the undeniable fact that humans *are* animals no matter what else they may be or think they are. And we also note, in fairness to other animals, that they often possess quite remarkable abilities to generalize, abstract, use tools, and communicate, which suggests that human abilities, while often vastly superior, are not an unprecedented development, different in kind to those exhibited by other animals. It has even been shown that some infrahuman animals possess the rudiments of what can be called culture (see Bonner 1980; Griffin 1981).

Like any animal, humans have evolved: we have not always been able to think and speak and perform as we have done for the past hundred thousand or so years. Our abilities to do these things are useful biological adaptations just as surely as our upright posture and manual dexterity, our gregariousness with familiars, and our suspicion of strangers.

A species-centered view also insists that we recognize how long a period of time has gone into refining our Grand Canyon of human morphology, anatomy, and behavior, compared to the relatively short period of time since cultural evolution has become predominant. Indeed, culture, or the human need for culture, can be considered a biobehavioral adaptation that occurred during our evolution.

In order to be receptive to a cultural milieu, we are born with genetically endowed tendencies to bond with others, to imitate and wish to please, to learn a language, to accept the beliefs of our associates, to resist and be suspicious of outsiders and their ways. Compared to other animals, we rely less upon innate resources and are far more dependent on our fellows to learn what we need to know to live, but we have innate proclivities to learn from our fellows, and to learn some things more easily than others. As I have already said and will have occasion to repeat, cultures and cultural practices are means of satisfying these characteristically human biological propensities or needs. The most promising position is not that of choosing between nature or nurture, genes or environment; it is to affirm that both contribute, necessarily and inseparably, to shaping our humanity.

It is just plain wrong to think that being cultural exempts us from biological imperatives. We are cultural creatures as we are tool-using and language-using creatures; indeed, tools and language are parts of culture. We use cultures—the elements of our cultures, like tools and language

and the arts—to get what we need, biologically, as well as what we are taught to think we need. We are predisposed to learn cultural things because doing so helped us, as hominids, to survive.

One universal cultural predisposition of humans is the trait of ethnocentrism: taking oneself and one's group to be the central fact in the universe and the unquestioned measure of everything in it. It is usual today to say that *anthropo*centrism has characterized Western society since the Renaissance, when man, not God, became the measure of all things. However, *ethno*centrism, which is much more ancient, claims that "we" (not "you") are the measure. This proclivity is detectable in most if not all human societies, as when groups call themselves by their word meaning "human" or "the true people" (see the discussion in Chapter 4); and virtually all human social groups find it easy to consider other human social groups to be inferior or not quite human. Ethnocentrism of this type characterizes not only Christian fundamentalists or creationists who see humans as being made in God's image and therefore centrally important and who believe in the historically recent divine creation of the earth and all that exists upon it, but, ironically, even some social scientists and humanists who claim that there are no universal human behaviors—a pronouncement that may reflect a largely unexamined belief in the preeminence of their social group. Arguably, ethnocentrism, undeniably of value when small groups required self-righteousness and solidarity in order to cooperate and survive, is responsible today in a very different world not only for the racist notions of the superiority or inferiority of one group compared to another, but for the humanists' and social scientists' opposition to species-centrism and the Darwinian view. In their view, species-centrism is "'reductionist" (bad word) because it focuses on what makes humans alike rather than on what makes humans different (and some of us, especially Westerners, superior).

Moreover, even apart from common sense and ethnocentric objections, the history of Western philosophic thought could hardly have been better designed to offer resistance to the Darwinian premises of human ethology. To begin with, the long-combined Platonic, Neoplatonic, and Scholastic traditions of adherence to notions of the fixed and final, the eternal and immutable, perfection, unity, and permanence were philosophically opposed to the acceptance of change and chance inherent in the Darwinian explanations of human existence. Gradually, of course, after the Renaissance, inductive science and empiricism largely superseded these essentialist or innatist doctrines. But, ironically, the legacy of Enlightenment reason in philosophy and the social sciences has also proved to be antagonistic to the scientific theory of Darwinism, in large

part because it has been regarded as in its own way "essentialist" or "innatist." The complex currents of Western social and philosophical theory over the past three centuries as they have affected the reception of Darwin's theory are ably traced by Robin Fox (1989).

The political and economic reforms that created the modern world were built upon notions of individualism (individual rights) and empiricism (the reliance on sense data for knowledge of the external world). These ideas in themselves are not at all incompatible with a Darwinian perspective. But in the Enlightenment context in which the ideals of liberty, equality, and progress were exalted over the long-standing ideology of the king's divine right, aristocratic privilege, and the status quo, it would have seemed contrary and unacceptable to view humans as a species (that is, a collective) characterized by universal, genetically endowed (inherent) behavioral potentials and tendencies. And, indeed, Fox shows that the legacy of the major modern philosophers, whether materialist or idealist, subjectivist or collectivist, ultimately resulted in the general tendency to view humans as blank "wax tablets" (to be improved by education and social reform) and thus to interpret any concept of "innate ideas" already etched on that tablet as threatening to liberal democratic notions.

It is interesting to note that eighteenth-century French *philosophes* such as Rousseau, La Mettrie, and d'Holbach in their musings on liberty and social reform invoked the ideas of "natural man" (man living in a state of nature) as support for their views, and opposed "natural law" to the oppressive law characteristic of a society ruled by "divinely" mandated kings. Although in this view Nature (a complex concept allied to that of the "primitive" described above) was a source by which a corrupt society could theoretically reform and purify itself, this Nature remained an abstract and immaterial concept. Individual humans themselves were still regarded as entirely moldable. It is as if these thinkers applied their idea of Nature to plants and animals, primitives, and young children (as many people would probably do today) while nevertheless continuing to think of adults as being entirely creatures of their society (see also Bloch and Bloch 1980, 28–31).

In sociology and anthropology, as in philosophy, a number of factors have conspired against a fruitful and influential acceptance of Darwinism. While some theorists adopted evolution as an explanatory paradigm, they applied it simplistically and piecemeal, and ultimately did more harm than good. Influential early anthropologists such as Lewis Henry Morgan and Edward B. Tylor proposed unilinear schemes of cultural evolution that, displaying a complacent nineteenth-century positivism

and ethnocentrism, placed "savages" at the bottom and white Western Europeans at the pinnacle of an ascending scale. No wonder that their successors in America, Franz Boas and Alfred Kroeber (whose students and, so to speak, grandstudents are important figures in today's anthropological establishment), rejected "evolutionary" schemes and "natural" or universal laws, and turned to investigate the subjective and distinguishing aspects of individual cultures.[10]

The majority of anthropologists associated with "evolutionary" thought today are those who espouse *cultural* evolution or who have proposed schemes of "cultural ecology" in which humans are viewed as adapting to different environments by means of culture (e.g., Rappaport 1984; Sahlins and Service 1960; Steward 1955; White 1969). Their works are not in any rigorous or fundamental way Darwinian or species-centered.

Emile Durkheim, the founder of sociology, has arguably been far more influential in European and Anglo-American anthropology than any other single theoretician. He espoused a version of collectivism when he declared the social group as primary, prior to its individual members. But the old prejudice against innatist and subjectivist positions precluded their being used by Durkheim or his followers in a Darwinian sense, as they could have been, to understand this collectivity as a real and tangible entity: a species with a specifiable nature, measurable and amenable to scientific investigation. Indeed, Durkheim argued that social phenomena have a distinct nature of their own and cannot be reduced to matters of individual psychology, much less to biology. Rather, imbued by the Western tradition, Durkheim viewed individuals as wax tablets upon which were impressed the "collective representations" (language, laws, belief systems, customs) of their group. Adherence to the position that individuals and individual cultures are unique, however, need not imply that there are not still general laws or principles that embrace them.

The possibility of building a common scientific basis for the study of humankind and of understanding cultures as ways of satisfying fundamental human needs was proposed by Bronislaw Malinowski (e.g., 1944) in a way that could almost unchanged serve as the beginning of a species-centered anthropology.[11] For Malinowski, culture was consistent with man's nature; there is neither a breach between the two (*pace* Durkheim) nor is one's natural self virtually obliterated by one's society (*pace* Boas and his American pupils, Ruth Benedict and Margaret Mead). Malinowski even proposed that the motivation for the individual's participation in society was largely that of ambition and self-interest. Yet his ideas have generally been dismissed as "naive" and empty functionalism, and the man himself has been recently pilloried for the "patriarchal" (racist,

sexist, and other Victorian) views revealed in his infamous posthumously published private diaries. Blaming people for expressing the views of their time and ridiculing their privately expressed revelations of all-too-human moods and personal idiosyncrasies is a fate one might wish on contemporary revilers of Malinowski (e.g., Torgovnick 1990) when they too are dead and gone.

In any event, the social anthropology of Durkheim and Radcliffe-Brown became well entrenched in the English-speaking academic world after World War I, and French structuralism made its claims on the human sciences after World War II. In my view, Malinowski has been unfairly demoted to the "historical-interest-only" category. He deserves to be acknowledged as the obvious historical link between Darwinian evolutionary theory and a species-centered study of humankind.

Apart from the accidents of history or the tenacious influence of stubborn strands of past Western philosophical thought, it must be admitted that nineteenth-century Darwinists themselves gave the term "Darwinism" an opprobrium that still adheres so that today, among laypersons, Darwinism means determinism, rapacious competition, and "survival of the fittest." "Social Darwinists," followers of Herbert Spencer, vindicated competitive individualism and laissez-faire economics in the service of an inevitable, progressive, cumulative social change. They took up Darwin's materialist theory of natural (biological or genetic) selection and adapted it to social evolutionary ends that, like Tylor's and Morgan's unilinear evolution, were opportunistic analogies based on misunderstanding and not implied in the biological theory at all.

Reaction to Social Darwinism has done much to undermine the possibility of an impartial, informed assessment of what Darwinism actually offers. To be sure, the possibility of misusing biological theory, as well as actual practice, for political ends is not farfetched: the Soviet promotion of Lysenko's erroneous genetic theories and earlier agendas of the American Eugenics Society (to say nothing of later Nazi programs to this same end) come readily and painfully to mind. With ample reason, the detractors of Darwinism fear its use to justify the more rapacious and self-serving political ends of Western capitalism. It is all too easy to blame the poor, whether individuals or countries, for their weakness in resisting the superior engines of exploitation and domination. Considering might to be right can provide a rationale for racism or policies of decreased social aid to the poor and distressed. The initial detractors of E. O. Wilson's (1975) sociobiological ideas—a development of neo-Darwinian theory—were members of a group called the Sociobiology Study Group of Science for the People, persons of radical leftist political persuasion who assumed

that sociobiology, applied to humans, was by its nature dangerously re-
actionary. (They did not object to its validity when applied to other
animals.)

In Chapter 2 I will describe the fundamental points of modern evolu-
tionary theory that are necessary to understand the emergence of *Homo
aestheticus* as presented in this book. Here I would like simply to em-
phasize that the theory of evolution by natural selection does not itself
proclaim or endorse a moral law of survival of the fittest.[12] It *describes* a
process by which, during countless generations, traits (influenced by
genes) that endow their possessors with greater survivorship in a particular
environment persist, and other traits that contribute less well to survivor-
ship decline; thus, gradually over time a species (the interbreeding group
that carries these traits) adapts (changes) to better fit its environment. This
is quite a different thing. For the true Darwinist, it is the *inclusive* survival
of the *fit* that matters, not the *exclusive* survival of the *fittest*, and the
former results from the selection of the successfully competing and co-
operating individuals, not the promotion of the most ruthless and self-
centered individual (or group) as (socio)biological singularities. Darwin
himself offered social and moral corollaries of his theory that are com-
pletely opposed to the smug and self-serving justifications of Social Dar-
winism and believed that an understanding of evolution would lead to a
stronger morality, not to more competitive rapaciousness.[13]

Yet even apart from the unpleasant residue of Social Darwinism, ev-
olutionary theory would still be suspect today for partaking of the "sci-
entific mentality," that, as I mentioned earlier, is itself under widespread
attack in a century that has seen the discoveries of science mushroom,
literally, into appalling consequences. Nazi gas chambers, Chernobyl,
the devastation of the ecologies of earth, sea, and atmosphere, the feared
excesses implicit in genetic engineering—all can be laid at the door of
"Science," or seen as effects of a mechanical and unstoppable inhuman
technological mentality that enlists science in order to exploit, dominate,
and destroy. Darwinism, being biology, and biology being science, is
roped off into the same "Beware" category and assessed as dangerous,
reductionist, opposed to beauty, peace, and the human scale.

New Age thinkers, most of whom devoutly believe in changing the
prevailing technorational consciousness and making a better world, seem
uniformly and even determinedly ignorant of biological evolution as a
process or as a useful framework for their own claims. It may seem unfair
to choose Riane Eisler from a field rich in evolutionary illiteracy, but as
her book, *The Chalice and the Blade* (1988), is prominently called on its
cover by Ashley Montagu "the most important book since Darwin's *Or-*

igin of Species," one might expect Eisler (and Montagu, for that matter) to have an inkling of what is in her predecessor's book. Yet it is obvious from her few sentences about "evolution" or "sociobiology" that her dismissal of these notions is not based on understanding even their most elementary principles. [14] This is unfortunate because her work, no matter how well researched with regard to historic times, should address bioevolutionary issues, not to mention non-Western cultures, in order to have the relevance, solidity, and range she claims for it.

Then, of course, there are the creationists who resist evolution because it displaces the biblical God, the Six-Day Wonder who created the universe. The controversy even today about teaching evolution in the public schools, more than a century after Darwin's death and sixty-five years after the Scopes trial, indicates how terrifying the idea of evolution can be. [15]

In this brief review, social and political philosophers and social scientists are seen to join hands with New Agers and creationists in their inherited prejudice against, ignorance of, and intrinsic lack of sympathy with Darwinism. And with the exception of two or three philosophers of the mind publishing in the last decade or so (see the discussion in Chapter 7), most contemporary philosophy is also unconcerned with Darwinian implications. Wittgenstein, for example, considered evolutionary argument to be irrelevant to his enterprise of analytic philosophy. By its main postulates, existentialism, insofar as it proclaims the unconditional freedom of individuals to choose their own destinies, ignores or is even conceptually blind to Darwinism. Phenomenology, despite its emphasis on Being, does not discuss biological concomitants or instantiations of active be-ing. The "primacy of perception" and the notion of the "lived body" in the thought of Merleau-Ponty, phenomenology's most famous twentieth-century aesthetician, are as dishearteningly without tangible relevance to the evolutionary biologist as Darwinian ideas are absent from Merleau-Ponty's thought.

Continental poststructuralist philosophy is so stratospheric in its concerns and so logocentric in its pronouncements that anything as earthbound as biological evolution is not even entertained. Marxist-derived social science and philosophy are both based on the importance of sociocultural determinants of (or effects upon) human behavior, even though Marx himself sent a copy of *Das Kapital,* with admiration, to Darwin, believing them both to be engaged in a similar enterprise. [16]

Yet it seems clear that an understanding of humans as a species that has evolved should be of great import to philosophy, particularly since philosophers tend to assume that their constructions have universal validity.

Simply being aware that brains (minds) and language have evolved as tools for survival allows a salutary perspective for one's pronouncements about Reality. For example, J. Z. Young, mentioned above as being one of the few biologists who is on record as considering art to be essential, has written *Philosophy and the Brain* (1987) because of his conviction that new biological knowledge can give important insights to old philosophical problems such as mind-body dualism, epistemology (in particular, what philosophers refer to as "intentionality"), and determinism. Churchland (1986, 482) claims that findings in neuroscience will transfigure epistemology, as we discover what it really means for brains to learn, to theorize, to know, and to represent (see also Chapters 6 and 7).[17]

Darwinism is attacked, then, from many directions and for many reasons. It has been actively resisted and dismissed as being of no account. Few specialists in the humanities or social sciences have devoted serious study to its basic tenets. With this long history of perceiving Darwinist ideas to be irrelevant or perverse, and the phalanxes of influential contemporary philosophers and social scientists either actively opposed to or blithely unaware of contemporary Darwinian theory and its implications, it is far from surprising that it remains an intellectual no-one's land. Indeed, one must applaud the few who have paid it intelligent respect.

Confusions and misunderstandings about how evolution works abound, and it is all too easy to propose what seem like plausible explanations for any trait. One can understand, then, specialists' objections to "vulgar" or "pop" sociobiology, but going to the extreme of distrusting any "adaptationist" arguments for human behavior, as have the eminent evolutionary biologists S. J. Gould and R. Lewontin (1979), seems unnecessary. They have called the assumption that what is there has evolved because it is "good"—helpful in survival—"Panglossian."[18] More deeply schooled evolutionary biologists than I have defended adaptationism against Gould and Lewontin's charges (e.g., Mayr 1983; Ruse 1982). One should just as surely avoid irresponsible evolutionary "Just So" stories about human behavior as one resists giving trivial "Freudian" symbolic interpretations. Yet, as Ernst Mayr (1983, 332) has written, "Aristotelian 'why' questions are quite legitimate in the study of adaptations, provided one has a realistic conception of natural selection and understands that the individual-as-a-whole is a complex genetic and developmental system and that it will lead to ludicrous answers if one smashes this system and analyzes the pieces of the wreckage one by one."

In this regard, perhaps it should be enough to assert that the narrow-minded reductionism of atomistic or simplistic evolutionary explanations

(i.e., one gene–one trait—an "art" gene for art) is as untenable and useless as the elitist and essentialist claim that art is too rarefied and complex to be amenable to any kind of scientific or biological scrutiny. An enlightened ethological or biobehavioral point of view (to be described in the following chapter) seems a good meeting point in the middle from which to avoid either untenable extreme.

Finally, as a nonspecialist bestriding the abyss between the ideas of evolutionary biology and *tout l'autre*, I have to say that in large part the Darwinists themselves have played a part in engendering suspicion and resistance to their subject among laypeople. Some, like naughty children, say their piece, often simplistically or cavalierly, with what seems to be a deliberate wish to shock or offend; others encrust their ideas with tedious jargon; some, like stereotypical Southern sheriffs, go about their jobs of enforcing the tough bottom-line rule of self-interest without a trace of sympathetic feeling for the tender-minded values and verities that for most people give meaning and beauty to their lives. Freud and Marx also based their theories on materialist and naturalist first principles that are not comforting to the illusions that help people get by, but they and their followers while explicating the sacred doctrines have written as if human feelings and needs were real and important, not epiphenomena of chromosomal programs. Darwin took some trouble to choose his words with care for their effect; I think contemporary Darwinists would do well deliberately to woo nonscientists with precise and interesting language, breadth of reference, and indications that they too are acquainted with the human condition.[19] If Darwinism is to be a convincing paradigm within which to view human history, endeavor, and thought, it should have a human face.

❧ 2 ❧

Biology and Art
The Implications of Feeling Good

Even the most rarefied aesthete, committed to the supremacy of the spirit and the divine in art, will have to agree that our experiences of the arts, in simple-to-profound ways, feel good. All over the world people enjoy making music, singing, dancing, reciting or listening to poetry recited, telling or hearing tales told, performing or watching performances, making beautiful things, and so forth. These activities unite participants with one another, performers with their audience, the community as a whole. They facilitate a mood in which attention is focused, aroused, moved, manipulated, satisfied. Whether as ritual or entertainment, the arts enjoin people to participate, join the flow, get in the groove, feel good.

Treatises on aesthetics rarely, if ever, mention this reality. They discuss topics such as relative repleteness, syntactic or semantic density, unity in variety, unity of an awareness and its object, significant form, presentational symbolism—all of which may be relevant or true, but none of which address, much less explain, the fact that art experiences, whatever else they may be, are physically pleasurable. Treatises explain what aesthetic experiences consist of, but not how they feel, or why they should feel sensuously good rather than just edifying, like attending a church service, or pleased with oneself, like solving a tough algebra problem.

Although the Western philosophy of art briefly tried to develop a concept of aesthetic emotion—thereby acknowledging that there was an emotional component to art—the very idea is definitely unpopular today, particularly among aestheticians. George Dickie (1969) examined and demolished the very idea of aesthetic emotion; Nelson Goodman (1968)

had earlier dismissed it as "aesthetic phlogiston." Psychological studies of emotion omit aesthetic emotion not only from their tables of contents but even from their indexes. Reading about the arts today, one has the feeling that they are matters of interest only when they reach the stage of being remote, like heavenly bodies or artificial satellites serenely revolving in the empyrean. We discount, disregard, or forget the blazing forces that got them up there and our sympathetic thrill of exultation and participation as they rose aflame, leaving earth and us behind.

Even if one does not claim that works of art arouse a specific emotion (in the manner that contemplating one's infant presumably arouses maternal emotion), talking about the feelings one has while experiencing art—however these are categorized—often seems only to cause harumphs or evasive glances, exactly as if one had said something unmentionable in a Victorian drawing room. When I read written descriptions like the following to my classes at the New School, students, if they don't simply look puzzled, appear embarrassed and smile uncomfortably. Yet such descriptions of responses to works of art unequivocally indicate that they may be as sensuous and physical as any human experience.

The experience of great art disturbs one like a deep anxiety for another, like a near-escape from death, like a long anaesthesia for surgery: it is a massive blow from which one recovers slowly and which leaves one changed in ways that only gradually come to light. While it is going on, the reported physical signs of such a magnificent ordeal have been reported to include sweating, trembling, shivering, a feeling of being penetrated and pervaded and mastered by some irresistible force.

Jacques Barzun, *The Use and Abuse of Art* (1974)

This blazing jewel that I have at the bottom of my pocket, this crystalline concentration of glory, this deep and serene and intense emotion that I feel before the greatest works of art. . . . It overflows the confines of the mind and becomes an important physical event. The blood leaves the hands, the feet, the limbs, and flows back to the heart, which for the time seems to have become an immensely high temple whose pillars are several sorts of illumination, returning to the numb flesh diluted with some substance swifter and lighter and more electric than itself. . . . Now what in the world is this emotion? What is the bearing of supremely great works of art on my life which makes me feel so glad?

Rebecca West, "The Strange Necessity" (1928/1977)

I hear the trained soprano she convulses me
 like the climax of my love-grip;
The orchestra whirls me wider than Uranus flies,
It wrenches unnamable ardors from my breast,
It throbs me to gulps of the farthest down
 horror,
It sails me I dab with bare feet they are
 licked by the indolent waves,
I am exposed cut by bitter and poisoned hail,
Steeped amid honeyed morphine my windpipe
 squeezed in the fakes of death,
Let up again to feel the puzzle of puzzles,
And that we call Being.

Walt Whitman, *Song of Myself* (1855)

Of course, not all responses to the arts are as extreme as these accounts, and most probably are only momentarily noted as pleasing or gratifying (or even neutral or negative). But the very fact that people can report such strong responses, and the implication that such responses might occur at any time, is intriguing. How can we explain them?

According to modernist theory, the only significant purpose of art is to engage the mind and enrich the spirit. Hence, despite the occasional report of aesthetic ecstasy, most official modernist discussions of the arts more often than not proceed as if the subject were bloodless and bodiless. The physical factor in aesthetic experience is traditionally ignored by critics and theorists as something irrelevant to art in the same way that the mechanics of digestion are considered irrelevant by a restaurant reviewer penning an appreciation of a good meal.

Somewhat surprisingly, postmodernist thought, while emancipated from adherence to old-fashioned ideas of the noble, the grand, and the high ideals of art, is if anything even more likely to consider the physical or emotional concomitants of art experience as irrelevant and somehow bad form. To its own works, the appropriate response most frequently is intellectual, conceptual.[1] While a raised eyebrow, a chuckle, or a hiss of rage might be allowed, a fully-fledged acknowledgment of being deeply moved or drastically affected by a postmodern work or by any other form of art is seen as evidence of one's unexamined cultural prejudices made public.

In a time when detailed descriptions of sexual feelings are common fare in literature and real life, it seems odd that we feel uncomfortable

about having or admitting to having full-fledged emotional experiences of art. Now that first religion and then sex have lost the aura of mystery, sacredness, and taboo that formerly protected them against being profaned by too much open acknowledgment of their emotional power, art is our last bastion of reticence.

Body and Soul

Historical reasons help us understand why in Western tradition physicality has been, if I can be forgiven the wordplay, a stumbling block. (In other traditions—notably Hindu and many premodern societies in Asia and Africa—the sacred and profane or spirit and body are inextricably joined.) Long before Calvinists repudiated the flesh or Bishop Berkeley dismissed the body, the Western World had a well-established tradition of mistrust and censure of the physical aspects that attend human experience. In classical Greece, for example, in philosophical discussions about the "moral" qualities of music ("ethical," "enthusiastic," "purgative," "convivial," "relaxed" modes) or about the superiority of one sense over the others, the important factor seems to have been whether these give bodily or mental pleasure. In music, the sober, intense Dorian mode was venerated because it was believed to most elevate the mind. The senses of sight and hearing were considered superior to the senses of taste, touch, and smell because the former two kept illusory but messy reality further away. Moreover, because sight and hearing were better able to discriminate fine differences—such as distinguishing colors or pitches whose hues or frequencies are exceedingly close to one another—these were considered to be closer to the workings of the intellect, the instrument best suited to apprehend True Reality (which for Plato, as for most philosophers in the Western tradition, was bodiless and nonmaterial).

The Christian attitude toward the physical can be summed up in the seventeenth-century admonition that the more abstract we are from the body, the more fit we will be to behold divine light. Indeed, for more than two thousand years, in theory if not always in practice, the body and the senses have been considered the opposites of the mind and reason, and relegated to an inferior status in any discussion of the characteristics of humankind.

These and other dualisms inherent in the Western philosophical tradition—spiritual-physical, objective-subjective, form-content—have been as firmly entrenched in aesthetics as in any other branch of philosophy, thereby ensuring the persistence of the belief that art is incorporeal.

And in the eighteenth century, when "disinterestedness" or critical distance became an essential feature of art appreciation, requiring perceivers to disregard their personal interest in the subject matter and attend instead to objective formal features, the physicality of art was dealt yet another blow.

Today, aesthetic disinterestedness is pointed to as an outworn relic of modernist elitism, but the inadmissability of strong emotional response to works of art—or anything else, for that matter—continues. The Kantian Sublime, the emotional response of awe in the presence of the grand and terrifying aspects of nature, is translated into the postmodernist liturgy as arising from "a representation that cannot be mastered"[2] or from the breakdown of meaning and the bankruptcy of teleological explanations.[3]

Nevertheless, even though the traditional establishment view of art is that art is ideal and mental, and the postmodern view is that art represents meaning deferred and desire unsatisfied, the attentive student can discover evidence of a subversive undercurrent attesting to the idea that at least some of the intense pleasures of aesthetic experience are insistently bodily, and that therefore physicality cannot be totally discounted as irrelevant. When Plato banished ecstatic poets, extravagant rhythms, and effeminate convivial harmonies from his ideal Republic and when Saint Augustine confessed the "peril of pleasure" that sung, as compared to spoken, psalms produced in him, the former's strictures and the latter's unease indicated awareness of an obstinate and indomitable intruder at the gate. *Jouissance* and "desire," recent critical terms that denote contemporary awareness of potential emotional transport, are tease-words, since for postmodernists desire remains by its very nature unsatisfiable and the pleasures of the text arise from the act of intellectual deconstruction—or at best intellectual play—rather than from physical rapture. Yet the words—lures that self-consciously titillate as they deny—are not just atavistic tokens of culturally engendered epiphenomena, but indeed indicate ever-present and potent susceptibilities.

History, then, helps to explain why our ideas about art are biased in favor of the intellectual and spiritual aspects of aesthetic experience. Moreover, the nature of art itself appears to offer persuasive reasons for discounting physicality. Let me give two oversimplified but instructive examples. It has been demonstrated that cows and suburban shoppers are both measurably more relaxed when their barns and malls are supplied with piped-in recorded music.[4] Yet we do not say these physical effects are "aesthetic." Whatever the good or bad quality of the music, the subjects are not consciously listening to or even necessarily aware of the sounds they are "hearing." And, in an opposite kind of example, disco-

theque patrons, who *are* overpoweringly aware of hearing sounds, similarly cannot be said to be responding aesthetically to the pulses and insistent chords that bombard their bodies and provoke uninhibited, almost reflexive, physical reaction. Sheer sense experience, whether unconscious or conscious, without mental mediation, is aesthetically meaningless. It is *what the mind makes* of the physical sensations that is interesting and relevant. Hence, to anyone who stops to consider the subject of aesthetic response, the mind (or soul or spirit) seems to be the relevant vehicle for the experience of art.[5]

Additionally, while it is not easy to propose a definition of art that covers all possible examples or that satisfies everybody, few would deny that an essential element of any eventual definition would be aesthetic *form*.[6] What distinguishes beauty in nature from beauty in art (or nature from art, in general) is that the latter has had form imposed on it by its human creator. When we smell a rose or taste a ripe peach directly, our senses may be excited, causing us to experience pleasure, but these exquisite experiences are not aesthetic in the same way as when we appreciate a ballet or poem which by contrivance embodies the spectre or the sickness of a rose, or a painting of fruit that has been arranged on a rumpled cloth alongside a blue and white vase. Whatever sensual pleasures inhere in the artworks, the distinctive and necessary aesthetic factor would appear to be the mental appreciation of how their makers have shaped and embellished the sensuous raw materials.

I believe the ethological view can resolve the confusion in aesthetics that I have been describing—the problem of successfully disposing of the body in art (which like the corpse in a Hitchcock film keeps insistently reappearing)—by showing how it can and must be incorporated into our thinking. An aesthetics that tacitly or overtly holds to an obsolete duality of "body" and "soul" and, by extension, of "biology" and "art," seriously and unnecessarily restricts its scope and power.

Ethology and Emotion

If the duality of body and soul is an erroneous legacy of Western philosophy, the separation (for purposes of study) in academic psychology of cognition and emotion has also been the cause of considerable muddle. While many psychologists today accept the idea that emotion and cognition are inseparable in most if not all instances (see Scherer and Ekman 1984),[7] the subject of emotion, as Catherine Lutz (1988) has pointed out in her study of the "everyday sentiments" of the Ifaluk of Micronesia,

often is devalued with respect to rational thought in general American popular attitudes, and treated as a "mental health" problem or as a female or animal or mammalian trait rather than as a particularly human, intellectual, and social adaptation.

It should be apparent, however, that every mental state has cognitive, perceptual, motivational, and emotional dimensions and cannot be properly understood if only one of its aspects is considered at the expense of the others. To modern biological thinking, of course, a feeling or physical response is no more or less bodily than an idea, a perception, a memory, or a thought. A "mental" or "emotional" apperception of color, shape, or process is comprised of physiochemical, neurophysiological events.

Thus, the best and most comprehensive way to regard most experiences is to recognize that they are *simultaneously* perceptual, cognitive, emotional, and operational. Thoughts and percepts have emotional concomitants; emotions and percepts are mental events; thoughts and emotions are often induced by perceptions; many percepts, thoughts, and emotions presuppose or lead to action. "Anger" or "love" are not just free-floating feelings: they describe a sensorily perceived and mentally registered and evaluated occasion or context.[8] "Jealousy" or "fear" are states of emotional being inseparable from our thoughts, perceptions, wishes, and cravings concerning the items or occasions that produce these states. They are less like individual ingredients that go into a mixture than the unique color or aroma of a mixture that is a product of a number of ingredients. Klaus Scherer (1984, 311) accounts for subtle emotions by the analogy of a kaleidoscope whose components or facets arrange themselves uniquely in a particular case.

In the previous section of this chapter, in order to make the point that in our experiences of art "body" is as important as "soul," I committed the error that I have just cautioned against, by isolating and overemphasizing "emotion" or the felt "physical" aspects of experiencing art. I acted deliberately, but not in order to advocate a simple aesthetic hedonism, as it may have appeared. For strong "emotion," the positive or negative physically felt quality of an (also perceptual and ideational) experience is to an ethologist a clue to the evolutionary significance of that experience, or type of experience. It should be self-evident that what we do not care about, we neither pay attention to nor remember (Armstrong 1982). Emotions are biologically adaptive, helping us to appraise and cope with our environment and let each other know what we are likely to do (Tooby and Cosmides 1990).

If something—in this case, the arts—feels (emotionally) strongly plea-

surable and compelling and thus is valued and actively pursued, this feeling state suggests that it must in some way contribute positively to biological survival. For one of the ways in which nature has ensured that we do the things that are essential for survival is to make them feel good.

Behavior is, essentially, choice: to act or not, or to act in one way rather than another. And we are drawn to appraise and choose things on the basis of our feelings. (In this regard, the concept of "desire" is even more critical to an understanding of species-centrism than of poststructuralist psychoanalysis or literary theory.) The tendency to behave in one way rather than another—to pick up the baby rather than let her cry, to help rather than ignore or hurt a friend—is grounded in emotion, in how we feel. We, not surprisingly, tend to choose what makes us feel positive and good, in preference to something else that makes us feel less positive. And, to repeat, what we choose—what makes us feel good—is generally what has had survival value for human evolution, so that behaviors are adaptations that have helped us to survive. People who are born with the behavioral tendency to act (choose) in a certain way in certain circumstances survive better in most cases than those who do not.[9] To mention obvious examples, we inherit proclivities to walk on two legs, to play, to talk, to like being close to other people. These are adaptive behaviors, behaviors that had selective value.

It is true that there are individual differences in the manifestations of a general behavior. Some of us may do it better than others. Some may enjoy doing it better than others. And having the predisposition does not mean we cannot refine and improve on it or that, in certain circumstances or lack of circumstances, it may be thwarted. Someone who grows up in a desert may never learn to swim. Under normal circumstances, however, one year olds want to walk, two year olds want to talk, and sixteen year olds want to make love. Doing these things feels better than not doing them because in general doing them has had survival value.

Such a simplistic summing up hardly covers the whole of human conduct. There are, of course, occasions when choices conflict, when the alternatives are not between doing or not doing but between doing one thing or doing another. Humans are complex and inconsistent beings, whose natural as well as cultural imperatives often conflict. Thus we may sometimes want or choose to do what in our present circumstances is disadvantageous. Or we may wish to have our cake and eat it too. While we may choose to defend ourselves when threatened, or to make love when an agreeable partner is at hand—thereby acting in accord with emotional inclinations that have survival value—we may also choose not to fight but to use reason and talk with an adversary instead, or not to

make love until we are better acquainted or because we wish to keep a vow of fidelity to our marriage partner. These choices are also based on our feelings, which to be sure are more complicated than those of other animals. Unlike dogs and cats, we are not prisoners of either our aggressive or our sexual drives. Our more complex abilities to remember and foresee, weigh alternatives, imagine, and reflect allow us to think of our long-term interests and choose *not* to do what our "natural" (or short-term) interests and inclinations might first suggest.

Yet it should not be surprising that what *feels* good in most cases is what *is* good for us. In fact, the two are sides of a coin: people universally do something because it feels good; and because something feels good, people do it. Even though there may be many shades of feeling, and even though calculations of duty, moral obligation, and so forth may greatly complicate what is rooted in simple preference, in the last analysis, in humans as in other species, the final choice of one alternative rather than another (i.e., to approach or to avoid) can be said ultimately to be based on its making us feel better than the other alternative.

A corollary of this view is that what feels good is also usually a clue concerning what we *need*. This might be called the third side of the coin: the enclosing perimeter. Without any special encouragement, humans take great pleasure and find positive reinforcement in performing activities and seeking out environments that are biologically essential to our (and our species') survival: eating, resting, being in familiar and secure surroundings; having sex, children, intimate friends; talking; engaging in activity that is perceived as useful and appropriate; and noticeably also engaging in song, dance, poetic language, drama with costumes and masks, music, self-adornment, and embellishing personal and public artifacts. In modern society where working to earn money in order to consume perpetually novel goods and experiences has become for many the purpose of life, these more ancient satisfactions are perhaps less evident than in premodern or traditional societies. However, few would claim that even in our own lives they could be easily or lightly altogether forsworn. [10]

The Human Need for Art

In Chapter 1, we saw that a naturalistic view of art eludes even biologically minded explainers of human behavior, who either neglect it altogether, say it is beyond explanation, or understand it only as a by-product of some other activity. Such hands-off or shrug attitudes are symptomatic

of the general modern Western attitude toward art and prevent our rec-
ognition of its importance. It is time to recognize that art is as normal,
natural, and necessary as other things that people do, and to try to
approach it ethologically, as a *behavior*.

Thinking of art as *a* behavior may seem strange, difficult, or awkward,
in part because the word *art* most commonly refers to visual art (objects
and artifacts such as pictures, statues, jewelry, masks, costumes), and
sometimes to the intangible qualities of these artifacts (beauty, form,
harmoniousness), that is, to the traces of art making rather than the art
making itself. While some other arts, such as music, dance, or perfor-
mance, could perhaps more easily be thought of as "behavior," since they
exist in time and "making" them is part of their time-bound nature, the
concept of art-in-general still retains its visual-art connotations of object
and essence, which seem too variform and elusive to be included in one
prosaic and clumsy notion of "behavior."

It might be easier to establish the viability of the idea of art as a human
behavior by considering it further as a human need (or as the satisfying of
a human need). As individuals, many of us know in our bones that we
need art, whatever that may mean. (It is often an unformulated, subter-
ranean feeling or conviction.) We cannot imagine life without music, or
poetry, or man-made beauty in one or more of its many forms. We thirst
or hunger for these, and feel deprived when they are absent.

But why, ethologically speaking, would there be a need for "art."
Usually the "reason" for art, when reasons are sought, has been found in
theology, history, sociology, or psychology—not biology. According to
previous explanations, art is a gift from, or manifestation of, God; it is
something learned from one's forebears; it is an emblem or tool of po-
litical or social power; it is an act of escape or catharsis or sublimation. All
of these ideas have been and may still be true. But there is a deeper sense
than these in which the fact of art requires explanation, and that sense
can be addressed only by biology.

Three indications suggest to an ethologist that a species trait (like
parenting, sex, or art) has evolved (i.e., that it has survival value, is a
biological need, and can be considered "a behavior"). The first is what I
just described, that it "feels good," and so people are positively inclined
to do it. The second is that people spend a great deal of time and effort
doing it. Frivolous pastimes that take energy and time from useful activity
are not selected-for, particularly in large numbers of the population,
which leads to the third criterion, universality.[11]

Even people who have not thought much about the notion, people
who do not noticeably need art themselves, would have to agree that

these three characteristics obtain for art. In every human society of which we know—prehistoric, ancient, or modern—whether hunter–gatherer, pastoral, agricultural, or industrial, at least some form of art is displayed, and not only displayed but highly regarded and willingly engaged in. By the criteria of energy investment, pleasure, and universality, it would seem that these activities (or perhaps one or more qualities that are expressed by or manifested in these activities) fill a fundamental human need, satisfy an intrinsic and deep human imperative.

To establish that humans universally *need* art is a claim that is ultimately biological. The biological rationale is easy to comprehend when we say something like "Humans need food" or "Humans need warmth"; this rationale is even obviously relevant when we say humans need more abstract things like recreation or security. No one would deny these biological needs: any thoughtful person can recognize that they are necessary for survival, or at the least for well-being.

Recognizing art as a biological need can give us not only a way to better understand art, but by understanding art as a natural part of us, we can understand ourselves to be part of nature. An ethological view of humans, a view that considers them as an animal species that has evolved to have a particular way of life in a particular environment, can suggest reasons why they have art, just as an ethological view of wolves can suggest reasons why they howl, play, and share their food. Art can be considered as a behavior (a "need," fulfillment of which feels good) like play, like food sharing, like howling, that is, something humans do because it helps them to survive, and to survive better than they would without it.

What It Means to Call Art "A Behavior"

We have seen that usually when people talk about art they refer to objects or entities like paintings or performances: "works" of art like *The Firebird*, the *Oresteia*, the Sistine Chapel ceiling. Or they imply that art is some sort of essence or excellence that is inherent to Picasso's paintings but lacking in those of Joe Bloggs.

The species-centered view requires a new and different kind of orientation, and its scope of inquiry is both broader and narrower. The species-centrist regards art not as an entity or quality but instead as a behavioral tendency, a way of doing things. This behavioral tendency is inherited, and thus both indelible and universal. That is to say, it is not the exclusive possession of just a select few; rather, like swimming or lovemaking,

art is a behavior potentially available to everyone because all humans have the predisposition to do it. (It is another question altogether to decide who is an "artist" in the restricted sense used by contemporary Western critics and philosophers of art, or to specify what makes some works "good" and others "not so good.")

By calling art a behavior, one also suggests that in the evolution of the human species, art-inclined individuals, those who possessed this behavior of art, survived better than those who did not. That is to say, a behavior of art had "selective" or "survival" value: it was a biological necessity. What is gained by recognizing art to be a behavior is an understanding that it is important intrinsically, not simply because a few individuals on an underfunded cultural committee proclaim it so.

"Survival," "evolution," "inherited," "selective value"—like "behavior," these are strange and unfamiliar terms to use in discussing art, and require some explanation. For the purposes of this book, the reader needs to understand the basic principles of the theory of evolution by natural selection. We can begin with three ordinary observations and deduce their implications.

1. All living things have the ability or tendency to overreproduce. A copulating frog pair produces thousands of fertilized eggs; a single vegetable may have hundreds or thousands of seeds; a single tree may bear hundreds of fruits each season. Even birds and mammals produce, or can produce, offspring every breeding season.

2. Resources—such as food, shelter, mates—are limited. If there are too many individuals—for example, if every frog egg became an adult frog—the world would soon be covered with frogs and the resources required by frogs would disappear.

3. Individual organisms such as frogs differ from one another. Some are more or less noisy, fast, or skittish than others; they have slightly different sizes, shapes, patterns, and colors. They receive these physical and behavioral characteristics from their parents and pass them on in varying combinations to their offspring, that is, the differences are heritable.

It follows from these elementary principles that if resources are limited *and* there is an overabundance of individually variable individuals, there will be some kind of competition or struggle for these resources. It also follows that individuals whose individual differences enable them better to acquire the resources will "survive" (i.e., live long enough to pass on their traits to their offspring) and the others will not. Over time these

"survival" characteristics become "adaptations" that characterize a species, "selected-for" by the environment of finite resources and hostile forces (predators, climate, competing species and other individuals, etc.). Having a white coat and a lot of subcutaneous fat are anatomical adaptations for life in the Arctic; being clever but not rash is a behavioral adaptation for most carnivores. Gradually a species characteristic is honed this way, as a trait—in the case of this book, a behavior of art—because those individuals who have it survive better (leave more successful offspring) than those who do not have it.

It is important to emphasize that survival is not simply continuing to exist. Survival implies reproducing. Hence in Darwinian theory, the terms "fitness" or "survival" refer to differential *reproductive* success and should be so understood when they are used here. (Strictly speaking, the outcome of one's reproduction, the offspring, are also reproductively successful and so on—see Clutton-Brock 1988.) For nonbiologists (and for the author of a book for nonbiologists) "reproductive success" is an awkward term. In most instances hereafter, I will use the terms "survival" and "survive" as a shorthand reference.

This book is not the place to defend evolutionary theory against the criticisms of "common sense" or to enter into debates about mechanisms of evolution that concern professionals. I should, however, say a word about the concepts of "proximate" and "ultimate" reasons for behavior.

An axiom of evolutionary theory is that individual organisms (people and other animals) in general follow what they perceive to be their own interests, even if they may not always know in a general sense what those interests are (just as dogs and cats go about their lives, satisfying their needs without "knowing" that they are following a general purpose). These interests may be stated simply: promoting the survival of their genetic materials. This is the *ultimate* cause or reason for the organism's choice to behave in one way rather than another. The *proximate* cause is the specific circumstance: to allay hunger, to buy frivolous rather than sensible shoes or the reverse, to enroll one's children in a good preschool, to go on a diet. These ultimately can be "reduced" to such things as fueling one's metabolism, advertising oneself socially as a certain type of person or being comfortable, giving one's children more opportunities for eventually passing on their genetic materials successfully in turn, becoming healthier or making a better appearance—all of which enhance one's fitness. Even though much of our behavior is instilled culturally, the ultimate results are on the whole the same: maximizing our interests (not necessarily at the expense of others: cooperation is arguably more salient than competition). We generally choose things that our culture values;

our underlying tendencies to behave in certain ways (e.g., to obtain and prepare food, form families, procure the goods of life, play, socialize, compete, cooperate, explain) will be channeled into proximate cultural and individual forms.

In the case of the arts, *what* behavioral traits are inherited? A tendency to scribble? An ability to sing? A capacity to enjoy rhythm? A responsiveness to beauty? These traits do seem to be inherited and it is not hard to think of possible selective values they might have. Singing and rhythm aid cooperative work, such as hauling nets and pounding grain. Music also makes boring tasks, like herding or traveling, endurable. Pictures teach, pass on information, tell useful stories without needing a thousand, or more, words. Dance is a means of self-advertisement, good for attracting mates, as well as being recreational. These "uses" of the arts are evident in many societies, past and present, including our own. And they are frequently cited by biologically minded thinkers as reasons for the arts to have evolved.[12]

It is important to understand that the notion of art as *a* behavior does not refer to a specific artistic activity or behavior like drawing or dancing (or the attribute of beauty—see the discussion in Chapter 4), but to a *general behavioral complex* that underlies these specifics. One can make an analogy with the behavior of attachment. Babies all over the world are born with the tendency to attach or "bond" with a particular caregiver at about the age of eight months. Attachment behaviors—crying when separated; reaching, lifting the arms to be picked up; moving toward; leaning against; turning toward; climbing on; clinging; smiling; and vocalizing—promote proximity and contact between child and caregiver. These individual behaviors are in a general ethological sense instances of *a behavior* of attachment. Similarly, music making, dancing, painting, dramatizing, speaking poetically—the arts—can be regarded as instances or examples of a general behavioral predisposition, "a behavior of art."

In this larger or general sense, a behavior—like attachment, aggression, reproduction, play (and art, if it is to be regarded ethologically)—is *an inherited tendency to act in a certain way, given appropriate circumstances*. When the brickbats fly, we duck or throw them back (defensive behavior); when the baby cries, we rock it or feed it (nurturing behavior); and in circumstances I have yet to specify, we compose poetry or decorate our dwelling (artistic behavior). Particular varieties or instances of a behavior are more suitable to some ways of life or temperamental inclinations than others. Hence, in certain societies or situations, people when behaving aggressively may hit, and in other societies or situations people may use insulting language; sexual behavior may manifest itself in pro-

vocative dress or love letters. Regarding artistic behavior, one may paint or carve, sing or dance, and so forth. Tooby and Cosmides (1990, 396) have distinguished between adaptations (e.g., aggression, attachment, making special) and their expression or manifestations, which may vary from context to context.

In the next three chapters I will present what I think is a comprehensive and cohcrent account of how art can be regarded as an inherited behavioral tendency to act in a certain way in certain circumstances, which during the evolution of our species helped us to survive. Like Darwin's theory of natural selection, my hypothesis does not claim to be inherently "true," but also like Darwin's theory it makes a large number of facts and observations comprehensible in a way that other theories concerning art's nature, purpose, and value so far have not. I believe and will try to show that art can be plausibly considered a biological need that we are predisposed to want to satisfy, whose fulfillment gives satisfaction and pleasure, and whose denial may be considered a vital deprivation.

❧ 3 ❧

The Core of Art
Making Special

When contemporary philosophers of art make the radical and rather astonishing statement that art has existed for only two centuries,[1] they are referring to the insufficiently appreciated fact that the abstract concept "art" is a construction of Western culture and in fact has a discernible historical origin.[2] It was only in the late eighteenth century—in Enlightenment England and Germany—and subsequently, that the subject of aesthetics was named and developed, that "the aesthetic" came to be regarded as a distinctive kind of experience, and that an art world of academies, museums, galleries, dealers, critics, journals, and scholars arose to address a type of human artifact that was made primarily and often specifically for acquisition and display. At the same time ideas of genius, creative imagination, self-expression, originality, communication, and emotion, having originated in other contexts, became increasingly and even primarily or exclusively associated with the subject of "art." (see Chapter 7) The concepts "primitive" and "natural" that I referred to briefly in the preceding chapters also developed at this time to become part of modern Western cultural consciousness.

Previously, the sorts of objects that in the post–eighteenth century West came to be called art—paintings, sculptures, ceramics, music, dance, poetry, and so forth—were made to embody or to reinforce religious or civic values, and rarely, if ever, for purely aesthetic purposes. Paintings and sculptures served as portraits, illustrations, interior or exterior decoration; ceramics were vessels for use; music and dance were part of a ceremonial or special social occasion; poetry was storytelling or

39

praise or oratory to sway an audience. Even when beauty, skill, or os-
tentation were important qualities of an object, they did not exist "for
their own sake," but as an enhancement of the object's ostensible if not
actual use. This enhancement would be called beautification or adorn-
ment, not art. The word *art* as used before the late eighteenth century
meant what we would today call "craft" or "skill" or "well-madeness,"
and could characterize any object or activity made or performed by hu-
man (rather than natural or divine) agency—for example, the art of
medicine, of retailing, of holiday dining.

It may be a surprise to realize how peculiar our modern Western
notion of art really is—how it is dependent on and intertwined with ideas
of commerce, commodity, ownership, history, progress, specialization,
and individuality—and to recognize the truth that only a few societies
have thought of it even remotely as we do (Alsop 1982). Of course, in the
preindustrial West and elsewhere, people had and continue to have "aes-
thetic" ideas—notions of what makes something beautiful or excellent-
of-its-kind—but such ideas can be held without tacitly assuming that
there is a superordinate abstract category, Art, to which belong *some*
paintings, drawings, or carvings and not *other* paintings, drawings, or
carvings.[3]

As Western aesthetics developed, something was assigned to the cate-
gory of genuine art if it was deemed capable of providing and sustaining
genuine aesthetic experience. Genuine aesthetic experience was defined
as something one experienced when contemplating genuine art. Note the
circularity of this argument. Moreover, difficulties arose in specifying the
cause or location of this genuineness (in the face of differences of opinion
about the validity of individual works or responses). People should have
recognized that these difficulties threw the concept of a pure or singular
art itself into doubt.

To be sure, philosophers and artists in the past (for example, Aristotle,
Saint Thomas Aquinas, Leonardo da Vinci) had proposed criteria for
beauty or excellence, for example, fitness, clarity, harmony, radiance, a
mirror held up to nature. Nineteenth- and twentieth-century thinkers
proposed other criteria, such as truth, order, unity in variety, and signif-
icant form, as being the defining feature of this mysterious entity "Art."

But, as every first-year student of Western aesthetics learns, determin-
ing what is beauty or truth, not to mention significance or harmony, is no
less difficult than defining art in the first place. And in any case, since the
romantic period artists themselves (influenced by the ever-growing West-
ern cultural emphasis on individualism and originality) have deliberately
flouted and contradicted the canonic aesthetic features, as they were

described or proposed by philosophers, critics, and other thinkers, as if to demonstrate that art, whatever its essence or validity, is protean, undefinable, and irreducible.

Hence the search for a common denominator, some quality or feature that characterizes all instances of art, that *makes* something "Art," gradually became both outmoded and a lost cause. Today's philosophers of art have totally abandoned trying to define the word or the concept. Looking at the plural and radical nature of the arts in our time, aware of the economic ramifications where canvases may be "worth" millions of dollars and where critics, dealers, and museum directors rather than artists or publics largely decide this value, philosophers concerned with art have concluded that art no longer exists (if it ever did) in a vacuum or ideal realm for its own sake, with its sacred essence waiting to be discovered, but must be considered as it appears in and is dependent on a particular social context. In a postindustrial, postmodern society, an art world (or "artworld") determines what "Art" is and what is "Art." It exists, if at all, only as a socially and historically conditioned label (see Chapter 7).

The reader must recognize, however, that this position arises from contemporary postmodern Western society, which despite our natural ethnocentrism (referred to also in Chapters 1 and 4) is not, of course, the apogee of humankind's enterprise and wisdom nor its ultimate destiny. We must not forget that although "Art" as a concept seems to have been born of and continues to be sustained by a commercial society, is therefore only roughly two centuries old, and hence is relative, even discardable, *the arts* have always been with us. And so have ideas of beauty, sublimity, and transcendence, along with the verities of the human condition: love, death, memory, suffering, power, fear, loss, desire, hope, and so forth. These have been the subject matter of and occasion for the arts throughout human history. Thus when contemporary theory accepts that art is contingent and dependent on "a particular social context," the mistake should not be made of assuming that the abiding human concerns and the arts that have immemorially been their accompaniment and embodiment are themselves contingent and dependent.

The species-centric view of art recognizes and proclaims as valid and intrinsic the association between what humans have always found to be important and certain ways—called "the arts"—that they have found to grasp, manifest, and reinforce this importance. That the arts in postmodern society do not perform these functions, at least to the extent that they do in premodern societies, is not because of some deficiency or insubstantiality of an abstract concept but because their makers inhabit a world—unprecedented in human history—in which these abiding con-

cerns are artificially disguised, denied, trivialized, ignored, or banished.

An ethological view of art, then, departs from the entrenched position of contemporary aesthetics and reinstates the search for a "common denominator," although in a manner never dreamed of by philosophers of art. In order to show that a behavior of art is universal and indelible, *it is necessary to identify a core behavioral tendency upon which natural selection could act.*

In trying to uncover this deep marrow of a behavior of art, we will not be primarily concerned with contemporary society, nor even with earlier civilizations or with traditional or what used to be called "primitive" societies. Rather, we must look for a behavioral tendency that could have been possessed by protohumans, the early hominids who existed one to four million years ago. These, our ancestors, were creatures who walked on two legs and lived in small, nomadic bands on the African savannah. They hunted, foraged, scavenged, and gathered their food, as hominids did until about 10,000 B.C. when settled agricultural communities began to establish themselves in certain parts of the world. Somewhere in this continuum of hominid evolution will have arisen a behavioral tendency that helped individuals who possessed it (and by extension a social group whose members had it) to survive better than individuals and groups who lacked the tendency. This core or common denominator of art will, however, be a behavioral tendency that is not incompatible with art today and elsewhere, yet can also characterize creatures such as these, our hominid ancestors.

The Extra-Ordinary

In my view, the biological core of art, the stain that is deeply dyed in the behavioral marrow of humans everywhere, is something I have elsewhere called "making special." Like other key phrases used to name or summarize a complex concept ("pleasure principle," "survival of the fittest"), "making special" can without elaboration or context sound trivial or woolly. Before describing it in more detail, here and in the next chapter, I would like to recount briefly the background of my search for this core tendency that I believe lies behind or within what is today considered to be the impulse toward (the behavioral tendency of) art.

Play and Ritual

My own earliest attempts to approach art as a behavior began when I first read ethological accounts of play. Play in animals (including hu-

mans) is an appealing and quite mysterious behavior. It occurs in many species in which animals play naturally, without being taught. Yet, unlike other behaviors, play seems to be, at the time of playing at least, biologically purposeless and even disadvantageous. The players do not gain a life-serving goal, as they do in other behaviors where they find food, mate, repel an intruder, rest, and so on. In fact, animals at play seem to expend a lot of energy for no useful purpose and risk hurting themselves, attracting predators, or otherwise decreasing their chances of survival. Yet young animals will play indefatigably. They seem to play for play's sake, for sheer enjoyment and intrinsic reward. Thus it would seem that play has hidden survival benefits that outweigh the costs of its energy expenditure and risks.

In play, novelty and unpredictability are actively sought, whereas in real life we do not usually like uncertainty. Wondering whether an untried shortcut will take us to the bank before it closes on the day before a holiday is different from choosing an unknown path just to see where it will lead while on holiday.

Play can be said to be "extra," something outside normal life. At least normal constraints do not hold. At play, you can be a princess, a mother, or a horse. You can be strong and invincible. You can act *like*, be *like*, a desperado or a soldier. You pretend to fight or pretend to have a tea party, but these are "not for real." Real weapons (like loaded guns or unsheathed claws) are not used; the teacups may be empty.

But play is marked by constraints nevertheless. One generally finds, even in animals, "rules" of play: special signals (such as wagging the tail or not using claws), postures, facial expressions, and sounds that mean "This is make-believe." Often special places are set aside for playing: a stadium, a gymnasium, a park, a recreation room, a ring or circle. There are special times, special clothes, a special mood for play—think of holidays, festivals, vacations, weekends.

As I read about play, its similarities to art became obvious. Art, as I knew it from aesthetics and art history classes, is "nonutilitarian," "for its own sake": Cellini's saltcellar was art, but not because it held salt better than a clay or glass container. Art, like play, was not "real" but pretend: the actor playing Hamlet did not really stab the actor playing Polonius. Art made exquisite use of surprise and ambiguity. There were special places like museums and concert halls set aside for art, special times, even special clothes for it—such as dark attire for symphony musicians. And there was especially a special mood, which I had learned to describe as "disinterested contemplation": one *did not* rush up on stage to help the hero overcome the villain, one *did* contemplate the

skill and subtlety of the actors, the craft and language of the playwright. Art, like play, was something extra, an embellishment, an enhancement to life.

As I looked further into the subject, I discovered I was only the latest in a long lineage to have noticed the resemblance between play and art and to have gone on to conclude that art was a derivative of play.[4] The new contribution I hoped to offer was making this conclusion plausible by means of ethological (rather than, as others had done, from psychological or historical or metaphysical) evidence. I thought that the "metaphorical" nature of both art and play, the make-believe aspect where something is, in reality, something else, was the salient core feature.

For an ethologist, the apparent absence of evolutionary purpose is a problem both for play and for art. Because humans everywhere avidly engage in both playful and artistic pursuits, these must serve some purpose, even if it is not immediately evident.

With regard to play, it is generally agreed that although there might not be immediate survival benefits associated with play, young animals in play are practicing (in situations that are not yet "for keeps") skills that eventually enable them to find food, defend themselves, and mate, among other adult necessities. Also—importantly—in play, they learn how to get along with others. Individuals who play, and thereby learn practical and social skills, survive better than individuals who are not inclined to play or who are deprived of play and therefore lack practice with these essential things. As with an insurance policy, the benefits of play are deferred.

Looking at art, I was aware that it consisted of more than exercise, practice, or socialization. But what? Freud claimed that the function of both play and art was therapy. They allowed for fantasy, for the sublimation or fulfillment of hidden wishes that in real life were denied or tabooed: if you can't get the girl, dream or fantasize or write a story or paint a picture about getting her. As I considered the problem from an ethological point of view, I concluded that art in human evolution must have done something more than give fantasy free rein. How much fantasy did our hominid ancestors practice anyway? Did they need more make-believe than they acquired from play? (It is almost certain that early hominids, like all primates, must have played.) Was it not more important that they accept and comply with *reality*: the daily "business" of meals, safety, cooperation?[5] Fantasy and make-believe may well be important safety valves for modern humans mired in the discontents of civilization, but I hoped to find a more plausible

reason to explain why early hominids would have developed art *as well as* or in addition to play. Practice, socialization, recreation, wish-fulfillment—these goals could have been satisfied by play without necessitating another sort of behavior that accomplished the same ends. Unless I were willing to accept the idea that art was simply a variety of play, which seemed an inadequate explanation, I had to look further into the matter of its ethological origin, nature, and probable selective value.

During the years that I lived in Sri Lanka, the small Buddhist country formerly known as Ceylon, I became acquainted with what sociologists call a traditional society. In such societies, modern technology is still relatively undeveloped: at building sites, for example, scaffoldings are made of bamboo tied together, and people rather than backhoes and bulldozers move the earth. Many families still live on the land and are relatively self-sufficient; village houses and utensils are largely made by hand from local materials and food is grown in the family garden. Custom and authority continue to provide the boundaries within which people lead their lives and find their satisfactions—most marriages are arranged by parents or other relatives, for example, and it is not considered unusual for important decisions to be made only after consulting an astrologer.

People living in traditional societies seem much closer to the verities of life than people living in highly technological societies like our own. Because they have known each other's families for generations, events like weddings and funerals—matters of life and death—are important occasions for socializing. I attended my first funeral and saw a dead body for the first time while in Sri Lanka, and I was initially amazed that babies and small children were also in attendance.

Traditional ceremony and custom thus play a much larger part in the life of a Sri Lankan than in ours. After a person dies in Sri Lanka, the mourners arrive during the course of the day at the home where the deceased is lying in an open coffin on a table in the living room, surrounded by flowers. The bereaved family members greet each visitor at the door, breaking down in sobs with each new arrival as they talk about the circumstances of the death and the merits of the deceased. The guest enters the house and joins other guests; they chat quietly with each other about any subject (I heard discussions about movies, business, and political matters); and after a decent interval they leave. Eventually the family and close friends go to the place of cremation or burial where Buddhist monks join them and recite the appropriate Pali texts—reflections on birth, death, decay, and reincarnation. Three days

after the disposition of the body the family and priests hold an almsgiving ceremony; other almsgivings in memory of the deceased occur after three months, one year, and at yearly intervals thereafter.

I realized that this kind of formalized handling of grief, with regular, community-sanctioned opportunities to weep and express one's loss at greater and greater intervals of time, gave to the bereaved a sort of patterned program to follow, a form that could shape and contain their feelings. Instead of having to suppress their grief and sense of loss in the interests of being brave or "realistic," or having to release it haphazardly or in solitude, the bereaved is enabled—compelled—by the ritual of mourning to acknowledge and express it publicly, over and over again, within a preordained structure. The temporal structure of the mourning ritual, simple as it is, assures that thoughts and feelings about one's loss will be reiterated at prescribed times. Even if one might not consciously have proper mournful feelings, the custom of successive almsgivings ensures that these feelings are elicited. The prescribed formal ceremonies become the occasion for and even the cause of individuals feeling and publicly expressing their sorrow.[6]

It occurred to me that in a very similar way, the arts also are containers for, molders of feeling. The performance of a play, a dance, or a musical composition manipulates the audience's response: expands, contracts, excites, calms, releases. The rhythm and form of a poem do the same thing. Even nontemporal arts, like painting, sculpture, and architecture, structure the viewer's response and give a form to feeling.

It is well known that in most societies the arts are commonly associated with ceremonial contexts, with rituals. So next I began to try to discover what art and ritual had in common. It was intriguing to learn that "ritualized behavior" in animals, like play, was an important ethological subject and that at least some anthropologists noted real, not just superficial, parallels between ritualized behavior in animals and ceremonial rituals in humans (Huxley 1966; Turner 1983). Perhaps like ritual (and play), one could call art "a behavior" also.

As I had suspected and hoped, the similarities between ceremonial ritual and art were provocative. For example, both ritual and art are *compelling*. They use various effective means to arouse, capture, and hold attention. Both are fashioned with the intent to affect individuals emotionally—to bring their feelings into awareness, to display them. A large part of the compelling nature of rituals and art is that they are deliberately *nonordinary*. In Sri Lankan—and our own—funeral services, for example, unusual language is used: ancient religious works with their archaic and poetic vocabulary and word order serve as texts for the

services, and these texts are intoned or chanted in a voice unlike that employed in normal discourse. Other nonordinary devices for making ritual (and art) compelling include exaggeration (the rhythm of funeral processions may be unusually slow and deliberate), repetition (the Sri Lankan funeral ritual punctuates time with repeated almsgivings), and elaboration (the profusion of flowers, the wearing of special clothing, other extravagances like the gathering of unusually large numbers of people).

The *stylization* of ritual and art also adds to their nonordinary aspect. They are self-consciously performed as if acted. During the ceremonial signing of a bill, the president of the United States speaks highly rhetorical phrases sanctified by use reaching back two hundred years, things like "Thereunto I set this seal." The ballerina or opera singer makes a

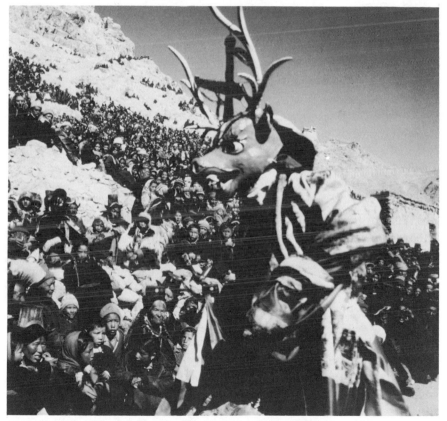

Crowd of devotees at Hemis Festival, Ladakh, Kashmir
Ritual occasions may bring together and unify great numbers of people through their common participation in extraordinary and compelling experiences.

ritualized—exaggerated, elaborated, formalized—series of bows to acknowledge the applause at the end of her performance (which itself was composed of exaggerated, elaborated, and formalized movements or vocalizations).

Thus, in general, both rituals and art are *formalized*. Movements—what people do—are prescribed, the order of events is structured, and the individual participants' perceptions, emotions, and interpretations are thereby shaped.

Ritual ceremonies and the arts are *socially reinforcing*, uniting their participants and their audiences in one mood. They both provide an occasion for feelings of individual transcendence of the self—what Victor Turner (1969) calls *communitas* and Mihaly Csikszentmihalyi (1975) calls "flow"—as everyone shares in the same occasion of patterned emotion. For a time, the hard edges of their customary isolation from each other are softened or melted together or their everyday taken-for-granted comradeship is reinforced.

Rituals and the arts are *bracketed*, set off from real or ordinary life. A stage of some kind—a circle, a demarcated area, a museum, or platform—sets off the holy from the profane, the performers from the audience, the extra-ordinary from the everyday. And both rituals and the arts make conspicuous *use of symbols*: things have hidden or arcane meanings, reverberations beyond their apparent surface significance.

Ritual ceremonies are universal, found in every human society. They serve numerous social purposes: they state and publicly reinforce the values of a group of people; they unite it in common purpose and belief; they "explain" the inexplicable—birth, death, illness, natural disaster—and attempt to control it and make it bearable. From the ethological perspective, people in social groups that did not have ceremonial rituals would not survive as well as those who did have them. They would be less cohesive and cooperative; they would respond to adversity in individualized, fragmented, unfocused, and ultimately less satisfactory ways.

Apart from the many similarities that ritual and art share as general "behaviors," they are virtually always linked together in practice. During ritual ceremonies one invariably finds the arts: the use of beautiful or arresting objects, the wearing of specially decorated attire, music, visual display, poetic language, dance, performances. It seemed nondebatable to me that an understanding of ceremonial ritual was relevant, even critical, to an ethological understanding of art (see Chapter 4.)

Because of the many close connections between art and ritual, I first wondered whether art could be considered as a derivative of ritual, much as I had earlier thought of art as a kind of play.[7] After struggling to make

sense of how and why this might have happened, an idea came to me: art was not a variety of play or ritual, but like them it was concerned with a special order, realm, mood, state of being. In play, ritual, *and* art things were not ordinary—they are less real or more real than everyday reality. I decided to try looking there for the behavioral core of art.

Differentiating Ordinary from Extra-Ordinary

My thesis that the evolution and selective value of a behavior of art arises from a tendency to make special rests on the claim that humans everywhere, in a manner that is unlike that of other animals, differentiate between an order, realm, mood, or state of being that is mundane, ordinary, or "natural," and one that is unusual, extra-ordinary, or "super-natural."

But is this a justifiable claim? In some premodern societies the former and the latter appear to interpenetrate. According to Robert Tonkinson (1978, 96), the Mardudjara, an Australian aboriginal group, make no clear distinction between natural and spiritual realms, considering them-selves and nonhuman entities and forces to be all equally real inhabitants of their cosmic order.[8] Other peoples, in Australia and elsewhere, sim-ilarly find "natural" and "spiritual" to be more continuous than we do—to consider the spiritual *as* natural. One might wonder whether an "obvious" separation between ordinary and extra-ordinary, like that be-tween profane and sacred, natural and super-natural, nature and culture, body and soul, flesh and spirit, is to be traced to the discontents and artificialities of civilization.

I am prepared to claim, however, that making such a distinction is a characterizing universal predisposition of human behavior and mentality. Moreover, I would argue that it is in this predisposition that we are to look for the core of a behavior of art. Even in human groups that do not articulate an explicit separation between extra-ordinary and ordinary, their actions demonstrate such an awareness. Tonkinson himself says of the Mardudjara: "the Dreamtime [the spiritual dimension or domain in which ancestral beings have their existence] is crucial because it is held to be the source of all power, given in response to ritual performance, but also available to individuals when they are able *briefly to transcend their humanity and tap this reservoir (for example, during dance, trance, vi-sions, dreams, and heightened emotional and religious states."* (Tonkin-son 1978, 16; my italics).

Many anthropological studies describe "other worlds": the mysterious permanent dimension of reality that the Yoruba call *iron* (Drewal and

Drewal 1983); the spirit of the forest of the Ituri forest pygmies (Turnbull 1961); the *engang*, or unseen world of dead spirits, of the Fang of Gabon (Fernandez 1973); the Eskimo *sila* or "life force" (Birket-Smith 1959); the *kore* ("wilderness") of the Gimi, otherworldly compared to *dusa*, the domesticated forms of plants and animals and the constraints of human social existence (Gillison 1980, 144); the transcendent reality of the Umeda which is grasped only through rituals that are the antithesis or opposite of what usually is (Gell 1975); the "underneath" side of things and words of the Kaluli (Feld 1982); the hyperanimacy of the powerful beings that the Kalapalo communally sing into being (Basso 1985); the *kia* experience of Bushmen (Katz 1982)—one would be hard-pressed to find an anthropological monograph about a people that did not recognize or manifest by their actions the recognition of a nonordinary if not sacred dimension along with everyday reality.

How and why would evolving humans perceive or create "other worlds" apart from the everyday? As I pointed out in the previous section, the penchant for acknowledging an extra-ordinary realm is inherent in the behavior of play, where actions are "not for real." The "as-ifness" of play, then, can be thought of as a reservoir from which more flexible, imaginative, innovative behaviors can arise—as when we "play around with" an idea. And in ritual also (both the ritualized behaviors of animals and human ritual ceremonies), ordinary behavior is formalized and exaggerated, thereby (particularly in humans) acquiring a meaning and weight that makes it different from what it usually is: it becomes extra-ordinary. It seems undeniable that at some point, evolving hominids, being acquainted in their daily lives with play and ritual, would have been predisposed (as individuals and eventually as a species) to recognize and even create "meta-" or "as-if" realities.

Yet it must be admitted that at the most fundamental level, being able to distinguish between ordinary and extra-ordinary is not a particularly remarkable ability at all. Every animal is equipped to differentiate the normal from the abnormal, the neutral from the extreme. A salamander or mosquito, as well as more complex forms of life, will know when there is a change that suggests something out of the ordinary might occur: a sudden shadow, a sharp noise, an unexpected movement. Life, after all, depends on reacting (or being ready to react) to changes in habitual existence. Moreover, many nonhuman animals also play, but did not go on to invent arts or imaginative works of any kind. And formalized, ritualized behaviors, analogous to ritual ceremonies in humans in their use of rare and extra-ordinary postures, odors, sounds, and movements (Geist 1978), are also widespread in other animals but have not given rise

in them to anything we can justifiably call art. out humans
that provoked or permitted them to recogniz⌐ ed to further
elaborate "other" worlds, special fanciful ˌ e invented in
play, invoked in ritual, or fabricated in tʰ

The evolving hominids we are conce⌐ a quarter of a
million years ago—were more intelliʃ ːeful than other
animals. Their brains were larger and r omposed, and the
mental and emotional complexity tʰ permitted led to a
wider range of thought and feeling animals can be as-
sumed to inhabit a continuous presˌ concerned with what
happened yesterday and what migʰ row, gradually during
the Middle or Early Upper Paleˌ must have become, as
Walter Burkert (1987; 172) haˀ regard to the biological
origins of religion, "painfully ˌ i future."

I suggest that the standard nal animal inclination to
differentiate ordinary from eˣ recognize specialness, would
have been developing over tenˌ s of years, along with other
higher-level cognitive abilities that weɪ o evolving, such as planning
ahead or assessing causes and their consequences.[9] At some point in their
evolution, humans began deliberately to set out to *make things special* or
extra-ordinary, perhaps for the purpose of influencing the outcome of
important events that were perceived as uncertain and troubling, requir-
ing action beyond simple fight or flight, approach or avoidance (see
Chapter 4).[10]

A Closer Look at Making Special

In *What Is Art For?* I proposed that we could understand the arts etho-
logically by considering them as ways of making important things and
activities "special." That is to say, I emphasized the "behavior" or activity
(as described in the last section of Chapter 2 above), rather than, as other
art theorists have done, the results: the things and activities themselves as
"works of art."

I suggested that elements of what we today call the arts (e.g., pattern,
vividness) would have existed first in nonaesthetic contexts. But because
these elements were inherently gratifying (perceptually, emotionally, cog-
nitively) to humans, humans who had an inherent proclivity for making
special would use them—not for their own sake, but instead, in etholog-
ical terms, as "enabling mechanisms"—in the performance of other se-
lectively valuable behaviors.

To begin with, I thought that the reason making special first occurred might have been to persuade oneself and others that what was being done was worthwhile and effective. This is a reason for embellishment in other species—notably, songbirds, who elaborate their songs much more than is necessary simply to advertise their presence or individuality. My reasoning went something like this. If you are an early human who wants to achieve a goal—to kill an animal, for example, or to cure a sickness—you will take pains, take the activity seriously. If you accidentally or deliberately say or do something extra, and are successful, you may well remember to do the extra something again the next time, just in case, as when a baseball player touches his cap and ear in a certain way before throwing a pitch, or a performer or pilot always carries a particular trinket that has in the past brought her or him good luck.

It is clear that taking serious and important activities seriously should be of immense survival value. Every bit of psychological reinforcement would count, for yourself as well as for the others who observe you. (As I pointed out, people who spent time and trouble to reinforce and elaborate deleterious things would not have survived.)

The idea of making special as persuasion or rhetoric seemed promising. Making life-serving implements (tools, weapons) special both expressed and reinforced their importance to individuals and would have assured their more careful manufacture and use. But equally or more important would have been the contribution of making special to ritual ceremonies. When language was used poetically (with stress, compelling rhythm, rhyme, noteworthy similes or word choice); when costumes or decor were striking and extravagant; when choruses, dances, and recitations allowed vicarious or actual audience participation, the content of the ceremonies would have been more memorable than when left "untreated." Whatever message the ceremony intended to communicate ("In union is strength"; Death is an end and a beginning"; "We are the best"; "Transitions are scary but unavoidable"; "We need food for the coming season") would be first engendered and then reinforced, acquiring special import by virtue of the special effort and attention expended upon it. At the same time, the fellow-feeling arising from the mutual participation and shared emotion was a microcosmic acting out of the general cooperation and coordination that was essential for small groups to survive in a violent, unpredictable world.[11] Groups whose individual members had the tendency to make things special would have had more unifying ritual ceremonies, and thus these individuals and groups would have survived better than individuals and groups that did not.

In ritual ceremonies, then, one can see that making special could

acquire even more important than in individual occurrences. Because it is used to articulate substantive and vital concerns, it is drawn from, expresses, and engages one's deepest and strongest feelings.[12] This is an important point that I introduced in Chapter 2 and to which I will frequently return in this chapter and the ones that follow.

The Relationship of Making Special and Art

As I described in Chapters 1 and 2, I was first led to develop the concept of making special because of my dissatisfaction with Western culture's general perplexity surrounding the notion of art and, reflecting this confusion, the inadequacy of the available speculations about the role of the arts in human evolution. It seemed to me that if evolutionists did not recognize *Homo aestheticus*, that is, could not satisfactorily explain how and why art was a human universal and could view it only as an epiphenomenon, their concept of art itself must be aberrant. Something so widespread, pleasurable, and obviously important to those who did it should not be so inexplicable.

Trapped in the confines and presuppositions of my culture's concepts and attitudes regarding art, I too floundered and took circuitous detours around the subject, as when I tried for a time to derive art from play or art from ritual. I continually returned to the quality in the arts of all times and places of being *extra-ordinary*, outside the daily routine and not strictly utilitarian (in a materialistic, ultimate sense)—even when considered "necessary" to their practitioners. That was where evolutionary explanations always broke down because something "nonutilitarian" should not have been selected for. Yet nonetheless it existed.

The best word for this characteristic of the arts seemed to be *special*. *Extra-ordinary* with a hyphen might have served, but it is too easily read as "astonishing" or "remarkable"—that is, as a synonym for nonhyphenated *extraordinary*. *Unnecessary* and *nonutilitarian* emphasize what the arts are not, and also smack too much of Western ideas of art-for-art's-sake. *Elaboration* used alone disregards the importance of shaping, and like *enhance* suggests, in Western culture at least, the superficial or merely added. While "special" might seem too imprecise and naively simple, or suggest mere decoration, it easily encompassed an array of what is done in making the arts that is generally different from making nonarts: embellishing, exaggerating, patterning, juxtaposing, shaping, and transforming.

"Special" also denotes a positive factor of care and concern that is absent from the other words. It thus suggests that the special object or

activity appeals to emotional as well as perceptual and cognitive factors—that is, to all aspects of our mental functioning. Even though all three are inseparable, as I mentioned in the discussion of emotion in Chapter 2, the usual aesthetic nomenclature ("for its own sake," "beauty," "harmony," "contemplation") tends to emphasize calm or abstract intellectual satisfactions at the expense of sensory/emotional/physical/pleasurable ones. Hence "special" can indicate that not only are our senses arrested by a thing's perceptual strikingness (specialness), and our intellects intrigued and stimulated by its uncommonness (specialness), but that we make something special because doing so gives us a way of expressing its positive emotional valence for us, and the ways in which we accomplish this specialness not only reflect but give unusual or special gratification and pleasure (i.e., are aesthetic).

It is important to recognize that the elements used for making something aesthetically special are normally themselves inherently pleasing and gratifying to humans and thus can be called "aesthetic" or "protoaesthetic" even when they occur naturally in nonaesthetic contexts. These pleasing characteristics are those that would have been selected-for in human evolution as indicating that something is wholesome and good: for example, visual signs of health, youth, and vitality such as smoothness, glossiness, warm or true colors, cleanness, fineness, or lack of blemish, and vigor, precision, and comeliness of movement.

Thus we find that most, if not all, societies value agility, endurance, and grace in dance; sonority, vividness, and rhythmic or phonic echoing (rhyme and other poetic devices) in language; and resonance and power in percussion. The Wahgi of Papua New Guinea's Western Highlands, for example, explicitly judge body decoration, dancing, drumming, and ensemble performance in terms of their being rich, glossy, glinting, fiery, slashing, shining, flaming, that is, as the converse of dull, dry, flaky, matte, and lusterless (O'Hanlon 1989; see also Chapter 5).

In the arts of the West, high value has also been given to skillfully made polished marble statuary, implements and ornaments of burnished metal, vivid glowing tempera and oil paintings, and ornately sumptuous or softly diaphanous textiles. Indeed, it is the obvious lack of these inherently pleasurable or "beautiful" features that has made it so difficult for unsophisticated people to accept certain works of art made during the past century or so as "art," for the artists' deliberate choices to defy traditional expectations regarding pleasing characteristics have set their works outside the pale of "recognizable" art.

In addition to elements that appeal to the senses, particularly vision and hearing, there are others that are pleasing to the cognitive faculties:

repetition, pattern, continuity, clarity, dexterity, elaboration or variation of a theme, contrast, balance, proportion. These qualities have to do with comprehension, mastery, and hence security, and thus they are recognized as "good," when used outside a utilitarian context, to make something special. Visual prototypes (e.g., fundamental geometric shapes such as circles or other mandala forms like diagonal or upright crosses) also clarify and control untidiness and are thought and felt to be satisfying and good. (These and other "naturally aesthetic" or protoaesthetic elements will be discussed more fully in Chapter 6.)

The responses to "specialness" in the aesthetic sense—"This is (sensorily and emotionally as well as intellectually) gratifying and special"—presumably evolved alongside other responses to "specialness"—"This is dangerous, unprecedented, needs to be dealt with." As I suggested in speaking of salamanders and mosquitoes, not all specialness engenders or results from gratifying "aesthetic" acts or responses.

"Marking" of any kind for utilitarian identification, for example, the X's made by Hindus on the doors of railway cars that carried Moslems during the Indian-Pakistani conflicts after independence, is, strictly speaking, making something special, as is the construction by a state security police department of a special room, in a special place, without windows and with unusual equipment, in which to extract confessions from prisoners. But these unpleasant examples of "specialness" should not be included in the notion I am developing here of aesthetic specialness: the intention to appeal to (that is, to attract and, if successful, to satisfy) another's faculty for apprehending and appreciating a specialness that is more than what is necessary to fulfill a practical end. Additionally, the "artist" takes the protoaesthetic elements out of their "natural" context of indicating vitality and goodness, and "domesticates" them—deliberately using them in aesthetic making special. (The idea of domesticating the natural will be discussed at more length in Chapters 4 and 5.)

Thus, in order to be "aesthetically special," the X's made by the Hindus would have to have been made with care as to their proportion, color, and spatial relationship to the size of the door; and the room constructed by the security police would have to be arranged with an eye for visual relationship among the objects in the room, color coordination, or accent—that is, with a sensory/emotional component that originally evolved for enhancement, pleasure, and gratification over and above (or along with) the sheerly informational or purposeful aspects which, in an academic or analytic sense, we can isolate and separate out.

To evolving humans, as to those living in premodern societies today, the "aesthetic pleasure" derived from making special is not perhaps so

easily separated from the "message" it packages as it has become in Western art today. Although contemporary aesthetic (and evolutionary) theory considers making and responding to aesthetic specialness to be nonutilitarian or "more than necessary" (hence not understandable as a selectively valuable behavioral tendency in human evolution), in its original context it *was* necessary and utilitarian. To adapt an anthropological truism, the obligatory was converted—by making it special—into the desirable, and hence it was willingly done.[13]

But even after establishing that aesthetic making special (in the sense of being sensorily and emotionally gratifying and more than strictly necessary) can be differentiated from nonaesthetic making special such as marking or intimidating, it still remains true that even though all art can be included as aesthetic making special, not all aesthetic making special is art. In ritual and play everyday reality is transformed, as in art, in emotionally and sensorily gratifying ways, and thus can be appreciated apart from use or practical function. I have not always been able to separate instances of making special in "art" from those in "ritual" and "play," as from X's on doors or torture chambers.

I do not think, however, that this difficulty seriously jeopardizes the attempt to treat art—in the sense of making special—as a human behavior. For if we step outside our blinkered Western modernist and postmodernist paradigms where art is either grand, rare, and intimidating, or socially constructed, slick, and provocative, it should be possible to accept the larger, more inclusive entity, making special (including art, ritual, and play) as a universal behavior. That is, by expanding our notion from "art" or even "art as making special" to "the faculty for making and expressing specialness," we can understand in a humanly grounded and relevant way how "the arts" (instances of making special) originally arose and why they not only enhance our individual lives as *Homo aestheticus*, but have been essential for our evolution as a species.

The radical position that I offer here as a species-centered view of art is that *it is not art (with all its burden of accreted connotations from the past two centuries) but making special that has been evolutionarily or socially and culturally important*. That is to say, until recent times in the West, what has been of social, cultural, and individual evolutionary importance in any art or "work of art" has been its making something special that is important to the species, society, or culture.

There is no need to decide whether a theater or concert performance is "play," "ritual" or "art." The three often interpenetrate, since "metareality" and "specialness" generally presuppose the freedom, unpredictability, make-believe, imagination, and delight that are associated with play

(and art), or the formality, stylization, elaboration, and entrancement that characterize ritual (and art).

In *What Is Art For?* (59) I likened the modern Western concept of art to the Victorian notion of "vapours," an ambiguous ailment that has long since disappeared, or rather has been replaced by a number of particular named maladies: depression, premenstrual syndrome, hypochondria, flu, bad cold, and so forth. The analogy may have appeared to be merely an amusing aside, but I think it deserves further attention. Indeed, I think our understanding of art as a human behavior would improve if we altogether banned the word *art* in its singular, conceptual form, just as we no longer find it useful to invoke a broad term, *vapours*, for diverse complaints that gain nothing by being clumped together.

Postmodernists, who claim that art is in any case only two centuries old, should have little theoretical difficulty abandoning the word *art*, although to be sure it has permeated our thought from a practical point of view and is probably impossible to eliminate. The reader should try to remember, however, that henceforth in this book, reference to a "behavior of art" means "aesthetic making special" as elucidated in this section, which is a broader concept of "art" than is usual.

In Chapter 4, I will describe in more detail how a behavior of art could

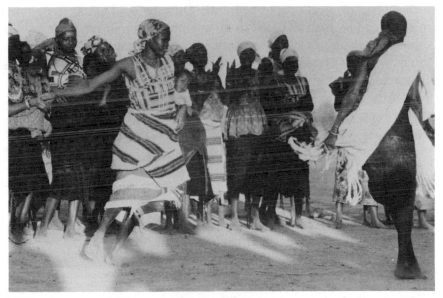

Village women of Zisgre singing and dancing to greet a foreigner. Upper Volta, 1980
Should we call these women's activity ritual, play, or art?

have developed from the tendency to recognize an extra-ordinary dimension of experience—that is, I will examine what circumstances in the human evolutionary environment could have called forth and refined such a behavioral tendency and hence why it should have been selected-for. Before ending the discussion of making special, however, I think it would be useful to summarize some of its implications for aesthetic theory today.

Implications of Making Special

The concept of making special, in the biobehavioral view of its being the core defining feature of a behavior of art, casts a new light on previously troublesome questions about the nature, origin, purpose, and value of art, and its place in human life.

1. It explains how a concept of art can comprise such variety, even contradiction. Art may be rare and restricted, as modernists believed, or liberating and problematizing, as postmodernists argue. It may be well or poorly done; it may be an individual original creation or a manifestation of a codified historical or regional tradition. It may require talent and long specialized training or be something everyone does naturally much as they learn to swim or cook or hunt. It may be used for anything, and anything can become an occasion for art. It may or may not be beautiful; although making special often results in "making beautiful," specialness also may consist of strangeness, outrageousness, or extravagance. As making special is protean and illimitable, so is art.

2. If the essential behavioral core is making special, a concern about whether one or another example of it is or is not "art" becomes irrelevant. One can, of course, ask whether one personally wants to take the time and trouble to appreciate or attempt to appreciate its specialness. Funding agencies will no doubt continue to debate whether certain Robert Mapplethorpe photographs, for example, are or are not "art" in some restricted culture-centered sense. But from the species-centered perspective with which this book is concerned, what is relevant is that *Homo aestheticus* "needs" to make special and appreciate specialness. Humans and their societies provide the means and parameters within which to do (or not do) this and within which to evaluate the results.

3. At the same time, the idea of making special would not allow the loose declaration (sometimes heard from postmodernist artists, composers, and critics) that art is everything and everything is art. It may be the case that anything is *potentially* art, but in order to *be* art, there is a

Toast to Old Glory, 1989, *from an exhibition inspired by the public controversy over burning the American flag. (Don Mohr, Anchorage, artist)*
Specialness may be strangeness, outrageousness, or extravagance.

requirement, first, of aesthetic intention or regard and secondly, of fashioning in some way—actively making special or imaginatively treating as special. If art is everything and everything is art, or sound is music and music is sound, as I have heard it said, why distinguish these activities by calling them "art" or "music"?

4. Making special emphasizes the idea that the arts, biologically endowed predispositions, have been physically, sensuously, and emotionally satisfying and pleasurable to humans. By using elements that pleased and gratified human senses—elements that themselves arose in nonaesthetic contexts: bright colors; appealing shapes and sounds; rhythmic movement; aural, gestural, and visual contours with emotional significance[14]—and arranging and patterning these elements in unusual, "special" ways, early humans assured the willing participation in, and

Manifestations of What Might Be Art, 1990, *from an exhibition called "What Is Art For?" using books and other found objects, with titles drawn from phrases in book.* (Don Mohr, Anchorage, artist)
Art may be used for anything and anything can become an occasion for art.

accurate performance of, ceremonies that united them. The arts "enabled" ceremonies because they made ceremonies feel good. Before they were ever consciously used to make things special, the satisfactions of rhythm, novelty, order, pattern, color, bodily movement, and moving in synchrony with others were fundamental animal pleasures, essential ingredients of life. Using these bodily pleasurable elements to make ceremonies special—elaborating and shaping them—the arts, and art, were born.

5. My theory recognizes that art, or, more accurately, the desire to make some things special, is a biologically endowed need. The impetus to mark as "special" an expression or artifact, even our bodies, is deep-seated and widespread. Quite naturally we exaggerate, pattern, and otherwise alter our movements or voices or words to indicate that what we

are doing is set apart from ordinary movement, intonation, and speech.[15] More essential than the result (the "work of art," which can be striking or dull, achieved or abandoned) is the behavior or the activity, and more interesting, for our purposes, is the impetus that animates the behavior or activity. Not all things are made special and those that are chosen are usually made special for a reason. That reason throughout our unrecorded evolutionary history, and also for most of recorded human history, was different, more serious and emotionally involving, than the reason or reasons involved with making special in the modern, industrialized, Western or Western-influenced world.

6. My theory reminds us that the desire or need to make special has been throughout human history, until quite recently, primarily in the service of abiding human concerns—ones that engage our feelings in the most profound ways. Until recently, the arts—when they were not play or entertainment (which are legitimate and age-old ways of making human life more than ordinary)—were used to address or at least to suggest or intimate serious and vital concerns. We moderns feel "art" to be a private compulsion, a personal desire to mold or make something out of one's individual experience. But art actually originated and thrived for most of human history as a communal activity: in the smaller and more interdependent and like-minded societies in which humans evolved, the need to make sense of experience was satisfied in communally valued and validated activities. Much art today is rather like the display of a captive, lone peacock vainly performed for human (not peahen) spectators, or the following by baby geese of a bicycle wheel instead of their mother. When an animal is removed from its natural milieu and deprived of the cues and circumstances to which it is designed by nature to respond, it will respond and behave as best it can but probably in aberrant ways or with reference to aberrant cues and circumstances.

The principal evolutionary context for the origin and development of the arts was in activities concerned with survival. As we look back through the eons, we see abundant evidence of humans making things or experience special. Overwhelmingly what was chosen to be made special was what was considered important: objects and activities that were parts of ceremonies having to do with important transitions, such as birth, puberty, marriage, and death; finding food, securing abundance, ensuring fertility of women and of the earth; curing the sick; going to war or resolving conflict; and so forth. In the past things were made special because they were perennially important, while today we consider something (anything) momentarily important because it has been made flashily if transiently special.

This is an important difference and points up, I think, why in the contemporary West we have been so preoccupied with and confused about art, seduced by it, expecting miracles from it, alternately feeling elevated or dispirited by it, feeling somewhat betrayed if not altogether scorned by it.

In Wallace Stevens's poem "Anecdote of the Jar" a round jar is placed on a hill in Tennessee and the "slovenly wilderness" surrounding it immediately seems to fall into place. The jar becomes a kind of focus or center—"it took dominion everywhere"—that gives meaning or relevance to what before was wild, haphazard, and insignificant. In my ethological terms, placing the jar in that unlikely place was "making it special": an instance, if you will, of artistic behavior. Stevens's poem that tells the story also makes the deed (real or imagined) special by choosing unusual word order ("and round it was upon that hill"), strange phrases ("and of a port in air," "it did not give of bird or bush"), and rhyme (round / ground; air / bare / where) for the telling. A beautiful and successful poem in the high modernist tradition, "Anecdote of the Jar" is an exemplum of what a modern or postmodern painter or sculptor does when she or he chooses a subject and material and shapes and elaborates them, making special what before her or his action and vision would have been ordinary and unremarkable.

Yet in premodern society, the hill, though slovenly and wild, would most likely have been already somehow important: it would have been the abode of a spirit, or the place where a valued person was killed, or the site where a vision had occurred. Or perhaps the jar itself would have been important—because of some sacredness involved in its making or some magical marks added to its surface—so that placing it on the hill would have been a way of bringing human or divine presence to the hill or imparting a power to it. While such motives may still be the impetus behind some artistic acts today, they need not be. The act alone, for its own sake, is enough and we have learned to respond to the act and its result quite apart from the intention or idea that gave rise to the act.

Human evolution may have involved gratuitous acts of making special, but it is difficult to see how these would have made sufficient difference to the survival of individuals or groups to have been retained by natural selection as a genetic predisposition (except perhaps insofar as they are considered part of the general behavior of play, whose motivation is quite different from acknowledging or creating or celebrating importance). I admit that making special manifested as playfulness or idiosyncrasy can be pleasurable and rewarding, but I doubt whether in themselves they would have led before modern times to the creations

that have been enshrined as our most representative examples of "art."

7. To suggest that making important things special was the original impetus for a "behavior of art" accounts for the close association in historic times as well as in prehistory between the arts and religion—more accurately, the ritual expression of religion.

The earliest anthropological observers noted the importance of religion in human societies everywhere. Emile Durkheim, the great French founder of sociology, called religion a unified system of beliefs and practices related to sacred things—things set apart and forbidden (1964, 62). These beliefs, practices, and things belong to a realm called by different authors the numinous (Dodds 1973), the serious (Shils 1966), the supernatural—all suggesting the extra-ordinary, outside ordinary life.

In the next chapter I will show that the origins of religious beliefs and practices and the arts must have been inseparable and that the ceremonies that have arisen in every human society for the purpose of dealing with vital, emotionally significant, archetypal concerns expressed these by means of arts. Yet before doing this I should remind the reader that today in the modern West very little is, in Durkheim's words, set apart or forbidden. Indeed, being considered forbidden or taboo seems cause and justification for being openly discussed and displayed.[16]

What is more, in the modern world, as Kaplan (1978, 86) has pithily remarked, the interesting is no longer important, and the important is no longer interesting. It seems worth asking whether the confusing and unsatisfying state of art in our world has anything to do with the fact that we no longer care about important things. In our predominantly affluent and hedonistic society survival is no longer paramount for most of us, and spiritual concerns, while perhaps given public lip service, are less and less privately validated. Our experience of the extra-ordinary tends to be an ever-growing involvement with such things as gambling, violent films, and mood-altering drugs. Caring deeply about vital things is out of fashion, and, in any case, who has the time (or allows the time) to care and to mark one's caring?[17] Human history has demonstrated that people can endure surprising amounts of hardship and suffering—conditions that usually elicit a serious and religious attitude toward life. Whether people are as well equipped to thrive under conditions of unprecedented leisure, comfort, and plenty is a question that is being tested on a large scale in our present circumstances: the answer does not appear to be promising.

❧ 4 ❧

Dromena *or "Things Done"*

Reconciling Culture and Nature

The desire to make something, the desire to hold something.
—LUCY LIPPARD, *Overlay* (1983)

Take an object. Do something to it. Do something else to it. Do something else to it.
—JASPER JOHNS (cited in Rosenthal 1988)

A number of animal species, particularly among the birds, perform behaviors that are remarkably "artistic." Some songbirds, such as the white-throated sparrow, individually improvise on a basic pattern of melody and rhythm used by all members of the species, so that fellow sparrows can recognize "That's Joe," just as jazz cognoscenti know after a few bars, "That's Charlie" (Mingus or Parker)—by his singular style. Sandhill cranes perform complicated dance duets: they bend, sway, pirouette, and flap their wings in an inspired pas de deux that would impress any choreographer. Perhaps the most artlike behavior in the animal world is that of the male bowerbirds of Australia and Papua New Guinea who construct and decorate what are essentially honeymoon suites. Both the structure and the decor may be astonishing: some birds mark off an area by placing stones or sticks in a kind of ring, others build archways or tunnels of grasses. The basic site is then carefully and artfully decorated with colored petals, leaves, pebbles, or whatever is available—bottletops or buttons are often incorporated if present.

These activities certainly look like examples of "making special." How, if at all, does human shaping and elaborating differ from these examples? An ethological view must address this problem, because some biologists have made the claim that bird song or bowerbird embellishment can legitimately be called aesthetic.[1] Thus, considering how and why a human behavior of art differs from the "aesthetic" activities of other animals

64

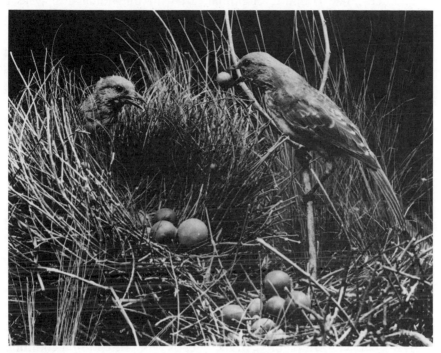

Australian fawn-breasted bowerbirds (Chlamydera cerviniventris)
The pair are shown in an "avenue"-type bower, decorated by the male with
green berries and a few green leaves gathered and replaced daily. The inside walls
are also "painted" nearly every day with well-masticated green vegetable matter
that is applied with daubing motions of the bill (Peckover and Filewood, 1976:
122).

provides further insight into its biological origin and function (selective
value).

The reason that songbirds and bowerbirds make their extravagant vocal
and visual displays is the presence of desirable females (and rival males).
The birds' efforts are saying to the ladies "Choose me." The song or
bower is made special for the purpose of attracting a mate. The cranes are
also concerned with mates, and the courtship dance stimulates, encour-
ages, and coordinates the partners' sexual readiness in a particularly en-
ergetic kind of foreplay.

Beauty and elaboration in the animal world is most obvious in con-
nection with courtship and mating, as in the conspicuous plumage or
bright coloration of male birds and fish at breeding time. Darwin con-
jectured that human artistic activity and the concept of the beautiful had
their origins in sexual selection, the choosing of one mate in preference

to another.[2] The coupling of human art with individual display as a means to achieving reproductive success has, as mentioned earlier, been frequently invoked by biologists ever since.

Darwin's association of human artistic activity with the extravagant sexual displays of other animals was bold, original, and cogent, given his theoretical premises. Yet on several counts I think his speculations are inadequate, even as starting points, for a contemporary ethological view of art. First, his nineteenth-century notion of art was inextricably bound to the concept of beauty, while today "beauty" is recognized as being only tangential to art. Second, it is not clear that females, such as those in the examples cited, choose their mates on the basis of "beauty" *or* "art": some other attribute that is also displayed—for example, concentration of yellow flowers, or stamina, or persistence—might well influence their choices. And third, by "art" I mean and want to explain more than visual display.[3]

To be sure, it is abundantly evident among humans that desire for the opposite sex encourages people to make themselves and their surroundings special and attractive. Courting, with its choice of the most becoming clothes, use of expensive cosmetics and perfume, candlelit dinners, dreamy music, and best efforts to please, certainly differs from normal, everyday behavior. In premodern societies as well one can find countless examples of human beautification and display being used as sexual attractants. Yet there are numerous *other* circumstances in which making special is as important or even more important than in sexual contexts for me at least to raise the question of whether its evolutionary function was originally something else.

As I described in Chapter 3, making special, and its antecedent, the recognition of an extra-ordinary dimension of experience, are inherent in play. This similarity helps to explain why play has frequently been invoked to account for certain aspects of art, for example, the exploratory, inventive, pleasurable playing with shape, color, movement, sound, or pattern for its own sake.[4] More important, however, for understanding the evolutionary origin and purpose of art as a human behavior, as well as its emotional power, is the close connection between making special and ritual ceremony. Even Darwin, I think, would have agreed that making special is most noticeable in human ritual ceremonies.[5] Rituals by their very nature are exceptional kinds of behavior, acts outside the daily routine. Or they may be—even when part of everyday life, as in particular observances at mealtime or nightly storytelling before bedtime—ways of making common but important occasions more significant or special.

*Boys lighting devotional lamps by a tulsi plant which represents the Hindu
god Narayana, protector of the household. Gorkha district, Nepal*
Rituals may be part of everyday life, ways of making common but important
occasions significant or special.

Certainly, the arts arose and developed together with ritual ceremo-
nies. It is as if the deep importance of these ceremonies, centered as they
are around vital human concerns, demanded that they be made special as
a way of acknowledging the seriousness of what they addressed—nothing
less than survival. Unlike with play, making ritual ceremony special was
done not for its own sake or for the practice of vital activities, but for the
sake of the maker's involvement in and care about the ceremony's con
cerns. Without such emotional investment, there might not have been
sufficient impetus for making special to have developed beyond playful-
ness and innovation.

To me, it seems ethologically sound to look for the peculiarly human
characteristics of art in the circumstances that gave rise to ritual ceremo-
nies. One good reason to search in this area is that ritual ceremonies,
unlike sexual displays, are peculiar to humans.[6] Although ceremonies
vary in form and content for each society, they occur in response to
strikingly similar circumstances. All societies observe "rites of passage,"
states of transition between one significant material or social state and
another, such as birth, puberty, marriage, death. Additionally, rites are
performed to assure prosperity or good fortune: in hunting, raising crops

or animals, or war; to cure illness; to obtain absolution; to achieve re-unification and mediation; and to proclaim allegiance(s). These may also be regarded as transitions: between seasons, sickness and health, discord and concord, and so forth.

Ritual ceremonies are things done to bring about desired results. They may be benign, as when performed to promote fertility or healing, or malign, as when sorcery and witchcraft are used with the intent of harming others. The sociological and anthropological literature on ritual is rich and vast; it makes abundantly clear how pervasive and crucial ritual observances have been and continue to be for human individual and community life. An ethological contribution to our understanding of the subject must be concerned to point out how ritual has been essential not only psychologically or sociologically but (as indicated by this emotional individual and community importance) to biological survival. In addition to appreciating an individual culture's rites with its unique songs, dances, myths, symbols, and so forth, and elucidating the general pancultural principles that have been found to lie beneath these,[7] one should also recognize that ceremonial ritual is a universal behavioral characteristic of the human animal, one that allowed individuals (and groups) that performed ceremonies to survive better than those who did not. Peter Wilson (1980, 105) goes so far as to claim that in human evolution the imperative to establish ritual was more pressing and immediate than the need to produce tools.

Human ritual is cultural, that is, it is learned, not innate. Humans perform ceremonies deliberately, not instinctively, as birds build nests or sing. Yet beneath the performance of ritual I believe there lies hidden an innate human behavioral tendency that is allied to making special. In circumstances that are perceived to be threatening or troubling or uncertain, where strong emotions are called up, humans have the tendency not just to fight or to flee or to wait, like other animals, but to *do something*; they have what Joseph Lopreato (1984, 299) has called "the imperative to act." Lopreato, in turn, quotes Vilfredo Pareto (1935, 1089): "Powerful sentiments are for the most part accompanied by certain acts that may have no direct relation to the sentiments but do satisfy a need for action." As Malinowski (e.g., 1948, 60) also realized, the impetus to do something about our perceived needs is overwhelming; we tend to express any strong emotion by some form of action.

These actions are intended to have an affect on the perceived uncertainty or threat: often what is done is to make things special in ritual practices. To better understand the relationship between a behavior of art (the making special that characterizes the arts) and ritual ceremonies, so

that we can appreciate the differences between animal and human "aesthetic" products, let us now look more closely at "doing something."

Dromena: *"Things Done"*

In her influential little volume called *Ancient Art and Ritual* (1913), Jane Ellen Harrison introduced a term, *dromena*, that I would like to appropriate and adapt for my own use here.[8] According to Harrison, "The Greek word for a rite is *dromenon*, 'a thing done.' . . . To perform a rite, you must *do* something—that is, you must not only feel something but express it in action . . . you must not only receive an impulse, you must react to it" (35). Harrison's study was concerned with distinguishing rite from art, and she viewed ritual as "a bridge between real life and art," which she saw as disinterested or "cut loose from immediate action," an idea in keeping with the aesthetics of her time. The plural word *dromena*, "things done," with its conjoined sense of feeling impelling actions, seems to me, in the present context, to extend the notion of "doing something" (just described as the innate human "imperative to act" in response to "powerful sentiments," as developed in the work of Pareto and Lopreato), to *what is done* (those "things done" and made special) *in ritual ceremonies.*

Transitions, Transformations, and Transcendence

Transitions from one state to another often provoke anxiety or heightened emotion because they mark the end of something known and the beginning of something unknown. Hence they are particularly apt to call forth *dromena*, and the *dromena* themselves frequently create another transition in response, the ritualized transformation of substances and selves from one state to another. In uncertain circumstances, following the "imperative to act," things are done to convert reality from one state to another more special one: the ore is smelted, the cloth dyed, the flesh tattooed. A person's being or consciousness also may be transformed through ceremonial rites of passage, so that he or she moves from a prior natural or neutral state through a "liminal" phase outside ordinary social life and then back to social reintegration in the new (and now "normal") state. These transformative acts themselves understandably carry or embody a large amount of emotional significance.

The word *liminal*, used by Victor Turner (1969) in his expansion of the ideas of Arnold van Gennep (1908), is derived from the Latin word

for threshold. "Liminality" is a state of being betwixt and between, neither here nor there, in a sort of limbo—fraught with the unease of not being one thing or another. Brackets, as it were, are placed around the extra-ordinary episode or condition, marking it as outside of, different from, even superior to ordinary life. Beginnings and endings of ceremonies are frequently given special treatment (as Drewal and Drewal [1983] describe for the Yoruba *gèlèdé* ceremony), just as greetings and partings are always socially ritualized.

The external transition or transformation marked by the liminal state may well produce a transformation in the participants too, a heightened emotional condition that Turner (1974) calls *communitas*. Individuals feel themselves joined in a state of oneness, with each other, with powers greater than themselves, or with both—a sort of merging and self-transcendence. This is a state outside ordinary life; indeed, ordinary life would be disrupted by it. Yet Turner claims that exposure to or immersion in *communitas* seems to be an indispensable human social requirement, and his claim makes evolutionary sense.

The capacity for self-transformation, felt as merging or self-transcendence, though manifested in diverse ways, seems to be a universal element in the human behavioral repertoire. Many premodern cultures provide occasions for self-transcendent experiences in ritual ceremonies. The words for experiences of transcendence may refer to boundary crossings (e.g., Umeda *yahaitav*) or merging and submergence (e.g., Tukano *miríri*), and may have slightly negative or fearsome connotations (*miríri* also means "to suffocate or drown," and alludes to coitus which is compared with drowning, drunkenness, and hallucinations, for example, and the Bushman term *!kia*, refers to an enhanced state of consciousness that results from the activation of *num*, a boiling energy originating from the gods, that wells up inside and fills one [Katz 1982]).

In later writings, Turner referred to the term "flow," which in Mihaly Csikszentmihalyi's (1975) work describes the holistic sensation felt when one acts with total involvement, as in play and sports activities, in creative work, in secular national celebrations, and in religious experiences. A person feels "flow" when action and awareness interfuse, when one is not self-consciously or objectively aware of what one is doing, yet does it with effortless "rightness." Although one may be very aware of body or mind, there is a felt loss of ego: one is danced by the dance, played by the music, becomes an instrument for the activity or experience. Hence the individual experiences a sense of blending, of dissolving the boundaries between "I" and "other."

Descriptions of aesthetic experience also often mention the individual's

sense of boundary dissolution and union with the "other": One is "carried away" by or "becomes" the work of art (e.g., Laski 1961). Viktor Zuckerkandl (1973, 29) claims that music in particular provides a state to enter that transcends individuals, in which we are not (as is usual) separate and sequential but seem to partake of a timeless unity: "tones remove the barrier between persons and things." Song with words has been for almost all cultures a vital bridge between what passes in separate lives and what endures in community experience (Booth 1981).

From Nature to Culture

In the preceding pages I have described a number of what appear to be inherent predilections in *Homo aestheticus*, all of which seem to intermesh and be interrelated: tendencies to recognize an extra-ordinary as opposed to an ordinary dimension of experience; to act deliberately in response to uncertainty rather than to follow instinctive programs of fight, flight, or freeze in place; to make important things (such as tools, weapons, and transitions) special by transforming them from ordinary to extraordinary, often in ritual ceremonies; and to have the capacity to experience a transformative or self-transcendent emotional state. All of these, I claim, have a potential to provoke naturally aesthetic behavior.

While "human universals" such as these are well established in the ethnographic literature, they are considered to be "cultural" behaviors: they are not generally seen in species-centric or ethological perspective as inherited predispositions, products of natural selection that aided survival during human evolution. Two other human predispositions that I am about to introduce are also widely described, but in recent years have become subjects of considerable controversy, in large part because they are seen to provide justification for racism, sexism, technological domination of the environment, and oppressive Western cultural imperialism. If I were a professional academic social scientist, I might be risking my reputation by emphasizing these traits and using them as integral evidence in my reconstruction of the biological evolution of art. However, the recorded facts support my own observations, and as the traits will be described as behavioral *tendencies* that are called forth in *certain* circumstances, hence not "determined" or inevitable, there is no implication that I advocate or provide biological foundation for their politically disagreeable manifestations.

Dromena, the need to act ritually and the ritual acts themselves, are related, I suggested, to the human penchant for making special, which I believe arose in turn from the ability to differentiate ordinary from extra-

ordinary. Additionally, it would seem that it became possible for humans, as they themselves became more and more aware of this separation, and of their own ability to make special, *to consider themselves (their kind) as different and special as well.* They not only differentiated, like other animals, between the commonplace and the exceptional, but could differentiate themselves from other animals and the rest of nature.

We see this in many societies today (e.g., Inuit, Mbuti, Orokawa, Yanomamo, Kaluli) where their word for themselves—their group or kind—is also their word for "man" or "human." Other animals, and even other people, are called by other names, although not everyone goes as far as the Mundurucu of South America who include other people and animals in one category: "game." However, it is widely observable how distressingly easy it seems to be to dehumanize other people, giving them demeaning labels—geeks, greasers—that allow the labeling group to consider the labeled group as not like itself and therefore assume the license to treat the "other" differently or even inhumanly.

Today perhaps more than ever we separate ourselves from nature and the cosmos. I think it is fascinating that even those modern humans who do not usually make adverse racial or national distinctions still tend to define themselves by what they are not. For example, "humanists" (those denounced by Bible-Belters as "secular humanists") call themselves that in order to indicate that their sphere of interest does not include the supernatural or divine. In the *Concise Oxford Dictionary, human* is defined as "having or showing the (esp. better) qualities distinctive of man. . . . as opp. to animals, machines, mere objects, etc." Extending this notion, "the humanities" as a subject are concerned with studying what is "humane," that is, what tends to confer civility and refinement—implying that "natural" or "unrefined" things are inhumane.

I am leading up to a hoary and recently controversial anthropological chestnut: the famous culture/nature dichotomy that all human societies have been said to display—at least insofar as they manifest "culture" that is an adaption of (or from) nature. Humans, unlike other animals, take raw food that occurs naturally, and, by cooking or otherwise treating it, transform it for their nourishment. They make clothes and implements from natural materials, thereby protecting themselves from natural adversaries like weather and predators. They domesticate wild plants and other animals, which are then considered to exist for human use. They give names to their infants, to places, to constellations, thereby humanizing them. They make clearings in the bush or jungle for their own habitation. Humans develop social rules and customs that control such things as whom one mates with, rather than indulging in what may seem

to a human onlooker to be "animal" or "natural" promiscuity. They place artifacts of their own making, like jars or shrines, in wildernesses, on hills.

Sigmund Freud, in *Civilization and Its Discontents* (1939), posited a stage at which the human animal renounced instinct and began to regulate primary desires. At the same time we gained control over fire, made use of tools, constructed dwellings. While "civilization" now refers to a much later cultural development, Freud was noting that though *of* nature, humans have made themselves, for better and worse, *apart from* it and thus reap discontents (but also, surely, many contents) from this difference that we now call "culture." Every human begins life as a wholly natural creature (with, to be sure, innate propensities to learn and become "acculturated"), but is gradually and inexorably transformed into a cultural one. The early hominids who were our ancestors were "cultureless," just like other animals then and today, and culture was evolved as a human biological adaptation.

The recent criticisms by anthropologists and other social scientists of the culture/nature dichotomy have focused on several important points. One is a current dissatisfaction with the theoretical paradigm, structuralism, that first emphasized it a generation ago. Claude Lévi-Strauss (1963), aware that human languages were built from innate, recognizable binary or dyadic sound patterns and grammatical structures, proposed that there were other inherent unconscious universal structures of mental functioning that at a deep level all humans shared, despite great apparent cultural differences on the surface. Today Lévi-Strauss's work is generally attacked as both simplistic and overcomplicatedly unclear; it has been more or less eclipsed or superseded, at least in anthropology, by the presently fashionable *poststructuralists* whose concerns include the inability of language (no matter what its underlying structure) to refer to reality, and who far from looking for universals espouse a radical relativism.

I will discuss binarism in Chapter 6 and poststructuralist thought in Chapter 7. Here I would simply like to say that a species-centered view is sympathetic to Lévi-Strauss's project of revealing how all humans are alike. Although he is accused of having "reduced culture to biology" (MacCormack 1980, 4), his own development of his ideas does not address their implications in a Darwinian framework,[9] and they are, in any case, frequently vague if not self-contradictory.

A second contemporary criticism of the notion of culture/nature arises from the general self-examination now going on in anthropology as a result of its awareness that all individuals look at the world with unrecognized tacit preconceptions that are inherent in their own language and

upbringing. Hence one person's interpretation of another can never be pure and objective. In particular, the very field of anthropology itself is derived from unexamined principles inherent in the Western tradition of cultural exploitation and dominance of non-Western people. The nineteenth- and early twentieth-century founders of the discipline of anthropology were trapped within the implicit ideas of their culture; these ideas influenced not only what they looked for in the "savages" and "natives" they studied, but their subsequent interpretations of "data," as well. One by one, the writings of all the great figures in the development of anthropological thought are being reexamined and deconstructed. We have discovered that they imposed chauvinistic ideological categories on their subjects, inherent not only in their thought but in the further distortions imposed by the necessity of transmitting their observations in writing.

Today's anthropologists may be forgiven if they feel hampered or muzzled by the inherent inability to make anything but prejudiced and inadequate observations and interpretations of other cultures. (In any case, there are no pristine subjects left for primary ethnographies: the remotest tribespeople are found wearing T-shirts emblazoned with "Yale University" or "Adidas" and listening to rock music on their transistor radios.) They now write about writing, examine previous anthropologists and their chauvinistic findings or the ideologically based concepts behind their studies, or show in their own fieldwork reports how their own worldviews are affected by the self-reflective process of writing about the worldviews of others. Rather than being authoritative descriptions and analyses of another culture's practices and beliefs, today's studies are often records of a particular encounter between two belief systems, or meditations on the impossibility of describing the way of life of another.

To contemporary anthropologists, then, the claim that humans universally make a distinction between culture and nature can easily be interpreted as arising from unexamined and fallacious Western presuppositions. To begin with, Western thinking is heavily dualistic, separating object from subject, observation from participation, soul from body, spirit from flesh—and culture from nature. Furthermore, control, domination, and subjugation of the base, raw, or natural is a strong Western theme, as described in Chapter 1. Hence it has been all too easy for Western thought to equate "nature" with primitive people (as in Freud's idea, described above, of civilization being the repression of the "natural" instinctive drives of the tribal horde) and with women (see MacCormack 1980; Torgovnick 1990), a habit reinforced by our ever-growing actual physical separation from nature. A number of recent anthropological

studies (e.g., Gillison 1980; Strathern 1980; Turnbull 1961) have declared that certainly not all societies make a culture/nature distinction where culture transforms or controls nature, and that in many that do make this distinction nature is considered to be an exalted domain not subject to control but instead viewed as a source of power from which to partake.

Although my own ideas might seem to conflict with some of these prevailing currents in anthropology today, I welcome them insofar as they encourage us to examine the presuppositions of Western culture; point out where we have misrepresented and shortchanged the lives, values, and worldviews of other peoples; and suggest where we can expand our own appreciation of these lives, values, and worldviews.

I would not, however, agree with a further derived assumption that a species-centered endeavor, like mine, to find universal predispositions that contributed to human survival as we evolved, must necessarily derive from exploitative ideological or political agendas. While I affirm that the Darwinist perspective no doubt arose because of the same secularized scientific and naturalistic trends that made possible the growth of anthropological theory, I also believe that the solution to the now admittedly mistaken emphases is not to throw out all hope of the possibility of theory but to accept the possibility that Darwinism can provide the basis for a truly universal study of human nature. Rather than use the findings of earlier anthropologists (or "Darwinists") to support prejudiced Western notions of primitives' inferior mental ability, superstitious beliefs, and general backward ways, we can reinterpret these findings to show the ways in which diverse human cultural practices are the means of satisfying universal human needs. For this reason, I have not hesitated to use illustrative material from the ethnographies of even the most currently unfashionable and challenged early anthropologists. In any case, without their studies we would lack any knowledge at all of the wondrous ways in which humans, in order to satisfy underlying biological imperatives, have developed and elaborated their cultures.

Non-Western societies may not have words or concepts for such things as "nature," "culture," "music," "art," and "religion"—and the constellation of notions embodied in our Western use of these terms makes them inadequate if not dangerous to apply unthinkingly to others. However, if we are willing to examine our own preconceptions, and to be sensitive to the subtleties of worldview in other societies (inherent in *their* concepts), I think we can use our abstractions to help us begin to understand another culture as it differs from as well as resembles ours. Even though another culture may not have such overarching concepts as music or religion, we

can identify musical and religious behavior and expand our understanding of human practices and human categorization. For example, if we discover that in Mount Hagen, Papua New Guinea, distinctions are made between "domestic" and "wild," even though these categories may not include the same ideas of power and transformation that we might naively assume in our distinction between "culture" and "nature" (Strathern 1980), we can enlarge our own appreciation of the variety of humans' perceptions of their place in the world and even perhaps become aware of the limitations of some of our own.

What seems difficult to deny is that humans are cultural, as other animals are not (or certainly not to the same extent), and that being cultural and acculturable is part of human biological nature. Culture, as a biological phenomenon, surely did not happen all at once. However, it seems likely that as humans evolved, as they saw themselves and their kind to be in at least some respects different from nature, and as they were increasingly better able to remember and plan, imagine and suppose, they would gradually begin to do more than just react, as other animals do, to disruptive events. Like all living creatures they would distinguish between ordinary and extra-ordinary, but more than any others they would deliberately try to do something to affect their own welfare, to influence, forestall, transform, or otherwise control the disturbing "other," to bring extreme or untrustworthy situations under control by extra-ordinary intervention.[10]

The idea of "control" of nature is also troublesome and unattractive to many, in view of the ever more distressing results of "patriarchal," "technological," "scientific," "Western" society's attempts to master, subdue, overcome, and dominate nature. (This is not the place to argue with the accusation, but one should at least point out that the goal of "science" and scientists has surely been *understanding* of nature, "intellectual mastery," if you will, rather than physical mastery [see Jungnickel and Mac-Cormmach 1986].) My concern here is with "control" in the sense of comprehension and negotiation with, in order to check and halt uncertainty, not with domination and subjugation in the sense of conquest. Frequently "control" is regarded as *influencing* or *harnessing* or bringing oneself into alignment with the powers of nature—as in the ritual practices of numerous societies (e.g., Anderson and Kreamer 1989; Gillison 1980; Strathern 1980). Also related to "control," as I develop the idea here, are notions of transforming nature into culture (or sometimes, even, the reverse, in order to participate in and appropriate its power),[11] and ultimately, at least for a time, *reconciling* the perceived discrepancy or disjunction between the two.[12]

The effect of ritual actions and performances—of *dromena*—is surely to make people feel better, and indeed one might suggest, as has Judith Devlin (1987) in her study of nineteenth-century French peasants' attitudes toward the supernatural, that ritual practices are not so much expected to work—though certainly it is hoped that they will—as to deliver people from anxiety. [13] Anxiety, particularly about truly dangerous or uncertain things, has surely been of selective value and should not be regarded as entirely an immature or neurotic and maladjusted response that one must outgrow or somehow disregard, although to be sure it must be acknowledged and dealt with (see also Malinowski 1948, 61).

A reviewer of Devlin's book (Weber 1987, 430) suggests how this might happen:

> If fairy stories present the impossible as possible, that is not because their audience does not know what's what, but because they are less interested in representing things as they are than as they wish they were and know they can never be. Charms, invocations, visions, prodigies, thrive on unsurmountable misery and need. Popular miracles . . . mercifully suspend a merciless natural order and offer tiny triumphs over suffering . . . fairies, goblins, elves and their ilk crystallize, then dispel, worry and stress.

Weber's summary suggests that "crystallizing" is the first step toward the neutralizing or dispelling of anxiety, even if the underlying adversity cannot be changed. And if it can, by calmer, more unified people, so much the better. Artifice of any kind (like the "crystallizations" by French peasants in supernatural creatures who live outside ordinary life and can influence or "mercifully suspend a merciless natural order") has the oft-remarked ability to manage distress, and for a time to reconcile nature or the "other" and culture or the human sphere.

The ultimate point I wish to make here (after all the detours I have made in an attempt to disarm the inevitable misperceptions and criticisms of my fundamental position) is that the artifices or crystallizations, whether in extra-ordinary beings or practices (*dromena*), that arise from the human creature's inherent efforts to deal with (to control) the uncertainties of its world tend also to be inherently and frequently, if not exclusively, what are called "aesthetic" or "arts."

The Aesthetics of Control

The impulse or wish to control (used, I repeat, in the sense of "to influence, deal with, comprehend, harness, align oneself with, trans-

form") nature requires that one's brain be of sufficient complexity to remember the past and imagine the future—one must be able to postpone, pause, and explore alternatives. It requires one to recognize possible ways to proceed and make choices among them, not simply respond automatically or instinctively, as male birds do when flooded with testosterone and in the presence of fickle females and virile rivals. Control is an "intellectual" behavior, even though it may make use of reflex responses or components of other spontaneous bodily movements.

What is controlled, then, may also be oneself.[14] By controlling one's behavior, one can feel, by analogy, that the provoking situation is also under control. One is doing something. Malinowski (1922) describes how during a terrifying storm a group of Trobriand Islanders with whom he lived chanted charms together in a singsong voice. Whether or not the gale subsided, the measured rhythm of the chanting and the sense of unity it provided would have been more soothing than individual uncoordinated fearful reactions. That the ship's orchestra played "Nearer My God to Thee" as the *Titanic* was sinking seems to me an instance of the same impulse. Members of the orchestra of the *Titanic* were not helped to survive by their behavior, but it seems undeniable that in general people who "do something" deliberately or conscientiously will "cope" more successfully than those who simply react blindly, who leave things as they are, or who wait around for things to get better.[15] And the examples of the Trobrianders and the *Titanic*'s orchestra indicate that what we would call "aesthetic" behavior (chanting, playing music) may arise naturally from the urge to do something.

Action itself may be soothing, as Malinowski (1948) described. One has something to do rather than merely waiting passively for something to happen. But activity that is deliberately (actively) shaped feels more effective and soothing than uncontrolled random flailing about. Even the anxiety or despair of caged animals is expressed by repetitive and formalized obsessional movements. Male chimpanzees may rhythmically run about, slap the ground, and vocalize in thunderstorms (see Chapter 5). We rhythmically tap toes, drum fingers, and wiggle our knee as ways of relieving impatience, boredom, or worry.

Once something is shaped, made comprehensible and structured, it may appear *more real* than life, and take on a life of its own. I believe this process explains how obsessional or soothing actions could become transformed into the movements, chants, and gestures of ritual ceremonies. The repeated, regular, formalized individual displacement activities or "comfort movements" provoked by personal uncertainty and stress, when elaborated and shaped further, could become group *dromena* in com-

munally perilous or confusing circumstances. Eventually these actions would be regarded as preexistent, revealed or passed down rather than made up by humans themselves.

Although *dromena*, in the sense of behavior made special, need not be aesthetic—fasting, garment rending, and other forms of mortification, for example, are *dromena* without an aesthetic component—in extraordinary circumstances people generally are moved to take pains, that is, to use care and contrivance and hence show their regard for and investment in the seriousness of the occasion on which human order and control is asserted against the recalcitrant or perturbing. The Fulani, like many people, believe that something that looks nice will be more effective than something that does not, and thus when going to market to sell their produce they always dress to look their best (Rubin 1989). The aesthetic actions of shaping and elaborating appear to be inherent responses to the world of the unpredictable "other," of unruly nature. They are responses that make us feel good.

Doing something and making special characterize our humanity; *dromena* are likely to take aesthetic shape and be achieved by aesthetic elaboration. The natural pleasurable and satisfying proclivities to shape and elaborate are evident in many contexts.

Shaping and Elaborating as Natural Propensities

The ability to shape and thereby exert some measure of control over the untidy material of everyday life is a well-known benefit of the arts, as Robert Frost (1973, 113) suggested: "When in doubt there is always form for us to go on with. Anyone who has achieved the least form to be sure of it, is lost to the larger excruciations." If given drawing materials around age two or three, young children happily scribble randomly on the drawing surface. As time passes, however, their scribbling becomes more and more controlled; geometrical shapes such as rude circles, crosses, and rectangles, at first accidentally produced, are repeated and gradually perfected. Although children, with parental prompting, may learn to label circles as "suns" or "faces," to begin with they do not set out to draw anything in the environment but instead seem spontaneously to produce forms that become refined through practice into precise, repeatable shapes. The act of making the shapes is pleasurable in itself and appears to be intrinsically satisfying; usually identification is provided, if at all, only after the child finishes drawing. Of course, shapes eventually suggest "things" to the child as the ability to use symbols develops, but in the beginning, pleasure and satisfaction occur without larger or more explicit

associations of meaning. This form of activity in the presymbolic child is perhaps truly an example of "art for art's sake."

Geometric shapes occur in human decoration all over the world, today and in the past.[16] Yet even though humans spontaneously and lavishly make geometric shapes, these shapes, strictly speaking, have few manifestations in nature. Flowers, shells, and leaves have a general formal symmetry, yet they do not display the straight lines or perfect circles that characterize man-made decoration. Even though the microscopic structure of minerals and protoplasm sometimes shows geometric exactness, the form visible to the unaided eye is irregular. Circles, rectangles, triangles, and diagonal, horizontal, and vertical lines are all abstract, nonnatural shapes imposed by humans on the natural world; they are also constructions to which the human mind is from childhood "naturally" disposed.

Humans, of course, share with other animals a preference for order rather than disorder. Regularity and predictability are the ways we make

Tectiforms and rows of dots drawn on rock wall. Cavern of Castillo, Santander, Spain. Gravettian to Middle Magdalenian (27,000–14,000 B.P.)

Geometric shapes occur in human decoration all over the world, today and in the past.

sense of our world. Understanding or interpreting anything means that we recognize its structure or order. A foreign language is gibberish until we know its vocabulary and the rudiments of its grammatical structure. We feel strange in a new house or new city or new country until we have found a pattern for doing things and have adapted our old habits to the new order. But the innate satisfaction that we feel for regular geometric shapes would seem to be more than a practical adjustment to order in preference to disorder. It is "super"-order, a manifestation of human or cultural rather than natural order.

Regular shapes seem to be inherent in the process of visual perception, the way in which it makes order from the multiplicity of the world (Arnheim 1966). Seeing—and each of our other sense activities—is not simply receiving imprints mechanically from the outside world on a blank screen like an image on a photographic plate (see Chapter 6). Psychologists have found that the human mind interprets what is perceived according to general schemes or preexistent "categories" or prototypes (such as roundness, redness, smallness, symmetry, verticality) to which sense experiences are matched. Like bees or butterflies who "see" ultraviolet-wavelength colors of suitable flowers, humans have developed senses that perceive and react only to certain features in our surroundings—presumably ones that are relevant to our existence and survival. And in these perceptual categories or "schemata" the features have been simplified so that one color, shape, or sound stands for a large variety of roughly similar colors, shapes, or sounds. This is what happens when we call magenta, crimson, scarlet, cerise, and a whole range of hues "red" or when we are able to recognize individual words in spoken language even when they are pronounced strangely by someone with a strong regional accent or totally mispronounced by a foreigner. On a visit to Florida I asked a native for the name of a local tree and was told it was a "soppers." Some minutes later my vowel-generalization ability deciphered the utterance to be the word *cypress*. If I were to live permanently in Florida, the native's pronunciation would no doubt become as instantly recognizable as "sy-press" is to me now.

When children are learning to talk they show category generalization. At first they will use the same word for many disparate things—most frequently things that share a similar overall contour or shape (Bowerman 1980). All four-legged animals might be called "dogs." I remember a little Sinhalese boy in a railway car pointing to the revolving fan and calling it "wheel." Roundness and length seem to be especially salient general features.

The fact that abstract and geometrical shapes appear in human arts, even though such shapes do not exist in nature for us to copy, is described by a "law" of Gestalt psychology: simplicity is the state toward which all configurations of physical and psychological forces tend (Arnheim 1986). Rudolf Arnheim (1966, 42) finds in this natural tendency of the mind to apprehend the world as well-organized form evidence that "art, far from being a luxury, is a biologically-essential tool."

Geometric shapes also have a direct neurophysiological basis. The Tukano Indians of the Amazon decorate their house fronts and ceremonial objects with geometrical design motifs, which they claim are what they "see" after ritually taking a hallucinogenic drink. Under the influence of *yajé*, everyone sees the same visions of geometric shapes and gives them the same cultural interpretations and associations. The shapes have been found to resemble phosphenes, the geometrical patterns of colored light that we "see" when we press on our closed eyelids, or that some people experience spontaneously. The drug in *yajé* may activate the production of phosphenes, which are "seen" and interpreted by the Tukano as having spiritual meaning (Reichel-Dolmatoff 1978).

It is also the case that once order becomes the "norm"—as in geometric patterns (or rhythmic temporal patterns, for that matter)—one can "make special" by deviating from expected order. The human liking for novelty and experimentation is just as much a biological predisposition as the human need for order. Not only formalizing, but playing with form, is an emotionally satisfying way of displaying involvement and mastery. Indeed, in much of sub-Saharan Africa, asymmetry and irregularity are used to express the idea of vitality (Adams 1989; Anderson and Kreamer 1989; Glaze 1981). This can be seen in the juxtaposition of unrelated designs or in the "syncopated" arrangement of patterns in textiles (and, of course, in music, dance, and versification, as described by Thompson 1974)—yet the whole demonstrates the mastery of regularity within which irregularity occurs.

Similarly, for the Navajo, whose main cultural concern can be said to be the opposition between the static and the dynamic (Witherspoon 1977), continued spatial repetitions of general themes without, however, ever repeating the same particular design emblemizes renewal, regeneration, rejuvenation, and restoration within an "unchanging" framework. Using constant and subtle variations by means of interruptions, alternations, return, pairing, progression, transection, and ambiguity, the Navajo weaver or pot painter adds the tensional interest of variety to the "repetitions" that the viewer expects (see Chapter 6).

Creating geometric form is a way of giving shape to, and manifesting

control of, space. Repetition and rhythmic variation do the same with time. Rhythm is the inevitable result of repetition. It seems accurate to say that rhythm is the earliest and most inherent environmental fact of which we are aware. Existence equals pulsation. Inside the womb the infant constantly hears the mother's heartbeat and the pulsing of blood vessels. After birth, the new noises, movements, and tactile changes the infant experiences doubtless seem erratic, brash, and unpredictable. It should not be surprising that rhythmic rocking and patting are universally used to help babies make the transition from a world of simple beats to one of complex chaos.

Even after life in the womb ends, rhythm and pulsation are the irreducible background against which the rest of life takes place. From brain-waves to circadian rhythms, lunar to solar cycles, periodicity informs animate and inanimate nature. Breathing, sucking, and crying—the infant's earliest repertoire—are all performed rhythmically. Older infants and children, healthy or compromised, respond to both stress and joy by rhythmic, repetitive action, from head banging and rocking to spoon banging and marching. Adults do much the same when we employ various "comfort" actions of moving parts of our body rhythmically when we are mentally or bodily confined. Margaret Mead (1976) described how the Manus engaged in monotonous chanting when chilled and miserable or frightened at night—much like the huddled Trobrianders in the storm described by Malinowski. A steady rhythm seems to establish and sustain a predictable ground or frame against or within which disturbances may arise, comport themselves, and even be ignored.[1] And apart from reducing anxiety, rhythm is positively enjoyable: the Manus also frequently turned any spoken phrase into a low monotonous repetitive song which appeared to be a pleasurable activity. It has been shown that when talking, people unconsciously choose words that will fit rhythmically into what they are saying (Bolinger 1986)

It seems likely that the early humans who wished to "do something" in response to problems and fears they faced would have found, as we and our children do today, emotional satisfaction and calm in the "controlled" behavior of shaping time and space, of putting these into comprehensible forms. I think of the retarded Stevie in Joseph Conrad's *The Secret Agent* quietly and incessantly drawing circles. Repeated radial patterns drawn over and over again on top of a circle, and concentric circles, have been found to be therapeutic for emotionally disturbed American children (Kramer 1979). Indeed, one might suggest that the reason art making is "therapeutic" has at least as much to do with the fact that, unlike ordinary life, it allows us to order, shape, and control at least

a piece of the world as to do with the usually offered reason that it allows sublimation and self-expression.

I am not suggesting or implying that early humans should be equated with retarded or disturbed or even normal children, but rather trying to make the point that the production and repetition of geometric shapes, like the repetition and patterning of sounds or movements, seems to be a fundamental psychobiological propensity in humans that provides pleasurable feelings of mastery, security, and relief from anxiety. Coleridge recognized this benefit when he referred in *Biographia Literaria* to "the calming power which all distinct images exert on the human soul." The contemporary sculptor Louise Bourgeois has stated outright:

> Once I was beset by anxiety. I couldn't tell right from left or orient myself. I could have cried out with terror at being lost. But I pushed the fear away—by studying the sky, determining where the moon would come out, where the sun would appear in the morning. I saw myself in relationship to the stars. I began weeping, and I knew that I was all right.
>
> That is the way I make use of geometry today. The miracle is that I am able to do it, by geometry.
>
> Cited in Munro 1979

One can easily understand that such stress-reducing behavior, incorporated into ritual observation and ceremony, would contribute to its survival value.[18]

Repetition is the origin of and simplest kind of elaboration. One curlicue is uninterpretable, for it may be a deliberate act, a random event, or a mistake, but a whole row of curlicues conspicuously demonstrates deliberation, control, or perhaps natural exuberance. Repetition also conveys a kind of emphasis. By its nature it suggests bigger or better, intenser or longer lasting. A *tarlow* is a simple pile of stones erected by some aboriginal groups in Australia and set apart, special and hallowed, as representative of their wish that life necessities multiply (Maddock 1973). Adding stone to stone unequivocally signifies increase. Perhaps this is what the rows of dots on Paleolithic cave walls stand for as well (see page 80). In body movement, gesture, music, and poetry, repetition or prolongation similarly express and evoke "more": the "redoubled prayer in its hope of surer fulfillment"[19] or the intensification of mood or plight—as in King Lear's unbearable five "Nevers" or Beethoven's astonishing twenty-nine bars of repeated C's

that emphatically conclude the last movement of the *Fifth Symphony*. At the same time, repetition creates abstractness or distancing, elevating the particular occurrence to a "special" plane of pattern-formalization and distinctness in its own right.

We must keep in mind that ritual repetition is *productive*, not only or merely palliative, as strict Freudians might claim. As Paula Gunn Allen (1983, 15), a Lakota Sioux, writes:

> [Ceremonial] participants do indeed believe that they can exert control over natural phenomena, but not because they have childishly repeated some syllables. Rather, they assume that all reality is internal in some sense, that the dichotomy of the isolate individual versus the "out there" only appears to exist, and that ceremonial observance can help them transcend this delusion and achieve union with the All-Spirit. From a position of unity within this larger Self, the ceremony can bring about certain results, such as healing one who is ill, ensuring that natural events move in their accustomed way, or bringing prosperity to the tribe.

By focusing attention and inwardly reenacting times that ceremonial observance effected certain desired results, the participants produce the best circumstances for beneficent results to occur once again.

Imagery, Imagination, and Symbolic Meaning

Paula Gunn Allen's description makes clear the truth that in actual ritual experience the form is not appreciated apart from the content. Therefore, it is artificial for any discussion to separate them. Because my own ethological viewpoint does not treat content—the actual thoughts, wishes, or images inherent in the actions or objects that are being made special (shaped and embellished)—I think it appropriate here to say a few words about my reasons for not doing so.

The majority of studies of art are concerned with the "meanings" that the arts express: their local and historical significance, for example, or their archetypal, mythological, or unconscious content. While such interpretation certainly has value, it follows upon a study of art as a human behavior and is not integral to it. The content of the arts, even though such content no doubt reflects universal concerns and images (as Anthony Stevens and Joseph Campbell have shown)[20] and even though it has been the stimulus and occasion for humankind's sublimest creations, need not be manifested artfully. Stories can be told and images can be

made without giving them a specialness that is more than what is necessary, without intending to create an emotionally appealing and gratifying metareality. To my ethological view, images or content are part of the "nature" (i.e., the natural subject matter) that making special is a way of "controlling."

This does not mean, however, that I see "content" in some way as less important than making special, just as I do not see food as being less important than the behavior of food preparation and utilization. The images and concerns that a faculty for making special treats are its "food"—it "cooks" these instead of leaving them raw and untreated. While one can study the raw material in order to understand its essential nutrients, or investigate how an individual person or culture prepares it for consumption, an ethological view wishes primarily to establish and emphasize that the transforming, treating, or making special *itself* has been of crucial significance in the evolution of the human species.

In a similar vein, making special may use the faculties of imagination and make-believe (inherent, as we have seen in play), but these also need not be specifically applied to emotionally gratifying metarealities (i.e., they can be used in nonaesthetic problem-solving or in daydreaming for quite instrumental purposes), and thus are not in themselves always or inherently aesthetic. For that reason, an ethological view of art will not stress the primacy of these capacities. However, it will make another point: that the presence in human societies all over the world of valued avenues and occasions for fantasy, make-believe, and imagination suggests that far from being mechanisms of escape and regression, or immature and trivial exhibitions of frivolity, as current received wisdom proposes, they can be positive and integrative activities. Fantasy and make-believe are not only means of wish-fulfillment, as Freudians would have it, substitutes for what cannot be achieved or possessed: they can create and generate new meaning as well. Artistic imagination, which represents feeling by means of images or configurations (visual, musical, verbal, gestural) and invests these images or configurations with emotion, may just as well be healing as pathological, creative as defensive, real as unreal. Its psychological value must surely be in what is positively given and added to life, as much or more than in what is disguised, repressed, or confabulated.

Just as art is usually equated with "imagery" and "meaning" and "imagination," it is also usually assumed to be necessarily symbolic. Indeed, in Paleolithic sites, evidence of "art," as with the presence of red ochre or identifiable images, is interpreted as evidence of the capacity for symbolic behavior. The ethological view, however, while interpreting ochre and

images as evidence of making special, is less inclined automatically to equate making special—and a behavior of art—with symbolization. Because this perspective is contrary to received ideas, it requires more discussion.

To be sure, the Paleolithic images that are often cited as the first instances of art—paintings and sculptures of animals and female figures—are undoubtedly meant to represent their referents, whether concrete (sources of food) or abstract (emblems of fertility). Mousterian beads, sewn onto clothing, are cited as evidence of, and may well have been used for, symbolizing status differentiation (White 1989a, 1989b).

Even geometric shapes generally "have meaning" and denote particular aspects of human experience. For example, the white triangles of caribou skin on the parkas of North Alaskan Eskimos represent walrus tusks, which in turn are meant to bring to mind beliefs about Walrus Men and the myth of transformation between humans and animals. Aboriginal tribes of Central Australia use what has been called "an art of circle, line and square" (Strehlow 1964) that is composed of stylizations or refinements of actual marks such as animal and bird tracks or objects like waterholes and camps. The Walbiri use simple visual shapes and arrangements such as circles, crosses, and concentric structures in a wide range of media and contexts to embody their ideas about order in the world. Concentric shapes, for example, denote waterholes and camps (enclosures) as well as birth (wombs and bellies) (Munn 1973; Strehlow 1964). Geometric shapes (such as V's, W's, circles, and pointed ovals) used by the Abelam of Papua New Guinea are both figurative or representational (anthropomorphic) and "abstract," and have several alternative meanings, even simultaneously, according to Anthony Forge (1973), primarily about the relations between things more than things themselves. These motifs are combined and arranged in harmonious designs, ancestrally sanctioned, and believed to be intrinsically powerful.[21]

With symbols being so pervasive in the arts, it is not surprising to find that most theorists take for granted that art must be symbolic to be art. The standard view is expressed, for example, by Ellen Winner (1982, 12) in an admirably synthetic and comprehensive book on the psychology of art in which she treats the arts as "fundamentally cognitive domains" and claims that both producing and perceiving art requires the ability to process and manipulate symbols. Prehistorians also, as I have indicated, frequently assume that art began when humans developed the ability to make and use symbols.

On the face of it, the symbolic nature of art seems self-evident and

unexceptionable. In the art of all times and places, the creation, evoca-
tive handling, and feelingful appreciation of symbols is one of its most
noticeable and distinctive characteristics. The ballerina fluttering in her
tutu and the sounds of the yearning orchestra both symbolize a dying
swan (and the dying swan itself symbolizes loss), just as the Australian
aborigines' emu dance symbolizes the emu or the presence of the emu's
spirit.

Notwithstanding (and not disputing) the evidence that the arts are
overwhelmingly symbolic, let us look a little closer at this assumption. In
the first place, automatically considering the arts to be "fundamentally
cognitive" grows out of, and lends itself to, the elitist, technorational view
of art and reality that I am concerned to revise. While I am sure that
Winner by her emphasis on cognition wished to stress that art making and
art appreciation require knowledge and deliberation—that is, they in-
volve more than simple making, movement, liking, or disliking—it is, I
say, much better to think of the arts equally as "fundamentally" emo-
tional and sensual as well as cognitive.

In Chapter 2 I mentioned that the tradition of body-mind dualism in
Western thought and our habit of categorization of what we know into
"fields" has tended to obscure recognition of the fact that experiences are
at the same time perceptual, ideational, and emotional, and that all of
these are "bodily." I should like to reemphasize this idea again here, so
that my readers will understand that symbols too are no less emotional
than cognitive. Indeed, one can presume that when the "reflex" pleasures
of patterning, elaborating, and repeating were annexed to the pleasure of
recognizing that resulting shapes had the meaning of similarity, art had
much greater possibilities for control.

The anthropologist Victor Turner (1974, 55–56) has combined the
emotional and cognitive aspects of art in his thinking when he regards
Ndembu ritual symbols as comprising as it were a continuum with at
one "end" an orectic, or physiological, "pole" or aspect (thus account-
ing for widespread ritual use of references to blood, sexual organs, co-
itus, birth, death, decay—all emotionally charged primal bodily
realities) and at the other end a "normative" pole or aspect—the ideal
and ideational moral requirements that are necessary to social contin-
uance and well-being (such as reciprocity, respect, generosity, and obe-
dience). These desiderata of group life receive their obligatory force
from association with the emotionally toned physical realities in which
they are embodied—the verb "embodied" is apt; the gutsy bodily real-
ities are in turn ennobled by their association with the "highest" truths
and values of the society.[22]

If the insistence that art depends on symbols does not thereby imply a corresponding denigration of feeling, then I am less critical of it. Additionally, however, it seems moot to decide exactly where and when making special becomes "symbolic" and hence, in the standard view, "art."

In the preceding section I suggested that the components and sources of artistic behavior and response were first of all extemporaneous expressions and evocations of pleasurable and satisfying human bodily feelings of security and mastery that arose naturally from acts of patterning and elaborating. To be sure, at some point they became "symbolic": they looked like or brought to mind something else. But just as children's drawings begin as spontaneous pleasurable markings and the making of shapes and patterns and then later gradually begin to acquire meaning, or their singing and dancing is shaped and elaborated but not symbolic of anything, artistic behavior in the human species probably developed in the same way, not as deliberate acts of presenting symbols but as the result of more fundamental and less practical or intellectual activity.[23] In some instances this activity would have been sheer exploration or playfulness (as Morris [1962], Alland [1977], and others have suggested); in other instances, as I have described, it would have been a means of working out anxiety and attempting to influence the outcome of uncertain events or feared possibilities.

One can assume that to early humans control of oneself "meant" (or was intended to result in, by analogy) control of nature; similarly, repetition by its very nature meant "more." Whether these associations are clearcut instances of symbol making is arguable. Surely the assigning of symbolic meaning is not an all-or-none activity, where suddenly a white triangle symbolizes a walrus tusk which itself symbolizes transmigration. We know that even in animal play something may "stand for" something else: the kitten's siblings are "enemies" to be ambushed or a ball of catnip is "prey" to be captured. But I do not think that siblings being enemies or catnip being prey are instances of symbolization, or that all examples or forms of "control" or "more" are symbolizations in the way that white triangles represent walrus tusks or the possibility of humans changing into animals.

Analogic or metaphoric thinking is intrinsic in human mentation (see Chapter 6), but regarding these mostly unconscious associations as examples of symbolizing, which suggests a more deliberate, pragmatic, and formalized activity, seems unwarranted. For example, Paula Gunn Allen (1983) says that use of the color red is not meant by the Oglala to "stand for" sacred or earth in a metaphorical or poetic way but rather to indicate

"the quality of a being, the color of it, when perceived 'in a sacred manner' " (16)—that is, psychically or mystically (or in the terms of this book, as extra-ordinary or special). It is a matter of being rather than representing.

Another important point I need to make here is that inseparably accompanying what control or more or redness "mean" cognitively or intellectually is what they feel like. "Good" (reassuring, pleasurable, gratifying, sacred/mystical) feelings relieve anxiety and also help to ensure that people continue to impose cultural pattern and elaboration on nature and by doing so increase their biological fitness (see my next section). A behavior of art is really as simple, and essential, as that.

The existence of nonsymbolic designs and patterns in human societies[24] further suggests that art making is not in any causal or inevitable way dependent on image making and symbolizing (which, as I have said, may not be artful). Perhaps this idea can be accepted more easily with reference to temporal arts like music and dance in which human experience and emotion are certainly suggested but not necessarily in a "symbolic" way. Rhythmic movement and vocalizing (dancing and singing) may well have been part of the human repertoire earlier than the special fashioning of visual artifacts ("art"), but they have left no traces for us to interpret today as being either symbolic or nonsymbolic.

It is perhaps ironic that in 1990 I am led in a new context to echo the point made by Franz Boas in 1927 in the introduction to his seminal book, *Primitive Art* (1955). In the decades immediately preceding Boas's book, a number of theories about the origin and nature of art had been suggested, most of which assumed that for "primitives" art was, like language, a means of expressing emotional states, and hence was essentially representational. Operating under a tacit unilinear theory of human evolution, many thinkers assumed that the matter would be settled once and for all by discovering whether the earliest art was representational or geometric. But Boas (1955, 13) wisely noted:

Since [human art], the world over, among primitive tribes as well as among civilized nations, contains both elements, the purely formal and the significant, it is not admissible to base all discussions of the manifestations of the art impulse upon the assumption that the expression of emotional states by significant forms must be the beginning of art, or that, like language, art is a form of expression. In modern times, this opinion is based in part on the often observed fact that in primitive art even simple geometrical forms may possess a meaning that adds to their emotional value, and that dance,

music, and poetry almost always have definite meaning. However, significance of artistic form is neither universal nor can it be shown that it is necessarily older than the form.

Today the concept of symbolism has replaced the "significance" and "meaning" and "expression" referred to by Boas and his contemporaries. While we might find his distinction between "formal" and "significant" overdrawn, I wish to resurrect it if only to stress that just as all symbols are not art, neither is all art symbolic. Making special, shaping, embellishing, repeating, and elaborating are gratifying in themselves, even though representational meaning be secondary or even absent.

The Necessity of Art

It is difficult in our time and place to appreciate what art's deep necessity, its ethological importance, might be. We look in vain in contemporary thought for something on which to build a plausible case for art having been necessary to human evolution. The dominant idea about art in our culture, ever since the idea of "art" itself arose in the eighteenth century, has been that it is superfluous—an ornament or enhancement, pleasant enough but hardly necessary.[25]

To be sure, some have viewed art as having psychological benefits, serving as an escape from or substitute for unacceptable or uncomfortable parts of reality, as in Freud's (1959, 22–24) well-known position that art is a symptom of a lack, a neurotic sublimation, or a palliative substitution. One may also cite the trenchant observation that we have art in order not to perish of the truth, or, more recently, Jasper Johns's remark, "Art is either a complaint or an appeasement" (cited in Rosenthal 1988).

The few minority positions that do suggest a positive or constructive role for the arts in human life seem to me too inadequately thought through to serve as plausible functions for art in human evolution. For example, the arts today are sometimes lauded as valuable means of self-expression or self-assertion, but it should be remembered that for much of human history, individual self-expression has been of far less importance than it is in modern societies. What is more, individualism can find avenues of expression—political, economic, social—other than the arts. Similarly, when art's use is found in making manifest salient symbols and images, as in Jungian-influenced theories, one should be aware that the value resides primarily in the symbol or image: in its meaning, rather than in its vehicle. Image making, important though it may be, itself is

insufficient to explain the origin and function of a behavior of art, even though art may be used in the making of images, as in making almost anything.

"Materialist" explanations of human history and endeavor—most notably those connected with the thought of Karl Marx—begin with the recognition that the human condition is before anything else based on appropriating from nature the material conditions of life (food, drink, shelter—the means of subsistence). Hand axes, spear-throwers, digging sticks, fire, and clothing were the earliest technology, the cultural tools that enabled humans to better control the aspects of nature on which material production depended, so that they could survive. In this view, art—along with religion, science, and politics—is assigned to the "structure" or "superstructure" that is dependent on the material subsistence base or "infrastructure."

As a human ethologist, I consider myself a materialist in that I wish to trace human behavior to its deepest material or physical roots, and to establish that, like human anatomy and physiology, it is ultimately in the service of our biological adaptation and survival. Yet I find the standard materialist position with regard to art to be inadequate, for it unthinkingly accepts the modern belief that art is extraneous.

My position, lone as it might be, is that making important activities special has been basic and fundamental to human evolution and existence, and that while making special is not strictly speaking in all cases art, it is true that art is *always* an instance of making special. To understand art in the broadest sense, then, as a human behavioral proclivity, is to trace its origin to making special, and I will argue that making special was often inseparable from and intrinsically necessary to the control of the material conditions of subsistence that allowed humans to survive.

For example, it is unlikely that something as important as procuring food would have been carried out lightly: the members of the group certainly would have had strong feelings about the success of their venture. In hunting societies that we know of (and those that practice head-hunting or other forms of raiding), "behavior made special" (included in what I have earlier called *dromena* or "things done") is as much a part of preparation as readying spears or arrows. Before the hunt the hunters may fast, pray, bathe, and obey food or sex taboos; they may wear certain special adornment; they may perform special rituals concerning their tools and weapons or mark them with special symbols in addition to sharpening them or treating them with poison. Controlling one's behavior and emotions, as I have pointed out, mimics the control necessary to achieve one's goal. Special practices such as spells or rites may also be

carried out during the hunt, and concluding rites after success such as propitiation and appeasement of the prey animal's spirit.[26]

In other words, the appropriation from nature of the means of subsistence often includes psychological or emotional along with technological components; the "nature" that requires cultural control includes human behavior and feeling as well as the physical environment. Where materialist thought is inadequate, I believe, is in not acknowledging that *means of enhancement* (i.e., the control of human behavior and emotion that I outlined above) are frequently if not always intrinsic to the control of the means of production.[27]

These means of enhancement do not necessarily have to be artistic or "aesthetic." For example, fasting, observing taboos, or sacrificing are certainly "special" or extraordinary behaviors even though they are not

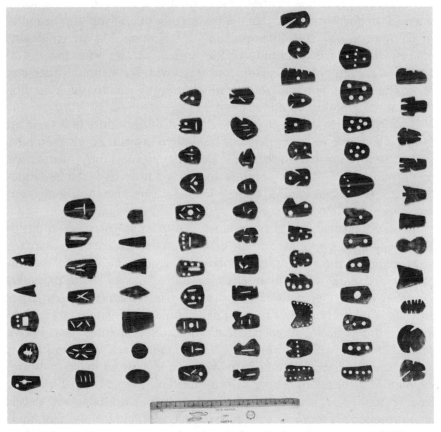

Pangolin scales, contents of sorcerer's kit, Bulu, Cameroons, 1958.
Important implements often require special marks in addition to being merely fashioned.

inherently artistic, that is, they are not themselves necessarily shaped or patterned or embellished for sensuous notice and gratification as are "arts" such as singing, dancing, adorning, or versifying. Yet as extraordinary behaviors meant to serve important ends, they tend to be the occasion for ritual and artistic elaboration: in word, gesture, and visual presentation. In the following chapter I will describe each art separately as a cultural means of making special "natural" behavior.

Do Humans Differ from Bowerbirds?

Social scientists, unlike biologists, tend to have been brought up on ideas that tacitly separate humans from other animals. Because spoken language (intrinsically based on symbols, with words arbitrarily standing for other things) is one of the most distinctive human faculties, social scientists frequently assume that the uniqueness of art must also be found in its "processing" and "manipulating" of symbols. As an ethologist, concerned with the continuity of the human species with the rest of animal life, I am not particularly concerned with the symbolic character of art: I find its presymbolic sources much more crucial to understanding its nature as a biological endowment.

But if, in the ethological view, the distinguishing feature of human art is not to be found in its symbolic or "cognitive" aspect, do we then have any grounds to say that human art is any different from the constructions or movements of "artistic" animal species such as bowerbirds, white-throated sparrows, or sandhill cranes? Let me summarize the argument so far.

I have established that early humans, like other animals, could distinguish between the ordinary and the extra-ordinary. Unlike other animals, however, their more complex mental endowments gave them the unprecedented ability to see themselves (rightly) as special creatures, different from the rest of nature. In uncertain circumstances where other animals would rely on instinct, humans could deliberately fabricate or imagine things to do, *dromena*, that would affect nature, what I have called "imposing culture on nature," and thereby seek to control it.

Humans discovered how to employ fire and how to make tools and weapons as a means of coping with a threatening world, but they must have responded to danger and ambiguity—as they do today—by developing emotionally soothing and satisfying acts of shaping and elaborating, which I have shown to be inherent in human perception and behavior.

So far this human "aesthetic" response to anxiety does not seem to be very different in kind, only in degree, from bowerbirds and sandhill

cranes whose "aesthetic" decorated bowers or impassioned dances are responses to the commands of courtship. Yet human art is unlike the aesthetic creations of any other animal, although this uniqueness does not (or does not only) reside in its being symbolic. Human making special, like that of bowerbirds and cranes, is undeniably based on inherited tendencies to shape and elaborate. But humans, unlike other animals, could exert more considered control and deliberation over their shaping and elaborating activities. Then, experiencing the emotionally satisfying result of their control, they could go on to shape and embellish these or other objects and activities in a prodigious variety of ways and in new and different circumstances. It is as if humans decided "This must be good because it feels so good," and were more right than they could know. Because when assembled in ritual ceremonies, or when given ritual significance, the arts *were* good: they helped unite people in communal belief and action.

In other words, along with gaining better control of the means of subsistence by the use of material technology, humans took an additional remarkable and unprecedented evolutionary step. They gilded the lily, making sure that their technology "worked" by deliberately reinforcing it with emotionally satisfying special elaborations and shaping. Thus, in the history of the human species, it is not only the development of language or the invention of technological "means of production" that has made us anomalous or unique. Our invention and application of what might be called the "means of enhancement" or "means of refinement"—for an infinity of possible objects and occasions—is equally impressive and equally deeply engrained in human nature.

Is Making Special a Universal Human Behavior?

To establish that a behavior is an evolved species characteristic, that behavior must be shown to have had plausible selective value. For example, one can see how recognized universal human behaviors such as attachment, aggression, hierarchy formation, and incest avoidance in their different ways could have helped individuals and groups who practiced them to survive better than individuals and groups who did not.

In the case of art, as I mentioned earlier, evolutionary explanations have foundered because theorists have understood art only within a narrow, modern, Western paradigm of art as something rare and elite. Selective value cannot be presumed if something, such as art, is performed by a few for its own sake.

My view, presented in the preceding pages, that art is a behavioral

predisposition called forth in certain circumstances—for example, making important objects and activities special in circumstances of high emotional and survival investment—seems to provide an ethologically acceptable way for understanding art as a normal part of the evolved behavioral repertoire of the human species. The arts were "enabling mechanisms" for the performance of selectively valuable behaviors and in that way were necessary, that is, selected-for in their own right.

Making special as the "core" of a universal behavior of art thus has plausibility, comprehensiveness, and explanatory power. Once pointed out, it seems an obvious species characteristic, like language, tool use, attachment, and the like. Yet no one else seems to have identified it as a universal behavioral proclivity. Certainly the score of evolutionary-minded theorists discussed in Chapter 1, whose inventories of universal human characteristics omit art altogether or treat it as a by-product of other activities, do not mention "making special." There are, as I have shown, cultural reasons for a limiting view of art, but a human proclivity to cognize an extra-ordinary realm or order different from the everyday and deliberately and positively to fashion "specialnesses" seems impossible to overlook.

Evidence of making special appears as early as 300 thousand years ago, ten times earlier than the cave paintings in France and Spain that (being visual and of grand scale and astonishing quality) are usually considered to mark the beginnings of "art." In a number of sites from that long ago, and consistently thereafter, pieces of red ochre or hematite have been found associated with human dwellings, often far from the areas in which they naturally occur. It is thought that these minerals were brought to dwelling sites to be used for coloring and marking bodies and utensils, just as people continue to do today. The use of ochre and hematite is usually identified as suggesting some approximation of "symbolic" behavior, although Klein (1989, 310) has pointed out that the earliest Mousterian (Neanderthal) uses of red or black color, not having been reduced or oxidized by burning or found in association with graves, may have been used only for the utilitarian purpose of tanning hides.[28] In any event, at least by 100,000 B.P. (Before Present), shaped ochre pencils were being used at Middle Paleolithic occupation sites (Deacon 1989), implying drawing or marking, and by the Upper Paleolithic period the use of ochres and other pigments increased dramatically.

Archaeologists and anthropologists describe other behavior in humans from the Middle Paleolithic (ca. 120,000 to 35,000 B.P.) that can better be described as recognizing specialness or making special than it can be described as anything else. Wandering Mousterian hominids, for exam-

ple, apparently spotted, picked up, and took with them "curios," such as unusual fossils or rocks, concretions or pyrites (Harrold 1989). Later, in the early Aurignacian (35,000 B.P.), exotic materials like shells and special serpentinite were transported to human occupation sites from over a hundred kilometers distance and made into beads for clothing (White 1989a, 1989b).

To me, these activities show more than "curiosity" or "foresight," the mental qualities they are usually said to indicate. To me, they suggest first an appreciation and second a deliberate creation of "specialness" for ends that are not known but must have included sensual pleasure and delight that was excited prior to and apart from their application to utilitarian or symbolic ends like personal and group identification or status differentiation. Indeed, I would venture to say that the faculty of appreciating specialness eventually led to the employment of special things for important utilitarian and symbolic purposes, not the reverse.

Many human evolutionists also speak of "innovation" or "creativity," but I find these terms less adequate than "making special" to explain the existence of the arts and the reason why they evolved. For example, Lopreato (1984) treats such traits as the human desire for new experience, the "instinct for workmanship," and the "creative impetus" as "sublimations of the hunting psychosis." He suggests that these attributes, along with curiosity and the exploratory drive, necessitated combining or associating one thing with another: hence the development of invention, ingenuity, creativity, imagination, experimentation, and curiosity. I suspect that making special could be included, or presupposed, in Lopreato's list.

Yet although he might posit its origin in "the hunting psychosis" (presumably the behavioral complex that accompanies the quest for subsistence), and although he mentions the human penchant for reciting certain words and performing certain acts, his theoretical position, since it lacks a specific notion of making special as a positive behavioral proclivity, does not explain as adequately as mine does why these words and acts should be combined and associated in a *special* sensorily and emotionally gratifying patterned and embellished way rather than just saying or doing them straightforwardly, or idly playing around with them.

Innovation and creativity are usually identified with the ability to solve problems, whereas making special, apart from perceiving or solving problems, takes ordinary things and makes them more than ordinary, heightens their emotional effect, or—to say the same thing—uses sensual/ emotional ways of drawing attention to them, thereby emphasizing their

importance and significance or making them alternatively or additionally real. I see this process as another level of dealing with "reality" above the pragmatic. It seems universally human, and yet it is uniformly overlooked.[29]

Even when "religion" and "ceremony" are mentioned as characteristic of prehistoric humans, theorists seem to have concern for these practices (along with "art") because they indicate a degree of cultural aptitude, not because they provide occasions for demonstrating an underlying biological predisposition to make and appreciate the extra-ordinary or special. Thus such practices as burying the dead, using red ochre, wearing ornaments, and other "cultural activities" are seen not as examples of making special but of the ability to symbolize. Marvin Harris (1989) suggests that natural accidents could explain the famous Shanidar flower-strewn burial of the Neanderthals, who are thought probably to have lacked complex language and therefore to have possessed only rudimentary symbolizing ability (see also Lieberman 1984). This theory rightly or wrongly dismisses the Neanderthals as symbolizers. But what are we to make of their faculty for recognizing and making special, as in curio collecting, incising stones, attaching exotic shells to their clothing, and using faceted ochre crayons?[30]

E. O. Wilson (1978) refers to a "mythopoeic" drive, and calls humans "the poetic species" (1984), alluding to the human search for understanding, explanation, innovation, original discovery, and exploration of the unknown reaches of the mind by means of myths and images. He acknowledges the content but seems to leave out the tendency to shape and elaborate that content by making it special. Mary Maxwell (1984) also discusses poetry as a way of disclosing a kind of transcendent reality (the extra-ordinary?), and is obviously taken with the mind's metaphoric capabilities. Yet she hardly scratches the surface of these proclivities, as Maxwell admits in her otherwise comprehensive and thoughtful book.

Eibl-Eibesfeldt (1989a, 665) defines *aesthetics* as "the science of those perceptive and cognitive processes that stimulate us in such a way as to bind interest and attention—i.e., to fascinate." But surely we are also fascinated by perceiving and cognizing a fast-breaking news event on television, a neighborhood fire, the aftermath of a traffic accident, or tigers mating at the zoo. Eibl-Eibesfeldt (1989b, 29) also states that art exploits our perceptual and cognitive biases "to convey messages by means of social releasers and cultural symbols encoded in aesthetically appealing ways," particularly messages that support cultural values and ethics. I will grant that artists exploit our perceptual and cognitive bi-

ases (see Chapter 6). However, they do this not only by simply *using* them but by making them special, in extra-ordinary contexts or to an extra-ordinary degree. While Eibl-Eibesfeldt's studies present much fascinating information about protoartistic and artlike elements and activities, his definition and subsequent treatment of human aesthetic behavior does not address the shaping or elaborating that I have called making special, or provide a satisfactory general theory of what makes art different from nonart.

While art was left out of the inventories of universal human behavior because of restricted elitist assumptions that considered it to be nonutilitarian, at least some evolutionists tried to include it, as I noted in Chapter 1, if only tangentially, or in deference to its high repute. But in the case of making special, perhaps a culture-bound obsession with the pragmatic (and consequent lack of regard for the "special" that is deemed cost-ineffective and hence impractical) has made it difficult even to be aware of it, much less to detect in it a plausible source for the arts.

Although he did not treat the arts in his earlier books, Richard D. Alexander, one of the foremost advocates of human sociobiology, has recently (1989) produced an ambitious, admirably clear, and comprehensive hypothesis that describes the evolution of the human psyche, that is, "the entire collection of activities and tendencies that make up human mentality" (455). Central to Alexander's hypothesis is the trait of *scenario-building*, "the construction of alternative scenarios as plans, proposals, or contingencies. . . . [as] *social-intellectual* practice for social interactions and competitions" (459). He regards "[e]very trait and tendency that represents or typifies the human psyche—every mental, emotional, cognitive, communicative, or manipulative capability of humans—. . . . as a part of, derived from, or influenced by the elaboration of social-intellectual-physical scenario-building, and of the use of such scenarios —to anticipate and manipulate cause-effect relations in social cooperation and competition" (480).

With the concept of scenario-building, Alexander claims to have shed light on a collection of human enterprises that had seemed "virtually impossible to connect to evolution" (459): humor, art, music, myth, religion, drama, literature, and theater.[31] These can be regarded as involved in "surrogate scenario-building, a form of division of labor. . . . that may be unique to humans" (459). Surrogate scenarios are more condensed (hence less time-consuming), more elaborate (hence more effective), and more risk-free than one's own efforts (481), so that people reward others (artists and the like) for building them.

I will grant that Alexander's notions of scenario-building and surrogate scenario-building seem valid, as far as they go. But I do not think they adequately include what I have called making special. What about piercing nasal septums, stretching lips, and otherwise sculpting the body? What about collecting beautiful pieces of natural glass or fossils, or putting flowers in one's hair? Making one's tool from rare and less easily worked material? Singing and moving to music? What social-intellectual practice do these give? What scenarios do they build?

Like Wilson's mythopoetic drive, Alexander's scenario-building refers to the content of the plans, proposals, and so forth. It does not address or even seem to recognize that humans are frequently equally or more concerned with the *way* in which the plans or scenarios are presented, and also may not even be concerned with "scenarios" at all. I do not see that Alexander's scheme explains why scenarios should be packaged artfully rather than just presented (even if "condensed" or "elaborated," procedures which in themselves need not have very much emotional and sensory appeal—think of notes in shorthand or automatically turning a prayer wheel).

Perhaps I am not allowing the concept of scenario-building enough elasticity to include making special—I suppose the word *building* might be stretched to encompass making special or aesthetic shaping and elaborating. But it is difficult to be certain that Alexander has recognized their importance.

Alexander might ask from where, in his scheme, I would derive making special. I would reply that the tendency to recognize and fabricate an extra-ordinary "other" world is already inherent in play, as I described in Chapter 3, which is where he himself would probably also place it. But why does he not mention it, along with "subconsciousness, self-awareness, conscience, foresight, intent, will, planning, purpose, scenario-building, memory, thought, reflection, imagination, ability to deceive and self-deceive, and representational ability" (455), the long list of tendencies he ascribes to consciousness? It is not satisfactorily reducible to any of these qualities, and it is also conscious. While thought, reflection, and imagination might be taken to include the ability to recognize or produce specialness, I think the ability deserves specific mention in its own right. In circumstances of uncertainty and anxiety, the tendency to make special, as I have suggested, can become "ritualized": important things are elaborated and patterned, not playfully for their own sake, but in order to influence or control the "other."

Until it can be shown that making special is not found universally in human behavior, or that it can be reduced to or amalgamated with other

traits, I can only say that future inventories of inherent human species characteristics or "secondary epigenetic rules" (Lumsden and Wilson 1981) will be incomplete if they do not include making special (at least along with scenario-building or mythopoesis), thereby acknowledging that the arts have been integral in human evolution.

❧ 5 ❦

The Arts as Means of Enhancement

> Song and dance are central to nearly all the rituals celebrating rain, birth, the second birth, circumcision, marriage, funerals or to all ordinary ceremonies. Even daily speech among peasants is interspersed with song. . . . What's important is that song and dance are not just decorations; they are an integral part of that conversation, that drinking session, that ritual, that ceremony.
>
> —NGUGI WA THIONG'O (1986, 45)

The notion of "adornment," in English, says Michael O'Hanlon (1989, 10), suggests the superficial, the nonessential, even the frivolous. We generally think of adornment or enhancement as an artificially added layer, something that conceals what "really" lies beneath. But for the Wahgi, a people of Papua New Guinea's Western Highlands (whose adornment includes plaited cane armbands, headbands made of rows of beads or green beetle carapaces, dried-grass or cordyline-leaf rear coverings stuck into bark belts, immense barkcloth wigs decorated with burrs, human hair, and golden tree gum, large bailer-shell forehead ornaments and smaller shell and tooth necklaces, a marsupial pelt breastbone strip, facepaint of red, yellow, and sparkling metallic earth, and soaring and brilliant headdresses made from the plumes, feathers, and bodies of about a dozen kinds of birds, among them parrots, lorikeets, egrets, cassowaries, and birds of paradise), the decorated appearance is more often thought to reveal than to conceal. The Wahgi, reports O'Hanlon, do not consider adornment and display to be frivolous; instead, they believe adornment and display to be deeply implicated in politics and religion, marriage and morality. Thus, the Wahgi believe that an adorned person is more important and "real" than an unadorned "natural" person, a belief totally at variance with contemporary Western ideas, where "dressing up" is considered by many to be a waste of time or money.

The Wahgi are excellent examples of some of the ideas I have been developing in the foregoing chapters. They specifically distinguish between an everyday and a special realm: *tangalying* (lit., "morning")

signifies the workaday daily round, and *yu pam* (lit., "there is talk") signifies special occasions when people gather. As with us, the Wahgi wear casual dress (now primarily Western attire such as T-shirts and old shorts for males, skirts and blouses for females) for everyday activities, and pay more attention to their dress and appearance when going to market, to church, or to visit relatives and friends (when they might wear newer, smarter Western clothes, with perhaps token traditional decor—such as a bark belt, front apron, a spot of facepaint, or inexpensive plumes in the hair). But for their most important social activities, the traditional festive and martial ceremonial displays where individuals present themselves to substantial numbers of spectators as members of a group, a maximum degree of lavish adornment is appropriate. Such occasions now include the extended ritual Pig Festival, and food exchanges and payments that honor reciprocal family or communal obligations, and used to include war-making (now no longer practiced, but earlier waged over the means of subsistence: women and pigs) and peace-making ceremonies.

According to O'Hanlon (1989, 87) *yu pam* or special occasions require "more." In addition to more lavish display of wealth, special occasions

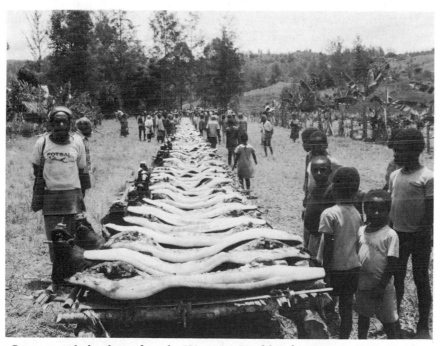

Ceremonial display of pork. Western Highlands, Papua New Guinea
The Wahgi value gloss and richness as indicators of prosperity, and mount their often prodigious displays of pork with the fat side outermost.

require more of everything that is customary for informal individual decoration: more pork fat, paint, or charcoal to decorate the skin, bulkier aprons, more massive cordylines, more plumes for headdresses, in particular the wearing of the long, black stephanie and sicklebill plumes. These occasions demand a greater expenditure of time and attention on the process of decorating which will usually take one to two hours.

The most important preoccupations of Wahgi men are group strength and solidarity. Therefore, it should not be surprising that it is for display as a group that their visual appearance and behavior are made special and the individual makes himself special so as to participate appropriately in the social order.

The Wahgi use naturally occurring materials to adorn their natural bodies. But the materials used and the body adorned both become special, "cultural," befitting the special occasion and special effect that is desired. The results are assessed for their success in manifesting social relationships.

In society after society we find practices that indicate the esteem given to the opposite of spontaneous and "natural" behavior or appearance. Aristocracies all over the world distinguish themselves by public signs of self-control, complex systems of etiquette, and other unnatural elaborations of behavior and speech. The Javanese, for example, classify behavior and people as *alus* (refined, controlled) or *kasar* (crude, vulgar, natural), a distinction that democratic Americans have effectively telescoped so that the vulgar may be stylized but the refined is suspect, even ridiculous—something dismissed as "affected."[1]

Even in traditional societies without strict social hierarchies or classes, the distinction between human control and natural disorder is nevertheless made. The African Basongye distinguish between "music," which consists of sounds that are human, organized, and patterned, and "noise," which is nonhuman sound (Merriam 1964). The Dinka notion of *dheeng* indicates a person's honor, dignity, and inner pride as well as his or her outward bearing: it esteems traits such as beauty, nobility, elegance, grace, gentleness, generosity, and kindness, which are considered to be civilized and aesthetic: cultivated, not natural (Deng 1973).

To the Temne, the Igbo, and many other West African groups, beauty is inseparable from refinement so that it is said that a homely but well-groomed Temne woman with refined ways would be more likely to attract male attention than a fine-featured woman who appears disheveled. In such societies, beauty, like morality, comes by acquisition, and is achieved by manipulating nature: it is not a natural endowment. The Igbo in fact use a term, *ndu oma*, "the good life," to refer to the ideals of

good health, strength, abundance, wealth, children, communal feasting, and enjoyment, all of which are sustained by adherence to custom (Willis 1989): obviously, these also contribute to individuals' survival.

Among traditional Igbo people, adolescent girls observe a period of ritual seclusion (*mgbede*) during which they are prepared to become wives and mothers. In addition to being taught traditions and customary law, they are fed choice high-calorie foods and their bodies are painted with intricate patterns (*uli*) by elder women. These emphasize the girls' well-being and health as well as their beauty and sexual attractiveness. Patterns are chosen that emphasize the body's plumpness and that draw attention to a girl's best features. They also are used to minimize her faults—for instance, if a girl's neck does not show the much-desired rings of flesh, patterns that hide the defect may be drawn in that area (Willis 1989).

Beautification, such as the use of cosmetics or hair styling, can be regarded as a means to instill culture, to cultivate, to civilize. Some Temne hairstyles require several days to fashion and complete; such plaiting of the hair suggests the order of civilization just as the cultivation of the land in fine rows indicates the refinement of the natural earth (use of the term "cornrows" to designate such hairstyles nicely embraces these notions) (Lamp 1985).

Many African societies inculcate civilized behavior in their members by employing complex systems of tutelage that may continue throughout a lifetime, in which values and standards of behavior are passed on along with practical knowledge and skills. Individuals are progressively formed and transformed, first from raw material to having an identity and subsequently to higher and higher stages of perfection. These stages are often represented externally by alterations to the body such as circumcision, tattooing, and scarifying, all of which serve as emblems and proofs of refinement. For the Senufo, civilized behavior implies self-control and is opposed to "bush" or uncivilized behavior (mindless force, erratic violence, and lack of control); "self-control" is also an aesthetic ideal that the Senufo embody and express in their sculpture (Glaze 1981).

In our own English language traces are preserved as etymologic fossils of the association between enhancement and embellishment as ways of civilizing or ordering nature. Our word *cosmetic* comes from the Greek *kosmos*, which meant order, adornment, arrangement—conceptually much closer to the Wahgi or African view of adornment than our present notion. Additionally, our words *decorum* and *decorate* come from the same Latin root. "Decorum" means that which is seemly, becoming, fitting, proper, and suitable, all words that suggest moral behavior, civil-

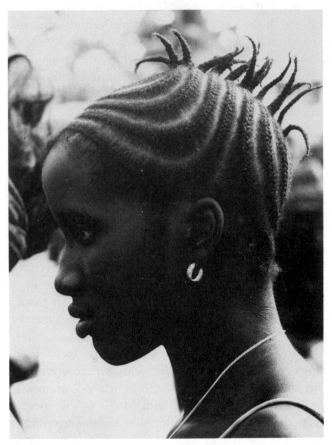

Girl with plaited hair, Dakar, Senegal, 1966
Plaiting of the hair suggests the order of civilization just as
the cultivation of the land (in fine rows) refers to the re-
finement of the earth.

ity, and refinement. "Decorate" means to adorn and beautify, thus to add
cultural form and embellishment.

Modern psychoanalytic theory and terminology recognize the distinc-
tion between culture and nature, although in typical twentieth-century
fashion we think of control as bad and repressive, and uncontrolled
spontaneity as healthy and good. In *Civilization and Its Discontents*
(1939), Sigmund Freud observed that civilization inevitably imposes re-
straints such as conscience, rules, laws, and custom, what he called "the
secondary process," on the natural instinctive drives, what he called "the

primary process." The primary process is characterized as being unconscious, untidy, ambiguous, and excessive; it is timeless, as in our dreams, not heeding the realities and rationalities of past, present, and future, or the realms of possibility; it is the world of the infant or the animal—that is, of nature. The secondary process is conscious, neat, bold in contrasts, patterned, amenable to communicable analysis and rationality; it is the world of the civilized adult. Hence, using Freudian vocabulary, what I described in the previous chapter as the inherent "aesthetics of control"— geometric shape, rhythm, pattern—can be viewed as impositions of the secondary process or cultural artificiality on nature: ways of making nature comprehensible by making it special (unnatural).

In the pages that follow I will show how each of the arts in turn can be understood as cultural control (shaping and elaborating) of natural material that in its raw state is unfinished and unseemly. In the beginning, I propose, the core behavioral tendency of making special exemplified itself in each of the arts as various means of enhancement to accompany and reinforce the material control of the means of subsistence, that is, the things that individuals and societies most cared about. Art is as sure and fundamental a way of civilizing and controlling nature as the development of technologies like toolmaking or institutions like agriculture. In this regard, as J. Z. Young's comment at the beginning of the book suggests, enhancement or art has been at least as important in a literal, practical sense as they.

Controlling the Natural

Visual Display

Human social existence is based on sharing and reciprocity, giving and receiving. Giving is closely associated with status: those who give the most thereby show that they have the most to give, while those who give little indicate either inability to give or social inadequacy and obtuseness. Hence generosity, while it may deplete one's material resources, serves at the same time to expand one's social distinction by displaying the wealth at one's command. Paradoxically, self-deprivation results in self-glorification.

Malinowski (1922) commented on the fundamental human impulse to display, share, bestow, and exchange gifts, suggesting that these activities were all parts of one social-behavioral complex, which indeed they are. And when gifts are given, offerings made, wealth displayed, they are made special, arranged to show their sumptuousness and beauty.

Gifts may be mere tokens, but as often as not, particularly in primitive societies, the giver gives the best: the choicest fruits, the finest textiles, the fattest or most valuable animal. One takes pains not only with the gift itself, but also with the manner of its presentation: often the bestowal is ritualized by means of an exchange of compliments, the donor's praise of the recipient's unusual individual (or titular) qualities, the recipient's acknowledgment of the donor's generosity, taste, and so forth. Even if the gift is merely a token, it is seldom given in a token manner: ceremony helps to make the giving and receiving a special occasion.

Visual display has surely been one of the primary arenas for development of the arts, not only in gift-giving but also in self-presentation where one's own appearance is a kind of "gift." Like all gifts, self-display elevates the prestige and attests to the refinement of the giver even while it pleases and compliments the receiver. Again, pains are taken to be more splendid or beautiful than one's natural unadorned form. Body decoration may advertise status (e.g., noble/common; rich/poor; married/unmarried; male/female; marriageable/unmarriageable). Often it is used to exhibit one's potency, beauty, or desirability. Costume allows a temporary opportunity to change identity, to acquire exceptional powers, to escape ordinary tedium, in other words, to participate in an order different from the ordinary and everyday.

"Adornment inspires desire," said the Dogon elder, Ogotemmeli, in his explanation to the French traveler, Marcel Griaule, of the ways of his tribe (Griaule 1965). With an aesthetic reminiscent of the Temne and Igbo, the Dogon say that when undressed and unadorned a woman is not desirable even if she has natural good looks. But even an ordinary woman can become desirable through dress and ornament. To be naked is to be speechless, said Ogotemmeli, thereby suggesting that the ability to change one's "natural" appearance is just as important as the ability to use language.

West African societies in general place a high value on cloth, which is a means of adorning the body and is itself a cultural product, for it is transformed by human agency from plant fiber to fabric and perhaps transformed again by the use of dyeing agents and decoration. The Dogon word for woven material, again echoing their notion of the close relationship between human speech and human dress, is "the spoken word," and it is said that the shuttle across the warp, while weaving on the loom, is like the breath passing between teeth (Joseph 1978).[2]

Dyeing is a ritual act of transformation that may require special preparations, such as abstention from sexual activity, before starting a new dye pot. Dyeing is generally performed only by a single sex—usually, but not

always, women.[3] In the Dan, where women are the dyers, men are not allowed near the dye vats (Joseph 1978).

Even though young people of the Kau tribe of the Sudanese Nuba might seem naked (they wear no clothing) to a Western observer, they do not consider themselves so because they rub a mixture of colored pigment and oil into their skin every day. Unoiled, or without a belt and jewelry, no self-respecting Kau over the age of four would appear in public: in this state they would feel naked and ashamed. But only the young and healthy, those who are slender and firm, go about proudly without clothes. After a female becomes pregnant or a male stops engaging in the ritualized contests of strength that characterize early manhood, they put on loincloths and never go unclothed again.

Decoration of the body has been practiced from earliest times. Quite possibly the first art, it can be regarded as the prototype for the visual arts in which naturally-occurring substances like clay or stone or wood (or, in some societies, yams, manioc cakes, and pieces of pork) are refashioned, embellished, and thereby "humanized"—made finished or complete.

In body decoration, the raw material is human flesh: the natural body serves as the canvas for the imposition of cultural designs, or human clay to be refashioned to cultural purpose. In tattooing and scarification, impressive, patterned, usually symmetrical cultural designs are applied to naked, natural human skin. Mutilations, such as piercing of the ears, lips, or nasal septum to receive decorations, circumcision, tooth filing, and head or foot binding, are other ways of taming or domesticating or "sculpting" natural human flesh and bone.[4]

Such practices, which may seem barbaric and ugly to Western eyes, become more comprehensible when viewed as "means of enhancement," imposing human shaping and elaboration to bodies that otherwise would be plain and unfinished. Plaiting or barbering the hair, as in the Temne and countless other societies, is another example of the same impulse: the hair is civilized, its natural unruliness is controlled, it is made unlike animal fur. In other instances, "nature" (in the form of plumes, leaves, fur, grasses) is used, as described earlier in reference to the Wahgi, to decorate the hair and body, often with the intent of appropriating some of its beauty and power.

In the *ida* ritual of the Umeda of Papua New Guinea (Gell 1975), the participant's bodies are painted with special colors and combinations of colors in prescribed proportions and prescribed designs. Such painting of the body with beautiful designs or its oiling or coloring are ways of refining its own incomplete nature. The Brazilian Yanomamo shaman,

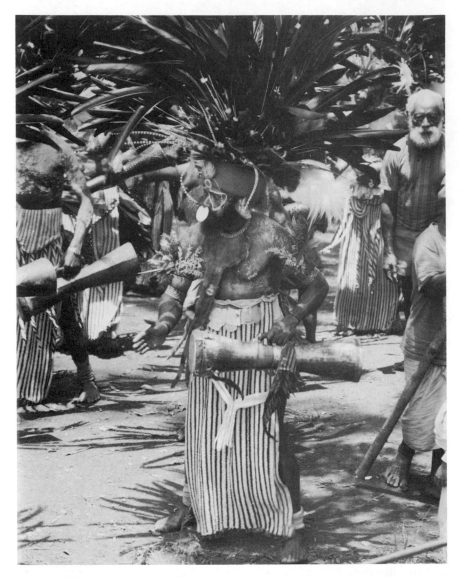

Wahgi dancer in full festive display, Western Highlands, Papua New Guinea

The dancer's attire includes plumes from four different kinds of birds of paradise, among them King of Saxony bird of paradise plumes looped through the nose and curved around to meet a MacGregor bowerbird crest attached to a marsupial fur headband, a crown circlet of red parrot feathers, shells hung from the waist and a *Conus* shell disc supported by the nose, a marsupial fur breast covering, narrow plaited cane armbands, and a front apron of white and blue nylon wool respun with marsupial fur.

knowing that the spirits he wishes to reach love and require beauty, decorates his chest and stomach with pigment and dons his best feathers before summoning them (Chagnon 1983). Scores of groups in Africa, Oceania, and North America construct and wear masks and costumes that allow them to acquire a new identity or to appropriate or propitiate the powers of supernatural beings.

Polychrome painting dominates the art of the Iatmul of the Sepik River in Papua New Guinea (Forge 1973), and the act of painting—whether of people, carvings, or ceremonial house facades—is considered to be sacred. Yet the paint substance itself, outside ritual conditions, is mundane and ordinary. It becomes "special" only when used ceremonially. Then it makes initiates and ritual objects complete and sacred.

In order to ensure the regular occurrence of the wet season, aborigines of northwestern Australia would periodically touch up their rock paintings of ancestral beings—what are today termed Wandjina images—with new paint. Not only did humans first impose these images on the natural cave walls, but once they "naturally" resided there, humans renewed them as needed. Contrary to modern Western aesthetic preference for muted and worn surfaces that look old and more authentic, fresh new colors are considered more civilized and efficacious in most societies. *Uli* painters, for example, like the majority of traditional artists, value contrast and brightness, clarity and precision, (Willis 1989, 65). Such attributes are associated with health, vitality, youth, regeneration, respect, and moral goodness.

It seems clear that beautiful cultural attire, like the gorgeous natural crests, plumes, manes, patterns, and colors of other creatures, has been used primarily in the service of sexual advertisement, and as such can easily be seen to have had selective value in human evolution. Dancers show their vigor, virtuosity, and comeliness, hence sexual desirability, not only by their tireless and attractive movements but also by the use of eye-catching and astonishing ornaments and clothing—whether with fresh bright colors and strong contrasting patterns that connote vitality, or with rich shining oils or alluring designs that emphasize radiant health. One is attracted to a potential mate who is the visible opposite of weak, sickly, and unable to bear, sire, or provide for a child.

Insofar as body ornamentation displays and manifests supernatural power, appropriated from nature or the spirit world, it also enhances an individual's social position and hence reproductive potential. Ornaments generally have ceremonial or magical purpose, as Radcliffe-Brown (1922/ 1948) noted in the Andaman Islands seventy years ago; in this sense they are *dromena*, not only giving one something to do but displaying to

others that one is doing something and is not just a passive receptacle for malign forces, hence an undesirable fellow or mate.

What seems to set humans apart from other animals in the evolutionary results of their often fantastic garb is that humans invest the fact that their appearance is attractive with supraindividual meaning. Looking handsome, proud, vigorous, and healthy is a way not only of winning mates, prestige, admiration, and hence individual reproductive success, but equally of indicating that one upholds and respects the moral values and ideals of one's social group. Concern for dress goes along with concern for one's bearing and manner, and these reflect the self-control and civility that humans from the earliest times seem to have deliberately imposed upon their "natural" or animal inclinations and regarded as essential to harmonious social life. This social consensus in turn has contributed to the survival of the individuals who affirm it.

Shaping and Embellishing Surroundings

Melpa men of the Mount Hagen area of highland Papua New Guinea say that for their *moka* celebrations—elaborate ceremonial exchanges of shell valuables and pigs—they follow the example of the bowerbird, which first clears a space in order to dance and thus attracts sexual powers to itself (Strathern and Strathern 1971, 176). In laying out their ceremonial areas, villages, and cities, as in decorating and "civilizing" their bodies, humans everywhere have imposed culture on nature, giving some kind of spatial regularity to natural irregularity, marking off human habitation from what is "bush" or "boondocks." Generally the spatial regularity is geometric—circles, for example, or the long straight "ley" lines shown by aerial views of Nazca in Peru.

In many parts of the world impressive or evocative places such as the tops of mountains or caves are considered to be the dwelling places of powerful spirits. Humans often build temples, shrines, and monuments in such places. Impressive stone structures are a feature of prehistoric sites in many parts of the world, such as the megalithic menhirs or the three thousand parallel stones arranged at Carnac in Brittany. Even as early as 50,000 to 60,000 years ago, inside a cave at Monte Circeo, Italy, *Homo sapiens neanderthalensis* laid out a small ring of stones around a skull; Hayden and Bonifay (1991, 14 ff.) give examples from earlier Mousterian sites of clusters of large stone blocks and walls intentionally arranged by their Neanderthal occupants.

Contemporary Eskimos "humanize" their featureless landscape of snow and ice by constructing cairns "for company" (Briggs 1970). A poet,

as we have seen, imagines a jar on a hill in Tennessee. Wherever people live, anywhere in the world, one sees the shaping and embellishing of dwellings and their surroundings—from marigolds and plastic flamingoes to topiary, from painted shutters to fretted eave edges.

For the Australian aborigine, the whole physical world is already "special" because their concept of the creation of the world, "the Dreaming," infuses significance into every corner of the landscape.[5] Even so, aborigines have traditionally modified and shaped their surroundings for ritual purposes by such activities as excavating pits, raising mounds, laying out paths, circles, and rectangles, putting down lines of stones, erecting poles, building structures of boughs, lighting fires, cutting, painting, or molding figures on trees or on the ground, and making temporary or permanent monuments (Maddock 1973).

Enhancement of space is achieved additionally when, within humanly shaped or elaborated space, the normal everyday arrangement of people in that space is itself altered for ceremonial purpose. Women and men may be spatially separated; performers or initiates may occupy a stage or arena apart from onlookers; some people may be excluded from the proceedings altogether. Dances usually require that individuals form rows, circles, or other regular configurations in space.

Poetic Language

T. G. H. Strehlow, a German born to missionaries in Central Australia, grew up speaking the language of the Aranda and was intimately acquainted with their ways. In his monumental study of Aranda poetry, *Songs of Central Australia* (1971), in which he makes comparisons with English poetry from Shakespeare to the romantics, Strehlow describes verse rhythm as "a mould, in which the untidy scrap material of everyday speech is melted and reshaped" (19). Literary language everywhere, whether spoken or written, differs from ordinary language not only in being more formed and patterned, but by using special elaborating devices to increase beauty, memorableness, and effectiveness.

Malinowski (1935, 213–22) remarked that in the Trobriand Islands most magic was chanted in a singsong voice, which made it from the outset "profoundly different from ordinary utterance." He also made the oft-cited observation that "all magical verbiage shows a very considerable coefficient of weirdness, strangeness, and unusualness." Magical charms are usually more important to their speakers, for the effects they are intended to have, than to listeners. Strictly speaking, they do not require listeners. Until very recently, in some premodern groups such as the

Dobu (Fortune 1963) private incantations were important individual uses of poetic language.

Ordinary, everyday language is itself naturally rhythmic. But in instances when a speaker was feeling anxious and strongly desired to bring about an effect, he might well have been inclined to repeat certain words or groups of words for emphasis, to make sure that the important matter was not missed.[6] This kind of repetition would tend to develop into incantatory patterns that could serve as measures for other words. For example, having said "I wish I may, I wish I might," one would feel constrained to continue in iambs for four more metric feet: "have the wish I wish tonight"—not just say "be rich" or "get well." Long before anything was preserved in writing, claims Berkley Peabody (1975), a scholar of ancient oral and written poetic compositions, metrical lines were developed and various combinations of these became established as expected units of special utterance.

Mircea Eliade (1964, 508–11) suggests that one of the universal sources of poetry was shamanistic euphoria: "In preparing his trance, the shaman drums, summons his spirit helpers, speaks a 'secret language,' or the 'animal language,' imitating the cries of beasts and especially the songs of birds. He ends by obtaining a 'second state' that provides the impetus for linguistic creation and the rhythms of lyric poetry. . . . Poetry remakes and prolongs language."

Ruth Finnegan (1977), another student of oral poetry—which, of course, has been the primary mode of poetic language throughout human history—strikingly describes it as an "italicized" type of utterance. She would certainly agree that written poetry is italicized too. Any poem, oral or written, is set apart from ordinary speech in many ways: the mood and manner of its delivery (which is usually more serious or portentous); the context and setting of its performance (in a public place before an audience or in a quiet place apart from mundane sources of interruption); the behavior of its audience (receptive, respectful, prepared to be moved); and certain stylistic and prosodic features.

Zulu *izobongo* (praise poems) are recited at the top of the voice and as fast as possible. This alteration of the ordinary manner of speaking, eliminating the normal downdrift intonation, creates emotional excitement in the audience and in the praiser himself, whose voice continues to rise in volume, speed, and even pitch, and whose movements become increasingly exaggerated (Rycroft 1960; Stuart 1968, 25–30).

Of the special features that distinguish poetic from ordinary language, repetition is the most common, occurring in multitudinous variety (Finnegan 1977). It may appear as repetition of syllables, verses, or whole

passages; repetition of key words, phrases, and even ideas by means of synonyms; reduplication of syllables to fill a meter; repeated formalized refrains; the use of antiphony (in which followers repeat or respond to the words of leaders); and parallelism in consecutive stanzas. These devices, of course, give vividness and assist the memory of the poet, an essential in oral poetry. Such common poetic devices as alliteration (repetition of initial consonants), assonance (repetition of sounds), and rhyme (full end assonance) are themselves instances of repetition.

Poetic language also makes use of original expression, using striking metaphors, as in the "cattle names" traditionally given to each other by young men of the Dinka, a pastoral people of East Africa. Cattle for the Dinka, as for other herding people, provide an inexhaustible topic of conversation and a wealth of references for describing and understanding the world. The "aesthetic" pleasure provided by a man's herd is considerable, often as important as their material value, so that an especially beautifully colored or strikingly marked bull will be castrated and kept solely for display. Young male age-mates give names to one another derived from these display oxen. For example, a man who owns a black display ox may be called such names as "spoils the meeting," "seeks for snails," or "thicket of the buffalo," which refer respectively to black or dark things such as rainclouds, a particular kind of ibis, or the forest (Lienhardt 1961). The Maroon, descendants of escaped slaves in Suriname, appreciate innovative use of language, especially newly-invented phrases, indirectness, and ellipsis (Price and Price 1980, 167). One might call a watch a "back-of-the-wrist motor," or a stool "the rump's rejoicing."

Poetic language also uses heightened, archaic, or deviant forms of words ("And his dark secret love doth thy life destroy"; "An added strut in chanticleer"; or the so-called bird sound words of the Kaluli people of Papua New Guinea). Eskimo poets (like the metaphysical poets of seventeenth-century England) deliberately obfuscate language with circumlocution and allusiveness (Birket-Smith 1959; Freuchen 1961). The Kwara'ae of the Solomon Islands distinguish between "speech vinelike" (*ala'anga kwalabasa*) for everyday speaking and "speech taproot" (*ala'anga lalifu*) for important speech (marked by a grave tone, low pitch, special intonational contours, and special phrasing and vocabulary) (Watson-Gegeo and Gegeo 1986).

It may well have been the desire to use language for control of supernatural powers or of other people that furthered the more considered control or "domestication" of language by means of poetic devices. While we like to think that poetry was born out of a love for beauty, the im-

portant subject of rhetoric, which dominated classical and medieval education, was first of all the *art of persuading*. Skilled speakers learned to use a time-tested battery of effective vocal and verbal techniques, tropes, figures of speech, and even gestures. Beauty served the practical ends of rhetoric; it was not an independent value celebrated only for itself.

The earliest recorded literature are the ancient Persian Gathas and the Sanskrit Vedas, both of which are collections of religious hymns, magic formulae, prayers, curses, and incantations—all attempts to influence and control the "other." Charms and spells everywhere make use of extra-ordinary language, whether it be unusual word order or phrasing ("A pox on you"), colorful words ("Eat flaming death!"), rhyme and strong rhythm ("Star light, star bright, first star I see tonight"), alliteration ("I wish I may, I wish I might"), or assonance ("Stick a finger in your eye . . .").

In his study of the subject matter and themes of Aranda songs, Strehlow found more than half to be directly concerned with control: charms against (or to bring about) injury, sickness, and health; charms to hurt enemies; charms to avenge or to revive persons who had died by violence; songs sung during totemic increase ceremonies; and charms to control the weather. An unusual but understandable type of control is the vigorous arhythmic chanting carried on during boys' circumcision ceremonies, which is meant to serve as an anesthetic. Only Aranda commemorative songs and their songs about love, beauty, and homeland are sheerly expressive, not concerned with *dromena*.

As if all these italicizing, making-special devices were not enough, poetic language, in its oral form, is generally further set apart from ordinary language by musical intonation, form, or accompaniment.

Song and Music

In Andalusian "deep song" (*cante jondo*), as described by Federico García Lorca (cited in Rothenberg 1985, 604), the distinction between speech and song is blurred. Noting "the reiterative, almost obsessive use of one same note," which also characterizes certain formulas of incantation, Lorca was moved to wonder whether song may be older than language, a suggestion also made by Jesperson (1922), Bowra (1962), Geist (1978), and Papousek and Papousek (1981).

Certainly oral poetry is usually chanted or "sung," as is evident in Strehlow's study of Aranda poetry which he called *songs* of Central Australia. Moreover, song and music of all types frequently accompany or are accompanied by movement—as Radcliffe-Brown (1922/1948) noted

concerning the Andaman Islanders, of whom he said the purpose of their song is to accompany a dance. Separating poetry, song, and dance into individual arts, as I do in this chapter, is misleading:[7] reconstructing the phylogenetic origins of music (and language) should probably take into account the close association and frequent inseparability of tone, rhythm, and gesture.

In preliterate societies, singing is rarely, if ever, done without accompanying rhythmic movement of some kind, by the singers themselves and frequently by their audiences. Parry (1971) and Lord (1960) found that Yugoslav bards could not compose their songs without the aid of their *gusles*, a one-stringed instrument capable of playing five notes to which the poetic rhythms are fitted. Mande bards (of the Bambara in Mali) when reciting play a *nkoni*, a stringed instrument with two fingered and two drone strings; when they were asked *not* to play while they recited they had to tap their fingers or lightly clap their hands in the same basic rhythm (Bird 1976). Vedda in Ceylon accompanied their songs with a slightly rocking trunk or leisurely moving toe (Max Wertheimer 1909, in Sachs 1977, 113). Watch children sing: preschoolers between the ages of three and five do not sing without moving their hands and feet simultaneously (Suliteanu 1979). These and countless other examples suggest that in human evolution, song and bodily movement of some kind were inseparable, and that the human species, as a child eventually does, had to learn to sing without moving.[8]

The origin of music is surely in human vocalization, although whether it arose more specifically from consciously imitating birds and animals (Geist 1978), from nonverbal emotional cries (Spencer 1928), from signaling across distances (Hall-Craggs 1969), from sounds made to synchronize cooperative effort (Bücher 1909), or from another source is a matter for speculation.[9] Yet it is not difficult to agree that in the terms of my present thesis, in human song the natural sounds made by the natural voice are culturally formalized and elaborated. Just as in poetic language the ordinary grammar and vocabulary of human speech are made special, in human vocal music the naturally occurring prosodic features that provide expression and emotional coloring to everyday spoken language— the ups and downs, the pauses and stresses, the rhythm, the tone and volume of voice—are exaggerated, sustained, and modified, thereby increasing their effect and affect. Alan Lomax (1968, 13) has called song "the most highly-ordered and periodic of vocalizations." Lomax, indeed, describes song as a kind of ritual in which behavior, words (text), and vocal elements are all more strictly prescribed and regulated than in everyday social intercourse.

Other societies may regard the distinction between music and speech somewhat differently than we do. To Western ears, the Venda children's song "Tahidula taha Musingadi!" sounds like spoken verse, while another children's song, "Inwi haee Nyadmudzunga!," sounds like a melody. But to the Venda, the former is more musical than the latter because its monotone is further removed from the patterns of speech tone of the spoken words (Blacking 1973). However, for both the Venda and us, the critical distinguishing factor is the degree of removal from what is considered to be "natural."

In his wide-ranging study of non-Western music, Curt Sachs (1977, 84–88) recounts some of the ways in which humans have made their voices unnatural. Singing Orinoco women pinch their noses when masked dancers appear; the Sioux use a nasal voice for love songs; Flathead Indians sing with clenched teeth or in a ventriloquist style. In Uganda, singers tap the throat with their fingertips, ululate, yodel, and use vocal glissando. In Arnhemland, there may be a strong expiration on every note, gasps and quaffing sounds, and abdominal grunting. Maori war songs were performed "prestissimo in a lashing microtonic falsetto."

The Kaluli people of the Southern Highlands of Papua New Guinea provide an interesting variation on the main notion of this chapter. In a public lecture that I attended at New York University in the late 1980s, Steven Feld, a student of Kaluli culture and aesthetics for many years, likened the Kaluli rainforest environment—to whose many sounds they pay a great deal of attention—to "a tuning fork" that provides a continual background sound—"something like tape hiss." Feld found that the Kaluli were always aware of the relationship of the various environmental sounds to each other, and that rather than "make special," the Kaluli "make natural," in the sense that they fit in their own talking and work or other activities with these natural sounds of birds, rustling leaves, and moving or dripping water. In their production of sounds—in ordinary talking as well as in storytelling and singing—and also in their body movement and body decor, the Kaluli *densify texture*. Feld says that an accurate description might be "in sync and out of phase"—just like the overlapping, interlocking, echoing sounds of the rain forest that surround them. In other words, the music of nature becomes for the Kaluli the nature of music. They do produce stylized sounds for specific occasions, such as whooping, and, notably, weeping, which I will describe later in this chapter when discussing aesthetic experience.

In those few small traditional societies like the Kaluli, where life as lived seems—especially compared to our own—so integrated and "aesthetic," their "art" too may seem to be, as Feld says, "doing what comes

naturally," not doing what requires special elaboration and formalization. However, if one tries to imagine how non-Kaluli humans would behave spontaneously in that rain forest, it is evident that the Kaluli, as a group, have "made their behavior special" in order to fit in with the totality of the forest that is the constant to which their comportment and ideas of right living are adjusted. We whose lives are compartmentalized and often out-of-sync with our surroundings can only admire and envy a society in which the cultural and the natural, art and life, can seem so seamlessly one.

Music does seem indisputably "natural" in its powerful, preverbal, physical effects. As Bruce Kapferer (1983, 188) has said, it is heard *in* the body—as an inner experience constituted in the body. It also has the power to move us "transcendentally." Viktor Zuckerkandl (1973, 51) has remarked that music provides "the shortest, least arduous, perhaps even the most natural solvent of artificial boundaries between the self and others." Certainly musical means are widely used to unify an audience. By means of music a supra individual state is created in which singer and listener can exist together, joined in a "common consciousness," a common pattern of thought, attitude, and emotion (Booth 1981). It is not

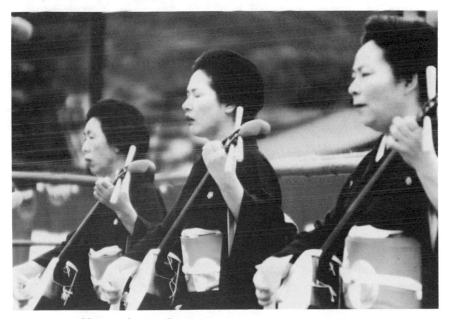

Musicians, Heian shrine, Japan
Music has the power to move us "transcendentally"; by means of music a supra-individual state is created in which singer and listener can exist, together, joined in a common consciousness.

surprising that ritual ceremonies whose purpose ultimately is to bond individuals into a sense of common purpose and oneheartedness find music to be essential to accomplishing this.

Dance

Intrinsic to one's actual "being-in-the-world" is the fact of one's material body, its rhythms and importunities, its idiosyncrasies and satisfactions, its growth and change over time, its effect on others, its vulnerability to accident, disease, and death. Of all the arts, dance—whose instrument is the body—in particular manifests and celebrates our physical, corporeal reality. Dance glorifies and dignifies sexuality as part of that celebration, and in its forms and movements is congruent with and symbolic of vital powers (Langer 1953; Sparshott 1988, 134). Yet what distinguishes dance from other human movement?

Human bodies are inherently communicative and expressive, as the antique Greek sculptors knew who made the entire body speak by gesture or pose and often left the face without much expression, even in moments of intense emotion. Rilke's sonnet "Torso of an Archaic Apollo" describes an antique Greek sculpture, a headless torso, that nevertheless seems to gaze at and even blind the viewer with the radiance of its curving breast and gently turned loins.

Body movements are an important expressive means in social life; they reinforce or deny what we may be saying with words. How we move "naturally" communicates who we are, individually and culturally. We can recognize loved ones some distance away by their posture and movements long before we can see their faces. In Sri Lanka I would nearly always identify Westerners from a distance (well before they were close enough to recognize by skin or hair color) by the way they walked: looser, often more ungainly, with greater shoulder, arm, and upper torso movement (in men) and longer strides (men and women). Most Western women look awkward wearing a sari, in part because their posture is too casual, their movements too forceful or fragmented.

Like the other arts, dance frequently is said to be affecting because it expresses emotion, yet a moment's reflection will make it clear that movements may be expressive without being dance. Throwing a plate against a wall because you are angry or caressing your lover's cheek because you feel affectionate are both expressive gestures. It is only when these movements are controlled, however, by shaping and elaborating, that dance can be said to exist.

The everyday "natural" movements of walking, stretching, and lifting

are generally diffuse, fragmented, unremarked. In dance, these ordinary body movements are defined, patterned, elaborated, exaggerated, repeated, coordinated with other movements—in the words of Judith Lynne Hanna (1979, 37) "more assembled, interfused, and ordered." Each culture develops dances whose gestures, postures, movements, and quality of movement are specifically characteristic of their everyday activities (Lomax 1968).[10] Traditional Balinese or Japanese dance reflects the formalized, hierarchic, aestheticized nature of their cultures, just as modern American dance displays the individualized, exhibitionistic, fragmented nature of ours. "Break dancing," which involves a display of dexterity and energy in relation to a small part of the surface of the ground, affirms, according to Francis Sparshott (1988, 136), a very personal power and freedom within that circumscribed range.

Yet many nondance activities are defined, exaggerated, coordinated—controlled. In a philosophical study of the dance, Sparshott (1988) considers the question of what makes dance "dance" in intricate detail, to which I can do scant justice in the present brief discussion. He describes the "neighbors" of dance—activities that use movement in patterned,

Dancers, Heian shrine, Japan
In dance, ordinary body movements are controlled, defined, patterned, elaborated, exaggerated, coordinated with other body movements. Each culture develops dances whose gestures, postures, movements, and quality of movement are specifically characteristic of their everyday activities.

skilled, even rhythmic ways: physical labor such as chopping wood or rowing a boat, ritual and ceremony, disciplined meditative practices such as yoga or martial arts, sport, athletics, gymnastics and acrobatics, figure skating, and even baton twirling. What seems to make dancing different from "dancelike activities," he decides, is a kind of "special mode of being" or transformational quality.

While emphatically insisting that he is not "a dancer," Sparshott's description of his own experience as a participant in a group that met for recreational English country dancing conveys this extra-ordinariness remarkably well.

> We were not dancers, and few of us got past the stage of getting through the movements without errors. Even so, my experience in some dances was unlike anything else I knew: a transposition into an altered state of being. The state in each dance was different: the "Newcastle" condition, the "Gathering Peascods" condition, and the condition of the "Fandango" were quite distinct. It was easy to recognize that the new state of being, the dance state, incorporated the sense of one's body movements, of the music to which one moved, of one's changing relation to the other dancers, of one's movement within the space of the hall. But the new condition of which one was aware was itself irreducible and distinct: a supervenient grace, one might have said, except that it was neither additional to the specific components of the experience nor a function of them, but, as it were, a new register into which they were transposed and into which I was myself translated. Insofar as I successfully learned any of the dances, in the sense that I came to move within them, a partial transformation of the sort took place; but it was only in a few that the metamorphosis was achieved (204).

Sparshott admits that in any social gathering or activity one can feel oneself to be partially transposed into a new state of being, a part within a whole. But he claims that the self-transformation that he felt in dance was richer than these.

> The sort of self-transformation I am referring to in dance is not something special or "mystical," discontinuous with everyday experience, but an enhanced version of a quality that, if one troubles to attend to it, pervades experience. . . . But the experience of becoming part of the dance is something much stronger, with a

much more marked savor; one sees why misguided people talk about dance "expressing emotion" even when it doesn't (204).

Near the end of his book of over four hundred pages, Sparshott concludes that dance cannot be neatly codified into a category nor given a determinate place and character in the world. Yet he states that "artistic dance has to be the art of human presence or a set of arts and practices in which the modes of human presence are at issue as they are nowhere else—except perhaps in dramatic rituals, which are constantly assimilated to dance by those who write about them" (397).

In the language of my own book, the cultural control of nature (the human body and its ordinary movements) that is "dance" seems to lead to a focused and felt awareness of human presence in the world. Dance enables that interpenetration of self and activity to be felt as "something much stronger," in Sparshott's words, than we are accustomed to feel in more instrumental activities (such as labor or the practice of gymnastics and martial arts) in our ordinary day-to-day existence. Certainly every known human society seems to value and perform the activity that is recognizable—if not succinctly definable—as dance.

Just as in most premodern societies "music" often includes words and hence is inseparable from "poetry," so too may music require bodily movement, or dance.[11] Indeed, dance can be considered an extension of music, its visual form. It makes music objective, externalizing the inner experience (Kapferer 1983), and even if there is no music to dance to, dancers move to some measure that suggests a kind of inner music.

As with dress and self-decoration generally in Africa and Papua New Guinea, dance may also have moral significance. The mutual responsiveness of dancers to each other, to the musicians, and to the spectators carries ethical meaning in embodying as well as symbolizing self-control and mutual respect (Sparshott 1988, 138). The Tswana of southern Africa use one term, *go bina*, that means to sing, to dance, and to venerate (Comaroff 1985, 111), implying that harmonious collective performance is a way of expressing honor.

Indeed, Sparshott points out the frequent association made by humans between danced order and not only social order but cosmic order: he describes it as "the imputation to the heavens and to large-scale or prevalent natural processes of rhythmic, purposeful, intelligent and intelligible, . . . beautiful, and repeatable movements such as some dances aspire to" (83). Sparshott mentions seventeenth-century French court ballet as only the most recent official European cultural emblem of a widespread analogy between earthly ceremony and heavenly decorum (49–52). A

similar analogy informed the Pythagorean idea of "music of the spheres" and the cosmic dance in Hindu mythology of the god Shiva Nataraj ("Lord of the Dance") who thereby creates, destroys, and sustains the universe.

Like music, and conjoined with it, dance is a means of unifying individuals and, as Sparshott described, transforming them. Such transformation can be of permanent as well as momentary duration. For example, after removal from their mothers' houses and undergoing circumcision at ages six through ten, young boys from a number of groups in the geographical area of southeast Angola, northwest Zambia, and southern Zaire attend an initiation school, *mukanda*, where they begin learning how to become "complete" persons or "human beings" (Kubik 1977). There, over a period of four or five months, a boy develops attachment to a group of peers that replaces his childish dependence on his mother. As described by Gerhard Kubik (1977), the novices' dances are "part of a culturally-tested repertory of techniques designed to achieve a lasting change in an individual's patterns of behavior. The coordination of movement patterns that are performed by more than one person is both an expression of and a tool for the creation of a feeling of group identity, group attachment, and solidarity" (259).

Whether in *mukanda*, in recreational English country dancing, or in countless other dances throughout human history, to dance together with a group is to participate in a greater unity, as the Dogon of Mali visually demonstrate in their *Sigi* dance, where each individual male (in order of age) becomes a vertebra in a long, composite serpent (Rouch and Dieterlen 1969). Dancers of the Kalapalo in central Brazil move from one house to another, uniting different houses into a spatial whole and thereby promoting social homogeneity (Basso 1985, 251). Basso speaks of the "wonderful power of community emerging from group performance, with a concomitant deemphasis on the inner self and the problems of individuals" (253). Yet body movement and dance can be individually therapeutic also, as Kubik found occurring in *mukanda* initiates as they learned to perform and personally incorporate movements of certain dances and rhythms while playing structurally regular patterns with sticks as a group (260).

Dance then can be a means of transfiguration to an altered state, either by gaining a sharpened sense of one's individual human presence or by transcending one's individuality and merging with a group. Like music, dance may draw in and subsume the participant who can no longer achieve or maintain reflexive distance. In many societies, rhythmic entrainment from repeated movements and sounds, and hyperventilation

and sympathetic arousal from exertion ultimately bring about ecstasies of possession or trance—arguably an important evolved capacity in the behavioral repertory of *Homo aestheticus* (see also the sections on ritual and dramatic performance and on aesthetic experience, which follow).

Ritual and Dramatic Performance

Drama, says the Kikuyu (Kenyan) author Ngugi wa Thiong'o (1986, 36), originates in human struggles with nature and with others. As I have repeatedly noted earlier in this book, in circumstances that affect them deeply, people naturally are inclined to ritual observance. Their feelings predispose them to employ means of enhancement, to make extraordinary gestures that provide *dromena*, "something to do."

I recently read about an American named Glen Wooldridge, who in 1917 was the first person to "ride" down Oregon's tumultuous Rogue River. He became a passionate lifetime runner of rivers thereafter, saying that he felt like a salmon when it was time to spawn: he just had to be on the river. In Wooldridge's eighty-ninth year, two young river runners named Rolli and Dave built a replica of Glen's original boat in order to take him for a last trip down the Rogue. They described how it feels to be on a boat on the river: one is an essential part of the wilderness, "not just passing through." They could see Glen "feeling" the water with his whole being: his body seemed to move with the river. When they reached the ocean, he tasted the sea.

Rolli and Dave wanted to commemorate that last ride and "the spirit of being part of the wilderness." They left the boat in which the journey had been made at Paradise Lodge so that everyone who came down the canyon would see it, and this "would keep the spirit of Glen and the boat alive." They didn't want the boat "just to sit someplace and die." In addition to displaying the boat at Paradise Lodge, Dave and Rolli had a bronze plaque made that they then placed in a hidden spot somewhere on the Rogue River. Unlike the boat, it was not intended for hundreds of people to see: "It's our thanks to him, and our goodbye."

In simple but significant ways like these we show our need for ends and beginnings, brackets that set our doings and our relationships off from the stream of ordinary, everyday life. What could be more common than the formalized greetings that we, like many other animals, give one another when we meet? We embrace, kiss, or otherwise juxtapose our "muzzles," or we may raise or bring together or extend our hands.

Starting right in and stating your business may be considered extremely rude. I can remember approaching a lady in a New York subway station

to ask directions, and she answered me with a fixed stare and a stern "Good afternoon." When I replied "Good afternoon," she then cordially answered my question. Legal proceedings, religious assemblies, and political meetings all require formalized openings and conclusions. No matter how urgent, one does not simply plunge right in with the day's business. We need beginnings and, just as much, we need ends, conclusions, closure. We say goodbye, and hug or kiss or shake hands and mention the possibility of meeting again. We taste the sea, or place a bronze plaque in a concealed spot.

Ritual *ceremonies* give us the opportunity not only to do something but to control what we do. Male chimpanzees have occasionally been seen performing a peculiar behavior that Jane Goodall (Lawick-Goodall 1975, 162) calls an "elemental" display. It seems to be provoked by exciting natural phenomena like thunderclaps, fast-flowing water, or strong winds. (I think it is worth mentioning that these are among what the Eighteenth Century called "the Sublime" and responded to aesthetically). While unlike other chimpanzee behavior, the rain dance does combine, slowly and rhythmically, the common motor patterns that are usually seen in aggressive contexts: tree shaking and running about on two rather than four legs, foot stamping, and slapping the ground while emitting "pant-hoot" vocalizations.

It has been suggested that in their "rain dance," the chimpanzees are orienting themselves toward a "zone of uncertainty" (Laughlin and McManus 1979), a disturbing or exciting stimulus that is perceived as possibly dangerous. The chimpanzees' reactions contain germs, albeit relatively unintegrated, of repetition, rhythm, elaboration, and exaggerated motor movements drawn from spontaneous emotional excitement. It is not difficult to imagine other hominoid creatures, with greater mental ability and more control of their behavior, deliberately patterning and shaping their vocalizations into chants, and the tree shaking and stamping into dance steps, thereby relieving their anxiety and, when all is said and done, "controlling" (neutralizing), with ritual, the storm.

For, as I discussed in the previous chapter, control of one's own behavior, by making it stylized or otherwise extra-ordinary, seems to be universally performed by humans as a way of controlling the unknown and unpredictable, just as an extra-ordinary gesture is "something to do" that matches the emotional magnitude of the provoking occasion.

Sacrifice, whether of life or blood, or the denial of something, food, for example, that under normal circumstances is indulged in without thought, is both extra-ordinary and deliberate, a visible sign of control. The strong and active beast is rendered weak and passive so that the

burden of human passions may be transferred to it. Overt willed deprivation demonstrates to the higher powers that they are honored, and thus compels their mercy or assistance.

And the opposite of denial, participation in ceremonies that celebrate the pleasures of life—singing, dancing, laughing, feasting—can be understood not merely as an indulgent attitude of "eat, drink, and be merry" or sheer recreation, but as a more positive action. For the Senufo of West Africa, the vitality of aesthetic expression in their funeral rites is "doing something" that counterbalances the grief and sadness of death and loss (Glaze 1981). The Tiv of Nigeria feel that dancing, song, and tale telling are displays of positive, life-affirming forces and values that are an antidote to *tsav*, negative power (Keil 1979).

Ritual ceremonies are primary examples of and occasions for the extraordinary. When the Huichol Indians of Mexico go on their ritual hunt for the sacred peyote plant, they do everything the reverse or opposite fashion of the way it is normally or habitually done, thereby demonstrating that their quest is also the opposite of mundane, that is, sacred (Myerhoff 1978). The Huichol peyote seekers disguise, minimize, and forego as much as possible their natural physiological requirements for food, drink, elimination, sleep, sex, and bathing; they minimize social, gender, and age distinctions; they alter or suspend the usual division of labor; they renounce discordant behavior and emotions; they say the opposite of what they mean.

For the Kalapalo of central Brazil, narrative art (*akina*) is formalized by means of a set of conventional structuring devices (such as special intonational contours and vowel lengthening of the voice, and parallelism and segmenting of content) for the tale telling, and by the use of a listener-responder (or "What-sayer") who assists the narrator to shape and elaborate the story. Narratives are important for giving meaning to human feelings and the problems that people have controlling them and showing *ifutisu*—the grace of demeanor that is necessary for social harmony; thus, didactic and explanatory ends are served along with entertainment (Basso 1985, 13). Kalapalo narrators separate their narrative performances from the rest of discourse by utterances that frame the narrative and alert the listener to the need for a special communicative role. Within this frame the listeners themselves become What-sayers who must attend to the speaker in a special way (Basso 1985, 25).

Watching or participating in performances of the extra-ordinary may not only express but create or cause extra-ordinary emotions. Weddings and patriotic celebrations, with their pomp and ordered predictability, carry us right along to the lump in the throat or actual tears when the

vows are made or the "Battle Hymn of the Republic" is sung. Knowing what comes next in a ceremony or dramatic performance may be as moving as not knowing what is going to happen. In his fascinating study of Greek tragedy and the emotions, W. B. Stanford (1983) points out that the predestined end is a characteristic not of life but of art (though it is not characteristic of *modern* drama.) To illustrate that its unfolding can be highly emotive, he mentions that when we watch a film of the motorcade of President Kennedy in Dallas, even though we know the horrifying inevitable conclusion, we are caught up in a strongly emotional timeless state that is similar to watching the artfully prepared progression to fore-ordained death of any tragic hero. Stanford also claims that in classical Greek drama, it is feelings, not events, that are orchestrated and arranged. "Like the great instrumental and choral compositions of Bach, Mozart, and Beethoven," he says, "the tragic dramas succeed by means of [emotional] crescendos and diminuendos, accelerandos and rallentandos, scherzo movements and maestoso movements, recurrent motifs, and ingenious variations" (115).

The manipulation of emotions is, of course, one of the essential features of ritual ceremonies and the reason for their effectiveness. Sharing strong emotions together is a potent means of bonding, as war veterans and survivors of catastrophes will attest, not to mention sexual partners or parents and children.

We consider classical Greek drama as an art form, but its origins go back to prehistoric ritual ceremonies of cleansing and atonement. Richard Schechner (1985), a New York City theater director and teacher who describes himself as a performance theorist, has pointed out many intriguing similarities not only between ritual ceremonies and drama as an art form, but among performances of all types. Schechner emphasizes the control or artificiality inherent in *all* performances by describing them as "twice behaved" behavior. In performances of every kind, he argues—including shamanism, exorcism, trance, dance, ritual, theater, and even psychoanalysis—"strips of behavior" are taken out of their natural context and used as "material" for the reconstructed whole. Life provides the material that performers—through their art of shaping, rearranging, controlling, interpreting, elaborating (to use the terminology of the previous chapter)—reconstitute and restore back to life in the performance.

Schechner also emphasizes the idea that both performers and spectators in ritual and theater are transformed in being or consciousness. Laurence Olivier, the person who is acting, is transformed into King Lear. The spectator is transported in imagination to the world of King

Lear and, also, perhaps, transported emotionally. In a ritual performance, the participants by donning masks and costumes or entering a certain frame of mind are transformed from their ordinary existences. They may also be transformed from "raw material" (say, a child) to an identity (a sexually mature adult), or from one form of identity to another (a sexually mature adult to a married adult). The emotional intensity upholds and reinforces the significance of the social transformation it echoes.

In his study of Sinhalese exorcism and healing ceremonies in Sri Lanka, Bruce Kapferer (1983) analyzes how the aesthetic forms of the ritual (the structured music and dance performed by the exorcists) "link the inner experience of the subject with the objective structure of the rite." The ritual creates and molds the appropriate emotions, then deliberately decomposes them at the conclusion, where the exorcists stumble, fumble, and make errors, gradually restoring the everyday world.

All the aforementioned "arts" discussed individually in this chapter as "means of enhancement" are, of course, used in ritual ceremonies— most often in combination. Dance (special gesture and movement, with music) and song (special poetic language, with music) are together what is frequently meant by the term "ritual," and these take place in a special arena and are usually performed by people who are adorned in a special way. All together—and separately, insofar as they can be separated—the arts contribute in numerous essential ways to the reproductive success of the individuals who have engaged in them.

In the first place, of course, as has been pointed out from the time of Darwin, persons who adorn themselves attractively and display this beauty along with good health and vitality in dances and contests, are attracting mates—as is the case in countless other living creatures. Display of other attributes, wealth or possessions or individual skills (often presented aesthetically—as described when I discussed visual display at the beginning of this chapter) is also a way of showing status and has a similar result in reproductive advantage.

Additionally, ceremonies themselves confer benefits to the group as a whole, which means that any individual member in such a group will similarly prosper. During human evolution, ceremonies, by making group knowledge more impressive and hence more compelling and memorable, helped to transmit vital information over generations (Pfeiffer 1982; Dissanayake 1988). And what is equally of consequence, insofar as ceremonies inculcate group values and promote agreement, cooperation, cohesiveness, and confidence, they also enhance survival. To adapt a maxim from the 1950s: the group that performs ritual ceremonies together stays together. And staying together, working harmoniously in a

common cause, ensures as much as any other human attribute the welfare of individuals.[12]

Aesthetic Experience

Humans everywhere receive pleasure from beautiful things—although, of course, what is considered to be beautiful may vary from person to person or group to group: you like tattoos, I like tapestries. But responding to beauty is not necessarily the same thing as detached aesthetic appreciation of acknowledged works of art. The latter appears to be a predisposition of certain members of technological society in which people learn to regard something aesthetically rather as they have learned to look objectively, with detachment, at themselves, or their relationships, or their religious upbringing. Jane Ellen Harrison's (1913) description of the aesthetic attitude makes the point about detachment quite dramatically: if a friend falls off a boat and begins to drown, the truly detached observer instead of going to the rescue would admire the white curve made by the body as it falls over the edge and the ripples of light and color on the surface of the water as the person flails about. When a photographer is more interested in lighting, camera angle, or an appropriate background than the suffering of her subject, she is exhibiting an aesthetic attitude. "There is no situation so terrible that it may not be relieved by the momentary pause of the mind to contemplate it aesthetically," wrote George Santayana (1955/1896, 218) a century ago.

The examples just cited are instances of regarding *life* aesthetically. Most people, even in modern, alienated, disembedded society, do not habitually practice such aesthetic distancing, especially toward other people. But regarding things (e.g., nature and art) aesthetically, without consideration of their use, their cost, and their social or spiritual significance is a mode of perception deliberately cultivated by some of us, at least some of the time. The craft of the object of study's arrangement, the unified nature of its form or composition, its relationships to adjacent forms, the beauty or skill of execution—these are the sorts of things that are appreciated in works such as Carl Dreyer's *Passion of Joan of Arc*, Henry Moore's reclining figures, or Paul Taylor's *A Musical Offering*. The subject matter, or content, may also excite appreciation, but when content is the primary or only source of appreciation it is not considered to be "aesthetic" but something else—patriotic, sentimental, outraged, shamed, sympathetic, and so forth—affiliative or otherwise personally affecting sorts of emotional response.

The requirement that appreciation of works of art be aesthetic rather

than direct made modernist art of the late nineteenth and early twentieth centuries mystifying and insulting to many people. How can you become personally involved with a slapdash painting called *X-121*? And, as Arthur Danto (1981, 124) has said, looking at an artwork without knowing it is an artwork (without knowing that it requires learned appreciation) is like looking at a book before you have learned to read.

Thus we can call aesthetic experience an imposition of culture on nature, to the extent that one responds not merely (or at all) to the "natural" subject matter or implications of the subject but to the culturally imposed shaping and patterning. One controls the "natural" reaction—for example, sympathy for the person in the photograph who appears to be grieving—and instead admires the skill and craft of the photographer whose eye for composition and lighting captures and distills that grief.

Obviously this sort of aesthetic attitude is a matter of degree, and as I have argued in Chapter 3, aesthetic experiences (even detached ones) are ultimately based on natural protoaesthetic elements (see also the discussion of cognitive universals in Chapter 6). In this respect, the response to a naturally aesthetic element would be at least in part "aesthetic" in that it is sensorily and emotionally gratifying, but unless "made special" in a context, it is not what we normally mean by aesthetic experience, and even less what we mean by *detached* aesthetic experience.

Additionally, one can say that the highly detached kind of aesthetic response, as an ideal if not a perfectly achieved reality, is highly specialized and unnatural and not available to the untrained person. (And, ironically, I think it is worth pointing out that it is of most concern to the very persons who in many other aspects of life are most concerned with the natural, or "authentic," and also that it partakes of the objective, detached, mental attitude that characterizes scientific thought, which aesthetes generally disdain or deplore.)

One can argue about whether premodern and unsophisticated modern people have detached aesthetic experiences.[13] Certainly they make value judgements, but their emotional reactions to the arts seem to be to the subject matter and its social or spiritual significance, even when they judge some works to be "better" than others. The anthropological literature provides numerous examples of people valuing such things as virtuosity (which some see as improvisational ability and originality and others as skill at reproducing formulae) and endurance—especially in dance, use of poetic language, and music making. The Chippewa distinguished between good and poor performers and good and poor compositions, admiring a singer's "expanded range," for example, and

the Hawaiians admired a deep and powerful chest resonance (Sachs 1977, 134). "Appropriateness" (suitability for use, conformity to group values, accuracy) is another attribute that is widely commended in what we would call "arts." All of these esteemed qualities, of course, can be linked to selective value—either in advertising the prowess and charisma of their individual possessors, or in reinforcing group virtues and precepts (for example, the Navajo and Hopi value and therefore strive to achieve balance and harmonization in their arts as well as in their lives).

The Kaluli—mentioned earlier with regard to "making natural"—have developed weeping into what might be called both a cause and an expression of aesthetic experience. They have turned natural weeping (the instinctive response to personal distress, whether from fear, anger, or pain) into several varieties of culturally expressed weeping. "Natural" weeping in the Kaluli is usually volatile, expressing disquiet, agitation, or anger; it is manifested by being choked up as well as by engaging in loud, uncontrolled, convulsive sobbing, or it may also take a falsetto melodic form. The forms of cultural weeping are even more varied: some indicate composure and reflection and are patterned performances very much like songs. Other forms of cultural weeping are an evaluative response to others' performances of songs—a ritual act or ritual response, an art form or a response to art.

In the Kaluli, then, a universal, natural human expressive form, weeping when in distress, has been culturally stylized with recognizable distinctions made between "sorrowful/pitiful melodic weeping" or melodic texted sung weeping." What is more, initially "spontaneous" and improvised "sung weeping" may develop into "crafted weeping" ("wept song"). These forms of weeping make use of various musical and poetic devices to pattern and otherwise manipulate words and music for evocative purposes that we would call aesthetic.

It is curious that the Kaluli, whose aesthetic behavior "makes natural," should have developed such a stylized aesthetic response. Perhaps it is a matter of analysis, ours versus theirs. They distinguish between *sound* (natural), given in the melody of bird calls, and *text* (cultural), which is found "inside" the sound, suggested by it or crafted for appeal in relation to it. In other words, the melody that people sing may be "natural"— imitative of natural bird calls—but the creative and newly composed aspect of a song (what I would call the art, or control) lies in the text (Feld 1982).

There may well be other examples of detached aesthetic experience in the anthropological literature, and I would be the last to deny that emotional and behavioral responses to *ritual ceremonies* (which, as I have

shown, make use of the arts)—like Kaluli weeping—are controlled and culturally patterned, if not strictly "aesthetic" in the modern Western sense.

It is interesting to note that in the modernist tradition, detached aesthetic experience, like response to the arts in some ritual ceremonies, on occasion leads to *loss* of control: to a sense of rapture, a feeling of self-transcendence and overflowing of boundaries during which one gives up the self to the flow of feeling. Some writers and critics, including Pater, Ruskin, Bernhard Berenson, and Clive Bell, have gone so far as to claim that the reason for living is to cultivate this kind of experience. (See also the discussion of modernism in Chapter 7).

In her stimulating and insightful book *Ecstasy* (1961), Marghanita Laski gathered together numerous written accounts of self-transcendent experiences and suggested that whether in response to nature, religion, love, or art, these are "widespread among educated and creative people"—evidence of Laski's "modernist" prejudices.

Yet thirty years later, although ecstasy from drugs, sex, and entertainment is avidly pursued as a perquisite of the good life and an escape from a bad one, it seems safe to say that self-transcendent responses to artworks, in the sense in which these were extolled by modernists like Pater or Berenson, are among the least sought-after or valued, both to people who have never heard of Pater or Berenson and to those who have but dismiss them as elitist fops. Theorists of the postmodernist persuasion, in their obsession with trashing the elitist values of the "high" tradition, dismiss the rapture that can arise from aesthetic contemplation as a mere individual interpretation, a "reading" of a "text" that is conditioned by one's culture and personal history and therefore no more real or valuable than any other person's interpretation or experience.

A human ethologist looking at human societies far, wide, and long ago, notes that self-transcendent experiences are not, *pace* Laski, confined to the educated and creative but are, in fact, widely achieved and valued—in more than 80 percent of human societies, according to one estimate (Bourguignon 1972, 418). Because such experiences, both for Laski's informants and in premodern societies, have a quality of revealing important and undisputable truth, the species-centrist can understand the capacity for achieving self-transcendence to have had survival value: that is, it would enable unquestioning adherence to the values of one's society, thus promoting group solidarity in communal enterprise.

It is just this "certainty," revealed in self-transcendent experiences, that is anathema to relativist postmodernists and, to be sure, scary to anyone who has witnessed the fervor of fundamentalists who believe with all their

heart in the truth of their position and the falsity of everyone else's. The propensity to in-group oneheartedness, so perilous in the world of today, evolved in much different circumstances where it contributed to individual and group survival. Yet if aesthetic experience and other self-transcendent states seem irrelevant and out-of-date today, one might ask, since the ability to have them seems to be a deeply rooted universal human proclivity, what do we do instead? Premodern peoples have varieties of "dissociation" experiences, such as trance and possession; their modern and postmodern counterparts have increasingly emphasized the literate skills of analysis and objectification, "formal operations" that render mythopoetic thinking obsolete and unselfconscious response impossible.

The skills of literacy are among the traits that divide modern from premodern people. I believe that an understanding of the social and individual effects of literacy helps illuminate the status of "aesthetic emotion" today and in the recent past (see Chapter 7). Social historians have noted the effects of individualism, secularism, and changing economic conditions on the arts. For example, Curt Sachs (1977, 123–24), finds that in contrast to nearly all musical forms in primitive, Oriental, or Western folk music which are "surprisingly shortwinded," post-Renaissance European music gradually became longer and more complex, with more instruments and voices and more musical development.

One characteristic of post-Renaissance (and particularly post–Industrial Revolution) music is that it was mechanically printed and hence easily and widely preserved in a fixed, accurate form. Until then, music had to be remembered or improvised, and it was in improvisation by single individuals or small groups that complexity resided. Increasingly, music improvisation in European classical music has declined (jazz, of course, is an offshoot of the "oral" or nonwritten tradition) and fidelity to a written score has become axiomatic. While this rigid adherence to a fixed score certainly has limited spontaneity and restricts the individual performer's liberty, it must be said that the ability to compose and reproduce music on paper has allowed a kind of complex aesthetic exploration and experience that was not known before. The possibilities for development of melodic themes, harmonic combinations, and voicing among instruments were expanded tremendously with writing and printing—for the composer who could work and rework them, for the conductor and performers who could practice and rehearse them, and for the audience that could study and hear and reexperience them. This has led to a profundity of expression (achieved through form—exposition, development, and recapitulation over time, manipulation and control of a com-

plex diversity of elements) from the intricate counterpoint of the Baroque era through the revisions and rerevisions of Beethoven to the present day when much music is so complex that it cannot be comprehended with the ear alone, but demands studied appreciation and analysis of the score.[14]

Appreciation at these high levels requires education and leisure in which to acquire competence, hence profound responses to this profound music have been of necessity confined to an elite. No wonder that Laski (1961, 275) found "aesthetic experience," an invention of the late eighteenth century, "to be confined to or to be more common among people of developed intellect or creative capacities."

Of course, the "aesthetic" experience is only one kind of the many kinds of "self-transcendent" experiences available to humans; dancing, for example, and other forms of repetitive physical movement made to music, drumming and the like, are widespread means for achieving ecstasy. It would seem that the cultivation of detached aesthetic experience tends to interfere with and even preclude unselfconscious participation in the more common kinds of self-transcendent experience. Likewise, the ability to have this latter experience is usually associated with a kind of life and upbringing that in effect bars one from comprehending or valuing the more "cerebral" satisfactions of the former, although both are matters of degree.[15]

Regaining the Natural

It can be argued that "man in a state of nature" never existed, for it was only by imposing culture upon nature, as anthropologists used to say, that *Homo* became human, that is, distanced themselves from nature, a process they have been accelerating ever since. Indeed, today we are so removed from "nature" that to imagine ourselves living on the land, as even our great-grandfathers may have done, seems highly unnatural.

As I have repeatedly pointed out, in this century in the industrialized world, for the first time in human history, the "natural" is more rare, precious, and costly than the "artificial." Fresh flowers; fresh meat, vegetables, and poultry; utensils made of clay; cloth of cotton, linen, or wool—all are more expensive than their plastic or frozen or synthetic counterparts. Not only are artificial bodily organs becoming as common as artificial flowers, many of us may spend most of our lives in artificial climates under artificial lights. In our whole lives, our bare feet may touch the bare earth rarely, if ever. Our own living energy rarely makes

anything happen: we are transported in various mechanical vehicles; we push buttons or turn dials to prepare our food and maintain our dwellings. We acquire our knowledge about the world from media, not through direct observation or experience.

No wonder that we may often long for a more "authentic" or "valid" existence, something deep and abiding, a kind of vital source that will flesh out and give emotional sustenance to the empty and discontinuous skeletons of mechanization, routine, and endless trivial novelty that largely compose modern life. For Lorca (1930/1955), the true artist possesses not only a controlling intellect and inventive inspiration but deep, inner physical-emotional *duende*: "Angel and muse approach from without; the Angel sheds light and the Muse gives form. . . . but the *Duende*, on the other hand, must come to life in the nethermost recesses of the blood" (156).

It is perhaps understandable that only the most "civilized" or artificial groups and societies glorify nature, as did the members of the French nobility in the eighteenth century, who dressed rustically as shepherds and milkmaids. As Peter France has pointed out, modern Western society has paradoxically condemned primitive life and culture to extinction or the museum, even as it exalts them as the true sources of energy.[16]

Culture, as this book has shown, is built on artifice, the control of nature and the natural self. Yet *artificial*—suggesting as it does the cheap, the synthetic, the posed, rather than the virtue of human skill and craft imposed on nature—is to our present way of thinking a bad word. Other words such as *cosmetic, adornment,* and *decoration,* as I pointed out at the beginning of this chapter, have also lost their social-as-moral emphasis where what is pleasing or beautiful is what is socially fit or proper, and now apply to ostentation, frippery, and the hiding of flaws. Beauty, which used to be indelibly associated with the moral and social, is now individual and, as proverbially sanctioned, solely in the eye of the beholder and only skin deep.

Certainly it is not usual any more for Western—at least American—society to value self-control. Personal expression and satisfaction of emotion is considered to be more healthy and honest than restraint and denial. "I don't hide how I feel," says the girl in the television commercial, as she boldly and provocatively tosses her hair to make it look wilder than ever.

For the past two hundred years, as the power of the aristocracy and the aristocratic ideal has declined throughout the Western world, the formality and artificiality that universally characterize civilized behavior have been suspect. Wordsworth praised the beauty to be found in the natural

rustic speech of ordinary people; since his time, poetry has moved further and further away from the characteristics that marked it as poetry for thousands of years: strong and easily discerned rhythms, rhymes at the ends of lines, an artificial and heightened use of language, and the expression of common—rather than personal and idiosyncratic— emotions (Strehlow 1971).

Twentieth-century Western artists have typically been concerned with making art more natural (using ordinary materials from daily life or depicting humble, trivial, or vulgar subjects) and showing that the natural, when regarded aesthetically, is really art. Blurring the boundaries between art and life, elevating the ephemeral or untidy to the status of art, and claiming that the trivial and simple is equal to the demanding and complex are unprecedented concerns of artists who heretofore have found art's difference from life, its specialness, to be its raison d'être.

In this they both lead and follow, absorb and reflect postmodern Western society which is the apogee of the trend I have been describing, where now the natural is elevated to the cultural, where nature and the natural, viewed as rare and "special," are deliberately inserted into culture as something desired. I have pointed out that most cultures like shiny, new-looking, bright, and conspicuously artificial things. In Sri Lanka, new blouses and sarongs are often stitched by village women so that manufacturing marks printed on the selvedge will show. But we prefer the worn and faded because they look natural and authentic. Casual, wrinkled dress expresses the naturalness we think is desirable.

Of course, one may question—as Herbert Marcuse (1972) did—how "spontaneous" spontaneity of thought and action really is, or how "natural" unreflective behavior. These most likely represent, even in the breach, unexamined values that have been absorbed from the surrounding culture. "Being me" is something that only postmodern people profess to want to do, and it is frequently indulged in by an expenditure of money or rebellious behavior that reflects our consumer and individualist society more than anything else. The relentlessly carefree girl in the television commercial displays her naturalness by tossing her chemically colored and expensively styled hair.(As any woman knows, the natural look is not easily achieved or paid for.) We think it is natural to compete, to progress, to dissent, to acquire more and more possessions, to value new experiences. Persons in other societies may find these things disturbingly *un*natural.

We are postmodern, and while we may be subject to the postulates, fashions, and insecurities of our age, at the same time we remain humans with an age-old nature, with common deep-dyed proclivities and needs.

"But in contentment I still feel the need of some imperishable bliss," thinks the usually complacent woman in a Wallace Stevens poem, on a relaxed and secular Sunday morning. As she muses on death, beauty, and paradise, she imagines a ring of "supple and turbulent" people chanting "their boisterous devotion to the sun," "a chant of paradise, out of their blood, returning to the sky."

And all over America people seem to be returning to older traditional practices, witchcraft, for example, or Native American sects, or other varieties of nature religion (Albanese 1990). They may develop new ceremonies, such as Gaia worship, and observe the winter and spring solstices with music and dramatic presentations. But are not these modern forays into the primordial of necessity superficial, partial, and hence ultimately unsatisfying? Such ceremonies are usually celebrated by groups of anonymous strangers who may clasp hands and embrace during the ceremony itself, but who then depart and never see each other again. While such activities are perhaps better than nothing, most of us still lack the comfort of having "something to do" with a community of familiars that provides the illusion of control or the reconciling of the familiar and strange. Therapy and psychoanalysis, while socially sanctioned *dromena*, are obviously not quite the same as communal ceremonies.[17]

In extreme situations humans have always looked to the formal and externally imposed to shape and control perplexity and suffering. A study of a British motorcycle gang revealed that when one of the members died on the road, the other boys marked the event by turning to the established church. They did so not because they were religious or accepted the church's teachings, but because its rituals gave them a ready-made and widely recognized formal way to accord significance to the death— *dromena* (Willis 1978).

Today's "traditional" ceremonies are frequently deplorable. I remember attending the funeral in England of a dear friend, preceded by a pensive taxi ride through a darkly beautiful November countryside where I noticed rich brown fallow fields, one occupied by a lone pheasant, rising against lowering rainy skies. Yet that growing mood of loss, regret, and remembrance was completely destroyed by the all-purpose service briskly performed at the anonymous crematorium.

My friend had been a paleontologist, a connoisseur of fossil man, so that his death might have been an occasion to remind his mourners of primordial things: the age of the earth and the precious fragility of human life in that immensity of time, the bravery and ultimate defeat by death of those who seek to know the eternal, my friend's return to earth to join the other humans who for millennia had preceded us. An elemental work

of music by Bach or Sibelius would have underscored and sustained our recognition of the inevitable and aided a mood of resignation and relinquishment to it. Some resonant, relevant lines from the King James Bible, from Shakespeare, Milton, or Wordsworth, even from a Victorian geologist, would have provided some sense of the continuity of my friend's life with his English heritage.

But the bland impersonal remarks of a stranger and the irrelevant hymn we were asked to sing only made us more aware that just as soon as the coffin slid neatly and efficiently behind that roseate polyester curtain we should leave quickly so that the flowers could be removed and exchanged, a new casket mounted on the dais, and the "chapel" made ready for the next lot of people, already milling about in the misty parking lot as we had been fifteen minutes before.

I found it difficult to believe that such a ritual was of any use to anyone, and I felt a sudden pang of loss, wanting to tell my dead friend about the meaninglessness of the stupid funeral I had just attended. I did not then remember Sri Lankan funerals such as those I described in Chapter 3, but comparing them now, the latter seem indisputably more humane. I did wonder whether others, like me, felt that we (and the deceased) had been shortchanged. Or like the music, books, entertainments, and arts that compose modern life, was this just one more experience to consume, hardly paying attention to or judging it because we had to get on with the next thing?

We may forget that the formalizations inherent in ritual ceremonies have provided important occasions during which humans throughout their history have experienced the arts, which themselves were emotionally saturated integral reinforcers of important communal beliefs and truths. In renouncing these as being too much trouble or too old-fashioned, we have thus also forfeited the centrality of the arts to life. And with that, we abolish age-old, naturally evolved, and time-tested means for making sense of human existence. Throughout human history the arts have arisen as enhancements, special behaviors shaping and embellishing the things we care about.[18] Without extravagant and extra-ordinary ways to mark the significant and serious events of our lives, we relinquish not our hypocrisy so much as our humanity.

❧ 6 ❧

"*Empathy Theory*" *Reconsidered*
The Psychobiology of Aesthetic Responses

The ardent language of the excerpts quoted in Chapter 2 describes responses to works of art that to a postmodern sensibility sound overwrought and embarrassing. "Aesthetic emotion" has today been pretty much deconstructed out of existence. But even though we may no longer revere or even admit to such experiences, we can ask *what* Barzun, West, and Whitman were referring to. If we no longer have experiences like theirs, are we therefore emotionally impoverished? Are we missing something? Or were they simply overdramatizing, propelling themselves into a spurious and self-induced rapture?

In the present chapter I would like to describe psychobiological findings that seem relevant to an understanding of human responses to the arts. They suggest that aesthetic experiences arise from the same neurophysiological processes that comprise the rest of our cognitive-perceptual-emotional life. Such a claim should not be surprising, yet it is not widely realized that "aesthetic" aspects are as deep-rooted, natural, and normal as our more "ordinary" behaviors. Indeed, "ordinary" behavior often contains the rudiments of what as "aesthetic experience" seems rare and strange.

Psychoanalysts have found universal themes that they claim inform the creations of all cultures and which therefore must unconsciously appeal to all humans. I am here concerned to demonstrate that in addition to recognition of the response to subject matter or symbolic content, there is other evidence of human commonality in the way we (as mind-body) actually "work" as we perceive, cognize, and respond emotionally to the

140

world of which we are a part. This natural psychobiological functioning provides an explanation for human aesthetic responses of a kind that a century ago went by the name "empathy," a word that now has another meaning.

During the half-century or so after 1870, a number of German and British thinkers became particularly interested in elucidating the physical or quasi-physical bases of aesthetic experience.[1] Their quest can be seen in a broader context as part of the general post-Darwinian scientific atmosphere in which naturalistic, rather than supernatural or mentalistic, explanations for human psychology and behavior were sought. Because their knowledge of neurophysiology was rudimentary, these thinkers propounded ideas that today sound naive and dated. Their contemporaries in most cases remained unpersuaded by a naturalistic approach that in effect was derived from the feelings the arts produced. Then, as today, feeling (at least its physiological correlates) was considered to be an epiphenomenon of the aesthetic experience, which was believed to be "mental" or "spiritual." Edward Bullough (1912) in his classification of three "perceptive types," called the lowest type "physiological," not realizing that the other two types, "objective" and "associational" perception, would also have to be physiologically mediated. The idealist aesthetician Benedetto Croce (1915/1978) ridiculed the investigation of the physiological or physical roots of art. The "naturalists" were competing with a powerful new aesthetic paradigm that seemed necessary for comprehending the revolutionary turns European art was taking during the same years. One could no longer judge or interpret an artwork on the basis of traditional standards of beauty, representational accuracy, or artistic skill. Instead, a growing insistence on the primacy of formal aspects apprehended by a special cultivated aesthetic sensibility began to take hold.

Although regarded as historical curiosities today, these thinkers, wittingly or unwittingly, are interesting and important precursors to my present endeavor to reconcile the mind-body dichotomy in aesthetics, and deserve to be given their due. They recognized and attempted to explain what other theorists had ignored or denied: that art gratified the body as well as the soul.

It is as if all at once a number of people decided that they could no longer ignore the swooping sensation inside the chest as one watches a dancer leap or a cathedral vault soar, or hears a gathering crescendo; the contraction of the throat or even trembling and weeping while one follows a complex harmonic progression; the sensation on the inside of one's hand of mentally caressing a sculpted curve of stone or wood; the wish somehow in some unimaginable way to gather a poem (its words, all it

implies) and fasten it to oneself, blend with it, possess it; the unexplainable feeling that words have shapes, that colors can be touched or heard, that sounds have contours and weight.

Today we would say that these sensations are actually mental phenomena: synesthetic, kinesthetic, associational—which is another way of saying that body and mind are a unity. Yet fifty years ago this was an unarticulated if not unimaginable concept, even though artists through the centuries have intuitively crafted their works as if they were molding feelings and bodily sensations at least as much as they were embodying spiritual truths in mentally perceived forms.

In this chapter, I will briefly resurrect empathy theory and some of its close relatives. Although the theorists of empathy are discredited today, I believe that they were onto something, something that became swamped by formalist theory and practice in the arts and is now dismissed along with the unfashionable idea of any kind of "aesthetic" emotion.

Empathy Theory Revisited

Empathy, even if it could be cleansed of its antique associations, would not be a useful or descriptive word for art theorists today. Although coined in the early years of this century (a translation of the German word *Einfühlung*, "feeling [oneself] into") to describe a kind of response to the arts, *empathy* has been appropriated by psychoanalysis to refer to "the capacity of an individual to feel the needs, the aspirations, the frustrations, the joy, the sorrow, the anxieties, the hurt, indeed, the hunger of others as if they were his own" (Arnheim 1986, 53); "empathy" is thus a kind of super sympathy. As such it has become the subject of a formidable amount of theorizing and the rallying point of a psychoanalytic "school" (see, e.g., Lichtenberg, Bornstein, and Silver 1984).

The word *Einfühlung* seems to have been used for the first time in 1873 by Robert Vischer.[2] Some twenty years later another German, Theodor Lipps (1897), described how "The vigorous curves and spring of [a Doric column] afford me joy by reminding me of those qualities in myself and of the pleasure I derive from seeing them in another. I sympathize with the column's manner of holding itself and attribute to it qualities of life because I recognize in it proportions and other relations agreeable to me" (quoted in Spector 1973). By 1900 Lipps had adopted Vischer's word *Einfühlung* in the title of his essay "Aesthetische Einfühlung,"[3] and in 1903, in *Einfühlung, innere Nachahmung*, he explained "aesthetic empathy" on the basis of an "inner imitation," which

"takes place, for my consciousness, solely in the observed object. . . . In a word, I am now with my feeling of activity entirely and wholly in the moving figure. . . . This is esthetic imitation" (quoted in Spector 1973). In his great treatise *Ästhetik* (1903–6), Lipps further developed the theory that the appreciation of a work of art depended upon the capacity of the spectator to project his personality into the object of contemplation.

Although when phrased in this manner Lipps's notion seems to resemble Freud's idea of "projection" (which was also being developed during these same years), it is difficult to be certain, since in elucidating *Einfühlung* Lipps was inconsistent and ambiguous (see Arnheim 1986). As used by Freud, projection referred to the phenomenon found in cases of hallucinatory paranoia and other defensive states in which persons would ascribe their own undesirable drives, feelings, and sentiments to other people or to the outside world rather than recognizing that these states belonged to themselves.

Freud, whose library contained works by Lipps to which he referred with admiration, himself used the word *Einfühlung* in early writings. In *Three Essays on the Theory of Sexuality* (1905/1953), for example, he mentioned the primitive connection between the senses of sight and touch, both of which originate in a sexual impulse to "feel into." Later the same year, in "Jokes and Their Relation to the Unconscious" (1905/1960), Freud appeared to develop a concept rather similar to *Einfühlung* in his notion of "ideational mimetics": he attempted to explain what occurs physiologically when ideas of largeness and smallness are imitated physically, as when a person describes a mountain by holding his hand high or a dwarf by holding it low, opens the eyes wide to mean "big" and squeezes them shut for "small," or alters the pitch of the voice to indicate relative size. He proposed that "during the process of ideation innervations run out to the muscles"; people express largeness and smallness in the contents of their ideas by means of a greater or lesser neurological expenditure in a kind of synesthetic economy termed *ideational mimetics*.[4] He used the word *Einfühlung* to describe this process of mentally behaving as though one were putting oneself in the place of the person observed.

Freud gradually stopped using the word *Einfühlung*, perhaps at least in part because of contemporary criticisms of its meaning and application by influential adversaries of Lipps such as Max Scheler and other phenomenologists of the school of Husserl (Spector 1973).[5] However, although Freud never developed a systematic aesthetics and said little about artistic perception and emotion in art, his ideas nevertheless have relevance to the concerns of empathy theorists such as Lipps. For example, Freud's

observations on dream symbolism extend the notion of ideational mimetics and apply to aesthetic theory. He noted, for example, that when consciously concerned about, say, correcting a troublesome passage in an essay, one may dream of planing a piece of wood to smooth out rough edges, or that when attempting to follow difficult trains of thought, one may dream about difficulty mounting a horse that pulls further and further away (Spector 1973). These physical analogies foreshadow T. S. Eliot's (1919/1980) notion of the objective correlative in poetic expression.

We can visualize the early years of the twentieth century as a battleground in aesthetics between romantic theories based on a nineteenth-century notion of Imagination, which attempted to elucidate the representational or symbolic content of works of art according to new scientific concepts (projection, *Einfühlung*, ideational mimetics), and more modern theories that attempted to incorporate primitive and non-Western as well as post-1900 European art into their purview and thus found it necessary to emphasize form at the expense of traditional ideas of representation or content. Both camps saw themselves, correctly, as being on the threshold of the new: the former by looking at the art of the past with new scientific eyes, the latter by including contemporary art, the art of other cultures, and previous European art all together as "art."

These two general notions became sharpened and polarized in Wilhelm Worringer's influential book, *Abstraktion und Einfühlung* (1953), written in 1906, published as a doctoral dissertation in 1908, and republished commercially in 1911. Whereas previous critics and theorists had evaluated works of art according to their success at copying nature, Worringer asserted that the apparent clumsiness or unnatural renderings of non-Western and contemporary European artists were due not to their inability to imitate nature but rather to their quite different purpose or starting point. Worringer saw abstraction and empathy as epitomizing two antagonistic impulses, and placed his sympathy with the former. Nevertheless, he did not altogether reject *Einfühlung*, explaining it as arising from a legitimate pleasure found in the organic and vital that did not want merely to imitate the objects of nature but rather "to project the lines and forms of the originally vital . . . outward in ideal independence and perfection [and thus] to furnish in every creation a stage [arena] for the free, unimpeded activation of one's own sense of life" (quoted in Arnheim 1967). Worringer distinguished between slavish imitation of nature lacking *Einfühlung*, which can be weak and mechanical, and naturalistic art achieved through *Einfühlung*, which has organized form.

Yet, although he considered the empathic rendering of nature to be a

legitimate artistic goal, Worringer claimed that there was more to art. He pointed out that large numbers of human groups both now and in the past had not approached nature with the trustful familiarity inherent in *Einfühlung*, the affinity of man and nature that easily served the art of classical Greece and the Renaissance, and proposed an early version of imposing culture on nature (cf. Chapter 4 above). He argued that primitive humans, feeling anxiety and fear in the face of the unpredictability of nature, created as a countermeasure geometrically lawful shapes that they preferred and perpetuated because their order and regularity seemed to control or to replace disturbing chaos. This manufacture of and preference for the geometric or antiorganic Worringer called *Abstraktion*.

By polarizing empathy and abstraction to refer to naturalistic and nonnaturalistic art, respectively, Worringer assured that empathy became increasingly untenable as a respectable or accurate description of aesthetic creation or experience. It did not help the *Einfühlung* case that Lipps, its greatest theorist, was aesthetically conservative, referring to the stylization of nature into geometric shapes as "unkunstlerische Barbarei," or inartistic barbarism (quoted in Wind 1965). Freud too all his life dismissed or ignored the nonmimetic and abstract art of his time. Thus many thinkers who wanted to include nonrepresentational art in their theory of aesthetic experience dismissed the relevance of "empathy" because it was tainted by the conservatism of its proponents. The popularity of Worringer's book, endorsed by the influential formalist Heinrich Wölfflin, who at the time occupied the prestigious chair in art history at the University of Berlin, assured that *Einfühlung* was soon pushed aside as an intellectually outmoded and even laughable theory.

A roughly similar story occurred in England. Independently of Vischer and Lipps, Vernon Lee (the nom de plume of Violet Paget, a peripheral member of the Bloomsbury group) elaborated a similar theory of *Einfühlung*, which was subsequently enriched by her discovery of Lipps's book. Lee first alluded to the concept in a lecture given in 1895 (later published as *Laurus Nobilis: Chapters on Art and Life* [1909]) where she called it "sympathy." By 1913, however, in *The Beautiful*, "sympathy" had become "empathy" and was defined as "a tendency to merge the activities of the perceiving subject with the qualities of the perceived object" (quoted in Reed 1984, 7).

In *The Florentine Painters of the Renaissance* (1896/1909), Bernhard Berenson stated that art awakens our consciousness of the "tactile sense" in our physical and mental functioning, giving us a heightened sense of capacity and enhancing our lives: "[Tactile values stir] the imagination to feel [the works'] bulk, heft their weight, realize their potential resistance,

span their distance from us, and encourage us, always imaginatively, to come into close touch with, to grasp, to embrace, or to walk around them."[6] Geoffrey Scott, in *The Architecture of Humanism* (1914/1924), introduced "empathy" as "a revolutionary aesthetic." The word became a permanent contribution to the English language and appears today in the *Supplement* (for words added after 1928) to the *Oxford English Dictionary*, and has been used frequently in writings on the arts and on aesthetic experience (as well as having been more recently and influentially appropriated by psychoanalysis and popular psychology). Rebecca West (1928/1977), for example, wrote about "the active power of empathy which makes the creative artist, or the passive power of empathy which makes the appreciator of art" (102).

Nevertheless, the growing influence of formalist approaches like those espoused by Clive Bell (1914) and Roger Fry (1925), which were concerned with establishing the aesthetic validity of the nonnaturalistic aspects of postimpressionist painting and sculpture, meant that empathy as a theory, like *Einfühlung*, was tarred with the brush of conservatism and reaction. Few seemed to appreciate that with appropriate changes, empathy, or at least the physical phenomena of aesthetic experience that empathy had tried to explain, could apply to nonrepresentational art as well as to representational art.

To be sure, one can find statements or even entire theories that, while not using the term "empathy," actively attend to its general aims.[7] For example, Victor Lowenfeld (1939), an influential art educator, stressed the importance of *kinesthesis*, the awareness of tensions inside the body, made possible by neural receptors in muscles, tendons, and joints, and *tactility*, the exploration by touch of the shape of physical bodies, in appreciating art. He called both of these processes *haptic perception* (*haptic* derives from the Greek word for "fasten"). The Scottish psychologist R. W. Pickford (1972) adopted the term "haptic" and claimed that the creation and perception of visual art, as well as other perceptions, involve the externalization of inner feelings and experiences, particularly bodily sensations of muscular movements, touch, and vibration.

Gestalt psychologists, notably Rudolf Arnheim, have made cogent and insightful contributions to uniting mind and body in aesthetics. Any modern account of empathy will owe much to Arnheim's pioneering and incomparable work. The philosopher Susanne Langer (1953) intuitively echoed empathy theorists when she made such remarks as "music sounds the way emotions feel."[8] Further, Peter Kivy's writings on the aesthetics of music (e.g., 1990) consider it to be "a 'sound map' of the human body under the influence of a particular emotion" and to be "expressive in

virtue of its resemblance to expressive human utterance and behavior."

In writing about dance, John Martin (1965) calls kinesthesis a "sixth sense," a kind of "inner mimicry." He claims that it is our human capacity involuntarily to mimic, to go through the experiences and feelings of others, that allows us to understand and also to participate in art form. Here Martin combines the psychoanalytical and aesthetic meanings of "empathy," without actually using the word.

Richard Wollheim (1968, 28) has written that "[W]hen we endow a natural object or an artifact with expressive meaning, we tend to see it corporeally: that is, we tend to credit it with a particular look which bears a marked analogy to some look that the human body wears and that is constantly conjoined with an inner state." Other British art critics such as Adrian Stokes (1978) and Peter Fuller (1980, 1983), whose general orientation derives from the object relations psychoanalytic school (commonly associated with the work of Melanie Klein and her followers), emphasize the intensely physical and bodily origins and concomitants of aesthetic experience. They could well be labeled contemporary empathists, were anyone to revive and refashion that label.

Yet, despite these isolated or little-heeded instances, and even though such significant and influential poets as Baudelaire, Rimbaud, and Mallarmé claimed that words or sounds embodied colors and other sensations or feelings, and painters from Seurat to Kandinsky associated feelings and ideas with certain lines, colors, and even abstract forms, the potential of empathy to make a serious and credible contribution to aesthetics has been largely overlooked. In contemporary books on aesthetics or art criticism, empathy theory, if mentioned at all, is included only as a dismissible curiosity of marginal historical interest.

The Natural History of Empathy

It may appear unwarranted and unproductive to join together thinkers as diverse as Freud and Berenson with proponents of dated and largely forgotten empathy theories such as Lipps or Vernon Lee. And, as even this brief review makes clear, the concept of empathy itself, as articulated by its proponents, has serious shortcomings. Nevertheless, I believe that the theorists mentioned here, in their use of such diverse terms as *fühlen sich hinein, mitsehen*, tactile values, ideated sensations, ideational mimesis, inner imitation, *Einfühlung*, and empathy, can be considered to be a group describable under one label: "empathists" (whether proto-, closet, or actual). I will consider them as adherents of the view that we

cannot properly understand aesthetic experiences apart from the psycho-
biology of sense, feeling, and cognition. And as psychobiological entities,
of course, human perception, cognition, and emotion have evolved to
characterize us as a species and to contribute to our survival. They are the
way we work, the way we are.

The remainder of this section presents in an elementary fashion some
current neuroscientific findings about the way we perceive, think, and
feel. Please note my use of the qualifying adjective "elementary." My
presentation might erroneously suggest a unitary agreement that does not
exist; controversy and disagreement mark this complex field, and no
overall integrative idea of how the information fits together has yet
emerged. The presumption of a nonspecialist who chooses to graze
among competing theories may seem rash to specialists in the midst of
this research who are aware of the difficulties.

However, I think the exercise has value in indicating to other nonspe-
cialists how aesthetic empathy may occur and why artworks may affect us
as they sometimes do. Whereas details and emphases may change, and
new findings may suggest further speculations, I believe that the individ-
ual pieces described below will eventually fit coherently into the total
puzzle and thus substantiate my belief that the kinds of feelings compris-
ing aesthetic empathy arise from our natural being-in-the-world and thus
have a "natural history." To biologists, such a statement will be self-
evident. But nonscientists have probably never even considered the mat-
ter. Therefore, I invite them to think in a new way about how the arts,
using our sensory-cognitive-emotional equipment, access and express the
world and ourselves in it.

Brain and World: Perceiving, Thinking, Feeling, Acting

No matter how informed we become about the unimaginably im-
mense cosmos or the equally unimaginably small universes of atoms, our
mind and senses have evolved to deal with a world of human proportion,
scale, and relevance. Along the spectra of color wavelength, sound fre-
quency, odor molecule density, tastebud receptivity, and touch sensitiv-
ity, we are responsive to those elements that have affected the survival of
our kind, but we are quite unaware of, say, infrared or ultraviolet as
colors, pheromones that lure male moths to their mates, and so forth. We
find millions and millionths—whether of dollars, miles, seconds, or
grams—equally difficult if not impossible to comprehend.

To be sure, our confinement within certain sensory limits can be partly
transcended by conscious intellectual effort. We use tricks of abstraction

such as numbers and other symbols to stand for these otherwise incomprehensible things, or we invent instruments that allow us to penetrate outer space and to peruse inner matter. And, of course, we can train our senses to perform more accurately, to detect smaller differences in pitch or to discriminate one cabarnet sauvignon from another.

For all practical purposes, however, perception remains tethered within the finite limits of our fundamental species sensory equipment, with respect not only to the classic five senses but to others as well: our subtle awarenesses of our position in space, to the effects of light, electromagnetism, atmospheric pressure, and conceivably even to psychic vibrations. We have surely evolved to operate with the specific gravity of the earth rather than with that of the moon or Jupiter.

All of this means that we have evolved in a world and are designed to live in that world, although our also evolved but overdeveloped ability to "leave" that world and to construct whole realms of abstract thought or fanciful imaginative alternatives permits us to disguise or forget our ultimate dependence on that inescapable base reality (see Chapter 7). Knowing seems to occur within our person, insulated from the outside world, particularly when we remember or imagine. Yet it is important to recognize that in large measure everything we know is ultimately based on our bodily senses: what we see, hear, and touch, in particular.[9] Thus, although from the time of Plato and particularly since Descartes it has commonly been presumed that knowledge, spirit, mind, soul, and even "experience" (what we "are") are separate from body, as sky is different from earth, there is another way to regard our minds and bodies: as interrelated, not only with each other but also with the world.

According to James J. Gibson (1979, 126), whose new perceptions of old notions of perception are rich and provocative, as we learn about the world, we learn about ourselves, and the two are inseparable. As bodies in the world, we perceive our environment in terms of what it provides or furnishes for our lives, for good or ill, what he calls its "affordances." A water surface is something different to a waterstrider, to a fish, and to us. The abstract physical properties so dear to perceptual psychologists and philosophers (size, shape, color, weight, mass, chemical composition) occur in the world only in a very specialized sense that is secondary to its affordances for support, nutrition, manufacture, manipulation, even companionship or betrayal (for other people are affordances too).

According to Gibson's "ecological" approach to perception:

The theory of affordances is a radical departure from existing theories of value and meaning. It begins with a new definition of what

value and meaning *are*. The perceiving of an affordance is not a process of perceiving a value-free physical object to which meaning is somehow added in a way that no one has been able to agree upon; it is a process of perceiving a value-rich ecological object. Any substance, any surface, any layout has some affordance for benefit or injury to someone. Physics may be value-free, but ecology is not. (1979, 140)

An affordance . . . points two ways, to the environment and to the observer. So does the information to specify an affordance. But this does not in the least imply separate realms of consciousness and matter, a psychophysical dualism. It says only that the information to specify the utilities of the environment is accompanied by information to specify the observer himself, his body, legs, hands, and mouth. This is only to reemphasize that exteroception [recognition of stimuli produced outside an organism] is accompanied by proprioception [recognition of stimuli produced within an organism]— that to perceive the world is to coperceive [perceive at the same time] oneself. This is wholly inconsistent with dualism in any form, either mind-matter dualism or mind-body dualism. The awareness of the world and of one's complementary relations to the world are not separable. (1979, 141)

Gibson's ecological basis for perception should remain as an ostinato or pedal point that grounds our understanding of all human sense experience. And with its insistence on the interpenetration of self and world, Gibson's ecological approach with its inherent bodily awareness provides a foundation for a theory of aesthetic empathy. He says, for instance, that one sees the environment not with the eyes, where most theories of visual perception begin, but "with-the-eyes-in-the-head-on-the-body-resting-on-the-ground" (205). That is, there is visual kinesthesis along with muscle-joint kinesthesis—both apprehended with respect to the earth and other affordances.

Knowledge about the structure and function of the brain further suggests how kinesthesis and other "empathic" phenomena may occur. Visual neuroscientists tend to agree that in the earliest stages of vision images are broken down into relatively simple context-independent parts and properties by different processing areas that are each specialized for the analysis of a particular stimulus feature, for example, color, brightness, orientation of lines, edges, direction of movement (Hoffman 1986; Treisman 1986). These areas, or modules, comprised of a pattern of

signaling activity in the cells, are called "maps" because they encode a spatial (or aural or tactile) representation of the world on a sensory region of the cerebral cortex. Our conscious experience of visual perception does not occur until "late" in the processing sequence, after the features have been reassembled. We see a book, not edges, color, and receding lines. Whereas this finding goes against common sense, it is important to appreciate that when the retina's photosensitive cells "observe something," the brain does not receive this visual scene as whole "complete" picture (in the manner of photographic film in a camera) but rather according to different features that are stored as such and have to be reassembled again within the brain.

Similar processing and mapping take place for hearing, movement, and touch. These sensory inputs are combined and categorized (often together with an emotional association—see below) in other brain regions in higher orders of abstraction and hierarchy. What we call knowing, or more precisely "cognition" ("those internal processes that are involved in the acquisition, transformation, and storage of information," Zajonc, 241) is a higher level process that takes sensory input and transforms it according to a specifiable code into "representations" (241). A neural "representation" is not a little picture or image; it is a pattern of relative synaptic strengths within the brain's neural networks.

What is interesting and most relevant for an understanding of aesthetic empathy is that the same item can be processed in different ways, depending on what is required (Bever 1983). In fact, an item can be multiply represented in separate and somewhat independent (parallel) processing modules (Gazzaniga 1985, 22–23) that are interconnected in associative networks to each other and to other percepts. For example, a phrase such as "naughty cat" can be encoded verbally in terms of its sound, as visualized words, as the meaning of those words, as an image of what the words suggest, and, if sung, even as a musical phrase. Such redundancy means that several bases are covered at one "go"—thus people whose verbal language functions have been injured can sometimes be taught to speak or to understand language by melodic intonation therapy or by rhythmic tapping (Helm-Estabrooks 1983) or even with visual images (Fitch-West 1983). We all have had experiences of trying to recall a word, phrase, or name but of retrieving only something oddly similar. Once, at the end of an afternoon of visiting art galleries, including an exhibition of paintings by the German painter Lovis Corinth, a friend and I were looking at a reproduction of a picture of a small-breasted standing female nude with a sly smile on her face, which I recognized. I was vainly trying to recall the name of the painter for my friend and

finally said, in desperation, "It's *like* Lovis Corinth," knowing that could not be right. Later we saw the artist's name: Lucas Cranach. Obviously my brain had been searching among the different memory modules or representations that had coded the initial letter and shapes of the written names, even the number of letters and some placement of vowels and consonants. This kind of experience happens all the time in dreams.

The physiological functional processes of perception and cognition reported above sound, as described, quite mechanical—if marvelously intricate. Indeed they are. Yet to the perceiver and cognizer, they may be, of course, full of and ripe with significance and meaning.

One role of emotion (and cognition—there is controversy about which is primary and whether one can occur without the other) in the process I have just described seems to be to add meaning, that is, to apprise the organism of what needs to be acted on. To give an elementary example: I breathe without much if any thought or feeling, although if respiration should be interfered with, autonomic nervous system mechanisms will be activated to restore homeostasis. These endocrine and other responses will create an intense need (felt "emotionally" as panic, urgency, fear) and will motivate me to act and to search for ways to try to breathe naturally again. In another example, as I write this chapter, my brain is registering (sensorily, apart from "thought") such things as the pressure of my pen on the paper and against my fingers, the sounds of birds chirping outside, a car passing, an overhead distant airplane, the green paper on which words appear. These are all being "detected," "filtered," or analyzed in their separate elements, and then combined, categorized, and evaluated in higher brain centers. Most of the above will be ignored and forgotten, but should the doorbell or telephone ring, the heating system fail, or my pen run out of ink, these percepts will generate emotion and will require more than mere registering and forgetting: I will pay attention to and then act (perform motor activity) with regard to them. Simultaneously, feelings of elation, sadness, or anxiety may be caused externally by things I happen to think about or internally by hormones or other neurochemicals: I will attend to and act on any that are more salient than the writing I am also motivated to keep doing.

According to some researchers (LeDoux 1986, 335), stimulus evaluation precedes and constitutes the basis of emotional expression. That is to say, when sensory input is processed cortically (as described above), it is also compared with stored (i.e., learned or "hardwired" [inherited]) information or knowledge and is evaluated as to whether the organism must do something about it (act). In other words, emotional coloration or "meaning" is added.

According to this and related views, emotion has evolved, as I suggested in Chapter 2, to make us care about what to seek and what to avoid. Thus awareness of our feeling, the subjective experience of this evaluation, is not simply a by-product but has a real function in the evolution of behavioral control by the individual and in social communication (Buck 1986, 281–85). In the simplest sense, then, whether something is emotionally attractive or aversive is generally a clue to its evolutionary benefit or detriment.

While neuroscientists and cognitive psychologists are required to specialize and thus to investigate either perception, emotion, learning, or attention (using one type of stimulus on one particular brain area of one particular anesthetized animal), it is obvious that for real organisms in the real world all of these processes occur simultaneously. They are experienced phenomenologically by the individual as one, as Gibson emphasizes in his "ecological" approach. I have described them as separate, at the risk of distortion and oversimplification, to provide background for my claim that aesthetic experience does not differ in any appreciable way from nonaesthetic experience, but like it is composed of perception, evaluation by matching and comparing, association, and accompanying emotional tone. What we call "aesthetic" are those perceptions that have more than usual emotional and cognitive interconnections and resonances, often felt to be "undescribable" or "ineffable." Before looking at some natural aesthetic predispositions, I will complete my account of brain structure and function with a brief introduction to current knowledge about cerebral lateralization.

For nearly a century it has been known that the right and left hemispheres of most human brains are specialized for different types of processes. Since the early 1960s a great deal of systematic research has been focused on mapping and understanding these specializations. Although in normal people the two hemispheres interact simultaneously, discovery of their specializations has important implications for the understanding of every aspect of human behavior and endeavor, including cognition, epistemology (what we can know and how we know it), language, and the arts.

Popular psychology has capitalized on the simplistic dichotomies of the two cerebral hemispheres, instructing us about how to "draw with the right side of the brain" and so forth. The left brain is popularly considered to exemplify rigidity, analysis, and "patriarchy" due to its association with temporal processing, language, sequential thought, and abstraction. The right brain, by contrast, is "holistic," intuitive, and "feminine" due to its association with visuospatial processing, emotion, imagery, and analog-

ical thought. Hence, to many critics of Western rationality and science, the left hemisphere is the villain and the right hemisphere the wronged maiden in an unequal struggle for control of the predominant stance toward the world. My interest here in hemispheric specialization is not to take the side of one at the expense of the other, for, in fact, like long-married partners, right and left brain hemispheres cooperate intimately for normal human functioning, can each do some of the work of the other, and must each contribute to the full functioning of the other.

An awareness of hemispheric specialization is relevant to an understanding of the psychobiology of aesthetic empathy, however, because it provides an explanation for often impossible-to-verbalize yet strong associations we make between one stimulus (a word, phrase, image, sound) and another. Research findings indicate that under most circumstances the right hemisphere is to a great extent if not wholly mute. Hence, because percepts are not verbalized, those that register and are stored there may not be "conscious" (see below). Experiments show that "split-brain" (comissurotomized) patients who "look at" a picture or other stimulus with their right hemisphere alone *say* that they do not see anything. This is the left hemisphere (which has not seen the stimulus) "talking." It takes over because the right hemisphere cannot speak. Yet when asked to draw what it sees, the left hand (controlled by the right hemisphere) draws a bicycle, or apple, or whatever the stimulus was. Looking at the drawing with both eyes (and thus both hemispheres), the person says (again, "talking" with the left hemisphere) "I don't know why I drew that" (Gazzaniga 1985, 97).

Such experiments indicate that rich cognition can exist without language (and language does not presuppose rich cognition). Cognition is *there*, though without words to describe it we do not consciously recognize that it is. As Gazzaniga (1985, 86) says, "most of the modular processing units can compute, remember, feel emotion, and act and need not be in touch with the natural language and cognitive systems underlying private conscious experience."

Nonlinguistic avenues of processing and expression—notably images, patterns, music, emotional intonation, and emotion in general—are as much a part of human experience and knowledge as language. But we can easily overlook or minimize them because language, like a competent and bossy older sibling, steps forward, hogs the limelight, and overrides the halting bids for attention of its inarticulate brothers and sisters. But extensive information processing is going on in the brain independent of verbal processes (Levy 1982).

Gazzaniga views the brain as a "confederation" of separate and some-

what independent processing modules, as described above, with a special brain component in the left hemisphere that he calls "the interpreter," whose job it is to construct a theory to explain why we do what we do. In a broad sense, he says, what we hold to be conscious experiences are verbally tagged memories that are associated with the interpretations we have given to our behaviors. According to this view, Freud's id or "unconscious" (the "primary process" described near the beginning of Chapter 5) could well be located in the nonverbal, nontemporal, "emotional" right hemisphere.

Yet, in an important sense, I think it is erroneous to equate consciousness or self-awareness with natural language ability, as do most neuroscientists (e.g., Gazzaniga [1985], Bever [1983], LeDoux [1986] who also cites Griffin and Luria), or with the cognitive capacities that make language possible (e.g., the left inferior parietal lobule described by LeDoux [1986]). I think this is too narrow a view of consciousness, which is surely possessed by language-impaired adults after injuries, preverbal children, and at least some nonhuman animals. A right-hemisphere "interpreter" would be undetectable by usual methods, yet could well exist: experiments with split-brain patients (Sperry, Zaidel, and Zaidel 1979) have demonstrated significant right-hemisphere social and self-awareness. In any case, our concept of "consciousness" (as well as our concepts of "awareness," "attention," "learning," and "memory") will undoubtedly require modification as we learn more about how the mind-brain actually works (Churchland 1986, 321, 368)

It seems improvident for natural selection to have fashioned and preserved an entire half-brain that is not "conscious." I agree with Buck (1986, 364), who feels that conscious experience of emotion and other subjective events has evolved hand-in-hand with the ability to have an internal cognitive representation of the environment (which need not be verbal), so that "consciousness is widespread in animals in direct proportion to the cognitive abilities of the species in question" (see also Levy 1982). In their language-centrism, today's neuroscientists resemble twentieth-century philosophers (see Chapter 7).

In any event, we can say that the human brain is a storehouse of emotionally toned, nonverbal, perceptual-motor memory structures, whose components are tightly integrated in associative "webs" or networks. [10] A new stimulus can be perceived in terms of others that share resemblances with it in any number of different parameters. "Lucas Cranach" and "Lovis Corinth," for example, are both names, both have similar sounds and syllable lengths, both share "Germanness" and connection to the arts, and so on. We can experience a Doric column in

terms of the perceptual/sensory/motor/emotional characteristics it shares with thousands of other things we have experienced, whether verbalized and verbalizable or not: verticality, the act of rising, curve and spring, strength, whiteness, antiquity, placement in a row, the association with the referents of its consonantal sounds: "derrick," "door-ic," a person named Doric. The symbolism of dream, myth, and visual art makes use of this interchangeability of shifting sensory images with their attached feeling tone that, if considered rationally, may seem inexplicable, or faintly "déjà vu."

And one's verbal, left-hemisphere "interpreter" can make "sense" of these unformulated percepts. Hence, I can tell a friend about, say, writing this chapter: "It's like taking a big clotted matted ball of yarn or fibers and trying to untangle skeins of different colors and to arrange them into a coherent pattern." Having said this, I have expressed something. No doubt there remain other ways to describe it, left unrecognized, mute, unformulated, sunk back into their cells, maps, and networks until joggled by another percept or wish to describe.

The above brief and elementary overview of the psychobiological processing of environmental information allows us now to examine a number of universal protoaesthetic features of mental life that I have chosen to treat under the resurrected term "empathy" as fundamental to understanding our responses to the arts.

In summary: Gibson's ecological model of visual perception emphasizes the idea that we are bodies in a world, and that "exteroception" (recognition of stimuli produced outside an organism) that contains information about the concreteness of the world is necessarily accompanied by "proprioception" (recognition of stimuli produced and perceived within an organism) that contains information about our embeddedness in the world. This postulate is borne out by the above description of human brain structure and function, where different components of a perception are analyzed individually in separate and somewhat independent processing modules, then stored in different modalities as "representations," not all of which are accessible to verbalization.

Representations are connected in various associative networks on the basis of their different sensory-emotional features. We will see—in the discussion of analogy later in this chapter—that even in preverbal infants, cross-modal association and matching ability in such stimulus dimensions as intensity, contour, shape, temporal beat, rhythm, and duration are inborn and obviously important capacities. One sensory-emotional-motor awareness can subconsciously suggest others that resemble it in one or a few features. These shapes or semblances, insofar as they can

be described at all, may seem not only "mental" and "cognitive," but also obscurely or inexplicably physical, bodily, kinesthetic—that is, "empathic." They seem ineffable because many of the components of the network, especially the motor/emotional ones, may not be accessible to left-hemisphere linguistic interpretation and, hence, to full articulate consciousness.

With this background, we can now examine some specific universal predispositions in human perception/cognition/emotion that are "empathic" in this sense. They may be called "naturally aesthetic" or protoaesthetic insofar as they are among the perceptual-cognitive-emotional elements that *Homo aestheticus* uses to make existence and experience special. When thus utilized (for aesthetic—"special"—effect), they can produce emotional responses that are compelling, insidious, and expressive because they elude the usual interpretive verbal explanations and instead set up resonances among other (universal or individual) nonverbal sensory/emotional representations.

Naturally Aesthetic Predispositions

SPATIAL THINKING

Western culture since at least the time of the Greeks has manifested a tendency to think of thinking as a careful, rational, orderly, somewhat lofty procedure of examining alternatives, constructing logical arguments, and arriving at truths. But what the West envisions as "thought" is really only one special kind of mentation, one that requires training with words and other symbols, and that employs abstractions from the concrete actual world and its affordances. Neurophysiologists describe the activity of human thought more broadly as an activity that involves the transformation of represented information from one form to another (Bever 1983, 25). Perceptions of what one sees, hears, or reads, for example, are transformed into representations in the mind: these are stored as knowledge, are perhaps acted on, and may be retrieved, combined, and transformed into other representations, and so forth.

The neurophysiologists' way of thinking about thinking not only accounts for rational abstract thought but also acknowledges that other quite normal but nonverbal mental transformations can be considered as kinds of "thought" as well. Indeed, Howard Gardner (1983) in an influential book has identified some of these mental propensities, which he calls "frames of mind." Of special importance to living organisms is what Gardner and other psychologists call "spatial thinking."

The position of our body in space, the amount of space we occupy, the

spatial distance between us and other objects—these are all existential givens of which we have unverbalized tacit awareness. Space is largely visually perceived, but even with our eyes closed we are still aware of our position (e.g., whether vertical, tilted, or resting horizontally), and the muscular, kinesthetic feeling of our occupation of space. Spatial awareness is so unconscious and pervasive a part of our being-in-the-world that we may not realize the degree to which we perceive and act in our everyday lives on the basis of concepts of objects, persons, and events that are in large part constructed out of *spatial* features and relations (Olson and Bialystock 1983).

Different cultures place different degrees of emphasis on conscious awareness of body self and its orientation in space—the Balinese, who always know where they are in relation to the sacred mountain Gunung Agung, are perhaps the most extreme in this regard (See Belo 1970; Mead 1970). But being human (to be precise, being an animal) entails awareness of one's own body orientation and boundaries,[11] an awareness that extends in all but the simplest creatures to territorial and even social boundaries.

Although these spatial concepts are, at bottom, unverbalized, human languages contain a large number of spatial terms that fall into classes of adverbials (here/there); prepositions (up/down, on the left/on the right, at the front of/at the back of, in/on, by, above/below); adjectives (big/small, long/short, wide/narrow, thick/thin, deep/shallow); and nouns (top/bottom, left/right, front/back, side/end). Olson and Bialystock point out that in English (and presumably in other languages) these spatial terms have several common properties that include: (1) all assume a point of reference—the speaker or some other object; (2) they are organized around particular dimensions such as verticality or length; (3) the terms come in contrastive polar pairs specifying the dimensions, as in the following:

Dimension	Contrastive Pair
where:	here/there
vertical:	up/down; high/low; above/below
horizontal:	right/left
frontal:	front/back
length:	long/short
distance:	far/near
height:	tall/short
width:	wide/narrow
depth:	deep/shallow
thickness:	thick/thin

Humans, like every other living organism, are provided at birth with "detectors" for the events that are likely to be relevant to their lives (Young 1978, 70). To walk upright on two legs and to use our hands and fingers precisely requires skills of balance, keeping track of one's location, estimating distances, recognizing visual patterns, and being able to solve other problems that themselves require a capacity for recognizing and forming appropriate mental representations of space.

The generality of spatial abilities, their universality, and their ease of acquisition all suggest that they are innate, part of the cognitive equipment passed on genetically as one of the important ways the brain works. One could say that spatial cognition begins (in a Kantian or Lévi-Straussian manner) as internal "structures" of the mind that are used to model "reality," constructing representations of objects, patterns, and events, including the self. They are among the codes, categories, or initial states of the mind out of which more complex perceptions, conceptions, lexical structures, and sentence meanings are composed.[12]

COGNITIVE UNIVERSALS

From the myriad sounds, sights, tastes, odors, and other perceptions of the external world, our senses and minds have not only to choose which ones to attend to, as described above, but also to store (i.e., organize and categorize) appropriate information once it is taken in so that it can be retrieved and used as needed. This is done according to ordering or coding principles,[13] two of which, binarism and prototype recognition, seem particularly relevant to an understanding of aesthetic empathy.

The description of spatial thinking indicated that we often perceive and organize experience in terms of opposing or contrasting pairs: up and down, large and small, deep and shallow, and so forth. The concept of one quality or aspect of experience (e.g., "long") seems to include the simultaneous latent idea of its opposite ("short"). Not only spatial but other qualities are classified binarily: good/bad, ripe/immature, rich/poor, and so forth. Linguists have described the importance of dyadic principles in our unconscious recognition and use of sound pattern (e.g., voice/voiceless, strident/mellow) and grammatical structure (Jakobson and Waugh 1979).

Binary categories seem to generalize easily to social phenomena (such as adult/child, we/they, sacred/profane, culture/nature), so that a considerable theoretical literature has grown up around the subject of binarism. It is a key feature in structuralist anthropology and linguistics (e.g., Jakobson 1962; Lévi-Strauss, 1963, 1964–68). Neither discipline, how-

ever, attempted to ground itself in cognitive psychology or biology, which could have provided empirical support for some of their claims. Whether binarism is a feature in all mental functioning, it is most certainly important and pervasive, leading us to be responsive overtly and tacitly to polarities and oppositions, and associating these metaphorically and analogically with many aspects of our experience.

As human perception sorts diverse incoming stimuli into meaningful categories (whether binarily or otherwise), it seems to have a representation of some as being best instances or prototypes of their particular category—the central or average representation of the class (Rosch 1978). When new stimuli are encountered, the brain assigns them to a perceptual category based on how closely they resemble the category's prototype. For example, although we may actually be able to discriminate hundreds of different hues, we tend to group these in our minds as a finite number of nameable colors. We recognize red or blue as prototypes, and note that some hues are light or dark red, bluish-red, brick red, and so forth, all with reference to the central or prototypical feature of redness.

With regard to language, we group the smallest units of language—vowel and consonant sounds—into acoustic categories. We perceive some sounds as better examples of a category than others, but remain able to understand our language even when it is pronounced and distorted by people with regional or foreign accents or speech impediments. Geometric forms such as the circle, square, and equilateral triangle become prototypes for shape recognition: for example, young children draw faces, which are not really circular, as circles. As I pointed out in Chapter 4, geometric shapes have become the basis for decorative patterns in the arts all over the world. Similarly, we can recognize the aging face of a friend we have not seen for twenty years. Facial expressions of the emotions for happiness, sadness, anger, fear, surprise, and disgust are also apparently coded prototypically (Ekman, Friesen, and Ellsworth 1972), and can become schematized into prototypes (Leventhal 1984) so that subjects can distinguish the best representation of a given emotion.

Organizing experiences according to average or prototypical features is obviously an economical way to handle a huge amount and variety of information, despite errors that must occur as a result of sometimes overgeneralizing. The fact that young infants (and even pigeons) can form concepts and abstract prototypes from individual members of a category (Cohen and Younger 1983; Quinn and Eimas 1986; Grieser and Kuhl 1989) indicates how important this ability is.

"Beauty" has usually been thought of as the exception rather than the rule. However, a recent study that examined college students' ratings of

the attractiveness of human faces in photographs reports that a face with features that approximated the mathematical average of all faces in a particular population was chosen as being the most attractive (Langlois and Roggman 1990). The faces of ninety-six male and ninety-six female college students were photographed and converted by computer into a matrix of tiny digital units. When these were then made into superimposed composites of two, four, eight, sixteen, and thirty-two faces, the most striking physical superiority was attributed to the composites of sixteen or more faces.[14] Langlois and Roggman suggest that what is being responded to is the prototype of "faceness": "unattractive faces, because of their minor distortions . . . may be perceived as less facelike or as less typical of human faces" (119). The fact that other studies reveal that infants of three to six months also prefer attractive over unattractive faces (as judged by adults) corroborates an interpretation that prototypical faces

Examples of computer-generated composite faces converted from 4 (top left), 8 (top right), 16 (bottom left), and 32 (bottom right) photographed faces of individual female college students.

The composites of 16 or more faces were judged to be more attractive than single faces or faces composited from 8 or fewer images.

are perceived to be attractive (whether or not attractive faces are perceived as prototypes). The Langlois-Roggman study fits in not only with prototype theory in cognitive and developmental psychology but also with evolutionary theory, which predicts that in natural selection the least extreme (that is, the average or mean) values of many of a population's features should be preferred to extreme values, which are more likely to manifest harmful genetic mutations.

Langlois and Roggman are careful to point out that their analysis makes no claim to have application to aesthetics in general, and that average (composited) art is not at all likely to be attractive. While this is undoubtedly the case, an awareness of the cognitive importance of prototypes may nevertheless be relevant to understanding human aesthetic behavior. Even though prototypes may be cognitively *satisfying*, and thus will be judged "attractive" or "pleasing," it is also probably true that it is in their manipulation that aesthetic tension and hence emotion is aroused and satisfied. The arts may make use of attractive, pleasing, or beautiful prototypical elements such as circles, major triads, and pure colors, but the arts treat these elements in special ways to achieve the marked effect that we call aesthetic. The brain is prepared for or "expects" certain prototypical features once a pattern is suggested or given. Emotion results from delayed and manipulated gratification of expectation, provided that deviations from the anticipated pattern are not so small as to be predictable and boring or so large as to be incomprehensible and confusing. (See Meyer [1956] and Bernstein [1976] for accounts of how musical emotion is generated in this way.) A beautiful face, like a circle or an octave, is stable and prototypical, but it is an element whose place in a larger context will indicate its larger significance.

Other cognitive universals are suggested by a fascinating study (McCorduck 1991) that describes the struggle and achievement of abstract painter Harold Cohen to construct a computer program that would use general rules about the processing of human cognitive representations in order to allow the program AARON to make autonomous drawings. The artist's objective was different from usual computer art (computer graphics), which uses programmed forms that are pretty much an extension of the imitative paradigm of photography or the conventional use of perspective transformations. Cohen wished to devise cognitive rules, so that the resultant drawing "would be a record of the artist's [i.e., AARON's] cognitive processes" (as Cohen and McCorduck claim all art is).

To begin with, Cohen asked himself what the minimum conditions were for recognizing any set of marks as an image. Among the cognitive "visual primitives," he decided, were closed outlines (or *closure*, "the

AARON computer drawings

Top: *The Conversation* (8½ × 11 inches), from the *Penny Plain* suite of litho-graphs, 1980, illustrates the evocative power of Harold Cohen's computer-generated imagery at this stage of AARON's development.

Bottom: *Simulated Portrait* (20 × 30 inches), 1991. Brush drawing made under AARON's control on a painting machine built by Cohen. Collection Dr. Diane Rothenberg. By this time, AARON's cognitive primitives have been overlaid with a significant body of knowledge concerning both the structure of the human form and appropriate strategies for its representation.

fundamental cognitive mode simply because . . . our ability to recognize objects in the world rests upon . . . [processes] in which the eye acts as an edge detector"); *division* (the line as a two-dimensional separator of space); *angles*; *scribbles*; *figure-ground* relationships: *insideness and outsideness*; *similarity*; *repetition*; and notions about spatial distribution such as "above" signifying "beyond" (64–66, 89).[15] Later, Cohen concluded that these visual primitives of his early work ultimately originate in a deeper innate tendency to "skew what we see in the direction of what we know" (104), a complex and controversial idea in philosophy and cognitive psychology which at least one recent set of visual neuroscience experiments has disputed.[16] However, the "basics" or "primitives" of spatial representation that Cohen identified do appear to be recognized and used in all drawings, from those of children to those of the most practiced professional artists.[17] (Cohen himself first began his quest for the cognitive basis of visual representation after viewing petroglyphs made by vanished Native Americans in what is now the Chalfant Valley of California.)

Cognitive universals—the features of visual perception that Cohen called "primitives" (and their counterparts in aural and tactile perception)—and organizational principles such as prototypes and binarism are the building blocks of organized perception. Their use in aesthetic contexts lets us respond to predictable satisfying regularities as well as to the tensions of their manipulation. They may well also have or suggest emotionally toned associations.

Even though closure, division, similarity, repetition, and so forth have their fundamental raison d'être in natural endowments that contribute to survival, the vital ability to recognize these cognitive universals is extended in humans to their deliberate manufacture, refinement, and elaboration. All animals can differentiate relevant figure from relevant ground, can appreciate that within a known framework an intruder or contrariety must be attended to, and can notice where one thing ends and another begins. In the continuous present that makes up an event, a day, a period of existence, there are aberrations, peaks and valleys, that are recognized because they differ slightly or contrast markedly from what is perceived as normal. Repetition is the rule, deviation the breach from which one may either benefit or lose. Hence, deviation or contrast— another universally salient "cognitive primitive"—may become, as just described in the discussion of prototypes, a source of and cause for emotion (see also the section on temporality and emotion in this chapter).

In humans, what is special (i.e., distinctive, constrastive) may acquire metaphysical significance. In every society the emotionality inherent in perceived contrasts and the associations recruited to these stimuli acquire

moral and aesthetic as well as perceptual and cognitive relevance. For example, human societies vary in their propensities to balance and harmonize or to emphasize and glorify oppositions. Some, like the Suriname Maroon, prefer sharp contrasts in their arts: of color (where the center stripes of textiles should "shine" or "burn"; where the flash of white teeth in a dark face is admired), and of position (interruptions in the main "grain" of a pattern, or abrupt "cuts" in speech, song, dance, and tale telling; horizontal and vertical design played off against each other) (Price and Price 1980).

Still other groups, in their own ways, seek to hold opposites in balance. The primary metaphysical assumption of the Navajo, for example, is the opposition between the dynamic and the static. Hence they avoid excess and seek harmony and balance by means of slow, careful, and deliberate imposition of control in both art and life. Navajo sandpaintings, the composition and design of which are rigidly established and must not be changed or altered if they are to be effective, are characterized by a

Navajo sandpainting, The Mountain Chant, *October 1937*
Sandpaintings are characterized by a rotational symmetry where circulating, dynamic movement is equilibrated and held in control.

rotational symmetry where circulating, dynamic movement is nevertheless equilibrated and held in control (Witherspoon 1977). Weaving patterns also manifest dynamic equilibration. Order, intellectualism, pragmatism, unsentimentality, and an avoidance of excess all derive from this concern with "balance," as a metaphysical as well as physical/mental/emotional principle, and are ideals of Navajo thought and behavior.

As Faris (1972) noted concerning the Nuba, aesthetic ideas of balance may ultimately be derived from the symmetry and structure of the human body: after all, ears, eyes, arms, breasts and legs come in pairs, and our singular parts, such as nose, mouth, and genitals, are centered. Yet sophisticated asymmetrical balancing is highly developed in many societies, including Nuba face and body painting (Riefenstahl 1976), Navajo weaving and sandpainting, Hopi painting in which line may be set against shade or surface quality against color (Thompson 1945), and much Middle African design where irregularities and interruptions of order are deliberately cultivated and admired as a sign of vitality (Adams 1989).

ANALOGY, METAPHOR

I mean that the ballerina *is not a girl dancing* . . . but rather a metaphor which symbolizes some elemental aspect of earthly form: sword, cup, flower, etc., and that *she does not dance* but rather, with miraculous lunges and abbreviations, writing with her body, she *suggests* things which the written work could *express* only in several paragraphs of dialogue or descriptive prose. Her poem is written without the writer's tools.

Stéphane Mallarmé, "Ballets" 1886

If our perceptions of the world and its affordances are processed and stored as many representations in different but interconnected areas of the brain that can register feeling and impel action without our conscious awareness, it is easy to understand how and why analogy and metaphor—the description or understanding of one thing in terms of another—are so pervasive in our thought.

R. B. Zajonc (1984, 243) describes musicians who, while trying to play a difficult high note, raise their eyebrows as if engaged in a matching process: "It seems as if they had in their eyebrows or tongue a representation of the ideal tone they wish to produce." Zajonc asks whether such movements are merely tension reducing or whether they represent essential cues, integral to the representation of the music.

The ability for "cross-modal matching" is apparently present from the first months of life. In his studies of mother-infant "attunement," where

in mutual play each synchronizes with and echoes the other's vocalizations, movements, and facial expressions, Daniel Stern (1985) found that in addition to imitating each other's smiles, sounds, and so forth, they also matched more general or abstract features of these behaviors. That is, the infant might accelerate the *intensity contour* of its physical movement to match the mother's vocal effort or gesture with its arm in the same *temporal beat* as the mother's head-nodding, while the mother might adapt the *shape* of her head motion to the infant's up-and-down arm motion.

Mothers and infants all over the world use echoing or matching, in the same or different modalities, as part of that everyday association with each other that psychologists call bonding. The side "benefits" of this playful interaction, which at first sight appears to be simply having fun, have been found to contribute to the baby's emotional, intellectual, linguistic, and social development as it learns to anticipate, reciprocate, cope, predict, practice, and have effects on others. Stern describes a delightful example of how attunement works:

In the videotape of the initial play period, a nine-month-old infant is seen crawling away from his mother and over to a new toy. While on his stomach, he grabs the toy and begins to bang and flail with it happily. His play is animated, as judged by his movements, breathing, and vocalizations. Mother then approaches him from behind, out of sight, and puts her hand on his bottom and gives it an animated jiggle from side to side. The speed and intensity of her jiggle appear to match well the intensity and rate of the infant's arm movements and vocalizations, qualifying this as an attunement. The infant's response to her attunement is— nothing! He simply continues his play without missing a beat. Her jiggle has no overt effect, as though she had never acted. This attunement episode was fairly characteristic of this pair. The infant wandered from her and became involved in another toy, and she leaned over and jiggled his bottom, his leg, or his foot. This sequence was repeated several times.

For the first perturbation, the mother was instructed to do exactly the same as always, except that now she was purposely to "misjudge" her baby's level of joyful animation, to pretend that the baby was somewhat less excited than he appeared to be, and to jiggle accordingly. When the mother did jiggle somewhat more slowly and less intensely than she truly judged would make a good match, the baby quickly stopped playing and looked around at her, as if to

say "What's going on?" This procedure was repeated, with the same result.

The second perturbation was in the opposite direction. The mother was to pretend that her baby was at a higher level of joyful animation and to jiggle accordingly. The results were the same: the infant noticed the discrepancy and stopped. (150)

Some mothers found misjudgements hard to execute, and one said that it was like trying to pat your head and rub your stomach at the same time.

Stern reports that from the earliest days of life infants are able to form and to react to shape, intensity, contour, rhythm, duration, and temporal pattern—all abstract representations of the more "global" qualities of experience. He concludes that babies have an innate general capacity to take information received in one sensory modality and somehow translate it into another sensory modality, and that the ultimate reference for the match is the inner feeling state, not the external behavioral event (1985, 138; see also the discussion of infancy later in the present chapter). In order to be among its earliest behavioral sensitivities, this capacity is unquestionably of crucial importance, allowing a baby to enter and participate in a social "intersubjective" world (Trevarthen 1984).

Earlier studies (Gardner, Winner, Bechhofer, and Wolf 1978; Winner, McCarthy, and Gardner 1980) found six-month-old children to be sensitive to the similarity between a heard rhythm and a set of dots in a silent film that visually "echoes" that same rhythm in space. Gardner (1983) reports that the sensitivity to cross-domain analogies continues to develop. Once children are able to talk relatively fluently, to draw, and to engage in make-believe play, they

[find] it easy—and perhaps appealing—to effect connections among disparate realms: to note similarities among different forms within or across sensory modalities and to capture these in words (or other symbols); to make unusual combinations of words, or colors, or dance movements, and to gain pleasure from doing so. Thus the three- or four-year-old can note and describe the resemblance between a glass of gingerale and a foot that has fallen asleep, or between a passage played on the piano and a set of colors, or between a dance and the movement of an airplane. (291)

Formal schooling, and especially the mastery of operational and rational thinking, seem to bury or to seriously impede the early natural analogic-metaphoric abilities, at least regarding attention to analogical

resemblances and generating new metaphors oneself. Howard Gardner and his associates found that children exhibit wide individual differences in the propensity for active metaphoric connection and creation after several years of schooling.

Yet in rarely noted ways metaphor imbues language, thought, and action, as George Lakoff and Mark Johnson (1980) have compellingly shown. Although people differ in individual metaphor-making and metaphor-recognizing abilities, language itself is full of hidden metaphors that allow us to understand and experience one thing in terms of another (e.g., in this sentence I have presented "language" as a "container" that is "full" of metaphors). The great linguist and language theorist Benjamin Whorf noted this fact in 1956: "I 'grasp' the 'thread' of another's arguments, but if its 'level' is 'over my head,' my attention may 'wander' and 'lose touch' with the 'drift' of it, so that when he 'comes' to his 'point' we differ 'widely,' our views being indeed so 'far apart' that the 'things' he says 'appear' as 'much' too arbitrary, or even 'a lot' of nonsense." Lakoff and Johnson point out that because so many of the concepts that we use are either abstract or not clearly delineated in our experiences (e.g., emotions, ideas, the notion of time), "we need to get a grip on them by means of other concepts that we understand in clearer terms."

It is interesting (as Whorf wished to show in the paragraph just cited) that most metaphors are *orientational* or spatial (up/down; front/back; on/off; deep/shallow; central/peripheral). They also tend to be *ontological* (concerned with existence, personification, metonymy), or rooted in activity (note "get a grip" in the quotation above) and the relations between things. Being and activity are also among the concerns of children when they first put words together, as Melissa Bowerman (1980) has shown. The early sentences of children everywhere are largely limited to a small set of what seem to be universal operations and semantic relationships expressed by words such as *that, there, more, no more,* and *all gone,* which refer to the existence or nonexistence, and the disappearance and recurrence of objects and events.[18]

Not only is much of the content of human thought and language expressed in terms of spatial metaphor, but perhaps even the physical configuration of speech as produced with mouth and tongue is so expressed. This amazing but credible suggestion has grown out of the work of the linguist Mary LeCron Foster, who is trying to reconstruct "PL," primordial language, the presumed common ancestor language from which all other languages have derived. Foster's hypothesis (1978, 1980) rests upon two controversial but increasingly plausible assumptions about

human language: its single origin (monogenesis) and relatively recent origin. For many years theorists believed that human language developed along with toolmaking and was therefore several million years old. Now that macaques and other animals are known to pass on to each other techniques of toolmaking, the link between tools and language is no longer considered essential. What is more, recent exciting (if controversial) studies comparing mitochondrial DNA in different human races suggest a common origin of all modern humans in Africa about 200,000 years ago (Cann, Stoneking, and Wilson 1987). Taken together, these findings give plausibility to Foster's claim (also controversial) for the emergence of PL fifty thousand (or perhaps more) years ago. (If the common modern human origin hypothesis is correct, PL would probably have arisen at least somewhat further back.)

While routinely studying "unrelated" Native American languages, Foster began to notice resemblances among words for similar referents in different languages. These seemed to her too widespread to be attributed simply to chance or borrowing. She then began a comparative study to reconstruct ancestral forms of these words, using established linguistic principles about the regular ways spoken sounds change over time. Soon she discovered that the phonological similarities among words with similar meanings (and especially their verbal stems or roots) were not limited to the American continent but in fact extended worldwide. As she notes, "Quite unexpectedly I found myself committed to the theory of monogenesis and became bent upon discovery of the primordial system from which modern forms might plausibly and regularly derive" (1978, 81).

Comparing morphemes ("minimal meaningful partials," such as stems) or whole words from different languages and finding that similarity of sound configuration was coupled with similarity of meaning, Foster has proposed a genetic relationship among languages that had previously been considered unrelated (Indo-European, Dravidian, Hittite, Turkish, and Yurok), and has posited their common ancestry in PL. As if this idea were not exciting enough, she claims to demonstrate that "articulation and meaning are isomorphic, united through the spatial interaction that the moving parts of the mouth provide" (1978, 111):

> As we move from front to back of the oral tract we find both similarities and differences between consonants articulated at adjacent points. Sounds involving lip movements have meanings of peripherality, while sounds involving interaction between tongue and teeth or alveolar ridge have internal meanings. . . .

Meanings are all spatial and correlate analogically with relation-

ships effected in the oral tract between articulators. Thus *p, *f and
*m and *w all define external or peripheral space. (111)

For example, *m (which is physically produced by first pressing together
and then opening the lips, as readers can practice for themselves) is
frequently used as a stem in words with various meanings of "taking" or
"relating." Foster points out that taking or relating—like the two lips
meeting to produce *m—often involves a bilateral relationship: of two
fingers or two hands in taking or grasping, of upper and lower lips, teeth,
and jaws which meet in tasting, chewing, or swallowing; of two opposed
surfaces in tapering, pressing together, holding together, crushing, or
resting against; of two similar items such as tapered sides, encompassed
sides, and likenesses. The *m bilaterality that characterizes the mouth
itself (in lips and jaws as in the example just cited) is preserved today in
the [m] sound in English *mouth*. It also is used in French *main* and
Spanish *mano* "hand." In other words, in Foster's scheme, language
began as a sort of onomatopoeia where the vocal apparatus analogically
mimicked its referent (activity or object).

In another example, to form the sound of *pl* or *fl*, the lips protrude
forward and then the tongue pulls away from the alveolar ridge. In a
number of languages (Finnish, Nyanja, Hanunoo, Tamil, Yurok, and
English), *pl* and *fl* are often used in words that—like the lips and tongue
when making these sounds—describe outward extension and spread: for
example, in English *flood*, *fly*, *plain*, *flow*, *flat*, *field* (Foster 1980).
Foster gives more than a hundred such "semantic common denomina-
tors" (e.g., "protrude, gush forth," "stretch," "inner or body substance")
and their cognate sets associated with the same onomatopoeic morpheme
("*pl(e)y-," "*t(e)n-," "*w(e)m-") in five language groups, and presum-
ably from PL. (The reader who makes these sounds will mimic the
corresponding semantic common denominators above.)

Foster claims that her linguistic reconstruction demonstrates an elab-
orate capacity of the Paleolithic mind to organize and to classify experi-
ence. It also fits in with and supports claims that not only analogy, but
also spatial thinking and principles of opposition and hierarchy are in-
trinsic to cognitive organization, as described in earlier sections of this
chapter. Indeed, Foster finds the analogic configuration of primordial
language, with its attendant symbolic and conceptual capacities, to be
"undoubtedly the single most important evolutionary advance in biolog-
ical history" (1978, 116).

If Foster's theory is correct, the intrinsically "symbolic" nature of lan-
guage (where an "arbitrary" word stands for something in experience) is

based on more fundamental analogic (and hence nonarbitrary) resemblances between things and the sounds used to refer to them. At the very least, her scheme suggests that "free-floating" symbolizing ability developed from stricter analogizing propensities inherent in the way the brain works naturally. (See also Chapter 7.)

Spatial metaphors or analogies are also inherent in the emotional meanings of the sound patterns of human speech, according to studies conducted over many years by Dwight Bolinger. He notes that the "ups" and "downs" in intonation may simply symbolize height or movement directly, as when one says, "The swing goes up and $_{down}$, up and $_{down}$." But there are indirect metaphoric extensions as well.

Bolinger (1986, 341) identifies three primary or general "profiles" in the intonation patterns of spoken utterances. These profiles seem to carry abstract meanings that ultimately derive (historically, ontogenetically, or both) from metaphors associated with rising and falling, which are shared with facial expressions and bodily gestures. Profile A, the utterance with a terminal fall, indicates concluding (*coming to rest*). Downward intonation in general characterizes utterances that are meant to "play *down*," that is, calm someone, minimize the importance of something, negate, deny, or signal rest and completion. Profile B rises at the end and hence suggests incompletion (*up-in-the-airness*), as in questions that require an answer of "Yes" or "No," or nonfinal ends of clauses, as well as utterances made in states of excitement, anger, surprise, or curiosity (i.e., keyed-*up*ness or *high* emotivity). In general, "up" communicates arousal: the higher the rise, the greater the exasperation (of a statement) or surprise or curiosity (of a question), while conversely, the lower the fall, the greater the certainty or finality (of a statement) or confidence (of a question). In Profile C, the accented syllable is held down, but with no downward jump from that syllable as in Profile A. This communicates reining in, checking, restraint, control: hence courtesy or apology. The head concurrently may be bowed as a gestural echo of restraint, just as raised eyebrows may accompany utterances with profile B. Monotones are used in talking about the habitual and expected, hence they directly convey emotional *flatness*.

In their chapter "The Spell of Speech Sounds," Jakobson and Waugh (1979) support and enrich Foster's and Bolinger's findings. They remind us that the pitch and quality of spoken sound are produced by contracting or dilating the pharyngeal cavity, so that the resultant vowel sounds not only can be characterized as, but *are*, narrow and wide, tense and lax, strident and mellow, sharp and flat. They offer examples from numerous world languages of sound symbolism: for example, a vowel such as *i*,

which is high-pitched, clear, front, unrounded, and produced with narrow pharynx and small mouth aperture, is used for words (such as petite, teeny, wee, sweetie, kitty, puppy) that indicate what is small, slight, mild, quick, fine, insignificant, weak, and light (in weight or color) as in words for little, child, or young animal, small things, diminutive suffixes, verbs for making small, and so forth. Conversely, words that contain larger, wider back vowels (*u* or *a*) are associated with things (for example, in music, *grave*, *largo*, *adagio*) that are dark in color, heavy in weight, and large in size and movement.[19]

Jakobson and Waugh (188), after discussing numerous examples of sound symbolism in many languages, conclude that similar associations occur universally and thus are obviously far from being accidental: "Contrasts [such] as light-dark, light-heavy, and small-big belong to the 'elementary structures required by perceptual differentiation,' and it is no wonder that they build constant (or near constant) and universal linkages with the elementary features underlying the languages of the world."[20]

In their poetics, the Kaluli of highland Papua New Guinea also associate particular vowel sounds with specific sense qualities or sounds in nature, and these seem to be similar to the associations discovered and described by Jakobson and Waugh.[21] For example, front vowels "hum" when high (as in the English word *beet*) and "buzz" when low (as in *bet*). Back vowels "swoop down" when high (*boot*) and "swing out" when low (*bought*). Midvowels "crackle" when fronted (*bait*) and "pop" when backed (*boat*) (Feld 1982). Moreover, to Kaluli, the front vowels (i.e., those that hum or buzz) make sounds that are continuous: for example, sounds of rain sprinkling, or rain dripping after a rainfall, of leaves rubbing together in trees and groves, of the puckering and sucking of bats eating, or the rattle of a seedpod, of wheezing when ill, of sharpening axes on stones, and of insects swarming. Back vowels signal patterns of directionality in the movement of sounds from their sources: the vowel sound in *boot* is used in words whose referents have to do with sounds that originate above and dissipate below, the vowel sound in *bought* is used in words whose referents radiate over horizontal distance or concentrically out from a source. Midvowels mark sounds that stay at the source of their making (*boat* is durative; *bait* is sharp and crisp).

Although such onomatopoeia may vary in small details across cultures (or between poets), once one becomes acquainted with a particular language its "rightness," as a system, is highly likely to be comprehensible and aesthetically affecting. Readers and writers (or listeners and composers) of poetry are not unaware of the effects that physical associations of words have on their poetic effectiveness. The *l*'s in the line "I loll, I loll,

all Tongue," from Theodore Roethke's "The Other," reinforce the oral gratification expressed by the lover. In the line "beaded bubbles winking at the brim," from Keats's "Ode to a Nightingale," the *b*'s mimic rounded bubbles both physically as spoken and visually as read, while the *i*'s suggest brilliance and light as described by Jakobson and Waugh above (see also Cohn 1962).

It is not surprising that visual, auditory, tactile, kinesthetic, thermal, and olfactory terms are universally used metaphorically in human languages to describe psychological properties. The work of Solomon Asch (1955) has shown that certain adjectives that refer to physical properties (e.g., straight/crooked; hot/cold; right/left; hard/soft; and many others) have similar if not identical connotations in a number of languages. For example, in Old Testament Hebrew, Homeric Greek, Chinese, Thai, Malayalam, and Hausa a "hot" person is one who feels rage or wrath, enthusiasm, sexual arousal, worry, energy, or nervousness—states characterized by heightened activity and emotional arousal. People are deep and shallow, narrow and wide, hard and soft, as well as bright (light) and dull (dark), and these physical terms refer to roughly similar psychological qualities in all languages studied.

The tendency for individuals to think analogically and metaphorically can be used by an entire culture to encode not only individual characteristics but also group ideas. For example, the oral tradition, chants, architecture, and various material objects of the Belau of Western Micronesia embody and instantiate four main "diagrammatic icons" that metaphorically and analogically stand for or sum up an array of notions relating to the composition and interrelationships among persons, roles, and sociopolitical units (Parmentier 1987, 108ff).

The Belau word for *path* refers to a forest trail, but also includes other ideas relating to sequence: a way of doing something (strategy, method, technique, or skill), established linkages and ritual precedents that are a cultural imposition of linear order on inchoate experience, and the obligation to repeat the same actions and events. *Side*, emblemized as the banks of a river or the symmetry of the human body, encodes ideas of balanced reciprocity, exchange, and mutuality. *Cornerpost* combines the features of paths and sides to express underlying support and coordination of the different functions of the culture as the supporting stones or pillars hold up a building. The graded continuum of *larger/smaller*, visualized as relative physical size, ripeness or maturity, refers to the social fact of hierarchy—dominance and subordination—based on greater social rank, power, and sacredness. According to Parmentier's analysis, these four "icons" encoded in words, concrete physical referents, and a wealth of

associated metaphorical meanings are the way Belauans think about the important social realities of their world (see also Fernandez's work on the Fang, which I discuss near the end of this chapter).

TEMPORALITY AND EMOTION

The work of Mark Johnson and others indicates that metaphor is not merely a poetic or linguistic mode of expression but also and more importantly a cognitive structure by means of which we are able to have coherent, ordered experiences. In fact, Johnson (1987, xii) goes so far as to assert that metaphor is "a pervasive, irreducible, imaginative structure of human understanding." In this view, imagination, far from being an idle, fanciful, escapist type of activity, peripheral to the real nuts and bolts of practical life, is essential to the structure of rationality. Central to metaphor in Johnson's view is the human body: "bodily movement, manipulation of objects, and perceptual interactions involve recurring patterns without which our experience would be chaotic and incomprehensible" (xix). Certainly, the description above of the brain's modular storage of representations suggests how making "connections across domains of our experience" (which is how Johnson describes metaphor [103]) is the way, or one of the ways, that the brain works.

For the sake of simplicity of exposition, I have been describing cognitive universals, metaphors, and analogies rather abstractly, primarily as they exist in space (e.g., language as a container; the comprehension of ideas requiring a "grip") or in the mind (e.g., personal characteristics as sense qualities). It is necessary now to emphasize the point that existence in time is of equal, critical importance to an understanding of the universal predispositions to aesthetic empathy. Indeed, a notion of temporality necessarily underlies and accompanies our appreciation of the spatial or ideational entities that I have been describing, for these entities' permanence, changeableness, directionality, and similar qualities in time affect their nature as affordances.[22] Mallarmé's beautiful description of the ballerina dancing experiences her spatially as a sword, a cup, or a flower, as well as a body "writing" a poem in space in time.

In surveying our surroundings, we tend to pay special notice to movement, that is, to temporal change—at least until we mentally mark it as familiar, hence predictable or benign. Changeability in itself is a sign of potential danger, alerting us to attend and to prepare for the consequences of the change. A noise that becomes softer, or especially louder, compels attention or even action, as does an approaching figure or a temperature that becomes colder or warmer. Thus, perception of tem-

porality is closely tied to emotion (and the world *e-motion* itself contains the idea of movement) because it usually portends a change that affects oneself for good or ill.[23]

But even "static" visual entities contain a temporal element. The importance of this truth has been pointed out by Gestalt psychologists such as Rudolf Arnheim, who have shown that percepts are potentially dynamic, that is, they may suggest "directed tensions" that appear to us, because of our experience in the world, to be inherent components of the perceptual stimulus. As Arnheim (1984) has said, an object like a tree or a tower is seen to reach upward, and a wedge-shaped object like an axe appears to advance in the direction of its cutting edge. Such tensions give "character" to an object or event and recall the similar, metaphorical or analogical character of other objects and events.

For example, as is borne out in the rise and fall of spoken intonation (described earlier in this chapter), being downward directed means physically "giving in" (to the forces of gravity), being inert, striving toward safety. Upward direction, in contrast, suggests the tension associated with getting up, lifting, physically overcoming, making an effort, being proud and adventurous, in general escaping the pull of gravity that decrees that states of rest must somehow involve movement down.

Arnheim has made numerous fertile contributions to the psychology and psychobiology of art. His pioneering thought and work over the past half century is an ideal introduction to the subject of emotional experience of the arts. To begin with, he reminds us once again that "emotion" is inextricably linked to perception and cognition, so that to say simply that "'art expresses emotions" is misleading and inadequate. Instead, emotion is better understood as the tension or excitement level produced by the interaction of brain processes of perception, expectation, memory, and so forth, and does not exist apart from this. As Arnheim (1966, 313) puts it: "Once we examine concretely what people do when they apprehend expression, it becomes apparent that the instrument they use is perception, not some other mysterious cognitive faculty, for which we need the special term feeling. It is perception, not of the static aspects of shape, size, hue, or pitch, which can be measured with some yardstick, but of the directed tensions conveyed by these same stimuli."

Arnheim's notion of "isomorphism" is tantalizing for a study of aesthetic empathy insofar as it suggests that there may be neurophysiological grounds for understanding the "directed tensions" inherent in the physical/bodily metaphors by which we comprehend the world. The word *isomorphism* (equal form) refers to the correspondence or matching of two things in their structural organization—a kind of "exact analogy."

Hence Arnheim has suggested that isomorphism could occur in the electrochemical processing of the brain which would "iconically" match the psychological processing and analogically produce corresponding physical or psychological emotionally toned movements in us. In other words, in this model, what we perceive as the physical forces in an object or event is isomorphically related to or echoed in the psychical dynamics of our perceptual processing apparatus.

Arnheim proposed the idea of isomorphism in 1949 in a classic paper written before feature detectors, cortical maps, and processing modules in the brain had been described. Arnheim addressed the phenomenon that, much earlier, Freud had called "ideational mimetics" (described at the beginning of this chapter): the fact that we often feel that a particular pattern of muscular behavior is accompanied by an analogous psychological state of mind. Arnheim further wished to explain how a percept of shape, movement, and the like could convey to a perceiver "the direct experience of an expression which is structurally similar to the organization of the observed stimulus pattern" (164). Arnheim proposed that the projection of a perceptual stimulus on the brain, and particularly on the visual cortex, would create a configuration of electrochemical forces in the cerebral field (the perceived organization or Gestalt pattern) and these in turn would have a psychological counterpart. From such a basis, then, "expression" could be defined as the psychological counterpart of the dynamic electrochemical processes in the brain that organize perceptual stimuli.

Thus, claimed Arnheim, a weeping willow does not "express sadness," as earlier empathists proposed, only because it looks like a sad person. It might be more adequate to state that because the shape, direction, and flexibility of willow branches convey an expression of passive hanging, a comparison with the structurally similar psychophysiological pattern of sadness in humans may impose itself secondarily. Just as sound calls forth a vibration of similar frequency in a string, said Arnheim, various levels of psychological experience, such as the visual, the kinesthetic, and the emotional, seem to elicit in each other sensations of similar electrocortical structure.[24]

While neuroscientific understanding has not yet shown actual isomorphic processing, it may eventually be demonstrated and is certainly conceivable. As I noted above, one global percept may be coded in a number of different sensory modules that are connected into association networks. Perhaps the way these percepts are coded and then subsequently decoded and recoded takes place according to isomorphic patterns. While at present we lack an agreed-upon hypothesis to explain how perceptual

signals interact to constitute complex messages or interpretations, the topographically precise maps of the sensory surfaces (the retina, skin, or ear) on the surface of the brain could isomorphically code their respective information. Using a linguistic analogy, Young (1978, 52) has written: "For each sense there is a series of such maps, each recombining in a new way the words of information provided by the cells. So the grammar of this language has something to do with spatial relations. It communicates meanings by topological analogies. This illuminates many questions about the means by which we think, often using spatial analogies."[25]

Certainly there is evidence of behavioral isomorphism. Arnheim mentions, for example, that in handwriting, the individual script pattern reflects dynamic features of a writer's motor behavior and hence her psychological behavior. This occurs whether the writer uses small muscle skills to write on a sheet of paper or large sweeping movements on a blackboard. Other examples of isomorphism include those cited previously: the musician raising his eyebrows while reaching for a high note, or mothers and infants who match vocal and gestural intensities, rhythms, or durations.

A wonderful example of melodic-geographic isomorphism in Australian aborigine culture is provided by Bruce Chatwin in *Songlines* (1987, 108).

> Regardless of the words, it seems the melodic contour of the song describes the nature of the land over which the song passes. So, if the Lizard Man were dragging his heels across the saltpans of Lady Eyre, you could expect a succession of long flats. . . . If he were skipping up and down the MacDonnell escarpments, you'd have a series of arpeggios and glissandos. . . .
>
> Certain phrases, certain combinations of musical notes, are thought to describe the action of the Ancestor's *feet*. One phrase would say "salt-pan"; another "Creek-bed," "Spinifex," "Sandhill," "Mulga-scrub," "Rock-face," and so forth. An expert song man, by listening to their order of succession, would count how many times his hero crossed a river, or scaled a ridge—and be able to calculate where, and how far along, a Songline he was.
>
> . . . So a musical phrase is a map reference. Music is a memory bank for finding one's way around the world.[26]

AMPLIFICATION OF AFFECT

It should be clear by this point that the coding of information in the brain probably occurs not only spatially by maplike arrangements of responsive

cells, but also temporally with patterns of sequence, duration, and stability or change (Griffin 1981). It is implausible that the brain deals with time and space separately; rather, time and space are integrated (Churchland 1986, 200). Two recent studies of emotion bear on an understanding of how temporal coding underlies aesthetic empathy.[27]

The first is the theory of emotion (or "affect") developed over the past thirty years by Silvan Tomkins (1962, 1980, 1984). Observing that the intensity of a stimulus can be measured by how many times the nerve fires an impulse, Tomkins suggests that such temporal frequency can be thought of as the objective physiological counterpart of the degree of felt emotion. (While he does not mention it, the degree of felt emotion would also arise from "spread" or "generalization": the recruitment of other nerve pathways or spatial density of excitation. Clynes [1977, 141] also mentions that in addition to the dimension of intensity there is often a further qualitative order of pervasiveness and satisfaction that may characterize emotions.)

According to Tomkins's scheme, there are a limited number (nine basic types) of universal affects: positive affects of interest excitement, enjoyment-joy, surprise-startle, and negative ones of distress-anguish, disgust, contempt, anger-rage, shame-humiliation, and fear-terror. Unlike emotions, which are learned, affects are biological givens: they are displayed by infants, although adults may learn to control and to mask them to some degree, and cultures can elaborate or modify their expression, including, of course, the stimuli that evoke them.

Each affect is characterized by innately patterned responses (of facial muscles, blood flow, and visceral, respiratory, vocal, and skeletal responses) and innate activators. A particular affect is activated by a variant of a general characteristic of neural stimulation, namely its density, where "density" is defined as the number of neural firings per unit of time.

The theory posits three discrete classes of activators of affect, each of which further amplifies the sources that activate them. These are stimulation increase, stimulation level, and stimulation decrease. If internal or external sources of neural firing suddenly increase, the human being will startle or become afraid, or become interested, depending on the suddenness of the increase in stimulation. If internal or external sources of neural firing reach and maintain a high, constant level of stimulation, which deviates in excess of an optimal level of neural firing, he will respond with anger or distress, depending on the level of stimulation. If internal or external sources of neural firing suddenly decrease, he will laugh or smile with

enjoyment, depending on the suddenness of the decrease in stimulation. (1980, 148)

The discrete affects evoked in this way act as *amplifiers*. They produce an analogue of the gradient and intensity of the stimulus by means of the correlated physiological responses. For example, a sudden loud noise will evoke a startle response—a sudden, intense jerk of the body. The suddenness and intensity of the jerk are an amplified analogue of the suddenness and loudness of the noise. In similar ways, argues Tomkins, each affect amplifies in an analogic way the gradient or level and the intensity of its stimulus, and it also imprints the immediate behavioral response with the analogue. Hence an excited response is an acceleration, whether of walking, talking, eating, or getting dressed. An enjoyable response is decelerating and relaxed.

According to Tomkins (1984, 167, 170), we are responsive to whatever experiences, innate or learned, activate the varieties of positive and negative affects. Hence the significance or "meaning" of any stimulus is assessed according to whether neural firing is accelerated, decelerated, or remains level. The neural firing profile can be produced by perceptual, cognitive, memory, or motor responses (insofar as these are separable).

The biological consequence of this amplification through affect is that the organism cares about quite different kinds of events in different ways. According to Tomkins (1984, 186), "Affect, by being analogous in the quality of the feelings from its specific receptors as well as its profile of activation, maintenance and decay, amplifies and extends the duration and impact of whatever triggers the affect." It makes good things better and bad things worse. It makes us care.

Understanding the felt quality of our emotions as analogous to the physiological intensity of the neural processes that caused them helps us to appreciate their evolutionary value as indicators to us of the extent of our investment in the degree of benefit (positive) or possible damage (negative) from the various elements of our experience. Whereas it would be absurd to claim that the feelings evoked in our experiences of particular works of art had "survival value" in the early stages of human evolution, it is not absurd to point out that the building blocks of aesthetic experience (sensitivity to changes in tempo, dynamics, size, quality, and so forth) evolved in selectively useful contexts and possess intrinsic optimal stimulation levels (e.g., fast/slow, loud/soft, large/small, strong/weak) that are relevant to our biological nature. What is more, Tomkins's amplifications (more, less, or neutral) provide a physiological dimension for Arnheim's "directed tensions."

In his work with infants and mothers referred to earlier, Daniel Stern describes an important feature of infant sensory-emotional life that he calls "vitality affects" (as differentiated from "categorical affects" like anger, joy, sadness, fear, and so forth—what Tomkins has called "innate affects"). These are patterned changes over time, such as a sense of surging, fading away, sudden explosiveness, and fleetingness. Stern claims that infants are more likely to perceive their experiences directly and to begin to categorize them more in terms of the experiences' vitality affects than in terms of analyzed things such as "reaching for bottle" or "diaper being changed." In other words, our earliest cognitions are not concerned with the "what" (abstract, categorized activity) so much as the "how," the way it is done (concrete, sensory-emotional perception). The intonation contours of the human voice, the ups and downs, pauses and stresses, to which the baby responds (rather than to the lexical or semantic content), are "vitality affects" of this type.

Stern calls the underlying physical features of the vitality affects "activation contours." He suggests that these might be represented amodally in the brain as temporal patterns of changes in density of neural firing. Thus no matter whether an object was encountered with the eye or the touch and perhaps even the ear, it would produce the same overall pattern or activation contour (1985, 59). Again, this model joins with Arnheim's "directed tensions" and proposed isomorphism and Tomkins's affect amplification to corroborate cross-modal empathic feelings in life and in the arts.

Associations Arising from the Universal Experiences of Infancy

The "cognitive universals" or "primitives" that I mentioned above—binarism, prototype, closure (and boundedness), figure/ground, division, similarity, and repetition—were described largely in terms of visual and spatial manifestations. But, as I did when discussing analogy and metaphor, I should note that these universals have temporal manifestations as well, and indeed an individual stimulus is probably perceived and stored according to both modalities.

The "vitality affects" that Daniel Stern described for babies can be considered as "primitives" also, insofar as they are part of everyone's preverbal experience. What is more, because these appear to be very like the feelings described by empathy theorists, one can explore them as a possible source for aesthetic response.

Whereas adults from different cultures may appear strikingly different

from one another, when we look at our young we can appreciate that, whether black, white, or shades between, we are all of one species or one "race," the human race. Infants everywhere from birth engage in unlearned behavior that will help them to survive: this means, at the very least, that they make cries, gestures, and facial expressions that attract positive attention (care) from adults. Adults, in turn, are predisposed to respond positively to these communications: babies' distress cries are almost impossible to ignore, and their smiles and gestures of appeal almost impossible to resist.

While many animals are able soon after birth to move about independently and even to feed themselves, human infants are among the most helpless mammalian young and are certainly dependent on the care of adults for the longest proportion of their life span. When hominids became upright it was essential that the period of gestation be reduced so that the baby's head could pass through the now-narrowed birth tract. Neonatal helplessness and a long period of immaturity were selected-for in human young and have become one of our species' most distinguishing and critical characteristics.

Immaturity has made it possible for humans to rely more on learned, culturally instilled rather than innate, genetically programmed behavior. Human infants, to be sure, are predisposed to learn some things more easily than others and to learn certain things more readily during certain critical periods. But it is the lability allowed by the long period of childhood or immaturity that makes possible the widely differing cultural behavior among different adults of different societies.

Numerous people have pointed out the crucial effects that this long period of immaturity has had on human learning and sociability. However, what sometimes gets overlooked in such discussions is that human emotional depth and complexity are the inevitable accompaniment and facilitating agent for acquiring one's culture's ways during the long period of dependency, and is equally rooted there. Cultural differences begin to be acquired from the moment of birth. Nevertheless, the universal and compelling experiences of infancy have a continuing effect throughout life: with respect to the present study this permanent residue is of intrinsic importance in understanding responses to the arts.

In *What Is Art For?* I claimed as much in discussing the "modes and vectors" of infancy (see also Gardner 1973, whose scheme I adapted). *Modes* refer to aspects of physiological functioning (e.g., the active and passive incorporation of feeding, tasting, biting, orally investigating; the expulsion and retention of unwanted or digested food) and being-in-the world (e.g., proximity and separation; weight or pressure; constriction,

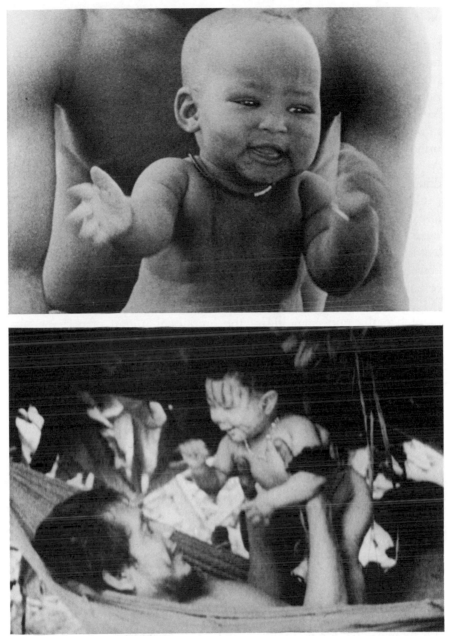

Top: *Female Gwi Bushman infant soliciting contact. Kalahari desert, Botswana, southern Africa*
Bottom: *Yanomano father and daughter in face-to-face play. Southern Venezuela*
Infants everywhere engage in unlearned behaviors that attract positive attention from adults, who themselves are predisposed to respond positively to these communications.

containment, resistance, and relaxation). *Vectors* are the way in which modes are experienced, such as their speed (fast or slow), regularity or irregularity, ease or strain, hollowness or fullness, openness or closedness, and so forth—which correspond to the vitality affects of Stern. Modes are primarily "spatial," space-organizing and configurational, as in/out, open/closed, extend/withdraw, expand/contract, contained/unbounded, incorporate/extrude, full/empty. Vectors have primarily to do with time and quality: fast/slow, regular/irregular, smooth/jerky, easy/difficult, surging/fading away, fleeting/explosive.

Gardner suggested in 1973 that the vectorally realized modes eventually develop into psychological modes of thought, extended and elaborated beyond their original association solely with physiology. In other words, they can be viewed as cognitive primitives or universals, with powerful emotional resonance, arising as they do from the earliest (preverbal) experience.[28]

I would like to add that modal/vectoral associations are also fundamental to the understanding of the emotional import of perhaps any experience but particularly for those inexpressible experiences that possess aesthetic feeling tone. Thus, much of our emotional response to metaphors, to analogies, to the spatiotemporal structures of the arts would appear to hark back to their preverbal, presymbolic, preanalytic, modal/vectoral origins.

As Walter Benjamin (1939/1970) said in another context of Baudelaire, "The *correspondances* are the data of remembrance—not historical data, but data of prehistory" (184). What we are conscious of, what we intellectually discern of our experiences of the arts, takes place only at the point from which the water wells out. Its sources and unique flavors come from forgotten commingling subterranean streams that have traveled through residues of rocky deposits far away, in our own prelinguistic prehistory.

Empathy Theory Reconsidered

It is my view that the naturally aesthetic or protoaesthetic predispositions just described provide the beginnings of a plausible psychobiological account of aesthetic empathy as it was articulated by its proponents during the past century. The predispositions arise from or themselves are universal psychobiological mechanisms that underlie and hence provide a naturalistic explanation for empathic associations or analogies: reported feelings of (spatial) expansion and contraction, weight and lightness,

diffusion, casting down, elevation, constriction, and relaxation, or (temporal) smoothness or unevenness, tightness and looseness, acceleration and deceleration. Before such grounding, these could be dismissed as subjective and idiosyncratic, hence trivial.

What is more, these psychobiological substrates also suggest a plausible framework for a universal species account of aesthetic experience. They confirm the postulate that *spatial and temporal (that is, formal) aspects of the arts (like other experiences and like art's overt and covert subject matter) have emotional effects.* They further account for the actual fact that in experience, and most economically or purely in artworks, time, space, and quality are inseparable interpenetrating aspects of one another.

Most empathists held that bodily feelings were projected outward from the perceiver onto the art object. Current neurophysiological findings, however, suggest that the work of art writes itself on the perceiver's body: electrochemically in the signaling patterns of activity that comprise the brain's cortical maps, which may in turn have concomitant physiological and kinesthetic effects. The sensation (in bones and muscles, in the being) that the empathists wished to explain—of union or communion between viewer and object, listener and musical work, reader and poem—is real, not illusory or only metaphorical. They simply lacked physical models that could account for it. Yet now we can understand that the arts affect at once our bodies, minds, and souls, which themselves are aspects—processing modules in the brain—of an individual that apprehends as one.

It is important to recognize that the psychobiological substrates of empathy described in this chapter permeate experience, indeed *are* experience. Until singled out and described as they occur in ceremony and the arts, it may not be realized how "aesthetic" they are or can be. Idealist and objectivist Western worldviews have tended to emphasize our "mental" (rational and practical) side, considering the "body" (senses and emotions) as inferior, something to manage and restrain rather than as the very stuff of which our life-in-the-world is composed and through which our thought is mediated.

At the same time, until they are analyzed and described as neurophysiological processes, aesthetic elements will not be recognized as "biological." Our perceptual apparatus, of course, originally evolved to help us survive, so that the sensory elements that artists use and to which we respond arose in life-serving, not life-"enhancing" contexts. In an important sense, we can say that to make something special is to make use of or intentionally to draw attention to its empathic properties, to engage

and to accentuate its emotion-rich associations. Seen in this way, the arts are extensions of what we have evolved to do naturally in order to survive and to prosper.

Aesthetic Empathy in Individual and Social Contexts

In the remainder of this chapter I will consider a number of aesthetic and protoaesthetic phenomena that seem to me to be better understood with the knowledge that I have presented, codified, and called "aesthetic empathy." For example, we can understand how a sense that has been lost will seem to persist, as in this description by David Wright, a deaf man, where what is seen becomes a sort of metaphor of hearing:

> Suppose it is a calm day, absolutely still, not a twig or leaf stirring. To me it will seem quiet as a tomb though hedgerows are full of noisy but invisible birds. Then comes a breath of air, enough to unsettle a leaf; I will see and hear that movement like an exclamation. The illusory soundlessness has been interrupted. I see, as if I heard, a visionary noise of wind in a disturbance of foliage. . . . I have sometimes to make a deliberate effort to remember I am not "hearing" anything, because there is nothing to hear. Such non-sounds include the flight and movement of birds, even fish swimming in clear water or the tank of an aquarium. I take it that the flight of most birds, at least at a distance, must be silent. . . . Yet it *appears* audible, each species creating a different "eye-music" from the nonchalant melancholy of seagulls to the staccato of flitting tits.
>
> Cited in Ackerman 1990, 192

The reverse happens in the Walt Disney film, *Fantasia*, where what is heard suggests visual counterparts.

The biological reality of such sensory blending makes more comprehensible the association of Greek musical modes and Indian ragas with mental/emotional states, insofar as interval width or narrowness and an ascending or descending tonal pattern reflect or create mood.[29] Incidentally, the words "sharp" and "flat" describe properties of substance and space, not sound, but indicate the upward-striving and downward-falling of their associated effects.

The phenomenon of synesthesia, where stimuli perceived by one sense really (not only metaphorically) produce sensation in another sense, is

understandable as a manifestation of especially close network connections
between sense reception and memory storage areas. In *Speak, Memory*
(1966), Vladimir Nabokov describes with remarkable preciseness his own
"colored hearing":

> Perhaps "hearing" is not quite accurate, since the color sensation
> seems to be produced by the very act of my orally forming a given
> letter while I imagine its outline. The long *a* of the English alphabet
> . . . has for me the tint of weathered wood, but a French *a* evokes
> polished ebony. This black group also includes hard *g* (vulcanized
> rubber), and *r* (a sooty rag being ripped). Oatmeal *n*, noodle-limp
> *l*, and the ivory-backed hand mirror of *o* take care of the whites. I
> am puzzled by my French *on* which I see as the brimming tension-
> surface of alcohol in a small glass. Passing on to the blue group,
> there is steely *x*, thundercloud *z*, and huckleberry *k*. Since a subtle
> interaction exists between sound and shape, I see *q* browner than *k*,
> while *s* is not the light blue of *c*, but a curious mixture of azure and
> mother-of-pearl. Adjacent tints do not merge, and diphthongs do
> not have special colors of their own, unless represented by a single
> character in some other language (thus the fluffy-gray three-
> stemmed Russian letter that stands for *sh*, a letter as old as the rushes
> of the Nile, influences its English representation). . . . The word
> for rainbow, a primary, but decidedly muddy, rainbow, is in my
> private language the hardly pronounceable: *kzspygu*. The first au-
> thor to discuss *audition colorée* was, as far as I know, an albino
> physician in 1812, in Erlangen.
>
> The confessions of a synesthete must sound tedious and preten-
> tious to those who are protected from such leaking and drafts by
> more solid walls than mine are. To my mother, though, this all
> seemed quite normal. The matter came up, one day in my seventh
> year, as I was using a heap of old alphabet blocks to build a tower.
> I casually remarked to her that their colors were all wrong. We
> discovered then that some of her letters had the same tint as mine
> and that, besides, she was optically affected by musical notes. These
> evoked no chromatisms in me whatsoever.
>
> Cited in Ackerman 1990, 291–92

While synesthetic individuals like Nabokov and his mother vary in their
associations of words with colors, they share an unambiguous tendency to
feel that back vowels are darker and front vowels lighter, demonstrated in

assigning darker colors to the former and light colors to the latter. Thus synesthetic perception involving "colored words" seems related to onomatopoeia, as described earlier in this chapter with regard to sound symbolism.

How else than by aesthetic empathy can we understand the wish of Henri Matisse (Bryson 1987, 328) "to invent something that would render the equivalent of my sensation—a kind of communion of feeling between the objects placed in front of me"? What Matisse was aiming for was "something which would evoke the presence of objects, but not their appearance—the feelings accompanying optical sensation, but not the sensation itself" (328). An account of Matisse's life and art by Jack Flam (1986), according to Bryson, demonstrates how Matisse (who has been dismissed by some critics as creating merely decorative or hedonistic art) discovered "a language the heart can read—the forms of feeling." (It would be interesting to compare these to Clynes's [1977] essentic forms.) Bryson and Flam suggest that Matisse, like many, if not all, artists in every medium, realized formal analogues of feeling through aesthetic empathy—that is, what I have described above as spatial thinking, cognitive universals, metaphoric, isomorphic, modal-vectoral, synesthetic means that move perceivers.

In premodern societies, where arts and ceremony are joined, aesthetic empathic means are invariably used to express the group's perception of its world. For example, the Walbiri, an aboriginal group of West Central Australia, use the spatial, analogic, modal-vectoral notions of "coming out" and "going in" in a variety of contexts and concrete images to explain their socionatural order as an ongoing continuum, where such important concerns as the birth and death of humans or the origin and death of the Dreamings can be conceptualized as both polarized and unified:

Through the circle-line configuration the notions of "world order" are bound up with manipulative and tactile as well as visual perception, and thus embedded in immediate sense experience. Philosophical premises about the macrocosmic order are continuously brought into the sense experience of the individual Walbiri man through the agency of this iconic symbolism. The symbols thus articulate the relation between the individual or microcosm and the macrocosm, and through the immediacy of touch and sight bind the two together.

Munn 1973, 216

One suspects that auditory and kinesthetic perceptions were also part of this synesthetic sensory-cognitive-emotional constellation.

The Kaluli have developed a patterned mythological complex in which birds, weeping, poetics, song, sadness, dance, death, waterfalls, taboos, sorrow, maleness and femaleness, children, food, sharing, obligation, performance, and evocation are all cognitively connected. Their metaphorical capacity links not only human words and weeping but also other natural sounds (such as those of birds and moving water) with the Kalulis' sentiments, social ethos, and emotion. Bird sounds, for example (which to the Kaluli resemble such human sounds as the cry of an abandoned child) metaphorize Kaluli feelings and sentiments "because of their intimate connection with the transition from visible to invisible in death, and invisible back to visible in spirit reflection" (Feld 1982, 85).

Critical remarks Kaluli make about each other's songs might include such culturally understood metaphors as "Your waterfall ledge is too long before the water drops," "There is not enough flow after the fall," or "The water stays in the pool too long." "There is much splashing" refers to unbalanced contours, phrases that end abruptly, overly centered lines, and poorly-paced meter (Feld 1982).[30] Other waterfall and moving-water sounds applied to poetry are *kubu* (irregular, water-splashing sounds: choppy meter, uneven or broken resonance); *fo* and *bu* (the pulsating and continuous quality of water rushing over rocks: verbal flow); and *golo* (variable whirlpool swirl: in a song, the whole pulse slows down and then comes back up to tempo).

Kaluli poetics are remarkable for their employment of modal/vectoral associations and analogies. Poetic language uses "turned-over words" that show their "insides" and "underneaths." The effect of such words, aesthetically presented, on the listener is the "hardening," the climaxing or culmination of the aesthetic tension of the song. The semantic field of water is used when talking about song making, especially words derived from *sa*, the generic name for waterfall whose connotations of "down" and "in," "tucking under," and "moving inside" make it applicable to poetic language (Feld 1982).

In the Kaluli *gisalo* ceremony, cross-sense modalities isomorphically suggest and reinforce one another. The visual aspect of the dancer's costume of leaves that by his up-down bobbing movement is made to shimmer and arch up and over like flowing water (which itself, it will be remembered, provides much of the conceptual imagery for poetry/weeping/song) is combined with the auditory aspect of the "out and down" motion and space of sound, including the up-down *wauk-wu* birdcall imitation, the "shimmering" rustle of the rattle, and the meter

and pulse adding their sensations of resonance and timbre. Sorting out these components into individual sense modalities is a task that emphasizes how limited analytic descriptions of multimodal synesthetic-emotional experiences really are in communicating the substantive unified reception of the whole.

Appreciating the existence of isomorphic and modal-vectoral mechanisms allows a fuller understanding of the power of ritual ceremonies (and art) to "transform" individuals,[31] as they experience transformations of sensations or elements of experience into others: these are perceived as and ultimately *become* or *are* something else. Hence Bwiti cult ritual of the Fang in Gabon (Fernandez 1969) uses "natural" associations among certain items of individual and social experience (in each encircled complex in Figure 1) and transforms these through ritual actions into corresponding elements in other complexes, all of which parallel and thus facilitate the larger ritual transformation of the solitary individual into unitary one-heartedness with the group. The kind of analysis presented in Figure 1 is oversimplified because it divides into neat abstractions what experientially is felt as an unbroken unarticulated progression, but it does assist the non-Fang reader to appreciate how the transformations are achieved.

A generation ago, without reference to "cognitive universals," structuralist linguists, cognitive scientists, cultural anthropologists, and literary critics proposed the existence of universal mental "structures" or principles from which such fundamental human abilities as language, thought, narrative or story, and myth are generated. In such schemes it was claimed, for example, that all humans have a similar innate aptitude for creating, recognizing, and responding to such components of myth as symmetry, inversion, equivalence, homology, congruence, and identity and union (Lévi-Strauss 1963, 1964–68). Literary structures all over the world make use of techniques for relating elements of the story, techniques that are variations (or violations) of the binary system: such things as contrast, polarity, difference, repetition, parallelism, successiveness, concatenation, counterpoise, juxtaposition, and progression. In the Kalapalo of Brazil, for example, storytellers make use of anticipation, connection, perpetuation, progression, and conclusion (Basso 1985, 36)[32]

Leonard Bernstein (1976) has provocatively suggested that in music there may also be transformations of a sort of "deep structure" grammar just as there are in spoken language. Bernstein lists such musical equivalents of Chomskyian linguistic transformations as antithesis (statement and counterstatement), alliteration (beginning each musical "word" with the same notes), anaphora (repeated musical words or phrases), chiasmus

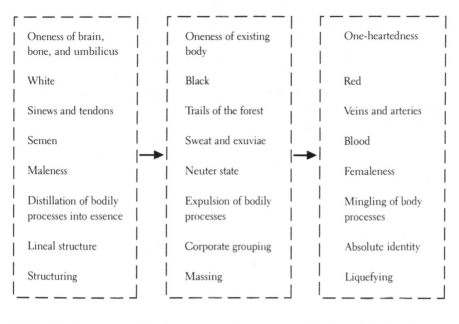

Oneness of brain, bone, and umbilicus	Oneness of existing body	One-heartedness
White	Black	Red
Sinews and tendons	Trails of the forest	Veins and arteries
Semen	Sweat and exuviae	Blood
Maleness	Neuter state	Femaleness
Distillation of bodily processes into essence	Expulsion of bodily processes	Mingling of body processes
Lineal structure	Corporate grouping	Absolute identity
Structuring	Massing	Liquefying

INDIVIDUAL ⟶ INCORPORATED INTO ⟶ WORSHIPPING BODY OF BWITI

Fig. 1. *Ritual Transformation of Bwiti*

The dotted lines circumscribe a group of related elements united by what in my scheme would be called analogical, metaphorical, and modal-vectoral associations (e.g., of color and physical character). Each item within the group is itself related conceptually (e.g., as "branching path-like structure," "bodily fluid," "gender," "physical state," and so forth) to a corresponding item in the other groups. Through the ritual process an individual person is transformed, like the components in each group, from singleness and isolation to identity and oneness with the entire membership, that is, the individual is incorporated into the worshipping body of Bwiti. The categories are "sensed" or "felt" rather than analytically objectified, and the resulting transformation is an emotional, not an intellectually realized, experience. The similarities with Western aesthetic experience are obvious. (*Adapted from Fernandez 1969; simplification of Figure 1, p. 15*)

(AB:BA), and so forth: "A piece of music is a constant metamorphosis of given material, involving such transformational operations as inversion, augmentation, retrograde, diminution, modulation, the opposition of consonance and dissonance, the various forms of imitation . . . the varieties of rhythm and meter, harmonic progressions, coloristic and dynamic changes, plus the infinite interactions of all these with one another. These *are* the meanings of music" (153). It should not be forgotten that structural cognitive properties such as those just described will also have emotionally toned modal-vectoral associations.

Individual societies may emphasize certain modal-vectoral elements and disregard others. To illustrate his claim that the song and dance style of any culture symbolizes and summarizes its attitudes and responses to its world in general, Alan Lomax (1968) analyzed among other things the movements used in the dances of a number of different societies according to the degree that they embodied certain (in our terms, "vectoral") variables: speed, duration, energy (strength or effort), cohesiveness, sonority, sinuousness (undulant or angular movement), and complexity. Lomax concluded that in complex societies and in societies whose members were confined spatially or restricted by a rigid system of status or caste differentiation, there was an increasing preference for narrower movements in their dance and (in other concurrent analyses) for narrower tonal intervals in their music.

Such analogic, even isomorphic resemblance between social organization and the realization of specific aesthetic elements is borne out by other Lomax findings. Using the same inherent "spatial structures" described by Olson and Bialystock (1983) and discussed earlier in this chapter, individuals and cultures construct, interpret, and express their experience in idiosyncratic ways that reflect their particular temperamental or cognitive norm, thus preferring, say, either narrow or sweeping movements, flexion of individual body segments or loose flagrant gestures of their whole body, undulance or angularity.[33]

Acceptance of the emotional salience of modal-vectoral associations may also assist our understanding of the oft-noted resemblances of art and sex: for example, when art is "explained" as sexual sublimation. Jack Spector (1973) lists a number of writers who, preceding Freud, like him were concerned with explaining art by its connections with sexuality. Among these were Ludwig Tieck (1796) who wrote that "Poetry, art and even devotion are only disguised hidden lust," and George Santayana (1896/1955), who noted that "The whole sentimental side of our aesthetic sensibility—without which it would be perceptive and mathematical rather than aesthetic—is due to our sexual organization remotely

stirred" (62). Other less-renowned persons cited by Spector made pronouncements such as "Poetry is produced by the genitals" or "Art is nothing but a game that sex plays with the brain."

Rather than reduce art to sex (or sex to art, which is an equally imaginable project), we might do better to consider them not as serving analogous functions of release of libido, and hence as substitutes or surrogates for each other, but rather as each being primal human behaviors that have become elaborated in the essential service of affiliation and bonding. Their common roots in infant experience make them important occasions for releasing modal-vectoral associations and thus ensure that the arts and sex often seem to embody, as well as to arouse and to satisfy, extravagant, indescribable, even strangely analogous kinds of associations and feelings.[34]

I realize that insofar as it has been conceived and written within the worldview of modern neuroscience, my discussion of aesthetic empathy may be dismissed by some readers in the arts and social sciences as "mechanistic" and hence irrelevant. I hope that others, whose prejudices are less dogmatic, have been persuaded that biological understanding underpins and augments the appreciation of our intrinsically aesthetic human nature. In the next and final chapter, I will examine some recent issues and shibboleths in contemporary art and social theory from a species-centered perspective, drawing when appropriate upon the various strands I have spun in the present and previous chapters. Ultimately, we should recognize ourselves as *Homo aestheticus*, underneath the crust of superfluous excrescences slapped onto us by the modern and postmodern way of life.

❧ 7 ❧

Does Writing Erase Art?

> . . . there was the insignificant Picasso sculpture with its struts and its sheet metal, no wings, no victory, only a token, a reminder, only the idea of a work of art. Very similar, I thought, to the other ideas or reminders by which we lived.
> —SAUL BELLOW, HUMBOLDT'S GIFT (1975)

To suggest that writing "erases" art (rather than itself being subject to erasure) might appear to be one more twist in the postmodern formulary of grammatological buzzwords, and not a particularly original one at that. According to Derridean scripture (expressed with typically obscure profundity, or profound obscurity—one is never quite sure which), writing is "the name of [the] gesture that effaces the presence of a thing and yet keeps it legible" (Spivak 1976, xli). Hence art—like "knowing" or "the psyche" or "Being"—can quite legitimately be put "under erasure" (*sous rature*).

My analysis here of the "erasure" of art by writing, however, is meant to be decidedly different from the garden-variety postmodern treatment. Instead, as in previous chapters, I will be guided by a down-to-earth species-centered orientation that is foreign to the Parisian literati and other mapmakers of the poststructuralist universe. Using plain language I will suggest, as a Derridean might, that writing does indeed erase art, but my thoughts concerning writing and art differ markedly from those of the Derridean persuasion. In the gap between Darwin and Derrida will, I hope, emerge a more fertile way to think of art than contemporary postmodern theory has been able to provide.

To begin with, it will be helpful to look briefly at the development of the concept and practice of art as it has arisen in the past two centuries or so. During this time Western culture has undergone those radical social changes that are broadly termed, when they happen now elsewhere in the world, "modernization" or "development"—that is, the change from a

194

predominantly rural or land-based, traditional, and religious society to a predominantly urban and industrially-based, modern, secular one. The confusions in contemporary life and art can be traced to the promises and perils inherent in this transition. For while unimagined comforts and opportunities become available as the road to modernization is traversed, so that everyone wants to set out on the journey, once it is begun there is no turning back. And along the way, the price paid for freedom from oppression and restriction seems to be a kind of rootlessness and insecurity that the human species has not previously encountered.

The Emergence of the Western Concept of (Fine) Art

Although early treatises about painting or sculpting or music making use terms that we translate as "art," we are being narrowly parochial whenever we assume that the authors thought about art in the same ways that we do. Plato discussed not "art," but beauty, poetry, and image making; Aristotle's writings deal with poetry and tragedy. They used a word, *techne*, which we have translated as "art," but this word was applied equally to angling, chariot driving, and other mundane activities. *Techne* meant "having a correct understanding of the principles involved," and would have been used in much the same way that we use *art* when we refer to "the art of cooking" or "the art of parenting."

In medieval times, the arts were predominantly in the service of religion, as they have been in human societies from the beginning. They were not regarded "aesthetically" as something meaningful and significant in and of themselves, but instead valued only insofar as they revealed the divine. Renaissance artists gradually replaced eschatological with anthropocentric concerns, but during the transition from a God-centered to a man-centered art their works portrayed either a familiar ideal/divine realm or the actual world in which they lived. The artists' "art" consisted of accurately representing that subject matter using craftsmanlike standards of beauty, harmony, and excellence.

The eighteenth century is recognized today as the period during which a number of social and intellectual trends came together, intertwined and influenced one another, and eventually produced what we have come to identify as "modernity." Among these trends I can mention (with the misleading brevity a short account requires): a gradual secularization of society, whose aim became life, liberty, and the pursuit of happiness for individuals rather than acquiescence to a humanly unknowable divine plan; the rise of science, which not only fostered questioning and dissent

but made possible the development of technology and industrialization; the ensuing replacement of affective ties of feudal and kin loyalty with instrumental relationships based on the exchange of money; an emphasis on reason as the most efficacious tool for understanding and controlling the matters of life; the great political revolutions in America and France with their subsequent division of society into workers and bourgeoisie and gradual weakening of the nobility and clergy.

Modernity brought with it many new "goods," but also a variety of associated "evils." With modernity came individualism and liberation from the rule of custom and authority, yet alienation from one's work and from other people; new possibilities for thought and experience, yet an unprecedented loss of certainty and security about one's place in the world; new comforts and conveniences, but increasing regimentation, clock-boundedness, and removal from the world of nature; the objectivity and fairness made possible by reason, but a concomitant devaluation of mythopoetic and visionary modes of thought that had been expressed in nonlogical but emotionally satisfying traditional practices.

Artists found the new order as liberating and insecure as everyone else. As the nineteenth century advanced, they lost their traditional patrons, the church and the court. They now found themselves dependent on the public—multiform, faceless, swayed as today by hype and novelty—in what was to become an art market. Aspiring artists no longer served an apprenticeship in a guild system, but learned what standards were acceptable from newly established national academies and collections in national museums. Private dealers and galleries appeared to intercede between artists and the public. Professional critics who wrote for newspapers and newly established magazines of art contributed to the new milieu as did schools and scholars of art who established their field as a sequential and developing history of particular works of art that every well-educated person should know.

Modernism: Art as Ideology

Rapid secularization during the Enlightenment period stimulated interest in a variety of new subjects. One of these new areas of interest came to be called "aesthetics": a concern with elucidating principles such as taste and beauty that govern all the arts and indeed make them examples of (fine) "art." Until the Enlightenment, no other society had considered art to be an entity in itself, to be set apart from its context of use (usually in ceremony or entertainment) or the content that it portrayed or suggested. What seems to us to be self-evident "art" (e.g., paintings, sculp-

tures, poems, motets, cantatas or—in other societies—carvings, urns, figurines, masks, ornaments, dramatic performances) were not regarded as such by their makers or users. They found no reason to assume that these belonged in a nameable superordinate category, "art," that suggests a special mode of working or noteworthy social identity (being an "artist" rather than simply someone who paints) or a special result (a "work of art" rather than an altarpiece or ancestor figure).

As the subject of aesthetics developed over the next century, a startling and influential idea took hold. This idea held that there is a special frame of mind for appreciating works of art: a "disinterested" attitude that disregards any consideration of one's own personal interest in the object, its utility, or its social or religious ramifications. This unprecedented idea led to still another: the work of art is a world-in-itself, made solely or primarily as an occasion for this kind of detached aesthetic experience, which was considered to be one of the highest forms of mental activity.

"Disinterest" implied that one could transcend the limitations of time, place, and temperament, and react to the artwork of eras far removed from one's own—whether or not one understood the meaning they had had for their original makers and users. In this sense, art was "universal." Another key idea that gradually developed in the field of aesthetics was that works of art were vehicles for a special kind of knowledge—a knowledge that, with the waning of religious belief, often took on the spiritual aura and authority once restricted to the church. Still another corollary was the idea of art for art's sake (or life for art's sake), suggesting that art had no purpose but to "be" and to provide opportunities for enjoying an aesthetic experience that was its own reward, and that one could have no higher calling than to open oneself to these heightened moments.[1]

As paintings became less and less like mirrors held up to nature or to society, viewers could no longer decipher or naively admire them. Critics assumed ever-greater importance as mediators between the artist and the public because someone had to explain to the mystified public what made an artwork good or bad and even what a work "meant." In England, in the early decades of the twentieth century, Clive Bell and Roger Fry were extremely influential as they invoked "formalist" criteria for appreciating the puzzling new work of postimpressionists such as Cézanne, or the cubists, work that could not be understood with the serviceable old standards (that anyone could recognize) of beauty of conception, nobility of subject matter, representational accuracy, or communication of valued truths. Art had become, if not a religion, at least an ideology whose principles were articulated by and for the few who had leisure and education enough to acquire them.

More elaborate and abstract formalist standards were developed in America by critics such as Clement Greenberg and Harold Rosenberg in order to justify abstract expressionism, a midcentury school of painting that affronted sensibilities and challenged what had previously been acceptable as art. Terms such as "flatness," "purity," and "picture plane" became the verbal tokens of the transcendent meanings viewers were told they could find in the skeins and blobs and washes of paint. Because these values were not easily apparent to the untutored observer, appreciating art became more than ever an elite activity, requiring an apprenticeship and dedication not unlike that of the artist. Never in question was the "high-art" assumption that works of art—no matter how strange they looked or how unskilled they seemed to be—were conduits of transcendent, supernal values, of truths from the unconscious, expressions or revelations of universal human concerns that the artist was uniquely endowed to apprehend and transmit.

As the "isms" proliferated and art became more esoteric and outrageous, the role of the critic became not only helpful but integral to the reception of works of art. Looking back, it seems inevitable that an "institutional" theory of art arose to explain what art is. As formulated by George Dickie (1974) and Arthur Danto (1964) (who were describing what was the case, not advocating or defending it), an artworld (one word) composed of critics, dealers, gallery owners, museum directors, curators, art-magazine editors, and so forth, was the source of conferring the status "work of art" on objects. What artists made were "candidates for appreciation," and if the artworld bought and sold them, wrote about them, displayed them, they were thereby validated as "art"—not before.

Implicit in this account is a recognition that what is said and written about a work is not only necessary to its being categorized as art, but is indeed perhaps more important than the work itself (Wolfe 1975). There is no appreciation of art without interpretation. We can tell that a pile of stones or a stack of gray felt displayed in a museum is different from a pile of stones on the pavement outside the museum or a stack of felt in a carpet store next to the museum because the objects in the museum are viewed through a lens of knowledge of their place in a tradition. "To see something as art at all," proclaimed Danto (1981, 135), "demands nothing less than this, an atmosphere of artistic theory, a knowledge of the history of art." In this view, there are no naive artists and no naive art: today's artists can both explain the theories behind the works that are to be seen in museums and galleries and place their own works in these traditions.

Postmodernism: Art as Interpretation

Acceptance of the indispensability of interpretation in appreciating artworks (not to mention simply recognizing them as art) opened a Pandora's box that is now called "postmodernism," a point of view that calls into question two centuries of assumptions about the elite and special nature of art. While the term "postmodern" is used (and abused) as indiscriminately as "modern" used to be, postmodernists are united by a belief that the "high-art" or modernist view I have just described is untenable and unacceptable. But they do not advocate a return to pre-Enlightenment views. Postmodernism is not simply another "ism" or movement. Instead, it is a declaration of the end of all isms and movements, of the impossibility of further theory. The postmodernists claim to reflect a pluralistic, rootless society whose consumerism, proliferation of media and media images, multinational capitalistic economy, and so forth make it vastly unlike any society that has previously existed.

Postmodernists eschew the very idea of overarching explanatory schemes (which they call "metalanguages," "metanarratives," or "metatheories") by which facts or things can be connected or understood. They distinguish instead a plurality of discourses that belong to different "interpretive communities" (Fish 1980), each of which has its own *parti pris*, its own axioms to grind and fields to till. Hence any "truth" or "reality" is really only a point of view—a "representation" that comes to us mediated and conditioned by our language, our social institutions, the assumptions that characterize individuals as members of a nation, a race, a gender, a class, a profession, a religious body, a particular historical period. Artists, just like everybody else, do not see the world in any singularly privileged or objectively truthful way, but rather—just like everybody else— interpret it according to their individual and cultural sensibilities. What is more, since individual interpretations are derivative, people cannot even find a unique private world or style to express any more. All the "new" styles and worlds have already been invented (Jameson 1983).

For the postmodernist what has been enshrined as "high" art is nothing more than a restricted canon of works that largely represents the worldview of elite, Western European, white males. Writers such as Joyce, Eliot, and Lawrence who have been accorded the status of "masters" are merely individual voices who offer restricted points of view, many of which today sound sexist, racist, politically conservative or reactionary, or otherwise unacceptable. Terms such as "taste" and "beauty" and "art for art's sake" are constructions that express class interests. To claim that one

can appreciate works arising from alien cultures is an imperialistic act of appropriation: one falsifies the alien work by focusing on those of its many characteristics that appeal to one's own standards while ignorantly ignoring or, even worse, dismissing the characteristics that were the standards for their makers and users. Art is not universal, but conceptually constructed by individuals whose perceptions are necessarily limited and parochial.

As a result of the discovery that modernist aesthetics masks chauvinistic, authoritarian, and repressive attitudes toward uneducated, nonestablishment, and non-Western people and toward women, postmodernist artists have thus set out deliberately to subvert or "problematize" the old "high-art" standards, often by parodying or otherwise flouting them. For example, instead of trying to create enduring, "timeless" works of art, postmodern artists deliberately create intermittent or impermanent works that have to be activated by the spectator or that cease to exist when the performance is over. Eschewing the site specification and religious aura of the museum, art is created on the street, in remote deserts, or found in humble or trivial objects and materials. Postmodernist artists challenge the integrity of individual arts by using hybrid mediums—sculptures made of painted canvas, or paintings made of words and numbers. Artists challenge the high-art concepts of uniqueness and originality by copying, photographing, or otherwise appropriating images from past art for their new works, or by making many repetitions or reproductions of an image or construction. They create "pastiches" in the styles of earlier artists and present them baldly and unapologetically, without satirical intent, indeed usually without any social or aesthetic justification. They make works out of fragments that have no apparent relation to one another except for their juxtaposition.

Although the label "postmodernism" is relatively recent,[2] postmodernist theory and practice was foreshadowed early in this century and even before this century.[3] What seemed at the time a shocking (or amusing) aberration, Marcel Duchamp's *Fountain*—the infamous urinal displayed in 1917 at the New York Society of Independent Artists exhibition—can now be recognized as a crack in the dike of high art that in the past two or three decades has released an ever increasing flood of antiestablishment theory and realizations-of-theory (i.e., works of art).

The works and ideas that are called postmodernist can be lamented or ignored, but like modernism's works and ideas, they certainly reflect the society that gave birth to them. In light of the political calamities and barbarisms of the mid–twentieth century—totalitarianism of the right and left, genocide, the possibility of nuclear annihilation—the modernists'

faith in human intelligence and their belief in the progress and perfect-ibility of human existence seem as antiquated and untenable as medieval theology. Socialism and, more recently, other underclass movements have challenged democratic societies' pretensions to providing objective, universal justice or equal protection under the law.[4] As for virtue, the recurrent scandals at the very heart of democratic government suggest that morality is as difficult to unite with power as it has ever been. Freud's theories have made it hard for thinking people to believe that objective rationality alone could drive human affairs. The explanatory success of relativity theory in physics suggests the theme of relativity everywhere, including the fields of philosophy and ethics. The polluting fungoid spread of the automobile and its concrete accoutrements of freeway and parking lot over city and landscape, not to mention other even worse environmental ills, certainly calls into question the wisdom of human technological domination over nature. The proliferation of images in advertisements and on television make all events—from an exciting new dentifrice or room freshener to a fire in the Bronx, a missile attack on Tel Aviv, Johnny Carson's monologue, a famine in Africa, the Superbowl, or an earthquake in Peru—appear equally real (or unreal), occurring as they do in succession, compressed in time and space and significance.[5]

To be sure, modernist artists certainly recognized confusion, multi-plicity, and relativity: one has only to read the novels of Joyce, Mann, Proust, or Musil. Some questioned the uses of science and reason, and used their art to offer a mythology that might reorient and revitalize a materialist, hypocritical bourgeois society (e.g., Eliot's *Wasteland,* Stravinsky's *Rite of Spring,* Lawrence's "blood consciousness," and the attraction of artists like Picasso and Nolde to primitive carvings). Yet these artists (whose work was also initially shocking and puzzling) believed they were by their experiments and distortions and abstractions better express-ing an underlying reality, however mysterious and complex.

Postmodernists, on the contrary, as David Harvey (1989, 44) points out, uncomplainingly embrace the ephemerality, fragmentation, discon-tinuity, and chaos of modern life without attempting to counteract or transcend it or trying to define any eternal elements within it. This is *the* significant difference that separates them from predecessors who may also have recognized imperfections in the status quo. The postmodernists' capitulation (expressed as relativism and defeatism), their "tolerance which finally amounts to indifference" (Harvey 1989, 62), their "con-trived depthlessness [that] undermines all metaphysical solemnities" (7) are what makes their work so displeasing and disturbing to a general public that has not as yet become so cynical and nihilistic. For many

people continue to believe (or want to believe) that the arts still have a mission to inspire and elevate or that philosophy is still obliged to search for and discover verities by which to live.

Although the art lauded by postmodernist critics is puzzling, if not shocking and offensive, to many people, the social problems and cultural predicaments it reflects cannot be gainsaid. Exposure of the rigid, exclusive, and self-satisfied attitudes that often lie behind the rhetoric of modernism should, in large measure, be welcomed, for it is preparing the way for the liberation and democratization of art. But the postmodernist proclamation that there are a multiplicity of individual realities, all of which are open to an infinite number of interpretations and equally worthy of aesthetic presentation and regard, troubles me. I find this aspect of postmodernist aesthetics inadequate: have not the postmodernists abandoned the crumbling edifice of modernist authority for an equally uninhabitable esoteric antistructure of relativism, cynicism, and nihilism? If everything is equally valuable, is anything worth doing? Is sprawling promiscuity really an improvement on narrow elitism? Is absolute relativism a more credible position than absolute authority? From the postmodern viewpoint, the answers would be "Unfortunately, yes. That's the way it is, like it or not." But the Darwinian metanarrative discerns a few encouraging handholds that should provide escape from the abyss and restore access to a world of human meaning and human reality.

Literacy, Art and the Modern Mind

In order to counter the postmodern claim that all worldviews are interchangeable, to be tried out and then discarded like so many lipsticks, I am proposing what may appear to be just one more metanarrative. Yet I believe that it can provide a real replacement for (not simply an alternative to) postmodern nihilism. For while both postmodernism and my own species-centrism may be outgrowths of Western culture, the former position is restricted and culture-bound in a way that the latter is not. Far from being a new mode of consciousness, postmodernism is rather the inevitable conclusion of a blinkered philosophical tradition that by the very tools of its profession is constrained in its presuppositions about language, thought, and reality, and, moreover, has yet to take into account the implications of evolutionary theory for a broad and truly universal understanding of human behavior.

Ironically, the "flaw" or blinker in postmodern thought is what made it, and Western philosophy and modernism themselves, possible: a reli-

ance on reading and writing. Literacy made science possible too, of course, so it is doubly, or perhaps triply, ironic that it is from a scientific viewpoint (appearing here in a book that was written to be read) that current naysayers and relativists are apprised of the true identity of that troll who guards the bridge to our lost arcadia.

To habitual readers (and writers and publishers) of books, it may seem preposterous to intimate that literacy is not unequivocally a good thing. Yet an appreciation of how it affects the mentalities of individuals and societies is central to understanding how writing not only erases art but has influenced the practitioners and apologists of postmodernist theory in ways that seem not to be evident to them.

It is worth pointing out that this "literate mentality" characterized only a fraction of the past members of the human species and continues to characterize only a minority of those humans alive today, so that pronouncements about "art," "being," "knowing," or "ultimate reality" arising from such a peculiar and anomalous origin may be as partial, mistaken, arrogant, and presumptuous as the ideologies or metanarratives they are meant to challenge or replace.[6] Born of literacy, I will argue, postmodernism (and indeed Western philosophy) is *scriptocentric* in the same way that the pre-Copernican world was geocentric. Taking a deep breath and a long view permits a clearer and less self-absorbed second look at some of the most perplexing and troubling postmodern concerns—in life as well as in art.

The Anomaly of Literacy

It might seem rather startling to many of my readers, but I would like to point out that for many millennia people did not read and write and yet were able to live full and fully human lives. In the forty thousand years since modern humans (*Homo sapiens sapiens*) emerged as a species, there have been some 1600 generations (counting twenty-five years as a generation). For 1300 of these generations we lived as hunter–gatherers, as nomads not unlike the Australian aborigines or many native American tribes before their contact with Europeans. For merely 300 of those generations have most humans become settled agriculturalists; we have lived in villages, towns, or cities only since about 7500 B.C. And although writing was invented about 4000 B.C. (150 generations back), it was not until the development of the alphabet (rather than pictographs, ideographs, or syllabaries) that reading could become an accomplishment of people other than specialists like priests or scribes. These of course had to spend decades learning an enormous number of signs and marks. Neither

priests nor scribes used their skills for gaining knowledge or receiving pleasure from reading, as we do: they used reading and writing for keeping records or for preserving and enforcing the pronouncements of authority.

For eight-ninths of their history, humans could not read at all. Reading and writing did not begin to play a significant role in general society until the invention of the printing press five hundred years ago, a mere twenty generations back. (In the time of Plato, of course, people did not learn from books, but largely by oral, dialogic teaching.) Thus, only about 20 generations out of a probable 1600 have even in theory had the opportunity to learn to read and write. And in practice, of course, most of those *potential* readers, even in the West where literacy was most widespread, never had the opportunity to become *actual* readers.

One of the features of alphabetic literacy is its "transparency," the way it seems to give, without laborious deciphering, instant and direct access to its subject, rather as a picture composed with one-point perspective appears to offer a window onto the real world. Once mastered, alphabetic script "dissolves" and reading seems natural, although the skills that produce the material being read are not natural at all. Language as speech *is* natural. It is innate, fundamental to our species. Everyone, even most mental defectives, learns to speak and to understand spoken language; the competency is encoded in our genes, and our brain has evolved to function with oral communication and in oral culture. But this is not the case for reading and writing, which many children find difficult to learn, requiring a disembedding from context that is quite unnatural to the spontaneous way the mind seems to work. To learn to read the mind must be retrained.

It is illuminating to compare "oral" cultures, those without writing, to "literate" cultures, those with writing. Of course, pure oral and pure literate cultures are abstractions: there is a continuum between groups that have never had a written language and groups, like ours, that more or less require literacy for full social participation and in which many years of training in literate skills (concomitants of reading and writing and schooling such as abstraction, quantification, analysis, efficiency, planning ahead) are practiced and made second nature. In between are societies where people learn elementary reading skills—enough to read a holy book, for example. Often the skills of reading and writing involve learning a language that is not a person's own mother tongue (as Latin was in medieval times, or English and French are today in former colonial countries); equally frequently, reading and writing do not permeate the workings of the society but are left, as in the West's Middle Ages, to an elite of priests or bureaucrats. It is also the case that any individual in

a highly literate society will participate in a variety of more and less literate encounters and activities.

Nevertheless, despite the artificiality of the poles of the oral-literate continuum, certain intriguing oppositions and comparisons can be made.[7] Oral communication is, first of all, *personal and involved*. Speaker and listener must be face to face or at least in each other's vicinity, allowing for a shared experience. Common knowledge and expectations can be assumed, so that much can be taken for granted. A lot can be left out, and if the hearer is confused she or he can ask for clarification. Written language, by contrast, is *impersonal and detached*. Writers cannot presume shared knowledge, so they must be explicit where a speaker is implicit; precise and careful where a speaker can be careless; streamlined and sparse where a speaker can be redundant. Written language is primarily technical, concerned with logical and coherent explication or argument. Spoken language is vivid, idiomatic, and at least as concerned with facilitating a social encounter as with accurately and unequivocally conveying an informative message.

These differences between spoken and written communication are reflected in the kinds of societies and kinds of people characteristic of the two types. In oral societies, analysis and questioning are not encouraged—indeed, they are hardly possible in the literate sense, where one has a text that can be reread, checked, compared, pondered, classified, and interpreted. Hence people look to tradition and authority—which are preserved by means of proverbs, folktales, ritualized formulations, and so forth—for instructions on how to live. Their attitude concerning the validity of these cultural repositories is one of certainty and belief. Because the entire group is joined in the same beliefs or world-picture, it is characterized by a sense of communality, a submersion of individuals within the larger whole rather than their being expected to rely primarily on themselves. The world-picture is what the anthropologist Jack Goody (1987) calls "meaningful-cosy," to be contrasted with the literate society's "mechanical-orderly." In the latter, knowledge replaces belief, an ideal of cool, impersonal, intellectualized exactness replaces warm messy emotionalism, and acceptance of the relative, provisional, arbitrary, and contingent replaces certainty and commitment. Indeed, it seems undeniable (see Todd 1987; Townshend 1988) that modernity cannot occur in a society without a high degree of literacy.[8]

Literacy and Modernity

The blanket characterizations of oral and literate persons and societies in the preceding section are admittedly overgeneral and require certain

qualifications in individual instances. In a "literate society," for example, and even in a highly literate person, residues of oral society and its mentality remain and occasions for oral thinking and practice occur. Also, I admit that a multiplicity of causes contribute to the alienation felt by modern men and women, and I do not mean to suggest that learning to read and write automatically catapults us, like Harmonia and Cadmus, out of paradise.[9] Yet it cannot be denied that the skills fostered by reading and writing lead easily to individuality and isolation and thus reinforce other changes that promote social fragmentation. One speaks and listens to another; one reads and writes alone, even if others are nearby. It is suggestive that it is only in the West that autobiography is a literary form: it first arose in the Renaissance. Historically we have been increasingly preoccupied by self and selves.

While individualism has its virtues and rewards, no evidence derived from the study of simpler or previous human societies indicates that we have been evolved as a species with innate resources for living in isolation, feeling as Duns Scotus said, that "personality is the ultimate solitude."[10] Quite the contrary. From the moment of birth, an infant begins bonding with its mother, and in most non-Western societies never really detaches but moves gradually to intimate associations with relatives and peers and eventually, often by means of compelling and unforgettable initiation ceremonies, to identification with the society as a whole.

In literate society, the usual prescribed means for adjusting to the anxiety or terror of solitariness is more analysis and detachment. In Freudian psychoanalysis—the term is unequivocal—says Philip Rieff (1966, 59), "the therapy of all therapies, the secret of all secrets, the interpretation of all interpretations . . . is not to attach oneself exclusively or too passionately to any one particular meaning or object." And while detaching, to aid this detaching process, one must examine the reasons for one's attachment. As Herbert Marcuse (1968, 68) has observed, the soul today contains few secrets and longings that cannot be sensibly discussed, analyzed, and polled.

Literacy promotes detachment and separation in part because writing makes it possible to see a word as a thing, separate from its referent. Nonliterate persons who have never seen words written and thereby separated from the stream of utterance and made into visual *things*, assume that the words they hear *are* what they refer to: the word (sound) for oak or elephant is inseparable from the oak or the elephant itself. An endearing story in this regard was told to me by a man I met, who as a child secretly worried that in the neonatal ward of the hospital the identification tags for himself and his twin brother had been switched and that he

was really David and his brother, David, was really himself, Paul. Then there was the lady who went to a lecture on the night sky and afterward was heard to say, "I think I understand how astronomers can figure out how far away the stars are, and even how they can tell what gases and things they are made of. But what I can't understand at all is how they find out their names."

To the primitive and to the traditional religious devotee everywhere, the statue *is* the god, the presence of the god, as the word *oak* is an oak and the stars' names are part of the stars themselves. Primitive carvings and masks are embodiments of the spirit: both participate in reality as does, for that matter, the persons themselves who do not feel themselves alone in ultimate solitude.

This embeddedness of preliterate society in its environment, the coherence and interpenetratedness of word and referent, image and reality, began to be lost to mainstream Western philosophy from the time of Plato. Plato was the first great philosopher to speak from a full literate perspective when he demonstrated how images *contrast with* reality. In his view, a painter or sculptor made works that were *images* or *representations* of an ideal reality that was forever separate and removed from any individual instance of it. In other words, as we have seen, they made "art." This concept is unavailable to the preliterate for whom image is not image—artifice, imitation, or simulacrum—but reality (or spirit) itself. This separation between real and ideal in Plato is different in kind from the Enlightenment superordinate category of "art" or the postmodern idea of *différance*, but all three are concepts that are accessible only to the literate mentality.

All of this seems paradoxically to confirm that rather than "erasing," writing and the literate mentality have "created" art, not only in the present day when art is in many instances inseparable from art theory, but already in fifth-century Athens when Plato and Aristotle showed how art and poetry were imitations, representations, images of reality, and thus separate from it.

Yet at the same time as writing and theory have created the concept "art," have constituted art (as the theorists say) by baptizing candidates for appreciation with the "art" label, those who write and theorize concern themselves primarily *with these concepts and labels*, as if concepts and labels are the significant defining features, the very substance of art. What is more, the referents of the word, concept, or label "art" are dismissed ("erased") by the philosophers and critics of the arts today as unknowable, unreachable, as meaningless.[11]

And it goes even further than that. In an essay called "The End of Art"

(1986) Arthur Danto describes how the idea of art has become more and more dependent upon theory for its existence, until today virtually all we have *is* theory, "art having finally become vaporized in a dazzle of pure thought about itself, and remaining as it were solely as the object of its own consciousness" (111).[12] To Danto this implies that since the concept of art is internally exhausted, transmuted into philosophy (84, 86), there is now only "the possibility of change without development" (85).

Beneath his sophisticated analysis and urbane prose, Danto's wistful pessimism is plainly apparent. "The age of pluralism is upon us. It does not matter any longer what you do, which is what pluralism means. When one direction is as good as another direction, there is no concept of direction any longer to apply" (114–15). He goes on to offer a little comfort: "Of course there will go on being art-making and art-makers" (111); "decoration, self-expression, entertainment are, of course, abiding human needs. There will always be service for art to perform, if artists are content with that" (115). Danto could have included "making special" when he made this list. Is the future of art to be nothing more than Sunday painting, housewives arranging flowers, and kindergartners churning out May baskets? How can a species-centered perspective counter this bleak prediction (which with the lofty imprimatur of Hegel seems unchallengeable)?[13]

Hyperliteracy and Postmodernity

Let us look a little closer at some of the key words and ideas of contemporary art theory. It will become clear that even more than previous philosophical terms they emerge from a limited and restricted view of the human mind and spirit that I have described (in my necessarily cursory outline of the differences between oral and literate mentalities) as characterizing the modern literate temper. Being by its nature "disembedded" and alienated, it seems to me no more able to describe the whole of human endeavor or human art than modern "case"-oriented medicine is qualified to make pronouncements about the healing of the human person.

Poststructuralism and postmodernism are openly and unreservedly preoccupied with reading and writing. Derrida and his followers are abundantly aware of the differences between spoken and written language. They see writing as being central to the postmodern awareness of the gap between reality and our ability to reach or enter and hold it. Hence their claim that everything, all cultural products—images, rites, institutions— can be regarded as *texts*, separated from reality just as words and works of

art contrast with the real things they attempt to describe.[14] As Arthur Danto (1981, 82) has said, "Artworks as a class contrast with real things in just the way in which words do"—in other words, they stand at the same philosophical distance from reality as do words.

Thus works of art, because they are cultural products, function like texts in that they require the active response of viewers who, like readers, must fill in, add to, build upon suggestive elements, supply extraneous historical, personal, and social references rather than, as in old-fashioned modernism or in nonliterate societies, transport themselves to the special world and time of the artist's original production or of the work's "being."

Joined with the concept of "text" in the postmodernist canon is that vaguely alarming though much-used word *deconstruction*. It sounds violent, but is not—in fact, rather than being destructive or explosive, the term is quite cerebral, referring to a mental taking apart or unbuilding.[15] "Deconstruction" is a word for a certain kind of detached and formal analysis (which it will be remembered is a skill made possible by literacy)."[16] A deconstructionist reading of a text aims to expose the text's hidden assumptions, most especially any pretense that it is talking about or representing reality. The deconstructionist reading shows that although texts may naively seem to be about reality, they are really about other texts, all of which inevitably conceal unexamined ideological and metaphysical assumptions. Conceptions like "the author," "authorial intention," "history," "man," "reality," and "the self" are shown to be only mental constructs, generated by the structures of language—and hence inevitably deconstructable. And as instances of postmodernist philosophy or literary theory, artworks today blatantly and unashamedly show their dependence on other works, their impermanence, their repeatability or replaceability, their boringness or triviality, their hybridization, their lack of resonance and authority. As Roland Barthes (1977, 167) has said, the artist must fissure the very representation of meaning.

The postmodernist is not motivated by destructive impulses, like an angry or naughty child who maliciously knocks down someone else's blocks—though one may be forgiven for suspecting something of the kind.[17] Rather the postmodernist, influenced by the careful study of language that is so characteristic of our century,[18] has accepted Ferdinand de Saussure's (1915/1966) recognition that the relationship between signifier (the word as sound or image) and signified (the concept referred to) is entirely arbitrary. Saussure's theory, pushed to its extremes by the sages of poststructuralism, has led to the claim that meaning does not reside in the world to be "expressed" or "reflected" in language (or art) at

all.[19] Indeed, meaning is actually produced by language or art—or, more accurately, by the reader or viewer who reproduces it.

As J. Hillis Miller (1987, 1104), a representative luminary of the movement, has said: "There is no such thing as an 'experience of being in the world and in time' prior to language. All our 'experience' is permeated through and through by language."[20] If he really "means" what he says (which is a perpetual problem in the exegesis of poststructuralist writing), he is asserting that we have meanings and experiences only because we have a language to have them in. And because language exists before we do, because we are born into a culture that comes to us complete with an already existent language that we learn and then use to articulate our meanings and experiences, we are in fact the product of our language which is by its very nature unable to "say" or see or grasp Reality.

According to the holy writ of postmodernism, we can never reach or get through to an unmediated Reality. There is an irrevocable, unbridgeable gap, fissure, cleavage between us and the wordless possession of meaning that we desire. Union is perpetually deferred, and an unremediable *différance* exists between us and everything else. The objectivity and disembeddedness fostered by literacy has now become utter severance and nonpresence.

One might suppose that the reaction to recognizing such a hopeless, helpless state of affairs would be an existentialist-like angst or nausea, leading to denial or catatonic despair. But not at all. The response to this bleak news, which only those at the higher reaches of the literate tradition can comprehend, much less formulate, is to write about it. And write and write and write with what looks suspiciously like smugness and glee. Yet while their philosophical findings are literally unthinkable without "literacy"—the type of mind made possible and fostered by the literate tradition—they discuss these in prose that is the reverse of the literate ideal of lucid exposition. Postmodern writers play with language, self-indulgently, learnedly, even perversely, and with detectible self-congratulation at their cleverness. While inventive and imaginative, this kind of writing, it must be said, has nothing to do with the old oral mode. No bard or troubadour worth his salt would use such obfuscation and labyrinthine arcaneness. He would know that the audience would soon be pelting him with rotten pomegranates or unripe olives, or at the very least would start to steal silently away after the first few utterances. Postmodernist writing is something new in human communication: it is a writing based on writing that yet sabotages and subverts writing. Like children of the rich who disdain and criticize their parents' materialism

while they accept monthly handouts that make possible their bohemian style of life, postmodern writers bite the hand that feeds them.

Language, Thought, and Reality

I would like to submit the scriptocentric nay-saying line of thought, just summarized, to species-centered scrutiny. By taking it out of its confined and protected literate framework (where it seems self-evident) and putting it into broader panhuman perspective—submitting it not to deconstruction so much as to emasculation—the inadequacy of the poststructuralist postmodern position becomes glaringly evident.

To begin with, the species-centered view does not dispute that we are the product of our language. We describe our experience in terms of the language that we learn as children, a language that preexists the individual, as Heidegger noted and as the postmodernists repeat, a language that in large measure produces our meanings and interpretations for us.

Yet, with their limited view, postmodernist philosophers do not seem to be aware that, in the first place, language was not "always" there. It evolved as an adaptation—like walking on two legs or developing an opposable thumb—to enable us to do certain things better, to better fill our needs.[21] The mistake made by postliterate postmoderns, I believe, is not that they say that we are the product of our language but that they imply that we are *nothing but* the product of our language. (It goes without saying that it is equally wrong to say that we are "nothing but" the isolated origin and generator of meaning, independent of language.)

As I have argued in previous chapters, our experience as humans arises from our being born with a species "package" (J. Z. Young [1978] has called it "a set of programs") of genetically endowed predispositions or readinesses both for patterns of how we think or respond to our environment and its affordances, and for what we require from or are impelled to seek both materially and psychologically from it: to bond, to attach, to share and reciprocate with others, to self-transcend, to order and classify, to join with a group to confirm an explanatory system about the world, to nurture, to be nurtured, to perceive our existence and activity to be of use and value to ourselves and to others. Whether we articulate these things, and no matter how we articulate them in language, we do them—in different ways and with different emphases in different cultures, to be sure, but by our very nature, human nature, meaning is there. If meaning, universal species-wide meaning,[22] were absent, these things would not have evolved and persisted, nor would language that helps us do them

have evolved and persisted. We would not have done them universally in every culture and still be doing them. Even postmodern philosophers do them, although their particular hyperliterate worldview (inherent as they would argue in their "language") leads them to feel and proclaim that they are separated from and missing something.

And just as language evolved to help us get what we need in order to survive, so that what human language refers to has human meaning, the human world—those things that we need or do not need—is real as well. In other words, the things language evolved to refer to (the affordances of the environment) must in an important sense exist. Not only can we know or reference or experience the world, but the world is there to know and reference and experience.

This should hardly require emphasis, but in their epistemological and metaphysical anarchy, postmodern philosophers are joined by much of the rest of twentieth-century philosophy. This is a remarkable state of affairs considering that their methods, interests, and objectives are quite dissimilar and that they do not normally speak or listen to each other. I suggest that this is because beneath their theoretical differences, all share a similar "literate mentality," even though their respective views of language appear to be remarkably unlike.

Western philosophy from antiquity to the present has tried to understand Reality—the sensible world or a nonsensible something-behind-the-sensible-world—and the manner in which it exists apart from our perception (and hence knowledge or ideas) of it. This separation of Reality or "the world" from ourselves can be seen as inherent in the tendencies toward detachment, analysis, and objectivity, the separating of words from their referents, that are fostered by literacy, as just described. This is not to say that what objective analysis discovers may or may not be accurate, but to point out that one's very reliance on (written) language may privilege "language" (and particularly sentential or propositional language) in a way that leaves out much of human-world interaction—a point that I introduced in Chapter 6 and that I shall discuss in more detail below.

For now I would like to address the "relativity" issue inherent in the view, generally accepted by postmodern philosophers, historians, sociologists, and other theorists of knowledge, that Reality has no independent existence apart from our theories about it. Adherents of relativism believe that the empirical sciences all describe different realities, each with its own internal structure. They further believe that these "realities" cannot be compared because there is no common basis outside theory against which they may be evaluated (see also Goodman 1978).

The species-centric view that provides a framework for my discussion can be dismissed, then, as one more worldview or metanarrative that is no more fundamentally provable, true, or real than, for example, Neoplatonism or Confucianism. But this seems to me a decision based on willful closed-mindedness. Scientific explanations are tested not only by reference to their internal coherence but also by reference to their consistency with other explanations and their ability to predict and to "work." Moreover, as Eibl-Eibesfeldt (1989a, 53) has pointed out, the "theories" that have been built into our perception (as described in Chapter 6) have been "more comprehensively tested over millions of years of evolution than have scientific theories." So even if our scientific theories are limited, being based on our imperfect senses and cognitions, they refer to a world, not just to our minds. Eibl-Eibesfeldt quotes Konrad Lorenz, who wrote in 1941 that "our cognitive and perceptual categories, given to us prior to individual experience, are adapted to the environment for the same reasons that the horse's hoof is suited for the plains before the horse is born, and the fin of a fish is adapted for water before the fish hatched from its egg" (cited in Eibl-Eibesfeldt 1989a, 8). And, Lorenz continues (contra Kant), "It is as unlikely that the fins of fishes determine the physical properties of water or that the eye determines the characteristics of light, as that the way we think and view the world has 'invented' space, time and causality" (Eibl-Eibesfeldt 1989a, 53).[23]

Be that as it may, much of contemporary philosophy seems wedded to the idea that our scientific or physical ideas of space, time, and matter are mere mental constructs that rest upon a particular version of the constitution of matter and the origin of the universe. Therefore we cannot *really* know anything.[24] This position is bad enough, but some postmodern versions of our epistemological impotence are even worse: not only are all worlds relative, but they are all equally plausible and meaningful (or implausible and meaningless).

I concede that the human mind is limited: as I noted in Chapter 6, we do not see ultraviolet light, smell moth pheromones, or understand millions. But these limitations make up our reality: the environment's affordances and our senses, cognitions, and emotions that respond to them. Hence I would most certainly dispute such pronouncements as Baudrillard's claim that we no longer have any means of testing pretense against reality. Zygmunt Bauman (1988), reviewing two books by Baudrillard, comments that for many people, reality remains what it always was, solid, resistant, and often harsh: indeed, they might be happy to find it was only simulated. Surely soldiers at the front or women in childbirth have the ability to discriminate pretense from reality. As Terry Eagleton (1987) has

said, apparently the Nicaraguans and the African National Congress have not heard, either, about the epistemological illusions of metanarrative.[25]

I must also dispute a perspective found in the Translator's Preface to Derrida's *Of Grammatology* (Spivak 1976, xxiii) that regards our responses to "nerve stimuli" as a "need for power through anthropomorphic defining [which] compels humanity to create an unending proliferation of interpretations whose only 'origin,' that shudder in the nerve strings, being a direct sign of nothing, leads to no primary signified." Nothing? Fire is hot. Hunger is bad. Babies are good.

Despite the postmodernists' theoretical notion that all realities or texts are equal, the fact remains that some realities and some texts (and not all) are chosen or avoided. They draw and hold people and seem to impel us to return to them again and again, or they do not. It would seem that these regularities would be a good place to begin to look for meaning, realizing, of course, that not everyone will want or choose all of them all the time, or even some of the time. (An evolutionist, I should repeat, would not disagree with the idea that there is variation within a population.)

In this regard, the following disquisition on a cooking pot by a Sioux medicine man would seem to be worth pondering.

What do you see here, my friend? Just an ordinary old cooking pot, black with soot and full of dents.

It is standing on the fire on top of that old wood stove, and the water bubbles and moves the lid as the white steam rises to the ceiling. Inside the pot is boiling water, chunks of meat with bone and fat, and plenty of potatoes.

It doesn't seem to have a message, that old pot, and I guess you don't give it a thought. Except the soup smells good and reminds you that you are hungry. Maybe you are worried that this is dog stew. Well, don't worry. It's just beef—no fat puppy for a special ceremony. It's just an ordinary, everyday meal.

But I'm an Indian. I think about ordinary, common things like this pot. The bubbling water comes from the rain cloud. It represents the sky. The fire comes from the sun which warms us all— men, animals, trees. The meat stands for the four-legged creatures, our animal brothers, who gave of themselves so that we should live. The steam is living breath. It was water; now it goes up to the sky, becomes a cloud again. These things are sacred. Looking at that pot full of good soup, I am thinking how, in this simple manner, Wakan Tanka takes care of me. We Sioux spend a lot of time

thinking about everyday things which in our mind are mixed up with the spiritual. We see in the world around us many symbols that teach us the meaning of life. We have a saying that the white man sees so little, he must see with only one eye. We see a lot that you no longer notice. You could notice if you want to, but you are usually too busy. We Indians live in a world of symbols and images where the spiritual and the commonplace are one. To you symbols are just words, spoken or written in a book. To us they are part of nature, part of ourselves—the earth, the sun, the wind and the rain, stones, trees, animals, even little insects like ants and grasshoppers. We try to understand them not with the head but with the heart, and we need no more than a hint to give us the meaning.

What to you seems commonplace seems to us wondrous through symbolism. This is funny, because we don't even have a word for symbolism, yet we are all wrapped up in it. You have the word, but that is all.

<div align="right">Lame Deer and Erdoes 1972</div>

Looking at this text with unsentimental postmodern eyes, we could conclude that like any cultural product Lame Deer's interpretation of his cooking pot *is* limited and partial: it can be deconstructed. But so what? The desk at which I write gives the illusion of being solid, although physicists inform me it is really composed of atoms with vast spaces between them. But it still supports my books and typewriter, and should the lights go out and a visitor unfamiliar with the room—say Jacques Derrida—bump into it, it will be solid enough that he won't fret about being irremediably separated from Reality. In a similar way, solid, substantial meaning and "impact" can be found in our cultural constructs once we look to the universal species realities they embody.

As I have said repeatedly, cultures are ways of articulating and satisfying precultural needs. I submit that perhaps it is these precultural needs—such as those for community and reciprocity, the extra-ordinary and transcendent, for play and make-believe, for attachment and bonding, for system building, for reconciliation with and reverence for natural environments and natural phenomena—that art is, and must in the West start again to be concerned with: with what is not accessible to verbal language, what cannot be said or deconstructed or erased, but nevertheless exists to be perceived by nonverbal, nonliterate *pre*modern ways of knowing. What is more lamentable than Lame Deer's naive adherence to his metanarrative, I suggest, is our own estrangement from the mystery of

simple, everyday things, our interpretation of shudders in the nervestrings as a "sign of nothing."

There are hopeful indications that some contemporary philosophers have been willing to take the natural and physical sciences into account, if not directly, at least by basing their statements on what can be shown to be scientifically derived and testable claims. For example, Jürgen Habermas's theory of communicative action stresses the autonomy of the human "life world" and the primacy of human intersubjective relations that are governed by an interest in communication and mutual understanding. He has argued that not only knowledge, but the criteria for its validation, can be found in the "interested" activity of the human species (Bauman 1987).[26] A species-centrist could scarcely improve upon this formulation.

At least two modern philosophers of mind have based their work on bioevolutionary explanations of the human intellect, claiming that beliefs are functional and that they reflect the environment. Daniel Dennett (1987, 47) says that a system's beliefs are "those it *ought to have*, given its perceptual capacities, its epistemic needs, and its biography," and thus in general its beliefs are both true and relevant to its life. Moreover, its desires are also "those it *ought to have*, given its biological needs and the most practicable means of satisfying them." Dennett's work describes "the intentional stance" we take (note: he does not call it "interpretation") when we make sense of each other and the world—finding meaning, giving reasons, forming beliefs.

David Papineau's (1987) "teleological theory of representation" similarly adopts a biological approach to the problem of mental representations, seeing these to be best understood as a matter of the biological functions of our beliefs and desires. We form beliefs of a certain type, he says, "because in the past its tokens have generally had advantageous behavioral effects and thus have led to its preservation" (65). Hence true beliefs are ipso facto biologically advantageous (77).

I suggest that hyperliteracy, like mercury in fish or DDT in mothers' milk, has insidiously permeated all twentieth-century Western thought and is in large part responsible for its excesses. All contemporary philosophy, not just continental poststructuralism, is characterized by a fundamental and thoroughgoing preoccupation with language, particularly the relationships between language and thought, and language and reality. This is a worthwhile pursuit, but it is flawed in the first instance by an unconscious predisposition to think of "language" as written text and a failure to recognize that written language is quite unlike really "human" language: spoken utterance.[27] To ignore the "thought" and "reality" of most of the species immediately renders suspect the universality of one's

pronouncements. What philosophers (and nonphilosophers too)[28] often mean by "thought" is restricted to their own brand of rational, critical, objective, propositional thinking—the kind of thought that is made possible by literacy. But this kind of thought is not the sum total of human mentation, although it may appear to be for superliterates who rarely step outside the academy gates.

Even if the advocates of language-of-thought accept that we think with natural language fragments (rather than sentencelike propositions), they relegate all the nonverbal mentation that was described in Chapter 6 to nonthought and nonexperience. For example, Derrida (1976, 50) states: "From the moment that there is meaning there are nothing but signs. We think only in signs." Contemporary knowledge about the brain, about child and animal behavior, or human mentality in cross-cultural perspective (e.g., the oral-literate continuum) makes this assumption at least debatable.

Brain physiologists quickly demolish such views, and, as I explained in Chapter 6, extensive information processing in the brain occurs independently of verbal processes (Levy 1982; Sperry, Zaidel, and Zaidel 1979; Trevarthen 1990). Neurophysiologists (e.g., Leventhal 1984) emphasize the importance to cognition and perception of emotions or affective experiences that need not have verbal tags to allow their access to consciousness. In any case, we have seen in Chapter 6 that the "mute" right hemisphere is far more important in processing linguistic materials than hitherto suspected (Gardner, Winner, Bechhofer, and Wolf 1983, Sperry, Zaidel, and Zaidel 1979). Indeed, much of the meaning of spoken language, even spoken propositions, is conveyed by paralinguistic or extralingustic features that would not be evident in writing without certain cues[29] so that even the processing of abstract sentences requires "experiencing" and "cognition" that is nonlinguistic. Such processing is mediated by "signs" only if these are conceded to be the elementary "representations" described in Chapter 6, stored as various kinds of knowledge in different modules of the brain.

When an automobile mechanic or washing-machine repairman examines and figures out what is wrong with a car or washer, he may not be using language, not even silently in his head. He will rely on spatiomechanical thinking that is probably largely right-hemisphere mediated. Ask him what the steps were in his assessment and the reasons why he did what he did, and you are likely to get circumlocutions about whatchamacallits and thingamajigs. The "clear, logical" instructions in the user's manual—the "text"—are likely to be unintelligible to someone who does not have the mechanical knowhow to be able to dispense with them in the first place.

I doubt that many philosophers spend much time doing mechanical repairs. And it seems obvious that they do not stay home with young children either, or they could never have come up with their assumption that you cannot think, you cannot have meaning and experiences, except in terms of language. Look at the toddler who has only a tiny vocabulary, yet can figure out (think) how to solve problems with her toys (which shape goes where in the puzzle, which ring goes first on the spindle), how to quietly drop her peas on the floor so she can have a cookie, how to engineer a second or third good-night kiss.

A pivotal element in Jacques Lacan's recasting of Freud is the child's inevitable awareness of *différance* and absence when it acquires "language." Lacan views all language as metaphorical, substituting itself for some direct wordless possession of the object itself. But not all language is concerned with objects or obtaining things actually or even metaphorically. Language is also used as a means of maintaining social relationship and demonstrating emotional reciprocity. We have seen in Chapter 6 that even very young infants transmit clear messages without verbal language, that emotional expressions are themselves a kind of language, neither defined verbally nor resulting from verbally mediated thoughts or reflections (Emde 1984; Trevarthen 1984). (If Lacan were correct, language would never have evolved, since people would never have obtained what they wanted.) Even chimpanzees and dogs are quite evidently thinking, drawing inferences, solving problems, predicting what comes next—all the time. We do not know *how* they do it, but we have no evidence that they are using language.

I have repeatedly emphasized that the right hemisphere of the brain (called with real literate chauvinism the "minor" hemisphere because it is mute) "thinks"—even though like babies and dogs it cannot report its thought processes to us. It is here that visual imagery and music, for example, are processed. Music, as Viktor Zuckerkandl (1973) has said, gives access to a whole dimension of reality added to time and space where we find ourselves and others in unity and togetherness rather than separate and sequential. Spoken and written language and analytic thought—left-hemisphere activities—of course, are separate and sequential; it is no wonder that when we rely on these it is easy to discount or not even to recognize other kinds of thought.

It seems more accurate to view thought and experience as occurring behind or beneath spoken words, as being something that saying helps to adumbrate and communicate and that writing (or rewriting) falsifies to the extent that it turns the natural products of mentation—fluid, layered, dense, episodic, too deep and rich for words—into something unnatu-

rally hard-edged, linear, precise, and refined. We "think" like logicians primarily on (and because of) paper. If we assume that thought and experience are made wholly of language it is only because, as twentieth-century hyperliterates, we read and write reality more than we live it. [30]

Language-as-writing is the prerequisite for a very specialized kind of propositional, logicodeductive thought. Hyperliterate societies undoubtedly owe their scientific achievements and consequent global economic and military power to being able to think in this way. And we hyperliterate individuals owe our larger salaries, more interesting jobs, our relative freedom, flexibility, and higher social positions to our mastery of literate skills. But we do not thereby acquire a monopoly on thought.

In *Frames of Mind* (1983) psychologist Howard Gardner described "intelligences" that have been overlooked or devalued in our society which rewards logical-mathematical and verbal ability (the kind that is tested by reading and writing). Again, these are skills that are highly developed in literate societies and not used at all in preliterate ones. (It is no accident that the perpetrators of the most extreme pronouncements of postmodernist liturgy are *literary* theorists.) But what about the purely oral verbal intelligence used by the bard or storyteller or speechmaker? What about the kinesthetic sense of athletes, dancers, throwers of spears and shooters of arrows, drivers of cars, all of whom must "know" where they are in space and who must "think" nonverbally about balance and timing? What about people blessed with awareness and sensitivity, the ability to assess the mood of an encounter or a gathering, and then "knowing" what needs to be done to correct, to improve, to enliven, to master the situation? What about awareness of the environment, which reaches a notable high point in the navigational skills of the Puluwat in the South Seas who find their way in canoes without instruments or maps over trackless expanses of the Pacific Ocean.

These are all "ways of knowing"; can anyone seriously claim that because language is absent or rudimentary, there is no thought, no meaning, and no experience? As I said, these other ways of knowing would be particularly valuable in simpler, preindustrial, premodern societies. [31] Allowed to atrophy in the industrialized world today, they are blindly disregarded by overintellectual hyperliterate philosophers whose navigational and social skills, one might say unkindly, have no more exercise than getting from one airport to another to travel from one seminar or lecture to another where others of like bifurcated mind may hear them descant and yet again descant about their supreme theme: the fissures between themselves and Reality.

The rewards of literacy, spiritual and material, are great and, as a

writer, I do not wish to subvert them. Neither do I wish to belittle the social and cultural importance to the unlettered of acquiring literacy. But I wonder whether perhaps we have read and philosophized too much when we begin to assume that life itself is a matter of language alone. It is not only, as Faust cried, that life is short and art is long, but that life—the existence of the human species on earth—is long and literate experience very brief. It often seems to me that, especially today, *what we need to learn most from books is what life was like before books.*

As humans, we were evolved over millennia to find meaning not only in language-mediated ideology but in the affordances of our human world, in such things as stones, water, weather, the loving work of human hands, the expressive sounds of human voices, the immense, mysterious, and eternal. Until we began to discourse about discourses, these are what our cultural texts were concerned with. It is important to remember that we do not necessarily or automatically respond to them with writing or even language.

Art Erased

At last it is time to return to art, that little monosyllable that has occasioned so much explicatory verbiage, that pixie that I claim has shrunk and withdrawn and like the Cheshire cat disappeared, leaving only a playful postmodern smile. [32]

The concept of art has indisputably been dealt a mortal blow by postmodernist theory and practice. "Fine" art has been demoted to little more than a transparent ideological banner by means of which one both displays and attempts to preserve one's elite status. Broader, more democratic notions of art now proclaim that art works are at best culturally constructed "texts" that concern only an individually interpreted and hence relative world.

As I suggested earlier in this chapter, as long ago as the time of Plato when art began to be conceptualized as something apart from life, art in the species sense—the innocent making of embodiments, enhancements, and transformations of reality (i.e., the world and its affordances)—began to disappear. It has taken 2500 years for postmodern philosophy to finish the job literacy began. Yes, writing does erase art, even though postmodernism claims that individual readers, writers, and viewers regenerate it again with their theories.

Despite the appearance of mounting a revolt against the literate tradition—deconstructing its texts, repudiating any notion of system and

logical development, calling into question the notion of "author" or "authorial intention"—the postmodern philosophical position is, as I have indicated, quite literally unthinkable without literacy.[33] Only those at the higher reaches of the literate tradition can comprehend, let alone formulate, the theoretical presences and absences or the subtle differences among signs, signifiers, signifieds, and significates so dear to postmodern theory. And the main tenets of their thought—disembeddedness from the environment, detachment from other people and from tradition, the claim that images and words are inadequate or only provisional attempts to convey an inherently unknowable Reality, the lament that no object will ever really satisfy, and that everything will only be a substitute for what you cannot get—are all concomitants of literacy and could not be thought by preliterate people. Deconstruction, and art made to be deconstructed, are dependent on a kind of involuted self-consciousness, attainable only to hyperliterates whose innocence is irretrievably lost.

It is only to be expected that as creatures of our time, many of us find contemporary art and art criticism enjoyable. Both are admirable for their cleverness, their daring, their knowingness. In their way, they make alienation and the abyss special. In a society like ours that takes its pleasures in frequent flashy and everchanging small gratifications, this may be all we can expect from our art. Seasoned spectators of the postmodern fashion parade look and see that our emperor does in fact have clothes, layer after loquacious layer of them—glittering, iridescent, filmy, each flutter of the breeze providing yet another tweak or shudder of titillation to those who look on. It is only when we return home and try to remember what was so exciting that we realize that, yes, the vestments were gorgeous and fun but—wait a minute—they kept us from noticing that underneath all the verbal dazzle there was no emperor.

Art Restored

The only way to understand and resolve the perplexing contradictions, inadequacies, and confusions of both modernist and postmodernist aesthetics is, I believe, by placing art in the broadest possible perspective: we must recognize that art is a universal need and propensity of the human species that posttraditional society by its very nature must deny.

It is significant that "art" acquired its modern meaning as something set apart at the same time that the arts themselves were being practiced and appreciated by fewer and fewer members of society. In small-scale, unspecialized, premodern societies, individuals can make and do every-

thing that is needed for their livelihood. Such societies may not possess the abstract concept "art," but they offer all their members frequent opportunities to be "artists": by decorating their bodies and possessions, dancing, singing, versifying, performing. Certainly, some persons in traditional societies are acknowledged as being more talented or skillful than others, but the special talents of the few do not preclude art making by the many. In these technologically simpler societies, as I described, the arts are invariably and inseparably part of ritual ceremonies that articulate, express, and reinforce a group's deepest beliefs and concerns. As the vehicle for group meaning and a galvanizer of group one-heartedness, art-conjoined-with-ritual is essential to group survival; in traditional societies "art for life's sake," not "art for art's sake," is the rule.

In our own highly specialized society, of course, the arts themselves have become specialties and do exist for their own sake apart from ritual or any other "ulterior" purpose. This separation, peculiar only to modernized or "advanced" societies, has made art a capital-P Problem. Art's heritage of specialization and its recent self-proclaimed irrelevance permits it to be dismissed by governmental budget-makers as a "frill." Art's traditional aura of sanctity and its association with the privileged class serves both to make it a highly desirable commodity for some members of society and the target of the bitter criticism of others. Thus art is simultaneously sanctified and dismissed as rubbish, becomes the subject of complex exegesis and is totally ignored, commands millions in the auctioneer's salon and yet is irrelevant to most people's lives.

To understand what art is, or again might become, we must look beyond that one-ninth span of human history (or, if we consider only history since the Renaissance, a one-eightieth span) for evidence of aesthetic proclivities in *Homo sapiens* before they learned to read and write. If we look at preliterate societies today and at young children in all societies, and combine information from these findings with what we can infer from Paleolithic artifacts, we will discover that art is both more protean and more simple than today's theorists would have it.

They, and we, commonly assume that art is concerned with images or texts—representations. But this "literate" approach takes for granted that art is objects—things, like words are things. Let us instead look at art as kinds of behavior, ways of doing things, including, but not confined to, visual or literary representation. When we look beyond the restricted case of modern, Western, and Western-influenced societies, when we expand our vision to include *all* examples of societies, past and present, we discover that people do a number of things that are artlike, congruent with what we think of as "art": they explore, they play, they shape and

embellish, they formalize or make order. These ways of doing are inherent in human activity: they come naturally to us without being taught.

Regarding art as a *behavior*—an instance of "making special"—shifts the emphasis from the modernist's view of art as object or quality or the postmodernist's view of it as text or commodity to the *activity* itself (the making or doing and appreciating), which is what it is in many premodern societies where the object is essentially an occasion for or an accoutrement to ceremonial participation.

"Making special" is a fundamental human proclivity or *need*. We cook special meals and wear special garb for important occasions. We find special ways of saying important things. Ritual and ceremony are occasions during which everyday life is shaped and embellished to become more than ordinary. What modern artists do, in their specialized and often driven way, is an exaggeration, an extension of what ordinary people also do, naturally and with enjoyment. Looked at in this way, art, the activity of making the things one cares about special, is fundamental to everyone and, as in traditional societies, deserves to be acknowledged as normal. And normal, socially valuable activities should be encouraged and developed.

Making important things special was a fundamental and integral part of human behavior for thousands of years before writing looked at its results and called them "art" or "texts." Writing told the explorers, players, shapers, and embellishers that they were making objects detached from reality, texts to be read and analyzed, self-consciously abstracted from their contexts. But until the present century, these explorers, players, shapers, and embellishers did not pay much attention, particularly to the more abstruse and esoteric implications of these literate pronouncements. Most artists until the present century did not care a whole lot about the words that their works provoked.

Textbooks tell us that the romantic nineteenth century was preoccupied with the artist or author; that the modernist twentieth century was preoccupied with the work or text; and that contemporary postmodernism is preoccupied with the critic/reader. It may be time now to turn from these to the human "reality" as expressed in species nature; that is, to perennial human needs, aspirations, constraints, limitations, achievements that along with "art" have been veiled, distorted, atrophied, or erased by the excesses of modern literate life.

Many of the "intelligences" described in Gardner's *Frames of Mind* are those that characterize artists: visual-spatial, kinesthetic, mechanical, musical. Yet instead of being the last holdouts against the nonhumanity of the worst excesses of postmodern life, many of today's artists, brainwashed

by their unbalanced hyperverbal educations, all too often make works that become primarily opportunities for verbalization—"statements" and "texts."

The contemporary trend toward primitivizing that Torgovnick (1990) deplores, which I described in Chapter 1, may be explained at least in part by the possibility that as hyperliterates we feel ourselves deprived of some essential rootedness in nature, and that reason and objectivity are not wholly satisfying. Danto (1986, 121) calls a certain kind of contemporary art "disturbational" because it seeks to break the "insulating boundaries" of art and life in a particularly disturbing way, using "obscenity, frontal nudity, blood, excrement, mutilation, real danger, actual pain, possible death."

What I find interesting and provocative about Torgovnick's and Danto's analyses is that these elements are the very stuff of much premodern ritual—as with the Ndembu and Fang, described in Chapter 4 and at the end of Chapter 6. The difference, of course, is that when used in ritual ceremonies they are charged with shared social meaning. Their "disturbingness" is used deliberately because it gives emotional reality to group verities that might otherwise seem abstract and pallid. But when used today in the "body art" or "performance art" of which Danto speaks, they are—like all art today—performed as an individual statement largely for their own sake, without a wider context of meaning and use.

To suggest that art is more common and ubiquitous than has usually been supposed does not have to mean that all standards fly out the window and anything goes. (Indeed, even with the idea that art is uncommon and rare, that has already happened.) To make something special generally implies taking care and doing one's best so as to produce a result that is—to a greater or lesser extent—accessible, striking, resonant, and satisfying to those who take the time to appreciate it. This is what should be meant when we say that via art, experience is heightened, elevated, made more memorable and significant. Everything is not equally meaningful or valid. The reasons that we find a work accessible, striking, resonant, and satisfying are biologically endowed as well as culturally acquired; they are not merely a matter of playful and shifting interpretations.

Adopting the species-centered view as the foundation for our personal understanding of art and life in a wider sense, we can better appreciate the continuity of ourselves and our art making with nature. Artistic behavior and response, which Western society treats as an ornamental and dispensable luxury, are really essential parts of our nature. Contemporary Western society's remoteness from nature and the body has obscured and

displaced the form-giving and elaborating propensities that, as I described in Chapter 6, are inherent in our human biological makeup. Our philosophy of art, which either exalts its subject or "problematizes" it past comprehension, remains unaware that art's distinctiveness resides not entirely in its disinterested stratospheric isolation but in its primordial biological rootedness. If a species-centered approach can make clear that the arts are as intrinsic and imperative in our lives as our lovers, our children, and our gods, it deserves the attention of all who claim to care deeply for art or the arts.

Once we recognize that art is intrinsic to our specieshood—to our *humanity*—each of us should feel permission and justification for taking the trouble to live our life with care and thought for its quality rather than being helplessly caught up in the reductive and alienating pragmatic imperatives of consumer and efficiency-oriented and "entertain-me" society. Perhaps those who are responsible for funding the arts might even begin to recognize that art is not confined to a small coterie of geniuses, visionaries, cranks, and charlatans—indistinguishable from each other— but is instead a fundamental behavioral characteristic that demands and deserves to be promoted and nourished.

Artlike activities exist in all societies and all walks of life. What is far more timely and relevant than its intrinsic sanctity or freedom should be the awareness that art, as the universal human predilection to make important things special, deserves support and cultivation—in schools, communities, and indeed the lives of everyone, not just artists in an artworld. Not only the National Endowment for the Arts, but federal, state, and local departments of education and community development should, in my view, be exploring ways to enable all people to make their individual and collective lives more significant through art—making things special—rather than acquiring, consuming, interpreting, disputing, destroying, or cynically repudiating them, which seem to be the entrenched if ultimately humanly unsatisfying responses to our postmodern world.

This long and complex text serves to substantiate, from a number of academic perspectives, what amounts to a quite straightforward and simple conclusion. Art is a normal and necessary behavior of human beings that like other common and universal human occupations and preoccupations such as talking, working, exercising, playing, socializing, learning, loving, and caring should be recognized, encouraged, and developed in everyone.

Notes

Preface

1. Other Latinized attributions of our species include *Homo duplex* (twofold—Durkheim 1964); *Homo clausus* (self-contained, isolate, enclosed in self—Elias 1978); *Homo hierarchicus* (socially ranked—Dumont 1980); and *Homo necans* (ritual killer or sacrificer—Burkert 1983).

2. Strictly speaking, the terms "Darwinian" or "Darwinism" refer to the theory of natural selection as Charles Darwin proposed it a century ago; more recently, "neo-Darwinism" is used to indicate the twentieth-century synthesis of genetics and population genetics with the original theory. In this book I will use the words *Darwinism* and *Darwinian* to refer broadly to the idea of human biological evolution, thereby forsaking the precision that would be necessary in a study intended for specialists, rather as people use the terms "Freudian," "Marxist," or "Christian" to indicate a general theoretical approach without engaging in the internal schisms, revisions, or disputes among the faithful. I will also use the neologism *species-centered* almost interchangeably with "Darwinian" to suggest that our evolution as a species unifies us as much as or more than our cultural and individual variability divides us (see Chapter 1). Later, after it is introduced and described, the term "ethological" will be used as yet another adjective to describe the Darwinian and species-centered approach to art as a behavior that this book is concerned with.

Chapter 1. Introduction

1. For a fascinating overview and bibliography of historical Western attitudes toward primitive peoples and "the primitive," especially as these have affected modern art and artists, see the essays by Kirk Varnedoe (1984).

2. See Varnedoe, "Abstract Expressionism" and "Contemporary Explorations" (1984); Lippard (1983); and Price (1989).

3. One American practitioner of shamanism has been giving workshops in Siberia and Hungary, where centuries-old shamanic traditions had vanished—which seems rather like repatriating the American pizza to Italy or the frankfurter as hot dog to Germany.

4. These books are: Alexander (1979); Barash (1979); Boyd and Richerson (1985); Chagnon and Irons (1979); Eibl-Eibesfeldt (1989a); Festinger (1983); Freedman

(1979); Geist (1978); Harris (1989); Hinde (1974); Klein (1989); Konner (1982); Lopreato (1984); Lumsden and Wilson (1981, 1983); Maxwell (1984); Midgley (1979); Morris (1967); Reynolds (1981); Tiger and Fox (1971); Wilson (1978, 1984); Young (1971, 1978). Some of these books even specifically listed or discussed "human universals." I deliberately did not include John Pfeiffer (1982) or Alexander Alland (1977) because their books treat art specifically. Pfeiffer and I have been in correspondence and common cause for over twenty years. Alland's book certainly deserves attention, but I find that his account (of primarily visual art) offers nothing substantially different from the authors of more general works on human behavior discussed in the text. To my knowledge, there have been only two other published attempts (besides *What Is Art For?*) that treat art specifically as a universal and biologically evolved human characteristic: Robert Joyce's *The Esthetic Animal* (1975) and David Mandel's *Changing Art, Changing Man* (1967). Both authors were laymen whose (privately published) works contained interesting ideas and thoughtful ruminations but did not view art within a comprehensive and informed ethological or evolutionary framework.

An extremely stimulating and thoughtful essay is Kathryn Coe's unpublished paper (1990), which approaches art's evolutionary origin and function by seeking a "replicable unit" that could have been copied by observing and learning. She defines art as "color [by which she appears to mean also vividness and noteworthiness] and/or form used by humans to modify an object, body, or message solely to attract attention to that object, body, or message. The proximate or immediate effect of art is to make objects more noticeable." She additionally speculates on reasons for this being done intentionally.

Coe suggests, as I do, that art arose gradually and accidentally from previously existing behaviors, but does not claim that it is itself a "behavior" (inherited species predisposition). Rather, in her scheme, art seems to be culturally derived (from observing, learning, and copying) based on natural or inherited endowments of liking and responding to color and form and then intentionally using these for attracting attention.

Coe's carefully reasoned essay is extremely useful, among other things, for her analysis of what art is not. It should be required reading for anyone who wishes to understand art biologically.

5. Which was Leon Festinger's (1983) position when he called the human aesthetic sense "a neutral byproduct of genetic changes that increased imagination and creativity" (36) and "an evolutionary peculiarity" (44). David Premack (1975, 602) has claimed that "a principal root of the aesthetic disposition is a preoccupation with the discontinuities of space and with the possibilities of their transformation." He mentions the tendency in chimpanzees and monkeys to manipulate things, and notes that even rats will find a small chink, gnaw at it, and "transform" it. But how do we get from the results of play or exploration or random activity to the active transformative impulse, a *behavior of art*? See Chapters 3 and 4 for my view.

6. Further explication of evolutionary theory will be found at the end of this chapter and in Chapter 2. See also notes 13, 17, and 18, this chapter.

7. The arts like anything may, of course, also be used competitively in conflicts of interest. See Glenn Weisfeld's observation in the text of this chapter.

8. See Preface, note 2.

9. As Mary Midgley has aptly observed, any animal is different from any other animal.

10. A comprehensive overview of the history of Darwinism in American social thought has recently been given by Degler (1991).

11. The distinguished American anthropologist Victor Turner (1983), toward the end of his life, indicated that he had been persuaded that contrary to the "axioms anthropologists of my generation—and several subsequent generations—were taught to follow . . . the belief that all human behavior is the result of social conditioning," it seemed to him that there are, in humans, "inherent resistances to conditioning"— that is, inherited behavioral potentials and tendencies. Unfortunately, Turner's particular "conversion," which seems to have germinated at the Conference on the Ritualization of Behavior in Animals and Man convened in 1965 by Julian Huxley, has not been experienced by significant numbers of Turner's fellow anthropologists.

12. Herbert Spencer coined the phrase "survival of the fittest"; Darwin adopted it and employed it in the second edition of *The Origin of Species* (Ruse 1982).

13. At present, there is some controversy among evolutionary theorists about the degree to which selection occurs at the level of the gene, individual, group, or species. Group- and individual-level-selection arguments are not entirely incompatible, although the latter is considered more important and deemed to have more explanatory power (Alexander 1987, 169–170). Selection at the level of the individual or the gene does not preclude cooperation.

 In a recent article, Simon (1990) suggests that altruism, whether defined socially or defined genetically, is wholly compatible with natural selection and is an important determinant of human behavior. He argues that a trait of "docility" (receptiveness to social influence or the tendency to learn from others) would be positively selected-for because it contributes to fitness generally, both in human individuals and the species, even though it might be occasionally maladaptive for individuals who because of their possession of this trait act in a sacrificially altruistic manner. It seems inarguable that human *groups* that were cohesive would have had a survival advantage over noncohesive groups so that selection for individual mechanisms (sociability, adaptability, educability, or "docility") to promote this cohesiveness would occur.

14. Eisler (1988, xx) remarks, for example, that "the argument that because something happened in evolution it was adaptive does not hold up—as the extinction of the dinosaurs so amply evidences." Or see her explanation of "the essential difference between cultural and biological evolution": "Biological evolution entails what scientists call speciation: the emergence of a wide variety of progressively more complex forms of life. By contrast, human cultural evolution relates to the development of *one* highly complex species—ours—that has two different forms: the female and the male," (60). Also see page 206, note 8: "a very effective refutation of the current sociobiological revival of nineteenth-century social Darwinism."

15. An ethological understanding of Darwinism will recognize that religion (or communal observance of spiritually satisfying practices) is a universal human predisposition and should therefore be facilitated, not prohibited or denied, by humanly oriented societies. The true Darwinist will not, of course, support any one religion as being more true or divinely dispensed than any other.

16. Sebastiano Timpanaro (1980), an Italian Marxist theorist, includes (as did Marx) the organic biological and psychological makeup of humankind in the material circumstances that affect a society's development.

17. Churchland (1986, 278) also discusses the frequent dismissal of biological approaches to human endeavor as "reductionist." She finds the term "reductionist" to have a

"bewildering range" of generally abusive and insulting applications, meaning variously: materialism, bourgeois capitalism, experimentalism, vivisectionism, communism, militarism, sociobiology, and atheism. I have also found that it implies ruthless and insensitive lack of regard for beauty, humane values and complexity. Churchland points out that "reduction" is first and foremost a relation between *theories*, where one theory stands in a certain relation (reduces to) another more basic theory. It results in explanatory unification and ontological simplification. The universe keeps on doing whatever it does while we theorize and while theories come and go. We are free to appreciate nature both as an instantiation of certain physical laws and as a thing of beauty, wonder, refreshment, and joy. Neither view automatically or necessarily excludes the other; indeed, the two generally go together.

Additionally, while the ultimate ("reduced") cause or explanation for biological adaptations is their contribution to survival in the environment of initial adaptedness, no competent ethologist would say that particular or proximate activities in some current environment, especially in humans, are to be viewed solely in terms of reproductive advantage. In the first place, no single adapted feature is ever ideal, as any organism, in order to meet many different and often conflicting demands, has to compromise, especially in the face of changing environmental circumstances (Geist 1978, 2; Tinbergen 1972). And, as we in modern America well know, our "natural" liking for calorie-rich (sweet and creamy-oily) food, which was obviously intended to direct us to the best sources of nutrition in a subsistence environment, is not adaptive today in an environment of gustatory abundance.

18. Ironically, for my purposes here, Gould and Lewontin (1979) indicate in the course of their criticism of the adaptationists that they share their opponents' presupposition that art is superfluous. They say that it is as fallacious to attribute biological function to what are by-products of the necessary "architecture" of an organism as it is to argue that the decorated spandrels of the Cathedral of Saint Mark in Venice have an architectural purpose. In the case of the spandrels, they imply, these simply fill in the gaps created by the arches and other structural features that hold up the building and are therefore incidental. My position in this book will be that what is put on the spandrels (and otherwise expressed in the way the building is planned and decorated) helps to explain why it was constructed in the first place. The Venetians did not simply need a large shelter from the rain. While it is true that cathedrals are not built to hide dead mice (as Saul Bellow remarked regarding simplistic Freudian explanations of the genesis of artistic creation), they *are* built in order to make manifest in a compelling way what is of value to their patrons and users. In this sense the decorated spandrels, even if not *architecturally* essential, are at another level the justification for erecting the building in the first place. Hence they are "necessary"; Gould and Lewontin should perhaps find a different analogy for their criticism.

19. While the observation may seem trivial, I think it is also a victim of its specialist language. Whatever their ambiguities or difficulties, the vocabularies of structuralism, poststructuralism, phenomenology, hermeneutics, Freudian psychoanalysis, and Jungian psychology have recondite appeal, enigmatic and poetic beauty, arresting and compelling suggestive symbolic reverberations that invite participation. One feels oneself to be one of the elect simply by saying *"différance," "Dasein,"* "aporia," "desire," "transcendence," *"alatheia,"* "Thanatos," "Eros," "mandala," "anima." One wants to learn what these words mean and how to use them. Whereas, for all its talk about the body, what could be more boring and unevocative than Darwinian

words like *species, evolution, phenotype, fitness, differential reproductive success, sociobiology*. Biologists seem to be burdened with remarkably unglamorous Greek and Latin words for their vocabularies, the most plebian of consonants and unalluring vowels.

Chapter 2. Biology and Art

1. Many postmodern works, to be sure, are not made with the intention of deeply moving their audience. Being playful, superficial, relative, and ephemeral, they cannot sustain the sort of attention that was demanded formerly by works of "fine" art. I must, however, point out that many contemporary artists are deeply serious and want to "move" and emotionally affect those who perceive their works.

2. Stephen David Ross, "The Unspeakable Greatness of Being" (Paper delivered at the Forty-seventh Annual Meeting of the American Society for Aesthetics, 25–28 October 1989, New York City).

3. Donald Crawford, "Kant and the Contemporary Sublime" (Paper delivered at the Forty-seventh Annual Meeting of the American Society for Aesthetics, 25–28 October 1989, New York City).

4. Incidentally, Maasai also sing to their cows, as it reportedly makes them easier to milk (Saitoti 1986).

5. The examples here arise from the historical formalist aesthetic perspective that holds to an unscientific dualistic notion of "mind." In later sections of this chapter and of the book (especially Chapter 6), I describe a monistic model of human mentation that, in my opinion, more comprehensively accounts for aesthetic experience.

6. As Lord Shaftesbury said in *The Moralists* (1709), "*The Beautiful, the Fair, the Comely* were never in the *Matter*, but in the *Art* and *Design*; never in *Body* it-self, but in the *Form* or *Forming* Power . . ." (cited in Carritt 1931, 65).

7. Zajonc (1984) and MacLean (1978) are notable exceptions.

8. Manfred Clynes (1977, 12) finds that each emotion has a precise spatiotemporal dynamic and expressive form that is "precisely and genetically programmed into our brains." For further discussion of Clynes's "sentics" theory, see Chapter 6.

9. "Survival," of course, means "reproductive success," so that it is an individual's genetic materials (as expressed in his or her more long-lived and long-reproducing kin and offspring) that "survive" better. See discussion in Chapter 1. The "unit of selection" is generally conceded to be the individual or the gene, not the group. But because humans are absolutely dependent for their long-term survival on living in a viable social group, one can speak of individual human behaviors that contribute to group cohesion and survival as being selectively beneficial to individuals. Also see Wilson and Sober (1988) and D. S. Wilson (1989).

10. Even our more humble entertainments (e.g., soap operas, adventure stories, pornographic videos) and packaged consumables (generally intended to make life easier, more comfortable, and more fulfilling) embody and reenact these universally salient values and experiences, albeit in often trivialized and abstracted, mostly fragmented, forms.

11. Marvin Harris (1989, 156) questions whether universal occurrence indicates that a trait is part of human nature: "It may simply be so useful under a broad variety of conditions that it has been culturally selected for over and over again." He says that no culture has resisted flashlights or matches; every culture makes fire, boils water, uses tools. But he is surely confusing *levels* of behavior. For example, the tendency

to make use of innovative technology would seem to be a human universal, by Harris's own description.

12. For example, in a society such as the Manam in Papua New Guinea, male beauty as expressed in dancing is a sign of *marou* (a manalike aspect of power) (Nancy Lutkehaus, lecture presented at the New York University Anthropology Colloqium, February 1985). For the Igbo of Nigeria, as for many other African groups, to be pleasingly adorned is a means of gaining power (Adams 1989). It is not difficult to see how beauty of bearing, movement, and attire (associated with youth, strength, endurance, vitality, and possession of wealth, as it most often is) could promote individual fitness—successful reproduction and the transmission of one's genes—by ensuring that persons who possess these qualities would attract mates and persons susceptible to them would choose mates who are so endowed. Yet, as I mentioned earlier, the fact that something is used in competitive display need not imply that its origin and selective value were solely for that purpose.

Chapter 3. The Core of Art

1. Paul Mattick, comment made during presentation in panel entitled "The Institutions of Art/2" (Forty-seventh Annual Meeting of the American Society for Aesthetics, 25–28 October 1989, New York City).

2. My account concerns Western aesthetics and does not attempt to address aesthetic concepts in other civilizations or how they relate to those in the West.

3. While my discussion in the text uses examples primarily from the visual arts, the history, criticism, and theory of the other arts are much the same. For example, Lydia Goehr (1989) makes a point similar to mine in her analysis of the development of an abstract concept of a musical "work."

4. "Play" theories of art are most commonly associated with Friedrich Schiller (1795/1967), Herbert Spencer (1880–82), Sigmund Freud (1908/1959), and Johan Huizinga (1949).

5. Richard Alexander (1989) explains human social play as leading "to an expanding ability and tendency to elaborate and internalize social-intellectual-physical scenarios," which itself underlies the evolutionary development of the human psyche—a neat combination of the human appreciation of fantasy and reality. See my discussion of Alexander at the end of Chapter 4.

6. Radcliffe-Brown (1922/1948) in his monograph on the Andaman Islanders, stresses that ceremonies produce changes in or structure feelings. They "maintain and transmit from one generation to another the *emotional dispositions on which the society depends for its existence*" (234, my italics). Being obligatory, they compel participants to act as though they felt certain emotions and thereby to some extent actually serve to induce those emotions in them. See also the section on ritual and dramatic performance in Chapter 5.

7. It was also intriguing for me to realize that play is often ritualized, as in sport, with its special arena, costumes, ways of behaving, structure in time. In rituals people often pretend (play or act "as if"): Australian aborigines, for example, imitate animals or pretend to kill them, and the Yanomamo Indians of South America do battle with spirits. Our "plays," and performances in general, can be considered simultaneously as art, as ritual, and as play.

8. Peter Sutton (1988, 18–19) also states that in traditional Aboriginal thought, there is no nature without culture. He quotes W. E. H. Stanner (*On Aboriginal Religion*

[1963, 227]): "Anyone who . . . has moved in the Australian bush with Aboriginal associates becomes aware . . . [that he] moves not in a landscape but in a humanized realm saturated with significations."

9. Evidence of deliberate foresight and planning has been claimed for Middle Paleolithic early *sapiens* hominids more than 100,000 years ago in their cooperative hunting strategies (Chase 1989); in their hafting of stone tools, which implies the ability to predict the likelihood of recurring tasks requiring a particular tool (Shea 1989); and in their transporting artifactual material from afar to be used at home (Deacon 1989). Hayden and Bonifay (1991, 6) marshal data that "provide overwhelming support for the notion that Neanderthals were curating lithic tools, exhibiting planning and foresight similar to Upper Paleolithic people, and acting in economically rational fashions."

10. The earliest archaeological evidence for body ornaments seems to date from the transition from the Middle Paleolithic to the Upper Paleolithic, that is, from around 35,000 B.P. It is interesting that these ornaments were made primarily from exotic (i.e., "special") materials, such as shell, soft stone, teeth, and tusks, that had been brought sometimes from hundreds of kilometers away from where they were excavated. Randall White (1989b) suggests that the ornaments were used for social display and were perhaps symbolic of social distinctions. Whatever their use or significance, it is interesting to see that when making themselves special, individuals also used special materials.

11. In *The Creative Explosion* (1982), John Pfeiffer presented a similar reconstruction of art and ceremony in the Upper Paleolithic. His concern was to elucidate the remarkable flowering of cultural behavior at that time, and not to address ethologically art's earlier origins and putative selective value.

12. It was both amusing and gratifying to later discover that Arthur Danto (1986, 21), who was not concerned with selective value or ethology, argued that "the structure of artworks is of a piece with the structure of rhetoric," and that "it is the office of rhetoric to modify the minds and then the actions of men and women by coopting their feelings." Danto's idea of "the transfiguration of the commonplace" in contemporary Western art (1981) is also congruent with a notion of making the ordinary extra-ordinary or "making special."

13. See note 6, this chapter. In his classic monograph (1922/1948), Radcliffe-Brown explicitly states that ceremonies (in which, of course, objects and activities are made special) transmit feelings. More recent anthropologists have been generally concerned with ceremonies primarily as a means of transmitting information, traditions, and symbols.

14. See Eibl-Eibesfeldt (1989a, 1989b) for additional and fascinating examples of appealing and arresting bioaesthetic elements arising from human perception and behavior.

15. Even in the gestural sign language of the deaf, poetic statements are signed in a different manner than everyday conversation. Rather than using a dominant hand, the two hands are balanced; a smoothness of movement is imposed on the signs; and they are given a rhythmic temporal pattern and an enlarged "designed" spatial pattern, with exaggerations of representational or pantomime aspects (Klima and Bellugi 1983).

16. In some areas of modern life disclosure and open discussion are still frowned upon—e.g., military, government, and industrial affairs—but the information associated

with these realms does not really correspond to the kinds of information formerly considered numinous. Revealing military or industrial secrets is considered far more deplorable than exposing personal emotional or spiritually significant matters.

17. It is not only that we are too "busy" or sated to care. Caring usually involves acting upon what one cares about (see Chapter 4). In our pluralistic and impersonal society, we cannot usually affect change, or by trying to do so we may at the same time be going against other important personal or group interests. Thus not caring is self-protective and a way of coping with impotence.

Chapter 4. *Dromena* or "Things Done"

1. See, for example, Thorpe (1966), Hall-Craggs (1969), and Beer (1982).
2. Another nineteenth-century savant, Sigmund Freud (1939, 30), also proposed that the idea of beauty was derived from the field of sexual feeling. Certainly, art and sex may resemble each other in the intensity and even in the kinds of feeling they may provoke. See Chapter 6, note 34.
3. Visual display in human art (as in body decoration and decoration of one's possessions) *does* largely seem to be associated with evidence of what boils down to display of sexual attractiveness or desirability, often interpreted simultaneously by participants as vitality and group strength.
4. In *The Biology of Art* (1962) and other works (*The Secret Surrealist* [1987]; *The Art of Ancient Cyprus* [1985]) Morris has proposed and elaborated his idea of art as a derivative of play and exploration. Richard Alexander (1989) also derives the arts and indeed all aspects of the human psyche from "scenario-building" that evolved originally from play. See discussion at the end of this chapter, and note 31 below.
5. Sexual displays, of course, are often performed in ceremonial contexts.
6. I do not mean to deny—on the contrary—the provocative resemblances in the nature and functions of ritualized behaviors in animals and ritual ceremonies in humans. These are explored from a number of perspectives by biological and social scientists in Huxley (1966). Laughlin and McManus (1979, 104) have called the chimpanzee "rain dance" a "danger ritual" that has been generalized from a display toward predators to phenomena that represent a "zone of uncertainty." See also the discussion of chimpanzee display in the section on ritual and dramatic performance in Chapter 5.
7. See the discussions in Van Gennep (1908/1960) and Turner (1969).
8. The classicist Walter Burkert, in his provocative studies of the origins of Greek religion that make use of concepts and findings from ethology (Burkert 1979, 1987), has also used the word *dromena*. I am grateful to Professor Burkert for informing me of Harrison's earlier use of the term.
9. Lévi-Strauss does claim that the incest prohibition works to initiate exchange of women and thus alliance among groups, but he does not use Darwinian theory specifically to substantiate this idea.
10. Psychological experiments have shown that when subjects were given control over their environment, excretion of epinephrine, a "stress" hormone whose output increases in situations of novelty and uncertainty, decreased (Whybrow 1984, 64).
11. Mary Douglas (1966) points out that in ritual the potency of disorder is recognized; structure is thus imposed on flux. Gillian Gillison (1980, 143) describes how Gimi men consider the wilderness to be an exalted domain where the male spirit, incarnate

in birds and marsupials, acts out its secret desires away from the inhibiting presence of women.

12. In Mount Hagen, apparently, there is no concept of transforming "the wild" to "the domestic," and "control" takes place entirely within the human or domestic sphere. The cultural is not made but affirmed or discovered and Hageners are less concerned with taming, fighting, or dominating than coming to terms with wild spirits (Strathern 1980). Not surprisingly, their rituals are primarily concerned with "this-world" ceremonial exchanges and competitive display, where individual body decoration (drawn from nature: shells, leaves, plumes, fur) shows individuals not so much transformed as being in an enhanced or ideal state of health and personal well-being (Strathern and Strathern 1971).

13. Geist (1978, 320–25) comments on the anxieties in the lives of Upper Paleolithic people. Radcliffe-Brown (1922/1948) reminds us that once rituals (*dromena*) are established in a culture, *not* performing them also produces anxiety. As I see it, this argument against ritual as reliever of anxiety confuses two different levels or sources of anxiety. G. E. R. Lloyd (1979, 2–3) views magic as performative or illocution-ary—in my terms, "something to do." It is, he says, less an attempt to be functionally efficacious than to be affective, expressive, or symbolic.

14. Both Paul (1982, 300–302) and Obeyesekere (1981, 78–79), in quite different con-texts but with Freudian underpinnings, make the interesting point that individual psychic disturbance is part of our species nature and that cultures must find ways of coping with this condition. Eibl-Eibesfeldt (1989b, 59) stresses that self-control of one's behavior is one of the universal "virtues" of humans.

15. This idea is given sociobiological resonance by Joseph Lopreato (1984, 211) who remarks a propos of "asceticism" (control of emotions, needs, desires, or instincts) that those individuals who were most able to make investments of time and re-sources with a view to a greater probability of success at a future time had a se-lective advantage over those who could not. Additionally, the oft-demonstrated "placebo effect," whereby ill people improve after taking a neutral substance that they are told will be an effective remedy for what ails them, substantiates the selective desirability of evolving a propensity to be suggestible. *Dromena* here—consulting a shaman, participating in a ceremony, or conscientiously following an authoritatively prescribed regimen—results in a better outcome than doing nothing.

16. The earliest graphic images, found in Aurignacian sites dating from 35,000 B.P., include abstract simple redundant designs such as X's, notches, incisions, and punc-tuations (White 1989b, 97–98). Because natural forms (animals, female genitals, and phallic images) occur as well, Randall White speculates that the abstract designs may be representational of natural objects, as some "abstract" marks on ivory pen-dants appear to imitate natural marks found on seashells.

17. Curt Sachs (1962/1977, 112) observes that "Rhythm springs from man as a slowly-developing psychophysiological urge. Its physiological part is the impulse to equalize continuous, regular movements such as walking, dancing, running, or rowing. Psy-chological is the awareness of greater ease and gusto through constant evenness in motion. Even the most primitive musician has a trend towards regular time units." I believe that Sachs attributes too much "will" to the process, which is surely in the service of more efficient movement and hence, because of its necessity, has evolved to feel psychologically satisfying. (See also Chapter 5, note 8.)

18. In "Obsessive Acts and Religious Practices" (1907/1959), Freud comments on the resemblance between the obsessive acts of neurotics and ritual religious acts, ordinary, "everyday" activities that are elaborated and made "rhythmic" by additions and repetitions. Freud's comparison seems to emphasize the desperate symptoms of maladjustment more than the productive *dromena* that give physiological relief along with emotional meaning and satisfaction to people in difficult or uncertain times. Oliver Sacks (1990) describes a memory-impaired patient, Jimmie, who "so lost, so disconnected, so disoriented most of the time, would 'come together' completely during the rite of Mass, would be enabled through its 'organic' coherence and continuity—with every moment referring to every other, every moment filled with meaning—to recover, if transiently, his own continuity."

19. Lord (1960, 67) claims that repetition in incantations arose not for the sake of meter, nor for the sake of convenience in building a line, but rather for the sake of "magic productivity." Hence the patterns of poetic formulas gave religious/magical rather than aesthetic satisfaction. In the beginning, I would offer, these were frequently inseparable. See my discussion in Chapter 5 under the subheading "Poetic Language," as well as note 6 in the same chapter.

20. In a bioevolutionary interpretation of C. G. Jung's notion of the collective unconscious, Stevens (1983) suggests that sensitivity to primordial human transformational experiences (in Jungian terms, the archetypes or what is universally felt to be sacred) was laid down during human evolution in "the phylogenetic psyche." Hence we have inherited predispositions to react in certain ways to certain life figures and circumstances (e.g., the family, the mother, the father, life stages, the feminine and masculine, the shadow, and so forth) as they arise, and to recognize certain ideas and experiences to be numinous or sacred and feel reverence and awe before them.

21. Basketry and weaving, frequently women's arts, lend themselves to geometric and patterned nonrepresentational decoration which can then be used elsewhere in body ornamentation, and on pottery and other implements and utensils. Rubin (1989, 45) points out that traditional women's arts tend to be diagrammatic and geometric, showing the networks of social relationships in which women participate, while men's arts are narrative and descriptive, showing their roles as warriors, hunters, and adventurers.

22. In his studies of ritual drama among the Ndembu (a Central African people), Turner (1967, 37) proposed that, like Freudian dream symbols, the most potent ritual symbols serve as a compromise formulation between two strong opposing tendencies: the necessity for maintaining social order and control (what Freud would call the "reality principle") and the equally strong force of allowing individuals to acknowledge and express innate and universal human drives (the "pleasure principle"), complete gratification of which would result in a breakdown of social control. In ritual ceremonies, with their social excitement and directly psychophysiological stimuli such as music, singing, dancing, alcohol, incense, and bizarre modes of dress, the ritual symbols "work" by allowing an interchange between these two poles of meaning. Desirable social norms and values, at one "pole," are saturated with emotion, while the gross and basic emotions, at the other pole, felt and expressed as natural and physiological phenomena and processes, are given dignity and social acceptability through association with acknowledged social values. Such fusion or exchange of cognitive and sensory qualities in the psyches of ritual participants results in reinforcing the sense of unity and continuity of the social group. The energizing and

compelling biological drives are thereby controlled and shaped to social ends. Turner's formulation, like Freud's theory of artistic sublimation, gives full cognizance to the importance of the "body" in generating and powering the emotional significance and hence social effectiveness of Nkang'a or other rites of passage to the Ndembu. See also the discussion of Bwiti ritual among the Fang (Fernandez 1969) near the end of Chapter 6.

23. Susanne Langer's meticulous and extremely influential writings on aesthetics (e.g., *Philosophy in a New Key* [1942]; *Feeling and Form* [1953]) are concerned with emotion in the arts, but she is resolutely convinced that aesthetic experience is a response to their "presentational symbolism."

24. Faris (1972) claims that the stylized geometric face painting of the Nuba of the Sudan is entirely abstract and nonsymbolic. Other instances of nonsymbolic designs are documented by Berndt (1958/1971) for Australian aborigines and by Price and Price (1980, 108) for the Suriname Maroon. Boas (1927/1955) used fifty-eight figures that illustrate nonrepresentational and nonsymbolic examples of artistry from primitive peoples.

25. See, for example, Festinger (1982; see also Chapter 1, note 5); and Durkheim's (1912/1965) notion of art as residue: a sort of exuberance or surplus spilling over from religious anxiety and fervor (381).

26. As I emphasized in Chapter 1, Malinowski offered a similar view, which seems to have had almost no influence. He noted (1944, 98–99), for example, that "An object, whether a cooking pot or a digging stick, a plate or a fireplace, has to be skillfully, lawfully, and reverently manipulated, since it is very often effective not merely by technology, but also by customary or ethical regulation." He does not specifically mention artistic shaping or elaboration, but this could be implied in what he does say. Before his untimely death, Arnold Rubin (1989) developed a "functionalist" view of art in society that, though without reference to Darwinism, is congruent with mine. He sees the arts as "a form of technology, a part of the system of tools and techniques by means of which people relate to their environment and secure their survival" (16). According to Rubin, art as technology has two aspects: power and display. "Power objects accumulate and concentrate cultural energy for the benefit of individuals or the larger community, and display objects are the visible, tangible results of accumulated powers" (20), for example, in conspicuous consumption. "Power" as concentration of energy or display would fit well into an ethological scheme, although Rubin himself does not attempt this kind of formulation. Apart from the general theory of Malinowski, Rubin's work is the most stimulating and insightful theoretical anthropological discussion of the arts that I have found, and has direct species-centric application.

27. Jürgen Habermas's (1984) concept of the "lifeworld" might well be congruent with my notion of the arts as means of enhancement: he finds Marxist social theory inadequate in that it emphasizes purposive-rational (or instrumental) action for "productive relations" and consequently neglects human intersubjectivity. Habermas has even attempted to enlist human evolutionary theory to support his views of work and communicative action as being fundamental to humans, but, as presented (e.g., 1979), this use of Darwinian theory seems confused and inaccurately applied. Informed use of the Darwinist or species-centered position would, I think, give biological credence to the realm of the lifeworld, which at present remains wholly cultural in its current formulation as "common understandings of shared convictions embodied in language, customs, and cultural traditions."

28. Hayden (1990) makes a plausible case for softened and worked hides as evidence of economic differentiation; if so, this would indicate the possibility that making special was done as a way of denoting high rank.

29. Both Geist (1978) and Coe (1990) stress the relationship between the arts and drawing or guiding attention to something. Geist (87–88) describes the rarity and unusualness of body postures, sounds, odors, and, in particular, movement patterns in ritualized dominance displays in some ungulates and points out that artists also use these principles of attention fixation (90). He stresses the "specialness" or "extraordinariness" in human and animal ritual display but does not extend this observation to a universal deliberate behavior of making special in humans. Coe states that "art, by drawing attention to an object or body, makes them more attractive and any messages they adorn more influential." Eibl-Eibesfeldt (1989b) also finds the basic function of art to be "message-reinforcement." Coe mentions deliberate cranial deformations occurring from 70,000 B.P., and intentional tooth filing and ablation during the Upper Paleolithic. Although undergoing or performing these activities on the self must have been painful, and certainly could not have produced sensual pleasure and delight, they could be categorized as early instances of making special and must have been *dromena* to affect circumstances and reinforce messages. Their *results* may well have given sensual pleasure and delight, that is, the resulting alterations may have looked attractive to those who created and valued them.

30. The popular picture of Neanderthals as brutish and backward compared to other *sapiens* has been increasingly challenged. It is now commonly believed that Middle Paleolithic (Neanderthal) subsistence appears to have been remarkably similar to that of the Upper Paleolithic (the beginning of "anatomically modern" humans) (see, e.g., Chase 1989; Harrold 1989; Hayden 1990, 1991; Shea 1989) and that Neanderthals were thus theoretically as behaviorally capable as more modern hominids (see also Chapter 3, note 9). Reasons given for the transition to the more complex technology, artistry, hunting, and foresight abilities that are seen in the archaeological record include environmental stress (harsher climate, reduced resources, perhaps from population pressure) that forced populations to cope or perish (e.g., Deacon 1989) and diffusion and migration, suggesting contact with more advanced groups (Harrold 1989). Hayden (1990), however, proposes that prosperity or at least adequate provisions (i.e., not environmental stress) accounts for the cultural elaborations of Upper Paleolithic peoples, in that rich environments could give rise to the possibility of status differentiation and display that would encourage greater artistic and artifactual expression.

31. These do not seem to me difficult to connect to evolution. If one grants (as Alexander [1989] does) that in humans social cooperation has been of supreme importance, then the existence of these as "we-reinforcers" (e.g., laughing together, music, and performance are age-old time-tested ways of uniting people in pleasurable and positive communality) would have been favored in the process of natural selection. Sociobiologists like Alexander generally look first for ways in which human traits directly serve self-interest, thus he proposes that humor "influences resource competition directly through status shifts" (481) or that the arts were used for competitive display. But both humor and the arts are better explained, I think, by their contributions to social cooperation and group unity (which, as Alexander has so clearly pointed out, contribute indirectly in their turn to the self-interest and hence survival of individuals). Alexander does comment that ritual, myth, religion, and ceremo-

nies, along with patriotism, xenophobia, cheerleading, and pep rallies, can all be seen as "related to the coordination (and testing) of emotions in connection with specific cooperative tasks" (498), but he does not mention the arts as contributing, within ceremonies for example, to help accomplish this.

Chapter 5. The Arts as Means of Enhancement

1. The contemporary Western concern with "naturalness" is in large measure a legacy and development of the democratic political revolutions of the late eighteenth century (which exalted the standards of the common man as challenging those of royalty and the aristocracy) and the "romantic rebellion" against the constraints and unnaturalness of industrialization. (See also the discussion in Chapter 1.)

2. Griaule (1965) reported that according to the Dogon, the separation between animals and men came about with the invention of "the word" (language) and of death (since animals, unlike men, do not know they are going to die). However, Jean Rouch, a more recent student of the Dogon, found that some at least disagreed, saying "We are not animals, and we thus do not know whether animals have a language we do not understand" (Rouch, "The Dogon on Film" [Lecture presented at the Metropolitan Museum, 8 May 1988, New York City]).

3. For the Hausa, Tiv, and Cameroon grasslands people, men do the dyeing. The Benin royal weavers, a craft guild that predates European contact, are men—although it is thought that at one time they may have been women (Ben-Amos 1978). In Benin culture, cloth is used not only to enhance individual appearance but to demarcate sacred space. The royal weavers, called *imona* ("beautifiers," lit., "pattern-makers or designers") include specialists who hang cloth to adorn shrines.

4. As mentioned in note 29, Chapter 4, Coe (1990) makes an excellent case for the earliest known art (ca. 70,000 B.P.) to have been body deformations and ornamentation, but she sees these as having been used for attracting (favorable) attention, not, as I propose here, to culturally domesticate nature. Both motivations, of course, could have coexisted.

5. As Peter Sutton (1988, 13) explains: "In a traditional Aboriginal sense, the world is made of signs. One may not know more than a fraction of their meanings, and not all their meanings are of equal significance, but the presumptive principle is that there is no alien world of mere things behind the signing activity of sentient, intelligent beings." Sutton continues, "The land is a narrative—an artifact of intellect—before people represent it. There is no wilderness."

6. The distinguished student of oral composition, Albert B. Lord (1960, 67), suggests that repetition originally indicated the wish for "surer fulfillment" of what was invoked in incantations. (See also Chapter 4, note 19.)

7. Verbal language may even be conceptually joined with visual marks, as with the Australian Walbiri whose word *yiri* comprises both verbal musical forms (e.g., a song "line" that recapitulates the sequence of sites associated with an ancestor and occurrences there) and the visual marks (*guruwari* designs) that evoke the ancestor's movements. Each is a repository of narrative meaning, and the production of one may evoke the other. Munn (1986, 145–46) finds that designs and songs constitute a single complex and are "complementary channels of communication" about an ancestor. In this conjoining, the Walbiri have made a superordinate conceptual category that includes songs and designs, as we have when we call both of these "art"—but their reasons for doing so are different.

8. Curt Sachs (1962/1977, 112) states that rhythm is basically a quality inherent in bodily movement, not in music or poetry. Following Bücher in *Arbeit und Rhythmus* (1896), he suggests that rhythm arises as a psychophysiological urge to equalize continuous regular movement such as walking, dancing, running, or rowing, hence allowing greater ease and gusto; only later does it become attached to melody. Yet I would add that music (song) and poetry (speech) are themselves "bodily movement" and it is difficult to see how they can be nonrhythmic or arhythmic if they are produced by a creature who is already respiring rhythmically and whose brainwaves and circulatory rhythms are providing the background to its very being. My own view would be that rhythmic regularity (what Sachs calls "rhythm": "recurrent, strictly gauged patterns of organization") and melody are both inherent in the prosodic features of spoken language and that these are further shaped and elaborated in song.

9. My hypothesis of the evolutionary origin and function of music will appear in *Music in a New Key* (work in progress).

10. Allison and Marek Jablonko's 1968 film, *Maring in Motion*, shows through choreometric analysis how Maring dance utilizes and emphasizes the natural movement patterns that occur in work and play.

11. The Dogon also believe that their masks must be in movement. Jean Rouch (see note 2, this chapter) recounts taking some Dogon visitors to the Musée de l'Homme in Paris, where they saw their *kanaga* masks displayed in vitrines and were confirmed in their belief that Europeans obviously "do not understand" them if they treat them in such a manner.

12. In historic times, the arts have become specialties performed by specialists. Individuals (artists or priests) who take it upon themselves to make things work well (to enhance/control important things) may appropriate for themselves the power that formerly belonged to the group acting together.

13. Jacques Maquet, in a book called *The Aesthetic Experience* (1986) concludes that noninstrumental forms and embellishment of objects are evidence of an "aesthetic intention" and "nothing more" (64). "These features are not necessary for the ritual effectiveness of the religious or magical rite" (62). I would completely disagree; in countless groups it is precisely the pattern of embellishment or its beauty that is necessary to the efficacy of an object or activity (e.g., the Abelam, for whom paint makes an object sacred; the Yanomamo shamans, who know that spirits love and require beauty; or the Wahgi, for whom the rich quality of the decorated appearance—glossy, bright, vivid—discloses the true state of moral relations). However, I would concede that art makers of all times and places can be presumed to judge their works and others' according to "aesthetic" criteria in a more informed, even detached, way than most or all spectators.

14. Mutatis mutandis, this discussion applies to poetry. Let me also say here that improvised music, for example that of the Hindustani and Carnatic traditions, can be as profound and affecting, in a similarly sophisticated way, as any Western "classical" works.

15. As I have been at pains to emphasize, "cerebral" does not mean nonbodily. But there does seem to be something in the conscious intellectual recognition (at some level) of the way in which the sensuous elements of the artwork are formed and elaborated that contributes and is essential to the profoundly felt "aesthetic" experience that makes it different in degree if not in kind from dissociation and ecstatic experiences reached by movement, repetitive drumming, hyperventilation, and the like. This

"cerebrality" I think is what Ellen Winner (1982) means to suggest when she calls the arts "fundamentally cognitive."

16. The ironies and paradoxes inherent in the recognition in eighteenth-century French thought of the fruits of civilization, its discontents as well as its compensations, is the subject of a recent set of collected essays by Jean Starobinski (1989). See the review by Peter France (1989).

17. It was pointed out to me that although therapy usually deals with one client at a time, the therapist "stands for" the entire therapeutic community and represents those who claim to understand certain mysteries. "Support groups" of all kinds, such as those for addicts, parents of disabled children, or caretakers of Alzheimers patients, provide both therapy and community.

18. Gregory Bateson (1972/1987) calls art "a part of man's quest for grace," and by "grace" he means naturalness, nonselfconsciousness, and nonpurposiveness. In this, his view is almost diametrically opposed to mine, a fact that I think can be understood as occurring because Bateson, although he purports to treat art cross-culturally and universally, operates with a modern romantic/religious view of art as the restorer of lost innocence.

Bateson's notion of the nature and function of art, that "it is a message about the interface between conscious and unconscious," and that it acts to correct a "too purposive" (i.e., rational, conscious) view of life by making the view more "systemic" (i.e., bringing in the unconscious) would seem to be very much an artifact of the modern temper, where art's associations with the nonrational are hailed and extolled as allowing a more balanced and healthy view than our lopsided technorational worldview. The latter is, however, a recent human perspective. I believe that early humans would have found the "corrective function" of art to lie in its answering to a too unintelligible and unconscious view of life and thus making it more systematic (not "systemic") by bringing in the deliberate, contrived, and humanly imposed. In modern and postmodern society, of course, art may serve many functions, but Bateson's view of art's function seems to me overly Westernized and applicable to premodern societies only insofar as they have come to resemble our own.

Chapter 6. "Empathy Theory" Reconsidered

1. These include Robert Vischer (1873, cited in Wind 1965, 150), Grant Allen (1877), Bernhard Berenson (1896/1909), Theodor Lipps (1903), Wilhelm Worringer (1911/1953), and Vernon Lee (Violet Paget) (1913).

2. In his book *Über das optische Formgefühl* (1873, cited in Wind 1965, 150). Vischer's father, Friedrich Theodor Vischer, had written (in *Kritische Gänge*, also 1873) that one *"fühlt sich hinein,"* feels or projects oneself into, nature through symbols, which he claimed was a universal and normal process (Spector 1973). Parenthetically, it is interesting to note that Heinrich Wölfflin, the influential theorist of style who is read even today by first-year art-history students, in his early work made use of current empathy theory as developed by Vischer, only to discard it when he propounded the purely visual aspects of style that he claimed were indifferent to emotion (*ohne Gefühlston, an sich ausdruckslos,* "without feeling tone, themselves expressionless"). Ultimately, as we know, the objective formalist view was victorious.

3. An analogous word, *mitsehen*, or "seeing with," was used contemporaneously by Johannes Volkelt in his *System der Ästhetik* (1905–14): "When we contemplate Michelangelo's *Moses*, the posture of his mighty figure and the turning of his head,

the wrath of the prophet is actually seen with (*mitgesehen*), a gesture which otherwise would be unintelligible" (quoted in Spector 1973).

4. Karl Groos in *The Play of Man* (1899) anticipated Freud's ascription of a physiological basis for mental imagery, in "inner imitation," later to be worked out more fully by Gestalt psychology. Groos wrote: "The sympathy of an aesthetic nature possesses such warmth and intimacy, and such progressive force, that the effects of former experience, however indispensable, are not sufficient. . . . Mere echoes of the past cannot bring about what I understand as the play of inner imitation [*Einfühlung*]; on the strength of my experience I hold fast to inner imitation as an actuality, and one connected with motor processes, which bring it into much closer touch with external imitation than [associative explanations] would indicate" (quoted in Spector 1973).

5. In "Group Psychology and the Analysis of the Ego" (1921/1955), Freud proposed a process of identification very close to empathy as a means of interrelating persons, together with an allied process of projection.

6. Vischer's book has been called "both the earliest and the most eloquent statement of the aesthetics of 'tactile values' and 'ideated sensations' which Berenson popularized in English" (Wind 1965, 150).

7. After completing this chapter, I discovered that Manfred Clynes (1977), a neuroscientist, inventor, musician, and general polymath, has developed "a new theory of emotion communication" called "sentics," in which the term "empathy" is an important element. See note 25, this chapter.

8. Langer's "forms of vital experience" (1953) and her other writings (1942, 1967) could be integrated smoothly into a biologically based view of aesthetic experience. Despite her expressed wish to elucidate biological bases for the arts, however, Langer does not consider art as a selectively valuable behavior in human evolution. Also, her interest in demonstrating that art is a product of a distinctly human symbolizing "mind" is quite unlike my claim that art need not depend upon the presentation or transformation of symbols.

9. This is the empiricist or objectivist philosophical/psychological viewpoint, usually contrasted with the idealist one that asserts the existence of innate ideas. My own position is a combination of the two, recognizing that we have evolved as a species with innate predispositions to "think" (perform mental operations) in certain ways—for example by noting cause and effect, using analogy and metaphor, and so forth. Indeed, this chapter is concerned with describing some of these dispositions. But these are carried out in the context of, and with regard to, an experienced external world, and it is through perceptual or sensory contact with that world that a mind is able to perform its operations.

10. Further, the neuromuscular and motor realms are significant in emotional experience and expression, and hence operate overtly or quasi-overtly in all mental states. Patients who have had throat operations, for example, may be forbidden to read until healed because even silent reading is accompanied by minute but measurable movements in the vocal tract.

11. A fascinating psychoanalytic perspective on the importance of "the tactile and cutaneous universe" and of the skin as both boundary and interface with the environment has recently been offered by Anzieu (1989).

12. Mark Johnson's (1987) notion of "image schemata" as cognitive structures that organize our experience recognizes that human "reality" is importantly "bodily" (or, as he says, "embodied"). Many of the image schemata treated by Johnson appear to be

spatially conceived, and he emphasizes their prelinguistic or nonsentential character. See also notes 22 and 28, this chapter, and Arnheim (1969).

13. For a sociobiological view of the matter, see Lumsden and Wilson (1981) for "epigenetic rules": "the genetically-determined sensory filters, interneuron coding processes, and . . . cognitive procedures of perception and decision making" (25).

14. See also Figure 9.1 in Eibl-Eibesfeldt (1989a), where photographs of female faces were superimposed by H. Daucher to much the same end.

15. Although "cognitive primitives" no doubt exist, I have not been able to find any agreed-upon list of them. Gibson, who undoubtedly would modify Cohen's notions of visual perception, described "invariant" characteristics of graphic marks or traces as straight, curved, zigzag, line and lined up, closure, intersection or connection, parallel, coincidence, and congruence (Gibson 1979, 276). See also Kellogg (1970). With regard to visual perception, current findings as described by Treisman (1986) suggest that the features extracted in early visual processing in humans are simple properties that characterize local elements such as points or lines—color, size, contrast, tilt, curvature, line ends, movement, and differences in stereoscopic depth—but not the relations among these properties. Closure appears to be the most complex property that is preattentively detectable in experiments but only when "distractor" percepts (in the experimental situation) do not share it. It is interesting to note that the French impressionist painters wished to depict what they saw—light and color, the basic visual percepts of a scene— and not what they "knew." In this respect, they were precursors of a sort of Harold Cohen and other seekers of cognitive primitives.

16. In one set of experiments, subjects did not generate illusory conjunctions of features to fit their expectations (Treisman 1986, 121–22), a finding that led to two implications: (1) prior knowledge and expectations do help one to use attention in conjoining features, and (2) prior knowledge and expectations seem not to induce illusory exchanges of features to make abnormal objects normal again. Thus, concludes Treisman, "illusory conjunctions seem to arise at a stage of visual processing that precedes semantic access to knowledge of familiar objects. The conjunctions seem to be generated preattentively from the sensory data, bottom-up, and not to be influenced by top-down constraints."

17. Children (and chimpanzees), by the way, require the actual physical trace of a marker to remain interested—it is not simply the motor activity that is rewarding. Children aged one and a half to three who scribbled zealously with a pencil would stop when a nontracing pencil that provided everything but the trace was secretly substituted. Three year olds refused to "draw a picture in the air" and asked for paper on which to draw a "real picture" (Gibson 1979, 275–76; see Morris 1962 for chimpanzees).

18. In addition, these first sentences express relations among agents, actions, and objects acted upon ("Teddy eat cookie"), between locations and objects located ("Daddy work"), between possessors and possessions ("My baba"), and between objects and their attributes ("Baby hurt") (Bowerman 1980).

19. Other examples of musical terms that contain vowels suggestive of quickness and lightness are *brio*, *capriccio*, *presto*, and *vivace*.

 It is interesting to note that earlier and hence independently of Jakobson and Waugh, Robert Greer Cohn (1965) demonstrated the occurrence of sound symbolism according to these principles in the poetry of Stéphane Mallarmé.

20. Marshall Sahlins (1976) proposes that light/dark may be a universal attribute not only of vision but also of all the senses and that the discrimination of lightness and darkness is perceptually the most rudimentary distinction, hence perhaps universally significant and semantically motivated for any given culture. The Umeda of Papua New Guinea associate colors with light and dark as well as with succulence and dessication (Gell 1975). The Keram, also of Papua New Guinea, have no isolatable concept of color, but rather describe things in terms of such factors as ripeness or unripeness and dirtiness or patterned contrast (cited in Gell 1975).
21. Kaluli poetics is intimately associated with and inseparable from song. Song and poetics, in turn, are inseparable from certain key metaphors from nature (especially birds and water) and from ritualized weeping (see Feld 1982). Onomatopoeic words are used in sung-texted-weeping to refer to birds, water, and journeys through known natural surroundings, and these have wider cultural metaphorical significance.
22. In Mark Johnson's work, the general Kantian model of the "structures" of spatial cognition is thus broadened. He (1987, 37) describes "image schemata" as dynamic and flexible, providing the bodily metaphorical bases for "giving definiteness, coherence, order and connectedness in our experience of anything."
23. This is probably one of the reasons why the temporal arts, especially music, are generally considered to be more emotionally affecting than the static, plastic arts. Meyer (1956), for example, as mentioned above with regard to prototypes, explains musical emotion as arising from the creation and release of tensions as one's expectations are manipulated, delayed, and finally resolved. Clynes (1977, 25, 157) asserts that the intensity of a sentic (emotional) state is increased, within limits, by repeated but *arhythmic* generation of essentic form (the inherent spatiotemporal form that expresses the emotion). In other words, regular rhythmic repetition does not build up the sentic state but tends to discharge it (just as patting tends to calm and comfort anger or distress).
24. To Jakobson and Waugh (1979), the "decisive import of the dyadic principle" in language (in the sound patterning, the grammatical structure, the hierarchical relations within and between dyads, and within the language as a whole) also "advances the question of isomorphisms between verbal coding and the central neural processes" (64).
25. In her admirable and stimulating review of the philosophical implications of neuroscience, Patricia Churchland (1986, 417 ff.) describes a plausible way in which representations might be transformed from sensory input to motor output using a coordinate system of coding in neuronal grids of axes and angles of these axes. Thus an afferent ensemble (e.g., visual, olfactory, or vestibular input array), coded as points comprising a literal physical map in one phase space, could be connected by nerve fibers to an efferent ensemble (the motor output) in another phase space that preserves the same relevant topographic relationships. While not conclusively demonstrated, this model in effect would be "neural isomorphism." It is compatible with parallel models of cerebellar information processing.

Clynes's theory of sentics (1977) claims spatiotemporal isomorphism (although he does not use the term) among all individual expressions ("E-actons") of any specific sentic (emotional) state. He gives characteristic sentograms for the essentic forms of anger, hate, grief, love, sex, joy, and reverence that are expressed isomorphically in a variety of modes from tone of voice to gestures, using many parts of the body.

According to Clynes, these characteristic spatiotemporal forms have evolved (been programmed genetically) for the communication and generation of specific sentic states, and when used in the arts will express these emotions. Clynes also claims (151 ff.) that with different sentic states the total ongoing electric activity of the brain (e.g., the presence and absence of various brainwaves and the degree of synchronicity between different portions) shows characteristic changes that can be correlated with the essentic forms.

Churchland's model suggests isomorphism between a particular sensory input and its motor output, while Clynes's model claims isomorphism among all instances of a specific emotional expression. What Arnheim (1949) proposed is a combination of both, where a coded pattern of sensory input and psychological/emotional response would be spatiotemporally equivalent. The possibility remains tantalizing.

26. In other examples of cultural isomorphism, Bruce Kapferer (1983, 193), writing about Low Country Ceylon healing ceremonies, calls the dancing an externalization of the music, an objectified interpretation of inner experience that (isomorphically) spatializes the music's temporal structure. He also speaks of the "iconicity" of the dance, of gesture and "feeling form." When the beat is slower and softer and more varied, it signifies the divine (188–89). Slow, stately movement to the West African Yoruba communicates age, wisdom, or extraordinary powers (Drewal and Drewal 1983, 219).

27. Manfred Clynes's studies of sentics (1977) should really be included here, but his ideas came to my attention too late to be adequately discussed.

28. It is interesting that Chinese compositional principles are based on opening and closing, void and solidity, frontality and reverse, expansion and contraction, excessiveness restrained and want supplied (Scharfstein 1988, 224). See also Johnson's (1987) discussion of "preconceptual gestalts for force" (42–48) and the "embodied structures of understanding" (206) (containers, balance, compulsion, blockage, attraction, paths, links, scales, cycles, center-periphery), some, if not all, of which have modal-vectoral underpinnings.

29. Some Greek musical modes could be played in three different forms, making them either more austere (diatonic with full tone intervals), more plaintive (chromatic with half tones), or more exciting (enharmonic with smaller intervals) (Stanford 1983). See also Arnheim (1984) for a similar explanation of the perceived mood differences between the Western major and minor scales.

30. Athenaeus (*The Sophists at Dinner*), ca. A.D. 200, criticizes Homer for carelessly composing verses that are "acephalous" (lame at the beginning), "slack" (lame in the middle), or "taper off at the end" (cited in Strunk 1950).

31. I would have liked to treat the psychobiology of self-transcendent experiences here, but it is outside the scope of the present study. In *Music in a New Key* I intend to discuss self-transcendence extensively.

32. In a recent book, which among other things explores the psychological effects of literature, Jerome Bruner (1986), who has always been at the forefront of the twentieth-century discipline that bestrides the psychology and philosophy of the mind now known as "cognitive science," suggests that there are two complementary but distinctive modes of human thought, each providing their own ways of ordering experience, of constructing reality: "Each of the ways of knowing . . . has operating principles of its own and its own criteria of well-formedness. They differ radically in their procedures for verification. A good story and a well-formed argument are different

natural kinds. Both can be used as means for convincing another. Yet what they convince *of* is fundamentally different: arguments convince one of their truth, stories of their lifelikeness. The one verifies by eventual appeal to procedures for establishing formal and empirical proof. The other establishes not truth but verisimilitude." (11).

Bruner's analysis concerns persons in literate societies. While his theories pertain to "utterances" and "texts" (which in theory may include both oral and written communications), the application seems to be almost entirely to readers and writers, or speakers who can read and write.

While members of preliterate societies are certainly able to construct and to act upon hypotheses based on their observations of cause and effect, and to organize their experience into conceptual categories or structures, it is not the case that they employ "argument"—the "paradigmatic," logico-scientific, consistent, abstract, formal type of thought that Bruner contrasts with "narrative." While Bruner's formulation underlines the universality and importance of narrative as *the* fundamental human mode of mental functioning, this should be a novel or surprising notion only to an academic intelligentsia (and those influenced by it) that has emphasized and internalized the primacy and supremacy of analytic, objective, hypothetico-deductive, propositional thought to such a degree that it has forgotten what is primordially human and universal in its own mental life.

"Narrative," concerned with psychic reality and the human condition, makes sense out of experience in a way quite different from well-formed logical argument. It is particular, not general; concrete, not abstract; and concerned with meaning rather than truth. Bruner states that "Insofar as we account for our own actions and for the human events that occur around us principally in terms of narrative, story, drama, it is conceivable that our sensitivity to narrative provides the major link between our own sense of self and our sense of others in the social world around us. The common coin may be provided by the forms of narrative that the culture offers us. Again, life could be said to imitate art" (69). Once more I submit that such a conclusion should surprise only people who are irrevocably imbued with Western academic theory.

If, as Bruner suggests, the very nature of mind includes the ability to create and respond to stories as a way of making sense of, or of imposing meaning upon life, it seems to me ill-advised to call this general propensity, as he does, "art." However, if there are innate as well as culturally validated criteria for the "well-formedness" of these stories, then it would seem that one could make a case that the ability to recognize that some experiences or products are well formed or aesthetic (as distinct from nonaesthetic) is a fundamental human ability. The Marghi of Nigeria (Vaughan 1973) are not the only society able to distinguish between a "good" and a "well-told" tale, which may or may not be the same.

33. This is not to say that social organization and cultural behavior always correspond or that an individual culture may not use both restricted and extravagant forms in order to convey different meanings, as described, for example, in note 26, this chapter. However, Lomax's findings and interpretations suggest a widespread and more-than-fortuitous analogue between social and aesthetic form. In any case, dance in general (whether restricted or extravagant, fast or slow) can exemplify, as Judith Lynne Hanna (1979) has claimed, such universal and salient individual human experiences as self-transcendence, self-extension, growing, continuity, and "becoming," and

thereby isomorphically describe and enact both particular and general human life concerns. Rudolf Arnheim, writing about music (1984, 226), made a similar point. Addressing the question of "what it is that expression expresses" in music, he finds that "emotion"—grief, joy, and so forth—is much too limited a category: "Dynamic structures such as the ones embodied in the aural percepts of music are much more comprehensive. They refer to patterns of behavior that can occur in any realm of reality, be it mental or physical. A particular way of coping with the task of how to move from a beginning to an end can be manifest in a state of mind, a dance, or a watercourse. Although we human beings confess to a particular interest in the stirrings of the soul, music, in principle, does not commit itself to such particular application. It presents the dynamic patterns as such." I tend to agree with Arnheim here and disagree with Clynes (1977) when he finds sentic forms in music that express particular emotions such as joy and grief.

34. Psychiatrist Ludwig Binswanger's (1963) explication of sexuality (in what can now be recognized as binary, associational, and modal-vectoral terms) could, mutatis mutandis, serve for art: "The main significance of sexuality and the erotic for the inner life history is easier to understand in individual cases if we consider the particular relations of sexuality to the experience of time and space (extension and momentization, broadening and shortening of existence), the experience of change and continuity, of the creative and the new, of repetition and fidelity, of drivenness on the one hand, and resolve and decision on the other etc.` (158 n).

Chapter 7. Does Writing Erase Art?

1. Terry Eagleton (1990) has described brilliantly how an "ideology of the aesthetic" arose alongside commodification, rationality, secularization, and other new features of life as Western society and consciousness became "modern." Eagleton sees the aesthetic as

the wan hope, in an increasingly rationalized, secularized, demythologized environment, that ultimate purpose and meaning may not be lost. It is the mode of religious transcendence of a rationalistic age. . . . It is as though the aesthetic represents some residual feeling left over from an earlier social order where a sense of transcendental meaning and harmony and of the centrality of the human subject, were still active. Such metaphysical propositions cannot now withstand the critical force of bourgeois rationalism, and so must be preserved in contentless, indeterminate form as structures of feeling rather than systems of doctrine. (88–89)

Yet even while 'the aesthetic' could provide a domain of human feeling in contrast to rationality, it also became "a weapon in the hands of the political right," upholding taste, manners, judgment, and morality as abstract and authoritarian principles.

2. Leo Steinberg used the term "postmodernism" with regard to the visual arts in 1968, with reference to Robert Rauschenberg's transforming of the picture surface into a "flatbed" picture plane (Crimp 1983).

3. For example, with the intermingling of "high" and popular art and the juxtaposition of disparate elements in the collages of Schwitters, Picasso, and Braque; the implicit questioning of art's sublimity and transcendence or the authority of the artist's hand in the use of readymades by the dadaists and others; the embracing of nontraditional

sounds as valid musical material by Edgar Varèse in the 1920s; the anti-intellectualist sentiments expressed by Proust in *Contre Saint-Beuve* (1909); and even Manet's discontinuities of technique within the same work or his use of alien iconographic elements in the apparently traditional *Dejeuner sur l'herbe*.

4. The failure of socialist regimes in the Soviet Union and Eastern Europe does not negate the challenges to Western capitalist democracy of political theories and movements that seek equal access for all members of a society to its protections and benefits: health, education, housing, justice, work opportunity and so forth.

5. Joan Didion (1988) in a discussion of the 1988 Democratic and Republican national presidential nominating conventions, shows how representations can be more real than reality. She notes that the convention arenas "became worlds all their own, constantly transmitting their own images back to themselves." She argues that voters are seen by the campaign organizers as responsive not to actual issues but to their adroit presentation. Didion also mentions "the contradictions inherent in reporting that which occurs only in order to be reported."

6. I exempt species-centrism and evolutionary biology from this partiality and arrogance on grounds that will be described below.

7. I am aware of much of the current controversy about the extent to which "literacy" affects individual humans and societies—the "impact of writing on the productions of the mind" (see, for example, the papers by a variety of scholars excerpted in Miller 1988). My own conviction is that oral and literate communication call upon and foster quite different human abilities. Therefore, on the continuum ranging from nonliteracy at one end to superliteracy at the other, those at either end will have very different minds from each other (Dissanayake 1990). In my view, an awareness of the concomitants of literacy should be part of every liberal education. Given impetus in the 1960s by the writings about media by Marshall McLuhan, the subject by now has a large and growing bibliography. The account I present here is by necessity over-simplified.

8. Even though educationists today bemoan the fact that children no longer read, and that television vies with recreational drugs as the substitutes-of-choice for literature and life, our society epitomizes "literate society." Indeed, it has been said that one of the characteristic signs of widespread literacy is the prevalence of what is commonly called "illiteracy" (Murray 1989). It can also be said that even while many of today's postmodern artists are in various ways concerned with giving art back to life, by challenging the authority and remoteness of concepts and labels, or by unashamedly confronting and portraying the tawdriness and meaninglessness of postmodern civilization, or even by attempting to reconnect with magical and spiritual modes of thought, their mentality is so stained with presuppositions and preconceptions inherent in the literate tradition that their attempts to subvert its greatest ills resemble the attempts of those feminists who in seeking to overcome male domination unconsciously adopt the very patriarchal tactics and trappings of victory that they deplore.

9. It is well known that Plato, in his *Phaedrus*, has Socrates discourse on the superiority of the spoken word and the dangers inherent in writing: reading and writing undermine memory so that knowledge in books need not be embedded in the mind and soul as wisdom; the written word is promiscuous and like a loose woman can fall into anyone's hands, even the ignorant and unsympathetic. But even Greek mythology implicitly reveals an awareness that literacy has ambivalent consequences through

the story of Cadmus and Harmonia, a sort of Greek Adam-Prometheus and Eve
 Harmonia, the daughter of Aphrodite and Ares (Love and War), marries Cadmus,
 who brings the alphabet to Greek civilization. At the end of Cadmus's life, Dionysos
 expels the pair from Thebes and they enter into the human condition—wandering
 the earth, separated from the gods, evoking nostalgically by their literacy the mythical
 life they were once so close to.

10. Cited in Bergounioux 1962. But not all societies regard personality as individual. For
 the Fulani, for example (Riesman 1977), personality is not considered to be localized
 in the body and mind of the person, but involves the others with whom one has
 relations. In other words, without others one lacks part of oneself.

11. The proliferation today of word processors for "writing" oddly underscores this eva-
 nescence of not only what writing refers to but the very words themselves (which, of
 course, when spoken are transient). For the first time in their history, written words
 are no longer engraved on stone, limned on parchment, or even printed on paper but
 have become mere traces of electromagnetically stored energy. The computer's res-
 toration to language of its inherent ephemerality seems appropriate in the present
 rarefied atmosphere of postmodernist literary theory which magisterially proclaims
 that literature has nothing really to do with reality. It is indeed ironic that the end
 point of the literate tradition, those now so fashionable theories promulgated by
 Derrida, Barthes, and the rest, is a realization that might well come from unsophis-
 ticated nonliterate tribespeople, who would be surprised to be told that marks on a
 page were simulacra of the world.

12. Danto (1986, 110) invokes Hegel's philosophy as intrinsic to this view where "art's
 philosophical history consists in its being absorbed ultimately into its own philoso-
 phy," and where progress is understood as

 a kind of *cognitive* progress, where it is understood that art progressively approaches
 that kind of cognition. When the cognition is achieved, there really is no longer any
 point to or need for art. Art is a transitional stage in the coming of a certain kind of
 knowledge. The question then is what sort of cognition this can be, and the answer,
 disappointing as it must sound at first, is the knowledge of what art is. . . . Art ends
 with the advent of its own philosophy. (1986, 107)

13. Hegel said: "It is no doubt the case that art can be utilized as a mere pastime and
 entertainment, either in the embellishment of our surroundings, the imprinting of a
 life-enhancing surface to the external conditions of our life, or the emphasis placed
 by decoration on other subjects" (*Philosophy of the Fine Arts*, cited in Danto 1986,
 113–14). Hegel's view, of course, reiterates the Western view of adornment as su-
 perficial and superfluous which, as described in earlier chapters, is not the case in
 premodern societies where it is considered to be essential.

14. Contemporary anthropology is also in the grip of a postmodern paralysis, having
 realized that its traditional task, representing and interpreting the worlds of others,
 has been necessarily dependent on writing (e.g., documentation, theory, categori-
 zation, classification, abstraction, comparison, method, interpretation based on read-
 ing texts, and producing a text of one's own) (Clifford 1988; Geertz 1988).
 Ethnographic reality thus does not exist apart from a literary version of it, and is seen
 as being a kind of dominance and authority of the ethnographers over the subjects
 whose cultural reality they purport to describe. In response to this predicament,

field-workers now write about their own questioning ambivalence, use "narrative" rather than analysis and metaphors or admitted fictions rather than "hypotheses," hoping thereby to avoid the worse excesses of authorial authority. Their hyperliteracy is evident also in that they give very little attention these days to societies' visual or musical arts but focus on their literature and dramatics, which are much more easily treated as "texts."

15. In the first published version of *De la grammatologie*, Derrida used the word "destruction." The procedure of deconstruction refers to "the unmaking of a construct" and implies the possibility of rebuilding (Spivak 1976, xlix). Derrida himself says that deconstruction has nothing to do with destruction, but "is simply a question of being alert to the implications, to the historical sedimentation of the language which we use" (Macksey and Donato 1970, 271). This used to be called philology, historical analysis, or close reading.

16. I am not suggesting here that preliterate people cannot "analyze," but I do maintain that literacy facilitates a kind of formal analysis based on a greater degree of distancing, constancy, comparison, and abstraction that writing makes possible.

17. Danto (1986) refers to "the frivolous sadism of the deconstructionists."

18. I have suggested elsewhere (Dissanayake 1990) that this century's preoccupation with language has been aided and abetted, if not wholly generated, by the ability to record (mechanically on tape) and transcribe living human speech. This ability has permitted people to see easily and read exactly what they or others actually informally say and hear (although, as I will soon make clear, it does not seem that many philosophers have actually looked at actual spoken languages). See also notes 27 and 29, this chapter.

19. For a delightful and readable philosophical critique of the movement, see Tallis (1988), who claims that post-Saussurean fallacies about the nature of language, reality, meaning, truth, consciousness, and self-consciousness, and the various relations between them constitute a giant leap backward in contemporary thought. The position has also been criticized by linguists. For example, Foster (1978), in her reconstruction of Primordial Language, criticizes Saussure's claim that the linguistic sign was unmotivated and arbitrary because there is no detectable relationship between sound and meaning. On the contrary, she maintains, "even after this relationship became obscured, the patterning and interrelationship of features, both of sound and meaning, [continue] to be so firm that we can hardly consider today's linguistic sign to be arbitrary" (118).

20. In this he echoes Jacques Derrida (1976, 21), who has written that "The sense of 'being' is nothing outside of language and the language of words." To this all I can say is "Poppycock." Split-brain studies such as those described in Chapter 6 (e.g., Sperry, Zaidel, and Zaidel 1979) show that significant self and social awareness occur without language.

21. I find it amusing that Roland Barthes (1978), invoking the psychoanalytic theories of Freud, Lacan, and Winnicott, suggests that language is born of infantile attempts to "manipulate" the absence of the "other"—the mother. His account of the "origin" of language is not meant to be in any way Darwinian. Yet Jane van Lawick-Goodall (1975, 164), from a quite different "interpretive community," also proposes that language may have arisen in mother-infant communication, to aid the human infant who (unlike other primate babies) is unable to cling. Thus verbal contact would reinforce (or temporarily replace) physical contact.

22. With regard to the meaning of "meaning," here I follow "intentionalist" theorists such as Searle (1983) and Johnson (1987), who find that meaning always involves human intentionality ("that property of many mental states and events by which they are directed at or about or of objects and states of affairs in the world" [Searle 1983, 1]), and that intentionality "is primarily a property of human mental states and only derivatively a property of sentences, upon which we impose our intentionality" (Johnson 1987, 181). Moreover, all meaning is context-dependent (Johnson 1987, 181).

23. Kant's view of the relationship between human categorical knowledge and "Nature" is no doubt regarded by students of his philosophy as more subtle and complex than Lorenz here suggests.

24. Perhaps even more than contemporary philosophy itself, it is the perception of others of what contemporary philosophy holds or implies. See, for example, Harvey (1989, 203) or the pamphlet *Speaking for the Humanities* (American Council of Learned Societies 1989), both of which misinterpret or oversimplify the claims of "science" or "modern philosophy."

25. While the culturally inculcated premises under which they may be acting *are* "metanarratives," their biological imperatives (precultural needs that these metanarratives realize and shape) are not. Eagleton here seems to privilege the actions of the ANC and the Nicaraguans; it should be said that their opponents also do not question the veracity of the metanarratives under which *they* operate. The point I wish to make is that actions and beliefs that impel action are crucial to life in the world, and this is particularly so when the stakes are higher than we in our comfortable armchairs and ivory towers are accustomed to play for and hence can cavalierly dismiss as illusory simulacra. Some metanarratives are more urgent and worth espousing than others.

26. To be fair, the later Wittgenstein, and the speech-act philosophers, recognizing that we are creatures of interests and purposes, do consider how language is used in the world. Recognition of language as a biological adaptation, however, is not included, as far as I can see, in their theories. Habermas (1989), who does invoke evolutionary theory to support his dubious and confusing claim that "labor and language are older than man and society," seems to have an incomplete understanding of hominid evolution and the processes of adaptation and natural selection. (See also Chapter 4, note 27.)

27. Here, for example, is a short verbatim transcript of a teacher explaining why she liked a film: "And the other is the video as experience, to in some ways get— In terms of— The reason I guess I like *The Ming Gardens* was I was trying to teach the difference between ying and yang, and that happened to be exactly where I was when the film was just waiting for me." Reading an unedited transcript of spoken language one might wonder how children ever learn to talk. They learn to do so, of course, because speaking is not a skill or craft in the same way as reading or writing: it comes "naturally." It is learning how to use the written word with its authority and aloofness that is unnatural and difficult. Hyperliterates tend to think of speech as an inferior form of literature when, in truth, it is literature that is an artificial and deviant offspring of spoken utterance.

28. Dennett (1987, 120) remarks that it is distinctly unsettling to observe the enthusiasm with which nonphilosophers in cognitive science are now adopting the idea (held, for example, by Bertrand Russell), that beliefs are "propositional attitudes," in the in-

nocent assumption that any concept so popular among philosophers must be sound, agreed-upon, and well-tested. Mark Johnson's (1987) challenge to propositional or sentence-based analytic philosophy, anchored in his recognition of the cognitive importance of "embodied" imagination, is a hopeful philosophical contribution to a species-centered understanding of human experience.

29. Paul Watzlawick, Janet Beavin, and Don Jackson (1967), using computer terminology, have usefully described two kinds of communication. They say that humans communicate both digitally and analogically, and point out that digital language (verbal, semantic) is unique to humans. It is crucial to sharing information about objects and for time binding. Yet in relationship (metacommunication), we rely like other animals on analogic communication (paralinguistic, nonverbal) with such things as vocalizations, intention movements, and other indications of mood.

Certainly, paralinguistic features would make more comprehensible the following verbatim transcript of a photographer explaining what she was trying to obtain in work she was doing for the Farm Security Administration in the 1930s. But the transcript also indicates, I think, the fluid and nonsequential nature of thought as it occurs particularly for nonverbal activities such as making artistic decisions.

And I concentrated a lot on the children because they were the next generation, I think. But also it was warping them so, as it warped her body. So I felt that that picture should, should move people and should also show the conditions of how they lived, how their, their breathing must have, even of the people who weren't in the mines, how it had to be, just the air. They were so close to the mines and to the, I mean to the coal cars, and the coke ovens, that it was miserable even to, even for me. And that was before I had respiratory problems, so . . .

30. Julia Kristeva, the French feminist poststructuralist, opposes Lacan's "symbolic" with what she calls the "semiotic," or residue of the preverbal stage—relatively unorganized pulsions or drives, the bodily or material qualities of language, as well as such features as contradiction, disruption, meaninglessness, silence, and absence (Eagleton 1983). Unlike her male colleagues, Kristeva seems to recognize the importance of what I in Chapter 6 called "modal vectoral associations" from infancy and the paralinguistic elements of language.

31. For example, Jean Comaroff (1985, 124–27) describes how the worldview of the precolonial Tswana was almost entirely implicit: "Models of space-time, the phenomenal world, and the community were borne by material forms and activities explicitly directed toward practical ends—the human body, agricultural production, and the built form of the settlement." Comaroff also notes that "there would seem to be important distinctions between modes of consciousness in societies like that of the Tswana and those where generalized media have been developed for the express purpose of systematic abstraction (through writing, enumeration, and theories of knowledge) and 'rational' exchange (by means of money and models of exchange)." In the precolonial Tswana system, relationships were "multiplex" and mundane signs carried a symbolic freight that condensed plural frames of reference. Human subjects and material objects were not definitely set apart: the moral, spiritual, and physical components of the perceptible world existed in an integrated and mutually transforming relationship. Personhood was not confined in space and time to a corporeal cocoon but permeated the world through its material and spiritual extensions. Or, as

Comaroff puts it, "An individual's name, his personal effects, and his footprints in the sand bore his influence, and could be used by sorcerers wishing to attack him."

32. In this chapter, and indeed the book as a whole, it should be clear that my discussions of "art" are largely concerned with the concepts of art that form the basis of contemporary art criticism, art theory, and art discourse. It goes without saying that these concern only a small fraction of people in modern society (although the ramifications of the concepts are important), and even less in the rest of the world, all of whom have their "popular" arts and ways of making special. As Churchland (1986, 288) remarks, "the stuff in the universe keeps doing whatever it is doing while we theorize and theories come and go." Certainly, people do keep finding and responding to ways that make their experience special (whether or not they or others consider these to be "art"). One of my aims in this book has been to broaden the present debate within art theory, and hence those who are unacquainted with the issues may not recognize "art" as I often use the term. I hope that these others will still find the points that I make to be of interest and value.

33. It should also be pointed out that the main features of the social and cultural predicament that postmodernist theory is a response to—image glut, omnivorous consumerism, pluralism, the failure of authority and ideology, the interchangeability of everything, ennui and emptiness—are possible only where the literate mentality is a largely unrecognized and unexamined sine qua non of the culture.

References

Ackerman, Diane. 1990. *A natural history of the senses*. New York: Random House.

Adams, Monni. 1989. Beyond symmetry in Middle African design. *African Arts* 23, no. 1 (November): 34–43.

Albanese, Catherine L. 1990. *Nature religion in America: From the Algonkian Indians to the New Age*. Chicago: University of Chicago Press.

Alexander, Richard D. 1979. *Darwinism and human affairs*. Seattle: University of Washington Press.

———. 1987. *The biology of moral systems*. New York: Aldine de Gruyter.

———. 1989. The evolution of the human psyche. In Mellars, Paul, and Chris Stringer, eds., 455–513.

Alland, Alexander, Jr. 1977. *The artistic animal: An inquiry into the biological roots of art*. Garden City, N.Y.: Anchor.

Allen, Grant, 1877. *Physiological aesthetics*. London: Henry S. King & Co.

Allen, Paula Gunn. 1975. The sacred hoop: A contemporary perspective. In Allen, Paula Gunn, ed. *Studies in American Indian literature*, 3–22. New York: Modern Language Association of America.

Alsop, Joseph. 1982. *The rare art traditions: The history of art collecting and its linked phenomena*. New York: Harper and Row.

American Council of Learned Societies. 1989. Speaking for the humanities. New York: American Council of Learned Societies.

Anderson, Martha G., and Christine Mullen Kreamer. 1989. *Wild spirits, strong medicine: African art and the wilderness*. Seattle: University of Washington Press.

Anzieu, Didier. 1989. *The skin ego*. New Haven: Yale University Press.

Armstrong, Este. 1982. Mosaic evolution in the primate brain: Differences and similarities in the hominid thalamus. In Armstrong, Este, and Dean Falk, eds., *Primate brain evolution: Methods and concepts*, 152–53. New York: Plenum.

Arnheim, Rudolf. 1949. The Gestalt theory of expression. *Psychological Review* 56:156–71.

———. 1966. *Toward a psychology of art*. Berkeley and Los Angeles: University of California Press.

———. 1967. Wilhelm Worringer on abstraction and empathy. *Confinia Psychiatrica* 10:1. (Also in Arnheim 1986.)

———. 1969. *Visual thinking*. Berkeley and Los Angeles: University of California Press.

———. 1984. Perceptual dynamics in musical expression. *Musical Quarterly* 70 (Summer) 295–309. (Also in Arnheim 1986.)

————. 1986. *New essays on the psychology of art*. Berkeley and Los Angeles: University of California Press.

Asch, Solomon E. 1955. On the use of metaphor in the description of persons." In Werner, Heinz, ed., *On expressive language*. Worcester, Mass.: Clark University Press.

Barash, David. 1979. *The whisperings within: Evolution and the origin of human nature*. New York: Harper and Row.

Barthes, Roland. 1977. Change the object itself. In *Image—Music—Text*. Essays selected and translated by Stephen Heath, 165–69. New York: Hill and Wang.

————. 1978. *A lover's discourse: Fragments*. Translated by Richard Howard. New York: Hill and Wang. (Original work published 1977.)

•Barzun, Jacques. 1974. *The use and abuse of art*. Bollingen Series, vol. 35. Princeton: Princeton University Press.

Basso, Ellen B. 1985. *A musical view of the universe: Kalapalo myth and ritual performances*. Philadelphia: University of Pennsylvania Press.

Bateson, Gregory. 1987. Style, grace, and information in primitive art. In *Steps to an ecology of mind*. Northvale, N.J.: Jason Aronson. (Original work published 1972.)

Bauman, Zygmunt. 1987. The adventure of modernity. *Times Literary Supplement* (London), 13 February, 155.

————. 1988. Disappearing into the desert. *Times Literary Supplement* (London), 16–22 December, 1391.

Beer, C. G. 1982. Study of vertebrate communication—Its cognitive implications. In Griffin, Donald R., ed., *Animal mind—Human mind*, 251–68. New York: Springer.

Bell, Clive. 1914. *Art*. London: Chatto and Windus.

Belo, Jane, ed. 1970. *Traditional Balinese culture*. New York: Columbia University Press.

Ben-Amos, Paula. 1978. Owina N'Ido: Royal weavers of Benin. *African Arts* 11, no. 4 (July): 48–53.

Benjamin, Walter. 1970. *Illuminations*. London: Cape (Original work published 1939.)

Berenson, Bernhard. 1909. *The Florentine painters of the Renaissance*. New York: Putnam's. (Original work published 1896.)

Bergounioux, F. M. 1962. Notes on the mentality of primitive man. In Washburn, Sherwood L., ed., *Social life of early man*. London: Methuen.

Berndt, Ronald M. 1971. Some methodological considerations in the study of Australian aboriginal art. In Jopling, Carol F., ed., 99–126. (Original work published 1958.)

Bernstein, Leonard. 1976. *The unanswered question*. Cambridge: Harvard University Press.

Bever, T. G. 1983. Cerebral lateralization, cognitive asymmetry, and human consciousness. In Perecman, Ellen, ed., 19–39.

Binswanger, Ludwig. 1963. *Being-in-the-world: Selected papers*. Translated by Jacob Needleman. New York: Basic Books.

Bird, Charles. 1976. Poetry in the Mande: Its form and meaning. *Poetics* 5:89–100.

Birket-Smith, Kaj. 1959. *The Eskimos*. London: Methuen. (Original work published 1927.)

Blacking, John. 1973. *How Musical is Man?* Seattle: University of Washington Press.

Bloch, Maurice, and Jean H. Bloch. 1980. Women and the dialectics of nature in

eighteenth-century French thought. In MacCormack, Carol P., and Marilyn Strathern, eds., 25–41.

Boas, Franz. 1955. *Primitive art.* New York: Dover. (Original work published 1927.)

Bolinger, Dwight. 1986. *Intonation and its parts: Melody in spoken English.* Palo Alto: Stanford University Press.

Bonner, John Tylor. 1980. *The evolution of culture in animals.* Princeton: Princeton University Press.

Booth, Mark W. 1981. *The experience of songs.* New Haven: Yale University Press.

Bourguignon, Erika. 1972. Dreams and altered states of consciousness in anthropological research. In Hsu, Francis K. L., ed., *Psychological anthropology*, 2d ed., 403–34. Cambridge, Mass.: Schenkman.

Bowerman, Melissa. 1980. The structure and origin of semantic categories in the language-learning child. In Foster, Mary LeCron, and S. H. Brandes, eds., 277–99.

Bowra, Cecil Maurice. 1962. *Primitive song.* Cleveland: World Publishing Co.

Boyd, Robert, and Peter J. Richerson. 1985. *Culture and the evolutionary process.* Chicago: University of Chicago Press.

Briggs, Jean L. 1970. *Never in anger: Portrait of an Eskimo family.* Cambridge: Harvard University Press.

Bruner, Jerome. 1986. *Actual minds, possible worlds.* Cambridge: Harvard University Press.

Bryson, Norman. 1987. Signs of the good life. *Times Literary Supplement* (London), 27 March, 328.

Bücher, Karl. 1909. *Arbeit und Rhythmus.* Leipzig: B. G. Teubner. (Original work published 1896.)

Buck, Ross. 1986. The psychology of emotion. In Ledoux, Joseph E., and William Hirst, eds., 275–300.

Bullough, Edward. 1912. Psychical distance as a factor in art and as an aesthetic principle. *British Journal of Psychology* 18:87–118.

Burkert, Walter. 1979. *Structure and history in Greek mythology and ritual.* Berkeley and Los Angeles: University of California Press.

———. 1987. The problem of ritual killing. In Hamerton-Kelly, Robert G., ed., *Violent origins: Ritual killing and cultural formation*, 149–76. Palo Alto: Stanford University Press.

Cann, R. L., M. Stoneking, and A.C. Wilson. 1987. Mitochrondrial DNA and human evolution. *Nature* (London) 325: 31–36.

Carritt, E. F., ed. 1931. *Philosophies of beauty.* Oxford: Clarendon Press.

Chagnon, Napoleon A., and William Irons, eds. 1979. *Evolutionary biology and human social behavior: An anthropological perspective.* North Scituate, Mass.: Duxbury Press.

Chagnon, Napoleon A. 1983. *Yanomamö: The fierce people.* New York: Holt, Rinehart and Winston.

Chase, Philip G. 1989. How different was Middle Palaeolithic subsistence? A zooarchaeological perspective on the Middle to Upper Palaeolithic transition. In Mellars, Paul, and Chris Stringer, eds., 321–37.

Chatwin, Bruce, 1987. *The songlines.* New York: Viking.

Churchland, Patricia S. 1986. *Neurophilosophy: Toward a unified science of the mind-brain.* Cambridge: MIT Press.

Clifford, James. 1988. *The predicament of culture: 20th century ethnography, literature, and art.* Cambridge: Harvard University Press.

Clutton-Brock, T. H., ed. 1988. *Reproductive success.* Chicago: University of Chicago Press.

Clynes, Manfred. 1977. *Sentics: The touch of emotions.* New York: Anchor Press/ Doubleday.

Coe, Kathryn. 1990. Art, the replicable unit: Identifying the origin of art in human prehistory. Paper presented at 1989 Human Behavior and Evolution Society Annual Meeting, Los Angeles.

Cohen, L. B., and B. A. Younger. 1983. Perceptual categorization in the infant. In Scholnik, E. K., ed., *New trends in conceptual representation: Challenges to Piaget's theory?* Hillsdale, N.J.: Erlbaum.

Cohn, Robert G. 1962. The ABC's of poetry. *Comparative Literature* 14, no. 2: 187–91.

———. 1965. *Towards the poems of Mallarmé.* Berkeley and Los Angeles: University of California Press.

Comaroff, Jean. 1985. *Body of power, spirit of resistance: The culture and history of a South African people.* Chicago: University of Chicago Press.

Crimp, Douglas. 1983. On the museum's ruins. In Foster, Hal, ed., 43–56.

Croce, Benedetto. 1978. *The essence of aesthetic.* Translated by Douglas Ainslie. Darby, Pa.: Arden Library. (Original work published 1915.)

Csikszentmihalyi, Mihaly. 1975. *Beyond boredom and anxiety.* San Francisco: Jossey-Bass.

Danto, Arthur. 1964. The artworld. *Journal of Philosophy* 61 (15 October): 571–84.

———. 1981. *The transfiguration of the commonplace.* Cambridge: Harvard University Press.

———. 1986. *The philosophical disenfranchisement of art.* New York: Columbia University Press.

d'Azevedo, Warren L., ed. 1973. *The traditional artist in African societies.* Bloomington: Indiana University Press.

Deacon, H. J. 1989. Late Pleistocene palaeontology and archaeology in the Southern Cape, South Africa. In Mellars, Paul, and Chris Stringer, eds., 547–64.

Degler, Carl N. 1991. *In search of human nature: The decline and revival of Darwinism in American social thought.* New York: Oxford University Press.

Deng, Francis M. 1973. *The Dinka and their songs.* Oxford: Clarendon.

Dennett, Daniel C. 1987. *The intentional stance.* Cambridge: MIT Press.

Derrida, Jacques. 1976. *Of grammatology.* Translated by Gayatri Chakravorty Spivak. Baltimore: Johns Hopkins University Press. (Original work published 1967.)

Devlin, Judith. 1987. *The superstitious mind: French peasants and the supernatural in the nineteenth century.* New Haven: Yale University Press.

Dickie, George. 1969. Defining art. *American Philosophical Quarterly* 6: 253–56.

———. 1974. *Art and the aesthetic: An institutional analysis.* Ithaca: Cornell University Press.

Didion, Joan. 1988. Insider baseball. *New York Review of Books,* 27 October, 19–30.

Dissanayake, Ellen. 1988. *What is art for?* Seattle: University of Washington Press.

———. 1990. Of transcribing and superliteracy. *The World & I.,* October, 575–87.

Dodds, E. R. 1973. *The Greeks and the irrational.* Berkeley and Los Angeles: University of California Press. (Original work published 1951.)

Douglas, Mary. 1966. *Purity and danger: An analysis of concepts of pollution and taboo.* London: Routledge and Kegan Paul.

Drewal, Henry John, and Margaret Thompson Drewal. 1983. *Gèlèdé: Art and female power among the Yoruba.* Bloomington: University of Indiana Press.

Dumont, Louis. 1980. *Homo hierarchicus: The caste system and its implications.* Chicago: University of Chicago Press.

Durkheim, Emile. 1964. The dualism of human nature and its social conditions. In *Essays on sociology and philosophy by Emile Durkheim et al.*, 325–40. Edited by Kurt H. Wolff. Translated by Charles Blend. New York: Harper and Row. (Original work published 1914.)

————. 1965. *Elementary forms of the religious life.* Translated by Joseph Waïd Swain. New York: Free Press. (Original work published 1912.)

Eagleton, Terry. 1983. *Literary theory: An introduction.* Minneapolis: University of Minnesota Press.

————. 1987. Awakening from modernity. *Times Literary Supplement* (London), 20 February, 194.

————. 1990. *The ideology of the aesthetic.* Cambridge, Mass.: Basil Blackwell.

Eibl-Eibesfeldt, I. 1989a. *Human ethology.* Translated by Pauline Wiessner-Larsen and Anette Heunemann. New York: Aldine de Gruyter.

————. 1989b. The biological foundation of aesthetics. In Rentschler, I., B. Herzberger, and D. Epstein, eds., *Beauty and the brain: Biological aspects of aesthetics,* 29–68. Basel, Switzerland: Birkhauser.

Eisler, Riane. 1988. *The chalice and the blade.* New York: Harper and Row.

Ekman, Paul, Wallace V. Friesen, and Phoebe Ellsworth. 1972. *Emotion in the human face: Guidelines for research and an integration of findings.* New York: Pergamon Press.

Eliade, Mircea. 1964. *Shamanism: Archaic techniques of ecstasy.* New York: Bollingen Foundation.

Elias, Norbert. 1978. *The civilizing process.* New York: Urizen. (Original work published 1939.)

Eliot, T. S. 1980. Hamlet. In *Selected essays,* 121–26. New York: Harcourt Brace. (Original work published 1919.)

Emde, Robert N. 1984. Levels of meaning for infant emotions: A biosocial view. In Scherer, Klaus, and Paul Ekman, 77–107.

Engels, Friedrich. 1972. *The origin of the family, private property, and the state.* New York: International Publishers. (Original work published 1884.)

Faris, James C. 1972. *Nuba personal art.* Toronto: University of Toronto Press.

Feld, Steven. 1982. *Sound and sentiment: Birds, weeping, poetics, and song in Kaluli expression.* Philadelphia: University of Pennsylvania Press.

Fernandez, James W. 1969. *Microcosmogony and modernization in African religious movements.* Occasional Paper Series no. 3. Montreal: Centre for Developing Area Studies, McGill University.

————. 1973. The exposition and imposition of order: Artistic expression in Fang culture. In d'Azevedo, Warren L., ed., 194–220.

Festinger, Leon. 1983. *The human legacy.* New York: Columbia University Press.

Finnegan, Ruth. 1977. *Oral poetry: Its nature, significance, and social context.* Cambridge: Cambridge University Press.

Fish, Stanley. 1980. *Is there a text in this class?: The authority of interpretive communities.* Cambridge: Harvard University Press.

Fitch-West, Joyce. 1983. Heightening visual imagery: A new approach to aphasia therapy. In Perecman, Ellen, ed., 215–28.

Flam, Jack. 1986. *Matisse: The man and his art, 1869–1918*. London: Thames and Hudson.

Forge, Anthony, ed. 1973. *Primitive art and society*. London: Oxford University Press.

Fortune, R. F. 1963. *Sorcerers of Dobu*. London: Routledge and Kegan Paul. (Original work published 1932.)

Foster, Hal. 1983. *The anti-aesthetic: Essays on postmodern culture*. Port Townsend, Wash.: Bay Press.

Foster, Mary LeCron. 1978. The symbolic structure of primordial language. In Washburn, Sherwood L., and Elizabeth R. McCown, eds., 77–121.

———. 1980. The growth of symbolism in culture. In Foster, Mary LeCron, and S. H. Brandes, eds., 371–97.

Foster, Mary LeCron, and S. H. Brandes, eds. 1980. *Symbol as sense: New approaches to the analysis of meaning*. New York: Academic Press.

Fox, Robin. 1989. *The search for society: Quest for a biosocial science and morality*. New Brunswick, N.J.: Rutgers University Press.

France, Peter. 1989. The remedy in the ill. *Times Literary Supplement*, (London), 14–20 July, 769.

Freedman, Daniel G. 1979. *Human sociobiology: A holistic approach*. New York: Free Press.

Freuchen, Peter. 1961. *Book of the Eskimos*. London: Arthur Barker.

Freud, Sigmund. 1939. *Civilization and Its Discontents*. Translated by Joan Riviere. London: Hogarth Press.

———. 1953. *Three essays on the theory of sexuality*. In Strachey, James, ed. and trans., *The standard edition of the complete psychological works of Sigmund Freud*, 7: 135–231. London: Hogarth Press. (Original work published 1905.)

———. 1955. *Group psychology and the analysis of the ego*. In Strachey, James, ed. and trans., *The standard edition of the complete psychological works of Sigmund Freud*, 18: 65–143. London: Hogarth Press. (Original work published 1921.)

———. 1955. *Totem and taboo*. In Strachey, James, ed. and trans., *The standard edition of the complete psychological works of Sigmund Freud*, 13: 1–162. London: Hogarth Press. (Original work published 1913.)

———. 1959. Obsessive acts and religious practices. In Strachey, James, ed. and trans., *The standard edition of the complete psychological works of Sigmund Freud*, 9: 117–27. (Original work published 1907.)

———. 1959. The relation of the poet to daydreaming. Translated under the supervision of Joan Riviere. In *Collected Papers*, 4: 173–83. New York: Basic Books.

———. 1960. *Jokes and their relation to the unconscious*. Strachey, James, ed. and trans., *The standard edition of the complete psychological works of Sigmund Freud*, 8. (Original work published 1905.)

Frost, Robert. 1973. *Robert Frost on writing*. Compiled by Barry, Elaine. New Brunswick, N.J.: Rutgers University Press.

Fry, Roger. 1925. *Vision and design*. London: Chatto and Windus.

Fuller, Peter. 1980. *Art and psychoanalysis*. London: Writers and Readers Publishing Cooperative.

———. 1983. Art and biology. In *The naked artist*, 2–19. London: Writers and Readers Publishing Cooperative.

Gardner, Howard. 1973. *The arts and humandevelopment*. New York: John Wiley and Sons.

———. 1983. *Frames of mind: The theory of multiple intelligences*. New York: Basic Books.

Gardner, H., E. Winner, R. Bechhofer, and D. Wolf. 1978. The development of figurative language. In Nelson, Katherine, ed., *Children's language*, New York: Gardner Press.

Gazzaniga, Michael S. 1985. *The social brain*. New York: Basic Books.

Geertz, Clifford. 1988. *Works and lives: The anthropologist as author*. Palo Alto: Stanford University Press.

Geist, Valerius. 1978. *Life strategies, human evolution, environmental design*. New York: Springer.

Gell, Alfred. 1975. *Metamorphosis of the Cassowaries*. London: Athlone.

Gibson, James J. 1979. *The ecological approach to visual perception*. Boston: Houghton Mifflin.

Gillison, Gillian. 1980. Images of nature in Gimi thought. In MacCormack, Carol P., and Marilyn Strathern, eds., 143–173.

Glaze, Anita J. 1981. *Art and death in a Senufo village*. Bloomington: Indiana University Press.

Goehr, Lydia. 1989. Being true to the work. *Journal of Aesthetics and Art Criticism* 47, no 1: 55–67.

Goodman, Nelson. 1968. *Languages of art*. Indianapolis, Ind.: Hackett.

———. 1978. *Ways of worldmaking*. Indianapolis, Ind.: Hackett.

Goody, Jack. 1987. *The interface between the written and the oral*. Cambridge: Harvard University Press.

Gould, S. J., and R. C. Lewontin. 1979. The spandrels of San Marco and the panglossian paradigm: A critique of the adaptationist program." *Proceedings of the Royal Society* (London), Series B, 205:581–98.

Griaule, Marcel. 1965. *Conversations with Ogotemmeli: An introduction to Dogon religious ideas*. Oxford: Oxford University Press.

Grieser, DiAnne, and Patricia K. Kuhl. 1989. Categorization of speech by infants: Support for speech-sound prototypes. *Developmental Psychology* 25: 577–88.

Griffin, Donald R. 1981. *The question of animal awareness*. 2d ed. New York: Rockefeller University Press.

Groos, Karl. 1901. *The play of man*. New York: Appleton. (Original work published 1899.)

Habermas, Jürgen. 1989. *Jürgen Habermas on Society and Politics: A Reader*. Edited by Steven Seidmann. Boston: Beacon Press.

Hall, Edith. 1990. *Inventing the barbarian: Greek self-definition through tragedy*. Oxford: Clarendon Press.

Hall-Craggs, Joan. 1969. The aesthetic content of bird song. In Hinde, Robert A., ed., *Bird vocalizations*, 367–81. Cambridge: Cambridge University Press.

Hanna, Judith Lynne. 1979. *To dance is human: A theory of non-verbal communication*. Austin: University of Texas Press.

Harris, Marvin. 1989. *Our kind: Who we are, where we came from, where we are going*. New York: Harper and Row.

Harrison, Jane Ellen. 1913. *Ancient art and ritual*. New York: Henry Holt.

Harrold, Francis B. 1989. Mousterian, Châtelperronian, and Early Aurignacian in West-

ern Europe: Continuity or discontinuity? In Mellars, Paul, and Chris Stringer, eds., 677–713.

Harvey, David. 1989. *The condition of postmodernity: An enquiry into the origins of cultural change.* Oxford: Basil Blackwell.

Hayden, Brian. 1990. The right rub: Hide working in high-ranking households. In Graslund, B., ed., *The interpretative possibilities of microwear studies,* 89–102. Uppsala, Sweden: Societas Archaeologica Upsaliensis.

Hayden, Brian, and Eugene Bonifay. 1991. *The Neanderthal nadir.* (Unpublished manuscript.)

Hegel, G. W. F. 1920. *The philosophy of fine art.* Translated by F. P. B. Osmaston. London: G. Bell & Sons. (Original work published 1835.)

Helm-Estabrooks, Nancy. 1983. Exploiting the right hemisphere for language rehabilitation: Melodic intonation therapy. In Perecman, Ellen, ed., 229–40.

Hinde, Robert A. 1974. *Biological bases of human social behavior.* New York: McGraw Hill.

Hobbes, Thomas. 1981. *Leviathan.* Edited with an introduction by C. B. Macpherson. New York: Penguin. (Original work published 1651.)

Hoffman, James E. 1986. A psychological view of the neurobiology of perception. In Ledoux, Joseph E., and William Hirst, eds., 91–100.

Huizinga, Johan. 1949. *Homo ludens.* Translated by R. F. C. Hull. London: Routledge and Kegan Paul.

Huxley, Julian, ed. 1966. *A discussion on ritualization of behaviour in animals and man.* Philosophical Transactions of the Royal Society of London. Series B: Biological Sciences, 251: 247–526. December.

Jakobson, Roman. 1962. *Selected Writings: Vol. 1. Phonological Studies.* The Hague: Mouton and Co.

Jakobson, Roman, and Linda Waugh. 1979. *The sound shape of language.* Bloomington: Indiana University Press.

Jameson, Fredric. 1983. Postmodernism and consumer society. In Foster, Hal, ed., 111–25.

Jesperson, Otto. 1922. *Language: Its nature, development, and origin.* London: Allen and Unwin.

Johnson, Mark. 1987. *The body in the mind: The bodily basis of meaning, imagination, and reason.* Chicago: University of Chicago Press.

Jopling, Carol F., ed. 1971. *Art and aesthetics in primitive societies.* New York: Dutton.

Joseph, Marietta B. 1978. West African indigo cloth. *African Arts* 11, no. 2, (January): 34–37.

Joyce, Robert. 1975. *The esthetic animal: Man, the art-created art creator.* Hicksville, N.Y.: Exposition Press.

Jungnickel, Christa, and Russell McCormmach. 1986. *Intellectual mastery of nature.* Chicago: University of Chicago Press.

Kapferer, Bruce. 1983. *A celebration of demons: Exorcism and the aesthetics of healing in Sri Lanka.* Bloomington: University of Indiana Press.

Kaplan, Stephen. 1978. Attention and fascination: The search for cognitive clarity. In Kaplan, Stephen, and Rachel Kaplan, eds., *Humanscape: Environments for people,* 84–90. North Scituate, Mass.: Duxbury Press.

Katz, Richard. 1982. *Boiling energy: Community healing among the Kalahari Kung.* Cambridge: Harvard University Press.

Keil, Charles. 1979. *Tiv song*. Chicago: University of Chicago Press.

Kellogg, Rhoda. 1970. *Analyzing children's art*. Palo Alto, Calif.: Mayfield.

Kivy, Peter. 1990. *Sound sentiment: An essay on the musical emotions*. Philadelphia: Temple University Press.

Klein, Richard G. 1989. *The human career: Human biological and cultural origins*. Chicago: University of Chicago Press.

Klima, Edward S., and Ursula Bellugi. 1983. Poetry without sound. In Rothenberg, Jerome, and Diane Rothenberg, eds., 291–302.

Konner, Melvin. 1982. *The tangled wing: Biological constraints on the human spirit*. New York: Holt, Rinehart and Winston.

Kramer, Edith. 1979. *Childhood and art therapy*. New York: Schocken.

Kramer, Hilton. 1988. Art now and its critics. Lecture presented at New School for Social Research, New York, 1 November.

Kubik, Gerhard. 1977. Patterns of body movement in the music of boys' initiation in south-east Angola. In Blacking, John, ed., *The anthropology of the body*, 253–74. New York: Academic Press.

Lakoff, George, and Mark Johnson. 1980. *Metaphors we live by*. Chicago: University of Chicago Press.

Lame Deer [John Fire] and Richard Erdoes. 1972. *Lame Deer, seeker of visions: The life of a Sioux medicine man*. New York: Simon and Schuster.

Lamp, Frederick. 1985. Cosmos, cosmetics, and the spirit of Bondo. *African Arts* 18, no. 3 (May): 28–43.

Langer, Susanne. 1953. *Feeling and form*. New York: Charles Scribner's Sons.

———. 1967. *Mind: An essay on human feeling*. Baltimore: Johns Hopkins University Press.

———. 1976. *Philosophy in a new key*. Cambridge: Harvard University Press. (Original work published 1942.)

Langlois, Judith H., and Lori A. Roggman. 1990. Attractive faces are only average. *Psychological Science* 1, no. 2 (March): 115–21.

Laski, Marghanita. 1961. *Ecstasy: A study of some secular and religious experiences*. London: Cresset.

Laughlin, Charles D., Jr., and John McManus. 1979. Mammalian ritual. In d'Aquili, Eugene G., C. D. Laughlin, Jr., and John McManus, eds. *The spectrum of ritual: A biogenetic structural analysis*, 80–116. New York: Columbia University Press.

Lawick-Goodall, Jane van. 1975. The chimpanzee. In Goodall, Vanne, ed., *The quest for man*, 131–69. London: Phaidon.

LeDoux, Joseph E. 1986. The neurobiology of emotion. In LeDoux, Joseph E., and William Hirst, eds., 301–54.

LeDoux, Joseph E., and William Hirst, eds. 1986. *Mind and brain: Dialogues in cognitive neuroscience*. New York: Cambridge University Press.

Lee, Vernon [Violet Paget]. 1909. *Laurus nobilis: Chapters on art and life*. London and New York: Lane.

———. 1913. *The beautiful*. Cambridge: Cambridge University Press.

Leslie, Charles, ed. 1960. *Anthropology of folk religion*. New York: Vintage.

Leventhal, Howard. 1984. A perceptual motor theory of emotion. In Scherer, Klaus, and Paul Ekman, eds., 271–91.

Lévi-Strauss, Claude. 1963. *Structural anthropology*. Translated by Claire Jacobson and

Brooke Grundfest Schoepf. New York: Basic Books. (Original work published 1958.)

———. 1964–68. *Mythologiques*. 3 vols. Paris: Plon.

Levy, Jerre. 1982. Mental processes in the nonverbal hemisphere. In Griffin, Donald R., ed., *Animal mind—Human mind*, 57–74. New York: Springer.

Lichtenberg, Joseph, Melvin Bornstein, and Donald Silver, eds. 1984. *Empathy*. 2 vols. Hillsdale, N.J.: Erlbaum.

Lieberman, Philip. 1984. *The biology and evolution of language*. Cambridge: Harvard University Press.

Lienhardt, Godfrey. 1961. *Divinity and experience: The religion of the Dinka*. Oxford: Clarendon Press.

Lippard, Lucy. 1983. *Overlay: Contemporary art and the art of prehistory*. New York: Pantheon.

Lipps, Theodor. 1897. *Raumaesthetik und geometrische-optische Täuschungen*. Leipzig, Germany: J. A. Barth.

———. 1900. Aesthetische Einfühlung. *Zeitschrift für Psychologie* 22: 415–50.

———. 1903. Einfühlung, innere Nachahmung. *Archiv für die gesamte Psychologie*, vol. 1.

———. 1903–6. *Ästhetik: Psychologie des Schönen und der Kunst*. Hamburg, Germany: L. Voss.

Lloyd, G. E. R. 1979. *Magic, reason, and experience*. Cambridge: Cambridge University Press.

Lomax, Alan, ed. 1968. *Folk song style and culture*. American Association for the Advancement of Science Publication no. 88. Washington, D.C.: AAAS.

Lopreato, Joseph. 1984. *Human nature and biocultural evolution*. Boston: Allen and Unwin.

Lorca, Federico Garcia. 1955. The *duende*: Theory and development. In *Poet in New York*, 154–66. Translated by Ben Belitt. New York: Grove Press.

Lord, Albert B. 1960. *The singer of tales*. Cambridge: Harvard University Press.

Low, Bobbi S. 1979. Sexual selection and human ornamentation. In Chagnon, Napoleon A., and William Irons, eds., 462–87.

Lowenfeld, Victor. 1939. *The nature of creative activity*. London: Kegan Paul, Trench, Trubner and Co.

Lumsden, Charles J., and Edward O. Wilson. 1981. *Genes, mind, and culture: The co-evolutionary process*. Cambridge: Harvard University Press.

———. 1983. *Promethean fire: Reflections on the origin of mind*. Cambridge: Harvard University Press.

Lutz, Catherine A. 1988. *Unnatural emotions: Everyday sentiments on a Micronesian atoll and their challenge to Western theory*. Chicago: University of Chicago Press.

McCorduck, Pamela. 1991. *AARON's code: Meta-art, artificial intelligence, and the work of Harold Cohen*. New York: W. H. Freeman.

MacCormack, Carol P. 1980. Nature, culture, and gender: A critique. In MacCormack, Carol, P., and Marilyn Strathern, eds., 1–24.

MacCormack, Carol P., and Marilyn Strathern, eds. 1980. *Nature, culture, and gender*. Cambridge: Cambridge University Press.

Macksey, Richard, and Eugenio Donato. 1970. *The languages of criticism and the sciences of man*. Baltimore: Johns Hopkins University Press.

MacLean, Paul D. 1978. The evolution of three mentalities. In Washburn, Sherwood L., and Elizabeth R. McCown, eds., 33–57.

Maddock, Kenneth, 1973. *The Australian aborigines: A portrait of their society*. London: Allen Lane.

Malinowski, Bronislaw. 1922. *Argonauts of the Western Pacific*. London: Routledge and Kegan Paul.

———. 1935. *Coral gardens and their magic*. 2 vols. London: Allen and Unwin.

———. 1944. *A scientific theory of culture*. Chapel Hill: University of North Carolina Press.

———. 1948. *Magic, science, and religion*. Boston: Beacon Press.

Mallarmé, Stéphane. 1956. "Ballets." In Cook, Bradford, trans., *Mallarmé: Selected prose poems, essays, and letters*. Baltimore: Johns Hopkins University Press. (Original work published 1886.)

Mandel, David. 1967. *Changing art, changing man*. New York: Horizon Press.

Maquet, Jacques. 1986. *The aesthetic experience: An anthropologist looks at the visual arts*. New Haven: Yale University Press.

Marcuse, Herbert. 1968. *One-dimensional man*. London: Sphere Books.

———. 1972. *Counterrevolution and revolt*. Boston: Beacon Press.

Martin, John. 1965. *Introduction to the dance*. Brooklyn, N.Y.: Dance Horizons.

Maxwell, Mary. 1984. *Human evolution: A philosophical anthropology*. New York: Columbia University Press.

Mayr, Ernst. 1983. How to carry out the adaptationist program. *American Naturalist* 221: 324–34.

Mead, Margaret. 1970. Children and ritual in Bali. In Belo, Jane, ed., 198–211.

———. 1976. *Growing up in New Guinea*. New York: Morrow. (Original work published 1930.)

Mellars, Paul, and Chris Stringer, eds. 1989. *The human revolution: Behavioral and biological perspectives on the origins of modern humans*. Princeton: Princeton University Press.

Merriam, Alan, 1964. *The anthropology of music*. Evanston, Ill.: Northwestern University Press.

Meyer, Leonard B. 1956. *Emotion and meaning in music*. Chicago: Phoenix Books.

Midgley, Mary. 1979. *Beast and man: The roots of human nature*. London: Harvester.

Miller, Christopher, ed. 1988. Selections from the symposium on "Literacy, Reading, and Power." Whitney Humanities Center, November 14, 1984. *Yale Journal of Criticism* 2:1.

Miller, J. Hillis. 1987. But are things as we think they are? *Times Literary Supplement* (London), 9–15 October, 1104–5.

Montaigne, Michel de. 1946. "Of Cannibals." In *The essays of Montaigne*, 173–84. Translated by Charles Cotton–William Hazlitt. New York: Modern Library. (Original work published 1579).

Morris. Desmond. 1962. *The biology of art*. New York: Knopf.

———. 1967. *The naked ape*. New York: McGraw Hill.

———. 1985. *The art of ancient Cyprus*. Oxford: Phaidon.

———. 1987. *The secret surrealist: The paintings of Desmond Morris*. Oxford: Phaidon.

Munn, Nancy. 1973. The spatial presentation of cosmic order in Walbiri iconography. In Forge, Anthony, ed., 193–220.

————. 1986. *Walbiri iconography: Graphic representation and cultural symbolism in a Central Australian society.* Chicago: University of Chicago Press.

Munro, Eleanor. 1979. *Originals: American women artists.* New York: Simon & Schuster.

Murray, Oswyn. 1989. The word is mightier than the pen. *Times Literary Supplement* (London), 16–22 June, 655.

Myerhoff, Barbara G. 1978. Return to Wirikuta: Ritual reversal and symbolic continuity in the Huichol peyote hunt. In Babcock, Barbara A., ed., *The reversible world: Symbolic inversion in art and society,* 225–39. Ithaca: Cornell University Press.

Nabokov, Vladimir. 1966. *Speak, memory: An autobiography revisited.* New York: Putnam.

Ngugi wa Thiong'o. 1986. *Decolonising the mind: The politics of language in African literature.* London: James Curry.

Nietzsche, Friedrich. 1967. *The Birth of Tragedy.* Translated by Walter Kaufmann. New York: Vintage Books. (Original work published 1872.)

Obeyesekere, Gananath. 1981. *Medusa's hair.* Chicago: University of Chicago Press.

O'Hanlon, Michael. 1989. *Reading the skin: Adornment, display, and society among the Wahgi.* London: British Museum Publications.

Olson, David R., and Ellen Bialystock. 1983. *Spatial cognition: The structure and development of mental representations of spatial relations.* Hillsdale, N.J.: Erlbaum.

Papineau, David. 1987. *Reality and representation.* Oxford: Basil Blackwell.

Papoušek, Mechthild, and Hanuš Papoušek. 1981. Musical elements in the infant's vocalization: Their significance for communication, cognition, and creativity. In Lipsitt, Lewis P., and Carolyn K. Rovée-Collier, eds., *Advances in infancy research,* 1:163–224. Norwood, N.J.: Ablex.

Pareto, Vilfredo. 1935. *The mind and society: A treatise on general sociology.* Translated by Andrew Bongiorno and Arthur Livingstone. New York: Harcourt, Brace. (Original work published 1916.)

Parmentier, Richard J. 1987. *The sacred remains: Myth, history, and polity in Belau.* Chicago: University of Chicago Press.

Parry, Milman. 1971. *The making of Homeric verse.* Oxford: Clarendon Press.

Paul, Robert A. 1982. *The Tibetan symbolic world.* Chicago: University of Chicago Press.

Peabody, Berkley. 1975. *The winged word: A study in the technique of ancient Greek oral composition as seen principally through Hesiod's "Works and Days."* Albany: State University of New York Press.

Peckover, William C., and L. W.C. Filewood. 1976. *Birds of New Guinea and tropical Australia.* Sydney: A. H. and A. W. Reed.

Perecman, Ellen, ed. 1983. *Cognitive processing in the right hemisphere.* New York: Academic Press.

Pfeiffer, John E. 1982. *The creative explosion.* New York: Harper and Row.

Pickford, R. W. 1972. *Psychology and visual aesthetics.* London: Hutchinson Educational.

Premack, David. 1975. On the origins of language. In Gazzaniga, Michael S., and Colin Blakemore, eds., *Handbook of psychobiology,* 591–605. New York: Academic Press.

Price, Sally. 1989. *Primitive art in civilized places.* Chicago: University of Chicago Press.

Price, Sally, and Richard Price. 1980. *Afro-American arts of the Suriname rain forest.* Berkeley and Los Angeles: University of California Press.

Quinn, P. C., and P. D. Eimas. 1986. On categorization in early infancy. *Merrill Palmer Quarterly* 32: 331–63.

Radcliffe-Brown, A. R. 1948. *The Andaman Islanders.* Glencoe, Ill.: Free Press. (Original work published 1922.)

Rappaport, Roy A. 1984. *Pigs for the ancestors.* New Haven: Yale University Press.

Reed, Gail S. 1984. The antithetical meaning of the term "empathy" in psychoanalytic discourse. In Lichtenberg, Joseph, Melvin Bornstein, and Donald Silver, eds., 1:7–24.

Reichel-Dolmatoff, Gerardo. 1978. *Beyond the Milky Way: Hallucinatory imagery of the Tukano Indians.* Los Angeles: UCLA Latin American Center Publications.

Reynolds, Peter C. 1981. *On the evolution of human behavior.* Berkeley and Los Angeles: University of California Press.

Riefenstahl, Leni. 1976. *People of Kau.* London: Collins.

Rieff, Philip. 1966. *The triumph of the therapeutic: Uses of faith after Freud.* London: Chatto and Windus.

Riesman, Paul. 1977. *Freedom in Fulani social life: An introspective ethnography.* Chicago: University of Chicago Press.

Rosch, Eleanor. 1978. Principles of category formation. In Rosch, Eleanor, and Barbara B. Lloyd, eds., *Cognition and categorization,* 27–48. Hillsdale, N.J.: Erlbaum.

Rosenthal, Mark. 1988. *Jasper Johns: Work since 1974.* Philadelphia Museum of Art.

Rothenberg, Jerome, ed. 1985. *Technicians of the sacred: A range of poetics from Africa, America, Asia, Europe, and Oceania.* 2d ed. Berkeley and Los Angeles: University of California Press.

Rothenberg, Jerome, and Diane Rothenberg, eds. 1983. *Symposium of the whole: a range of discourse toward an ethnopoetics.* Berkeley and Los Angeles: University of California Press.

Rouch, Jean, and Germaine Dieterlen. 1969. *Sigui 1969: La Caverne de Bongo.* (film.)

Rousseau, Jean-Jacques. 1984. *A discourse on inequality.* Translated by Maurice Cranston. New York: Penguin Books. (Original work published 1755.)

Rubin, Arnold. 1989. *Art as technology.* Beverly Hills, Calif.: Hillcrest Press.

Ruse, Michael. 1982. *Darwinism defended: A guide to the evolution controversies.* Reading, Mass.: Addison-Wesley.

Rycroft, David. 1960. Melodic features in Zulu eulogistic recitation. *African Language Studies* 1: 60–78.

Sachs, Curt. 1977. *The wellsprings of music.* New York: Da Capo. (Original work published 1962.)

Sacks, Oliver. 1990. Neurology and the soul. *New York Review of Books,* 22 November, 44–50.

Sahlins, Marshall. 1976. Colors and cultures. *Semiotica* 16: 1–22.

Sahlins, Marshall, and Elman R. Service, eds. 1960. *Evolution and culture.* Ann Arbor: University of Michigan Press.

Saitoti, Tepilit Ole. 1986. *The worlds of a Maasai warrior: An autobiography.* Berkeley and Los Angeles: University of California Press.

Santayana, George. 1955. *The sense of beauty.* New York: Modern Library. (Original work published 1896.)

Saussure, Ferdinand de. 1966. *Course in general linguistics.* Edited by Charles Bally and

Albert Sechehaye in collaboration with Albert Riedlinger. Translated by Wade Baskin. New York: McGraw Hill. (Original work published 1915.)

Scharfstein, Ben-Ami. 1988. *Of birds, beasts, and other artists: An essay on the universality of art.* New York: New York University Press.

Schechner, Richard, 1985. *Between theater and anthropology.* Philadelphia: University of Pennsylvania Press.

Scherer, Klaus, and Paul Ekman, eds. 1984. *Approaches to emotion.* Hillsdale, N.J.: Erlbaum.

Schiller, Friedrich, 1967. Fourteenth Letter. In *Letters on the aesthetic education of man.* Edited by Wilkinson, E. H., and L. A. Willoughby. Oxford: Oxford University Press. (Original work published 1795.)

Scott, Geoffrey. 1924. *The architecture of humanism: A study in the history of taste.* 2d ed. London: Constable. (Original work published 1914.)

Searle, John. 1983. *Intentionality.* Cambridge: Cambridge University Press.

Shea, John J. 1989. A functional study of the lithic industries associated with hominid fossils in the Kebara and Qafzeh caves, Israel. In Mellars, Paul, and Chris Stringer, eds., 611–25.

Shils, Edwin. 1966. Ritual and crisis. In Huxley, Julian, ed., 447–50.

Simon, Herbert A. 1990. A mechanism for social selection and successful altruism. *Science* 250 (21 December): 1665–68.

Sparshott, Francis. 1988. *Off the ground: First steps to a philosophical consideration of the dance.* Princeton: Princeton University Press.

Spector, Jack J. 1973. *The aesthetics of Freud.* New York: Praeger.

Spencer, Herbert. 1928. On the origin and function of music. In *Essays on education,* 310–330. London: Dent. (Original work published 1857.)

———. 1880–82. The aesthetic sentiments. In *Principles of psychology,* 2:2. London: Williams and Norgate.

Sperry, R. W., E. Zaidel, and D. Zaidel. 1979. Self recognition and social awareness in the deconnected minor hemisphere. *Neuropsychologia* 17: 153–66.

Spivak, Gayatri C. 1976. Preface. In Derrida, Jacques, *Of grammatology.* Baltimore: Johns Hopkins University Press.

Stanford, W. B. 1983. *Greek tragedy and the emotions: An introductory study.* London: Routledge and Kegan Paul.

Starobinski, Jean. 1989. *Le Remède dans le mal: Critique et légitimation de l'artifice à l'âge des Lumières.* Paris: Gallimard.

Stern, Daniel N. 1985. *The interpersonal world of the infant: A view from psychoanalysis and developmental psychology.* New York: Basic Books.

Stevens, Anthony. 1983. *Archetypes: A natural history of the self.* New York: Quill.

Steward, Julian. 1955. *Theory of culture change: The methodology of multilinear evolution.* Urbana: University of Illinois Press.

Stokes, Adrian. 1978. *The critical writings of Adrian Stokes.* 3 vols. London: Thames and Hudson.

Strathern, Andrew, and Marilyn Strathern. 1971. *Self decoration in Mount Hagen.* Toronto: University of Toronto Press.

Strathern, Marilyn. 1980. No nature, no culture: The Hagen case. In MacCormack, Carol, and Marilyn Strathern, eds., 174–222.

Strehlow, T. G. H. 1964. The art of circle, line, and square. In Berndt, R. M., ed., *Australian aboriginal art,* 44–59. New York: Macmillan.

————. 1971. *Songs of Central Australia.* Sydney: Angus and Robertson.

Strunk, Oliver, 1950. *Source readings in music history.* New York: Norton.

Stuart, James, comp. 1968. *Izibongo: Zulu praise poems.* Oxford: Clarendon Press.

Suliteanu, Ghizela. 1979. The role of songs for children in the formation of musical perception. In Blacking, John, and Joann W. Kealiinokonoku, eds., *The perform-ing arts: Music and dance,* 205–19. The Hague: Mouton.

Sutton, Peter, ed. 1988. *Dreamings: The art of aboriginal Australia.* New York: Braziller.

Tallis, Raymond. 1988. *Not Saussure: A critique of post-Saussurean literary theory.* London: Macmillan.

Thompson, Laura. 1945. Logico-aesthetic integration in Hopi culture. *American An-thropologist* 47:540–53.

Thompson, Robert Faris. 1974. *African art in motion.* Berkeley and Los Angeles: University of California Press.

Thorpe, W. H. 1966. Ritualization in ontogeny: 2. Ritualization in the individual de-velopment of bird song. In Huxley, Julian, ed., 351–58.

Tiger, Lionel, and Robin Fox. 1971. *The imperial animal.* New York: Holt, Rinehart and Winston.

Timpanaro, Sebastiano. 1980. *On materialism.* Translated by Lawrence Garner. London: Verso.

Tinbergen, Niko. 1972. Functional ethology and the human sciences. In *The animal in its world: Explorations of an ethologist,* 2: 200–231. Cambridge: Harvard University Press.

Todd, Emmanuel, 1987. *The causes of progress: Culture, authority, and change.* New York: Blackwell.

Tomkins, Silvan S. 1962. *Affect, imagery, consciousness.* New York: Springer.

————. 1980. Affect as amplification: Some modifications in theory. In Plutchik, Robert, and H. Kellerman, eds. *Emotion: Theory, research, and experience,* 1:141–64. New York: Academic Press.

————. 1984. "Affect theory. In Scherer, Klaus, and Paul Ekman, eds., 163–95.

Tonkinson, Robert. 1978. *The Mardudjara aborigines: Living the dream in Australia's desert.* New York: Holt, Rinehart and Winston.

Tooby, John, and Leda Cosmides. 1990. The past explains the present: Emotional adaptations and the structure of ancestral environments. *Ethology and Sociobiol-ogy* 2, nos. 4–5: 375–424.

Torgovnick, Marianna. 1990. *Gone primitive: Savage intellects, modern lives.* Chicago: University of Chicago Press.

Townshend, Charles. 1988. Recent, rational, and relative. *Times Literary Supplement,* (London), 8–14 January, 41.

Treisman, Anne. 1986. Features and objects in visual processing. *Scientific American,* November, 114B–125.

Trevarthen, Colwyn. 1984. Emotions in infancy: Regulators of contact and relationships with persons. In Scherer, Klaus, and Paul Ekman, eds., 129–57.

————. ed. 1990. *Brain circuits and functions of the mind.* Cambridge: Cambridge University Press.

Turnbull, Colin M. 1961. *The forest people.* London: Chatto and Windus.

Turner, Victor. 1967. *The forest of symbols: Aspects of Ndembu ritual.* Ithaca: Cornell University Press.

————. 1969. *The ritual process: Structure and anti-structure.* London: Routledge and Kegan Paul.

————. 1974. *Dramas, fields, and metaphors: Symbolic action in human society.* Ithaca: Cornell University Press.

————. 1983. Body, brain, and culture. *Zygon* 18 (September), 221–45.

Van Gennep, Arnold. 1960. *The rites of passage.* London: Routledge and Kegan Paul. (Original work published 1908.)

Varnedoe, Kirk. 1984. Gauguin; Abstract expressionism; Contemporary explorations. In Rubin, William, ed. *Primitivism in 20th Century Art,* 1: 179–209; 2: 615–59; 661–85. New York: Museum of Modern Art.

Vaughan, James H., Jr. 1973. əŋkyagu as artists in Marghi society. In d'Azevedo, Warren, ed., 163–93.

Washburn, Sherwood L., and Elizabeth R. McCown, eds. 1978. *Human evolution: Biosocial perspectives.* Menlo Park, Calif.: Benjamin/Cummings.

Watson-Gegeo, Karen A., and D. W. Gegeo. 1986. Calling-out and repeating routines in Kwara'ae children's language socialization. In Schieffelin, Bambi B., and Elinor Ochs, eds., *Language socialization across cultures,* 17–50. Cambridge: Cambridge University Press.

Watzlawick, Paul, Janet H. Beavin, and Don D. Jackson. 1967. *Pragmatics of human communication: A study of interactional patterns, pathologies, and paradoxes.* New York: Norton.

Weber, Eugen. 1987. Magical mud-slinging. *Times Literary Supplement* (London), 24 April, 430.

West, Rebecca. 1977. The strange necessity. In *Rebecca West: A Celebration.* New York: Viking. (Original work published 1928.)

White, Leslie. 1969. *The science of culture.* New York: Farrar, Straus and Giroux.

White, Randall. 1989a. Production complexity and standardization in early Aurignacian bead and pendant manufacture: Evolutionary implications. In Mellars, Paul, and Chris Stringer, eds., 366–90.

————. 1989b. Visual thinking in the Ice Age. *Scientific American,* July, 92–99.

Whorf, Benjamin. 1956. *Language, thought, and reality.* Cambridge: MIT Press.

Whybrow, Peter. 1984. Contributions from neuroendocrinology. In Scherer, Klaus, and Paul Ekman, eds., 59–72.

Willis, Liz. 1989. *Uli* painting and the Igbo world view. *African Arts* 23, no. 1 (November): 62–67.

Willis, Paul E. 1978. *Profane culture.* London: Routledge and Kegan Paul.

Wilson, David Sloan. 1989. Levels of selection: An alternative to individualism in biology and the human sciences. *Social Networks* 11, 257–72.

Wilson, David Sloan, and Elliott Sober. 1988. Reviving the superorganism. *Journal of Theoretical Biology* 136, 337–56.

Wilson, Edward O. 1975. *Sociobiology: The new synthesis.* Cambridge: Belknap Press.

————. 1978. *On human nature.* Cambridge: Harvard University Press.

————. 1984. *Biophilia.* Cambridge: Harvard University Press.

Wilson, Peter J. 1980. *Man, the promising primate.* New Haven: Yale University Press.

Wind, Edgar. 1965. *Art and anarchy.* New York: Knopf.

Winner, Ellen. 1982. *Invented worlds: The psychology of the arts.* Cambridge: Harvard University Press.

Winner, Ellen, Margaret McCarthy and Howard Gardner. 1980. The ontogenesis of

metaphor. In Honeck, Richard P. and Robert R. Hoffman, eds., *Cognition and figurative language*, 341–61. Hillsdale, N.J.: Erlbaum.

Witherspoon, Gary. 1977. *Language and art in the Navajo universe*. Ann Arbor: University of Michigan Press.

Wolfe, Tom. 1975. *The painted word*. New York: Farrar, Straus and Giroux.

Wollheim, Richard. 1968. *Art and its objects*. New York: Harper and Row.

———. 1987. *Painting as an art*. London: Thames and Hudson.

Worringer, Wilheim. 1953. *Abstraction and empathy*. Translated by Michael Bullock. New York: International Universities Press. (Original work published 1911.)

Young, J. Z. 1971. *An introduction to the study of man*. Oxford: Oxford University Press.

———. 1978. *Programs of the brain*. Oxford: Oxford University Press.

———. 1987. *Philosopohy and the brain*. Oxford: Oxford University Press.

Zajonc, R. B. 1984. The interaction of affect and cognition. In Scherer, Klaus, and Paul Ekman, eds., 239–46.

Zuckerkandl, Victor. 1973. *Sound and symbol: 2. Man the musician*. Princeton: Princeton University Press.

Index of Names

Index of Subjects

AARON: computer program as artist, 162–64; drawings by, 163

Adaptationist argument: criticism of, 22, 230; usefulness of, 22–23; inadequacy of San Marco spandrel analogy in, 230

Adaptive traits, necessity for compromise among, 230

Adornment: as essential, 102; Western view of as superficial, 249. *See also* Dress

Aesthetic detachment: described, 130; resemblance to scientific thought of, 131; not easily achieved, 131; question of universality of, 131–32, 240. *See also* Disinterest as aesthetic attitude

Aesthetic emotion: concept of, 24–25; nature of, 140; as delayed gratification of expectation, 162

Aesthetic empathy: in individuals, 186–88; in arts of premodern societies, 188–92

Aesthetic experience(s): as cultural control of "natural" response, 130–135; qualities responded to in, 131–32; in Kaluli, 132; to postmodernists, 133; as privilege of elite, 133, 135; in modernist tradition, 133, 197; as rapture and self-transcendence, 133, 135; reason for ineffability of, 153; relation of brain lateralization to, 154. *See also* Aesthetic response(s)

Aesthetic preferences as selectively valuable, 54, 111

Aesthetic response(s): nineteenth and twentieth century attitudes toward physicality of, 141–42; haptic perception in, 146; kinesthesis in, 146; tactility in, 146. *See also* Psychobiology of aesthetic responses

Aesthetics, historical origin of Western philosophical study of, 39, "the aesthetic" as ideology, 247.

Affect. *See* Emotion

Affect amplification, in Tomkins, 179–80

281